Quilt Arts of South Africa

THREADED LEGACIES

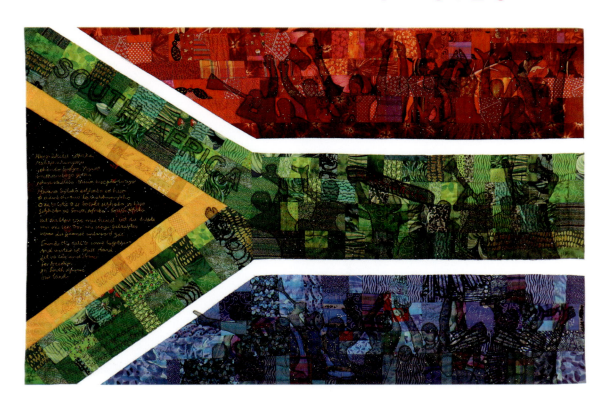

edited by
MARSHA MacDOWELL

INDIANA UNIVERSITY PRESS

This book is a publication of

Indiana University Press
Office of Scholarly Publishing
Herman B Wells Library 350
1320 East 10th Street
Bloomington, Indiana 47405 USA

iupress.org

© 2025 by Indiana University Press

All rights reserved
No part of this book may be reproduced or
utilized in any form or by any means, electronic
or mechanical, including photocopying and
recording, or by any information storage
and retrieval system, without permission
in writing from the publisher.

Manufactured in China

First Printing 2025

Library of Congress Cataloging-in-Publication Data

Names: MacDowell, Marsha, editor.
Title: Quilt arts of South Africa : threaded
 legacies / edited by Marsha MacDowell.
Identifiers: LCCN 2024058692 (print) | LCCN
 2024058693 (ebook) | ISBN 9780253072580
 (hardback) | ISBN 9780253072603 (epub) |
 ISBN 9780253072597 (adobe pdf)
Subjects: LCSH: Quilts—South Africa.
 | Quiltmakers—South Africa.
Classification: LCC NK9189.8.S6 Q55 2025
 (print) | LCC NK9189.8.S6 (ebook) | DDC
 746.460968—dc23/eng/20250208
LC record available at
 https://lccn.loc.gov/2024058692
LC ebook record available at
 https://lccn.loc.gov/2024058693

Quilt Arts
of South Africa

CONTENTS

Preface vii
Acknowledgments xi

The Border: *Piecing Together a History of Quilts and Related Textiles in South Africa* / MARSHA MACDOWELL 1

1. Traditional Bedding and Cloak-Blankets of the Indigenous People of South Africa / MENÁN DU PLESSIS 59

2. South African Kappies / VICKY HEUNIS 69

3. The Heritage Quilt: The Anglo-Boer War Women's History Quilt / VICKY HEUNIS 75

4. The Boer War Quilt: Discovering History through Studying a Textile / MICHAEL WALWYN 81

5. Isishweshwe: A Blueprint Fabric in Southern Africa / JULIETTE LEEB-DU TOIT 89

6. Potchefstroom: A Regional Center of South African Quilt History / MIEMS LAMPRECHT 103

7. The South African Quilters' Guild / ELSA BRITS 109

8. Fibreworks: A South African Textile Artist Organization / JEANETTE GILKS 113

9. Zamani Quilters of Soweto / MARSHA MACDOWELL 119

10. A Lone Star in Africa / DAWN PAVITT 129

11. The Empowering Stitch / SANDRA KRIEL 133

12. Amazwi Abesifazane—Voices of Women: A Textile History Collection / CORAL BIJOUX 137

13. South Africa, AIDS, and Quilts /
MARSHA MACDOWELL 141

14. The *Keiskamma Guernica* / BRENDA SCHMAHMANN 149

15. The Tapestries of the Bushman Heritage Museum, Nieu Bethesda / JENI COUZYN AND ARTISTS FROM THE BUSHMAN HERITAGE MUSEUM, NIEU BETHESDA 155

16. Defining a South African Quilt Aesthetic /
MARSHA MACDOWELL 163

17. Common Ground, Building Bridges: The Women of Color Quilters Network and South African Quilt Artists /
MARSHA MACDOWELL, CAROLYN MAZLOOMI, AND PATRICIA TURNER 185

18. The Quilt Index: South African Quilt History, Preservation, and Access / MARSHA MACDOWELL 195

Bibliography 199
Notes on Contributors 221
Index 223

PREFACE

Marsha MacDowell

A "quilt" is a material object that has many variations on a fundamental form. In its most basic form, a quilt is a rectangular-shaped textile, a "whole cloth," made by sewing three—but sometimes two—layers of fabric together. The variations on how this basic form is constructed are seemingly endless and are conditioned by cultural traditions, fashion, and the preferences of the individual maker. The top might be made of one, two, or many types of fabrics patched, pieced, and appliquéd together. The cloth used in the quilt might be homemade, commercially produced, or recycled fabrics from other sources, such as feed sacks, curtains, worn clothing, or even old quilts. The top might be further embellished with embroidery, painting, appliquéd fabrics, or attached buttons or ribbons. The piecework of the top might be done randomly, in strips, or in an overall pattern formed by blocks. The blocks themselves are usually pattern designs either created by the maker, secured from a friend or family member, or mass-produced, commercially distributed, and widely used. The colors of fabrics used in the block patterns, the way the pattern is "set" (pieced blocks put next to pieced blocks, blocks alternating with plain blocks, blocks set apart by strips of fabric, etc.) and the addition of one or more borders and hems or edging further vary how quilts may appear. The top, middle, and back layers of cloth might be stitched together with bits of string or yarn tied at various intervals or by quilting—sewing through all layers with stitches done in simple or elaborate patterns. The number of variations available to produce the resultant textile are endless. And further complicating the appreciation of that textile is that it might be referred to as a quilt, a bedcover, a blanket, or an example of fiber art. Quilt artists, and those who study and use quilts, take a broad view of what the word *quilt* encompasses. The term *quilt* not only refers to a bed covering constructed by piecing, patching, or appliquéing fabric together but also includes a wide range of artifacts of material culture that share elements of why and how they are made and used and the communities in which they are appreciated.

Quilts are made and used most extensively as bed coverings, but they can also be used for any everyday purpose for which a blanket or rectangular fabric might be used. Importantly, they can also be made by artists as personal expressions of ideas, memories, experiences, and beliefs; often these quilts are intended to be viewed on walls, not beds. The designation of a quilt—like any object—as "art" is inextricably tied to the intentions of its maker and to the cultural context in which it has been made and used.[1]

Quilt studies emerged in the first quarter of the twentieth century and by the close of the century had become a robust realm of scholarship. Individuals with diverse disciplinary and interdisciplinary interests began investigating the production and meaning of quilts. Studies have explored the biographies of individual artists as well as historical analyses of quilting related to geographic regions, cultural groups, religions, memory making, activist responses to community needs or world events, and health and well-being; these have resulted in publications, exhibitions, and digital resources, the acceptance of quilt studies in education, and the formation of major private and public collections. While the overwhelming majority of these studies initially focused on quilts, quilt artists, and quiltmaking in the United States, studies also have been done on the art in countries with long histories of quiltmaking or those with significant numbers of individuals engaged in quiltmaking, such as Japan, Canada, England, Ireland, Australia, France, Netherlands, and Sweden.[2] In the first quarter of the twenty-first century, quilt studies occur in nearly any situation or locale in which quilts or textiles made by similar techniques have meaning and agency.

The words *quilt*, *South Africa*, and *art* are not usually thought to be connected. Yet, in the southernmost region of the African continent, the act of piecing together materials to create bed coverings dates from the earliest Indigenous San and Khoi peoples. From the late seventeenth century through the early nineteenth century, an influx of Dutch, French, Indian, and British—military officials, traders, miners, and missionaries—came to South Africa, bringing with them their cultural traditions, including making and using quilts. There are hundreds of historical quilts in South African museums, especially those connected to the country's colonial-settler heritage. Today, in the first quarter of the twenty-first century, the making of quilts is flourishing. And although the art is predominantly done by artists descended from the colonial settlers, an increasing number of artists of color are now becoming engaged in making quilts for bed coverings and as art.[3]

For a time, especially prior to the formation in 1994 of the new democratic government, there was little scholarly or market interest in this type of expressive material culture. Most often, those artists who were "known" were ones who had used their work as instruments against apartheid. When the anti-apartheid boycott and sanction measures were removed and information and communications between South Africa and the rest of the world was restored, there was a surge of interest in learning about South Africa's historical and contemporary art. World-renowned South Africans such as William Kentridge became even more famous because of their place of origin and the inclusion of references to South African heritage within their work. South African artists such as Willie Bester, Claudette Schreuders, Jane Alexander, and Gerard Sekoto became sought after for museum exhibitions and private, corporate, and public collections. There also was a wave of activity on the part of the South African government to establish income-generating programs for mainly rural Black South Africans that drew on their traditional skills, especially pottery making, beadwork, embroidery, basket weaving, and woodworking. Large craft markets, informal sidewalk and roadside stands, and even national shows, such as the national VITA Craft NOW

Awards, helped draw attention to this work and fostered sales that improved household incomes for artists. Makers of certain traditional artistic forms, such as *imbenge* (the woven-grass lids on Zulu beer pots), were encouraged to use innovative new materials (such as telephone wire and plastic), colorways, and designs to attract buyers seeking to acquire affordable South African art.

Quilts were only a very small part of this vibrant market activity, and even those intended as art by their makers were not accepted as serious art for museums and galleries or for inclusion in African or South African art historical scholarship. Despite the fact that thousands of quilts have been made in South Africa, they were often derogatorily deemed craft or women's work or seen as products mainly of a White colonial-settler artistic tradition; thus, with few exceptions, they were ignored by museum curators, historians of art, and developers of government craft-based income-generation programs.

This book aims to address this oversight and recognize the centuries-long history of this art form in this part of the world. It aims to stitch together, just as quilts are formed, various studies that explore discrete aspects of the production and meaning of quilt history in South Africa, from its earliest appearance in that southernmost region of Africa to the first decades of the twenty-first century. Because the reasons for making quilts, the techniques used in producing quilts, and the spaces in which quilts are made and used often overlap with the production of other textiles, this volume also explores those intersections. For instance, included in this volume is a study of the cloak-blankets of the Indigenous Khoi. When the Khoi artist joins together small fragments of animal hide into a larger "whole" cloth worn as a garment or used to keep a body warm and dry while sleeping, it is not dissimilar to a quiltmaker piecing bits of cloth into a larger textile. Other studies included in this volume examine textiles in which the maker has extensively used appliqué and embroidery on rectangular fabric foundations to create wall-hangings; again this is akin to the techniques used by quilt artists in their work intended either for use on beds or as wall art. Two articles in the volume focus on kappies, South African bonnets that have brims featuring trapunto and quilted designs. All of these textiles share, in their construction and function, connections to the production and use of textiles known as quilts.

Moreover, the book itself is conceived of as a "text quilt." The introductory chapter will provide the framework that, just as textile borders do for quilts, holds together the "pieces" written by curators, linguists, art historians, artist-activists, folklorists, and historians. They were asked to contribute their piece to the text quilt because their particular area of study and practice reflected an aspect of the production and use of quilts and closely related textiles from the early history of South Africa to current times. Each of their voices provides a unique, yet connected, perspective on quilts and related textiles. The articles/pieces are expressed in personal stories, academic essays, and descriptive reports on particular activities, organizations, or quilts; they are varied in size, style, and content. Just as varied pieces of fabric—large and small, simple or complex in design, color, and texture—are sewn together to make a textile quilt of visual coherence and interest, each of these illustrated text pieces is important to "sew" together this text quilt. They connect this expressive art to place, tie the activity

to the unique cultural history and natural landscape of South Africa, and illuminate how the making and use of this art in South Africa is both similar to and yet different from that done in other regions around the world.[4]

Notes

1. See MacDowell, "Folk Arts," 24–29.
2. A good resource for understanding the history and scope of quilt studies is the digital resource World Quilts, https://worldquilts.quiltstudy.org/.
3. Tobin and Goggin, "Introduction: Materializing Women," 1.
4. Throughout this volume the word *Coloured* is used to denote individuals who, under apartheid, were part of a legally defined racial classification—Black, Indian, White, Coloured—designed and used by White South Africans to deny rights. Those classified as Coloured (also today referred to as Camissa) were neither White nor Black South Africans. While the legal classification no longer exists, the term is still commonly used, not in a pejorative way, to indicate those of multiracial, multiethnic backgrounds. The term *people of color* is more frequently accepted today.

ACKNOWLEDGMENTS

My interest in South African quiltmaking was initially precipitated by the investigation of African American quiltmaking, particularly in Michigan. A few of the Michigan quilt artists told about the quilts they made to draw attention to the political imprisonment of Nelson Mandela and then, later, in celebration of his release from prison. At the same time, I was aware that my friend Cuesta Benberry, the late quilt historian who pioneered African American quilt studies, had met and was writing and giving lectures on artists from Soweto, South Africa. When I first went to South Africa in 1997, sent by Michigan State University to conduct a needs assessment of and develop a strategic plan for the museums at the University of Fort Hare (the alma mater of Nelson Mandela and many other anti-apartheid activists), I carried with me my own interest in quilt studies and Benberry's encouragement that I keep my eyes open for quilts and quiltmaking activities. Thus, it is Michigan State University that I would first like to thank for underwriting the trip that, while focused on consulting and collaborative activities with South African cultural heritage workers on cultural heritage practice and policies, allowed me to start what has been nearly two decades of investigation of South African quiltmaking. Simultaneously, I am indebted to Benberry for her generosity in sharing with me information she had gathered and her continued interest as I shared with her what I found.

From 1997 on, I made annual (sometimes bi- or triannual) trips to South Africa as I continued to work on a variety of professional development activities, symposia, and project-based research activities with a group of cultural heritage workers from South Africa and the United States. Along the way I was able to squeeze in visits to artists, quilt exhibitions, quilt shops, art galleries, museums, and crafts-based economic development projects. It was not until 2010, when I was awarded an International Research Fellowship sponsored by the International Quilt Study Center and Museum (now the International Quilt Museum) at the University of Nebraska–Lincoln, funded by the Robert and Ardis James Foundation, that I was able to make quilt research the focus of my time in South Africa. With the generous support of this fellowship, I was able to visit museums across the country and to see the collections firsthand as well as to visit and interview many quilt artists. In short, it had a profound impact on my ability to collect data.

There is one person to whom extra special gratitude must be extended—C. Kurt Dewhurst—my husband and research collaborator for over fifty years. He offered ideas; served as primary chauffeur as we made visits to museums,

artists, and arts organizations; helped photograph and collect data; and read and provided feedback on drafts of this publication. I am indeed thankful for his ever willingness to support me in my individual projects, such as this endeavor. Family members Harlan and Betty MacDowell, Clare Luz, Marit Dewhurst, Nathan Sensel, and Desmondina Sensel-Dewhurst all provided emotional support or travel companionship.

At the Michigan State University (MSU) Museum, a core group of colleagues shared my interest in South African quilts, traveled at least once to South Africa to attend a national quilt conference, supported acquiring examples for our collections, photographed and cataloged quilt acquisitions, input data on South African quilts into the Quilt Index, and have included South African quilts in exhibitions and programs they have curated and conducted. I am grateful for the help and support of Lynne Swanson, Beth Donaldson, Pearl Yee Wong, Yvonne Lockwood, and Mary Worrall. Pearl was responsible for photographing most of the quilts in the MSU Museum collection. Lynne and Beth oversaw the cataloging of objects into the collection, and both provided help in so many other ways as the research project evolved.

The annual special acquisition fund of the Michigan State University Museum, awarded from the MSU Office of the Vice-President for Research and Graduate Studies and the MSU Foundation enabled the purchase of South African quilts and related textiles. This support has allowed us to strategically develop what is a unique collection that is used in multiple exhibitions and research projects and that will undergird further research, teaching, exhibition, and educational uses.

A constellation of curators, collection managers, artists, archivists, scholars, and friends played helping roles, large and small, in this study and in this publication. They accompanied me on travels, shared stories and information, provided encouragement, allowed me to present initial findings in articles and conferences, gave me photographs, and opened up their homes, museums, and studios to me. The generosity of time, knowledge, and resources of the following persons is deeply appreciated: Zaitoonisa Soni-Abed, Karen Alexander, Zohra Areington, Winnie August, Omar Badsha, Glyn Balkwill, Neeshan Balton, Michelle Barnes, Elisabeth Baratta, Helga Beaumont, John Beck, Mimi Behar, Jenny Bennie, Coral Bijoux, Vuyani Booi, Rod Botha, Elsa Brits, Carol Brown, Matilda Burden, Meryl Ann Butler, Annemarie Carrelsen, Hazel Carter, Owen Calverley, Sharon Calverley, Lucinda Cawley, Mwelela Cele, Lucille Chaveas, Linda Chernis, Renfrew Christie, Donald Cole, Abraham Collins, Jeni Couzyn, Pat Cox Crews, Jo Crockett, John Cunningham, Rosalie Dace, Candace Davis, Patricia Davison, Cecilia de Villiers, Sandra De Wet, Hannis Du Plessis, Menán du Plessis, Hlengiwe Dube, Prince Dube, Zohra Ebrahim, Rita Kiki Edozie, Leanne Engelberg, Jutta Farringer, Jutta Faulds, Fatima February, Maretha Flourie, Francois Fouché, Roger Friedman, Margie Garratt, Annette Gero, Jeanette Gilks, Benny Gool, Alison Gwynne-Evans, Neil Stuart Harris, Verne Harris, Grizel Hart, Janet Hasse, Sudré Havenga, Jomien Havenga, Wilma Havenga, Val Hearder, Jenny Hearn, Elrica Henning, Jenny Hermans, Vicky Heunis, Lailah Hisham, David Hlongwane, Barbara Hogan, Marianne Gertenbach, Spike Gillespie, Gretchen Ginnerty, Graham Goddard, Ruendree Govinder, Sue Greenburg,

Dean Jacobs, Robert James, Jonathan Jansen, Natasha Joseph, Anthea Josias, Ahmed Kathrada, Carol Kaufmann, Felicity Khan, Fiona Kirkwood, Natalie Knight, Mark Kornbluh, Lize Kriel, Ina Le Roux, Juliette Leeb-du Toit, Hannah Lewis, Moira MacMurray, Rajaa Majiet, Leonie Malherbe, Pumeza Mandela, Anthea Martin, Nomvula Mashoai-Cook, Carolyn Mazloomi, Bheki Mchunu, Annette McMaster, Betty Mgidi, Neliswe Mkhize, Gwenneth Miller, Vanessa Mitchell, Bongani Mjigima, Khwezi Mpumlwana, Jamie Monson, Geraldine Morcom, Agnes Mosoka, Glenda Nevill, Riana Mulder, Desré Buirski Nash, Diana N'Diaye, Fina Nkosi, Andre Odendaal, Elrica Oliver, Rooksana Omar, Pat Parker, Michele Pickover, Millie Pimstone, Jean Powell, Marilyn Pretorius, James Pritchett, Teddy Pruett, Narissa Ramdhani, Neo Lekgotla laga Ramoupi, Linda Reithman, Diana Riggs, Colleen Roberts, Chris Root, Albie Sachs, Kim Sacks, Razia Saleh, Anthony Sampas, Brenda Schmahmann, Eliz-Marie Schoonbee, Sally Scott, Vanessa September, Maria Sera, Milton Shain, Norma Slabbert, Anja Smith, Susan Sittig, Jim Sleight, Noel Solani, Deon Smit, Margie Smith, Masa Soka, Achmat Soni, Roy Starke, Linda Taylor, Kim Tedder, Erhardt Thiel, Paul Tichmann, Odette Tolksdorf, Gilbert Torlage, Teal Triggs, Morongoe Tsoaeli, Marline Turner, Patricia Turner, Desmond Tutu, Bonke Tyhulu, Janetje Van Der Merwe, Robert Vassen, Ursula Vassen, Shahid Vawda, Jill Vexler, Enid Viljoen, Alberic Vollmer, Mpho Tutu van Furth, Betty Van Zyl, Karen von Veh, Mike Walwyn, Sheila Walwyn, Fleur Way-Jones, Martha Webber, Kate Wells, Bob Wells, Roddy Williams, Jenny Williamson, Rob Williamson, David Wiley, Ulrich Wolff, Janine Zagel, and Vangile Zulu.

The following museums were generous in sharing their collections with me and a portion of them have already allowed their collections to be shared in the Quilt Index (www.quiltindex.org) so that they can be accessible for other researchers around the world: Drostdy Museum (Swellendam), National Museum (Bloemfontein), East London Museum (East London), No. 7 Castle Hill Museum and Bayworld (Port Elizabeth), Albany Museum (Grahamstown), Museum Africa (Johannesburg), Iziko Museums (Cape Town), Stellenbosch University Museum (Stellenbosch), War Museum of the Boer Republics (Bloemfontein), Durban Local History Museums (Ethekwini Municipality, Durban), KwaZulu-Natal Museum (Pietermaritzburg), Msunduzi Museum (Pietermaritzburg), and the Ditsong National Cultural History Museum (Pretoria).

In 2011, the South African Quilters' Guild permitted me to make digital copies of all of their *South African Quilters' Guild Heritage Project* records to date; these records of historical quilts in museums and private collections were an important resource for this study. A thank you to Marline Turner for assistance in accessing the records and a special thanks to Sheila and Mike Walwyn for their volunteer contributions in translating to English those documentation forms originally recorded in Afrikaans.

I am especially thankful for the assistance that Berkley Sorrells provided by proofing and formatting the first iteration of the document and then, along with Beth Donaldson, preparing it for submission to the external readers. Finally, I am deeply appreciative of KellyAnn Wolfe, who created the index.

Quilt Arts
of South Africa

The Border

Piecing Together a History of Quilts and Related Textiles in South Africa

MARSHA MacDOWELL

NEEDLE, CLOTH, AND THREAD are the three basic materials involved in making quilts, a broad term that covers many varieties of pieced and patched material culture. In South Africa, often referred to as the Cradle of Humankind, it is known that early humans clothed themselves in natural materials, and researchers have found evidence of bone needles in sites of human activity in South Africa that date to the Stone Age.[1] Before the advent of iron-forged needles and eventually widely available machine-made steel needles, the peoples of southern Africa used locally available carved bones (often of birds) and the thorns of the mimosa and acacia to piece various animal hides and skins into larger whole cloths.[2] In a late nineteenth-century published account of his travels in South Africa, writer John George Wood observed that "although not so strong, [acacia thorns'] natural points are quite as sharp as the artificial points made of iron, and do their work as effectually."[3] Wood also described in detail the knowledge and skills of those Indigenous individuals who were known in their communities as "kaross makers," those who stitched together pieces of animal hides to be used as cloaks or bed coverings.[4]

> When a kaross maker sets to work, he takes two pieces of the fur which he has to join and places them together with the hairy side inwards, and the edges slightly touching each other. He then repeatedly passes his long needle between the two pieces, so as to press the hair downwards, and prevent it from being caught in the thread. He then bores a few holes in a line with each other, and passes the sinew-fibre through them, casting a single hitch over each hole, but leaving the thread loose. When he has made two or three such holes, and passed the thread through them, he draws them tight in regular succession, so that he produces a sort of lock-stitch, and his work will not become loose, even though it may be cut repeatedly. Finally, he rubs down the seam, and, when properly done, the two edges lie as flat as if they were one single piece of skin."[5]

Wood remarks on the maker's skills and aesthetic sense, stating, "The man who designed this [one owned by Wood] kaross may fairly be entitled to the name of artist. It is five feet three inches in depth, and very nearly six feet in width, and therefore a considerable number of skins have been used in making it.

Figure 0.1.
Kaross (blanket) of dassie skins. South African Museum (SAMAE12674). Photograph courtesy of Iziko National Museums.

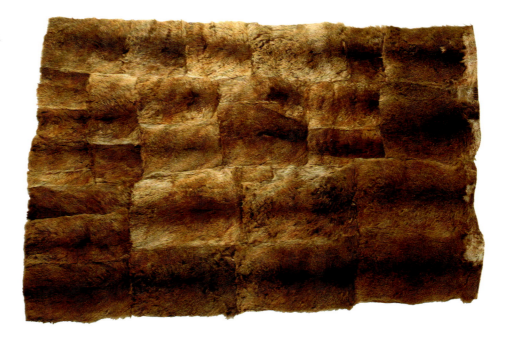

But the skins have not merely been squared and then sewn together, the manufacturer having in his mind a very bold design."⁶ Wood also notes this sewing skill is even more remarkable "when we take into consideration the peculiar needle and thread which he uses.... In the first place, it [the needle] has no eye; and in the second, it is more like a skewer than a needle . . . [and] the thread is made of the sinews of various animals, the best being made of sinews from the neck of a giraffe."⁷ Although Wood was speaking of Indigenous producers of karosses and other patched-together items that formed part of their material culture heritage, chroniclers of clothing worn by early colonial settlers told of making or using items of cloth and patched-together skins.⁸

The documented existence of man-made fabric in South Africa for use in clothing and domestic purposes, including bedding, dates back to 1652 when Jan van Riebeck was sent by the Dutch East India Company to the Cape of Good Hope for the purpose of establishing a refreshment station for traders on this major navigation point on the trade routes between India, the Far East, and the Netherlands. Van Riebeck was accompanied by a small group of men and women, mostly servants of the Dutch East India Company. Among them were two tailors. Although they had only been on land at what is now known as Cape Town for a few days and some cloth was likely among the provisions they brought with them, van Riebeck was already compiling a list of goods to be brought in future shipments. These included "fine and common bleached mouris (cotton) . . . salempoures (the cottons woven at Salem, India) . . . fine ginghams, also colored for outside wear and other stuffs serviceable for the same purpose . . . 1 packet inferior colored chintz, 2 packets cheap negros cloth (printed cotton for trading), 1 packet fine and common percallen (percaline or percale a cambric muslin) and 1 packet guinea linen of cloth."⁹ As the list of fabrics included those typically used in quilts made in that period, it indicates the potential for the making of quilts of cloth in southern Africa at this early date.

Ships carrying goods from China, India, and other Far Eastern sources to major European ports, such as Amsterdam, London, and Lisbon, and then later on to American ports such as New York, Boston, and Charleston, could not avoid rounding the Cape of Good Hope in order to reach their destinations. Cape Town soon grew in settled population and among its early colonial settlers were many that operated small trading businesses, even out of one of the front rooms of their homes. As interior trade routes were established, the Cape Colony became an important trade center on its own.[10] All manner of goods were soon available to the settlers for trade with Indigenous populations as well as to supplement their own production of items needed to establish homes and businesses.

From the late sixteenth century through the early nineteenth century, the influx into South Africa of Dutch settlers, along with their East African, Malay, and Indian laborers, was followed by French Huguenots seeking religious freedom; then British military personnel, traders, farmers, miners, and missionaries; and then later Chinese; members of these groups all brought with them their cultural traditions, including those related to textiles. By 1806, the British had seized the Cape Colony from the Dutch. Over the nearly next two centuries, this southernmost region of Africa saw numerous wars as Indigenous peoples battled settlers for their land rights and traditional governance systems, and then settler groups fought among themselves for land rights, ownership, and governmental jurisdiction. As the settler populations grew, so did the need for goods and the trade associated with goods. Already, by the period of 1750–1850 in the Cape, historian Antonia Malan noted, "All [the colonial settlers] were enmeshed in a world economy of pottery from the English midlands, German needles, Caribbean sugar, American cloth, and other goods and they [the settlers] were drawn inexorably into the net of dependency on European commodities."[11]

This early period of colonial history coincided with the development of important aspects of textile availability, world trade, and fashion that would impact the types of bedcovers and clothing used within South Africa. First, there was a keen interest by western Europeans in Indian cottons and silks, and secondly, there was a transformation in western European tastes for furnishing bedrooms. At the time of the Dutch East India Company outpost in the Cape in 1652, the trade in cotton from India was still in its infancy. As textile historian Rosemary Crill observes, "Both the cotton fabric itself and the dyes and techniques with which the textiles were patterned were completely unfamiliar to most Europeans until the beginning of the seventeenth century. While India had been exporting textiles of all sorts to other parts of Asia and East Africa for centuries, it was only with the arrival of the Portuguese, Dutch and British, all eager to trade with India in the sixteenth and seventeenth centuries, that Indian cottons and silks started to trickle into the European salesrooms."[12] Crill explains that while these newly available textiles had an impact on fashion, they also changed the tastes for interior furnishings. "The arrival of brightly colored, washable, and light cottons from India had a huge impact on the way Europeans dressed themselves and furnished their houses, starting with their bedrooms."[13] In her in-depth study of the trade in chintz, Crill notes that there was a "boom in pieces made specifically as bed-hangings" and "that quilts and palampores (from the Hindi and

Persian word palang-gosh [bedcover]) were ordered in great quantities."[14] In particular reference to construction and design of quilts, she reported, "Quilts were wadded and stitched both in India and in Europe; those made in India were filled with cotton-waste stuffing and those made in Europe with wool. . . . Styles of stitching on quilts also varied; some followed the outlines of the chintz design, while others were stitched in a completely independent pattern." By 1687, however, unquilted palampores were said to have put quilts "quite out of use."[15]

In her study of the interiors of Cape houses from 1670 to 1714, historian Caroline Woodward noted the scarcity of beds and bedding in homes except for those of the more elite. "For many people at the Cape, particularly before 1700, the bed, if they had a bed, together with its often more expensive bedding, was their most valuable possession. . . . One of the most common beds used in this early period was called a *ledikant* [field bed] . . . which could be taken apart and packed into a box or bag, a bed that could accompany its owner from one establishment to another and onto the field of battle."[16] Woodward also reports that beds and bedding were only economically feasible for those of some means; "those of lower ranks of society had to manage with very little. If one had a chest filled with one's belongings on which to sit by day and sleep by night, one was already a couple of moves away from extreme poverty. Many people sat and slept on the floor."[17] By the early eighteenth century, the use of imported and domestic beds became more widespread, and with this, the use of accompanying bedding increased.

The material evidence of historical bedding in South Africa, or even the fabrics of which they are made, is, however, scant. Archaeological investigations are able to unearth fragments of inorganic pottery, wood, and glass to substantiate aspects of domestic life. However, inorganic traces of human activity, like the use of fabrics, were either "used up" or have disintegrated over time. Indication of bedding—and beds—used by settlers in the early colonial period is largely gleaned from written records such as probate records of inventories or estate records such as auction lists. Even then, the documents often tended to simply list bedding as an overall category of goods and did not identify the individual pieces. In her close examination of household goods listed in historical records, Woodward determined that bedding for early settlers of wealth and later settlers of at the least middle class consisted of bed linen made of Dutch linen, Indian cottons, and Chinese silks. She observed that many of the finer households had counterpanes (unquilted fabric top bedcovers) but few had quilts.[18] Although quilts were mentioned by name in historical records, no information was given about whether they were brought by settlers from their home countries, purchased from traders or merchants, or made by those who owned them.

Quilts and other bedding would also likely have been made by enslaved women or indentured servants as they would have sewn clothing and other household furnishings as part of their work. One rare extant silk quilt in the collection of the Iziko Museum alludes to this possibility. The catalog

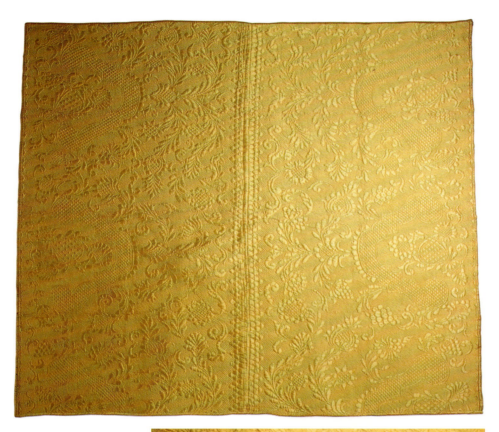

Figure 0.2A.
Eighteenth-century quilt attributed to an unidentified enslaved person.
Collection of the Iziko National Museums. Photograph courtesy of the Iziko National Museums.

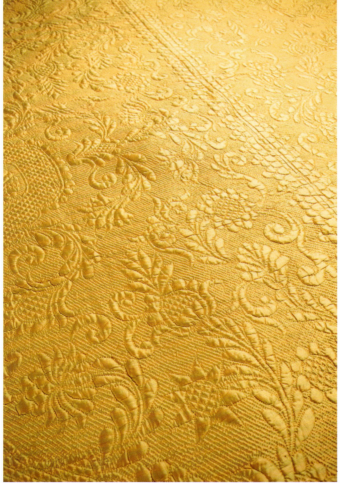

Figure 0.2B.
Detail of figure 0.2A.
Collection of the Iziko National Museums. Photograph courtesy of the Iziko National Museums.

record for the quilt carries the words "alleged to have been made by slaves" and "Jurgens family."[19] Members of the Jurgens family were among the original Dutch East India Company delegation and the estimated eighteenth-century date of the quilt would place it in a time period when slavery was practiced.

Numerous private individuals, especially of colonial-settler descent, and museums in South Africa with colonial-settler cultural heritage collections have historical quilts that date from as early as around the turn of the eighteenth century.[20] The oldest extant quilt known to have been brought to South Africa is in the collection of the National Museum, Bloemfontein. According to researcher Myra Briedenham, it is a baby quilt "made in the Netherlands during 1790 for Johannes Christiaan van Schouwenburg and was later given to Dr. Swinems, second wife of Derk Andries van Schouwenburg. The white work used on the quilt is similar to that used on English, Italian and French white work quilts of the 17th and 18th centuries."[21]

Another of the earliest documented quilts was brought to South Africa by one of the 1820 Settlers, a group of about five thousand middle-class immigrants from Great Britain. They were persuaded by the British authorities to leave their homeland and settle as farmers on tracts of rural land in South Africa to create a buffer zone between feuding settled groups of Dutch immigrants. Within three years, almost half of these 1820 Settlers had moved from those rural areas to established towns, notably Grahamstown and Port Elizabeth, to pursue the jobs similar to those they had in Britain. Museums in Grahamstown, Port Elizabeth, and East London have several examples of quilts brought by the 1820 Settlers from the British Isles. Many of these quilts employ the use of the central medallion-style design, the hexagon or mosaic block patterns, and paper piecing construction techniques popular at the time in England, Ireland, and Wales.

The earliest known quilt *made* in South Africa is owned by the Drostdy Museum in Swellendam. According to museum records, it was made around 1805 by Sara Christina Munnik (nee Dreyer), who was born July 17, 1768. Dreyer was born in the Cape of Good Hope and was part of the original

Figure 0.3.
Detail of the Van Schouwenburg quilt. Dr. Floris van Schouwenburg of Bloemfontein donated this quilt made for a baby's bed to the museum in December 1962.
Collection of the National Museum, Bloemfontein.
Photograph courtesy of the National Museum, Bloemfontein.
For more on this work, see Myra Briedenham, "The Van Schouwenburg Quilt," *CULNA Magazine of the National Museum, Bloemfontein* 48 (April 1995): 37.

Figure 0.4.
"This pieced and unquilted bedcover was made by Sarah Pike, daughter of the 1820 settler Elijah Pike. The top is made entirely of simple cotton fabrics, the center being appliquéd surrounded by a border of machine-stitched triangles and squares. The backing is a type of cotton sateen in a floral design in shades of bronze and green on a cream background." (Margie Smith, email communication to Marsha MacDowell, January 14, 2011.) The dimensions of the piece are 2-½ × 2-½ yds. Private collection.

settlement of the Cape Dutch Colony. Her parents were among the first owners of a farm at the foot of Constantia in Cape Town. Dreyer married Jan Albertus Munnik on May 2, 1790. The quilt is made of satin, brocade, damask, and shaded taffeta. Most of the brocade used in the center of the quilt was from leftover pieces of her mother's dresses. The embroidered flowers used in the hexagons of the pattern came from silk handkerchiefs.[22]

Beginning in 1836, thousands of original settlers, mostly farmers of Dutch origin and known collectively as Boers, left the Cape Colony for more inland regions of southern Africa, where they could establish farms and live without British control. Calling themselves Voortrekkers (or pioneers), they traveled mainly by wagons, often in wagon trains (groups of wagons). Along their trek, most slept on the ground, but sometimes, according to furniture historian Matilde Burden, "they used wooden bed frames which were carried on the wagon during the day. At night the bed frame was hung from the undercarriage of the wagon by leather thongs tied through metal loops or holes in the four corners of the frame. When these pioneers reached their destinations and set up homesteads, they often fitted the bed frames with legs to create freestanding bedsteads."[23] Bedding, along with weapons, furniture, clothing, fruit trees, and agricultural implements, was known to have been carried on the wagons.[24] Quilts were among the bedding items known to have been made and used by Voortrekkers; numerous South African museums hold examples in their collections. Textile historian Anne Marie Carrelsen has noted that Voortrekkers frequently used orange-colored fabrics in their clothing and quilts.[25] Thus, the presence of orange fabric in a historical South African textile may be a clue to its provenance even when other forms of documentation are not available.

The Border

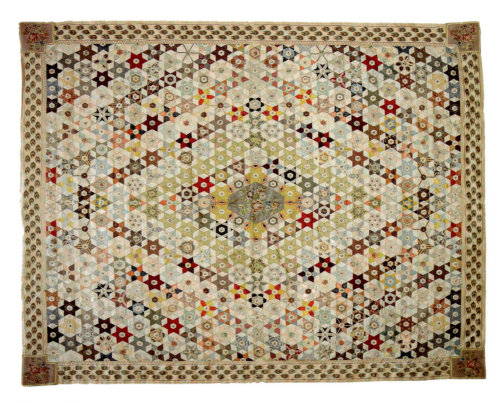

Figure 0.5A.
Hand-pieced and embroidered quilt by Sara Christina Munnik (nee Dreyer), 1805. The embroidered flowers used in the hexagons were sourced from silk handkerchiefs. Sara Dreyer was born July 17, 1768, in the Cape of Good Hope and was part of the original settlement of the Cape Dutch Colony. She married Jan Albertus Munnik on May 2, 1790. The quilt was donated to the Drostdy Museum by Mrs. E. Edmunds, a descendant of the artist from Luanshya, Zambia.
Collection of the Drostdy Museum, Swellendam, South Africa. Typescript paper by Ronel Pristorius prepared for 2021 South African National Quilt Festival.

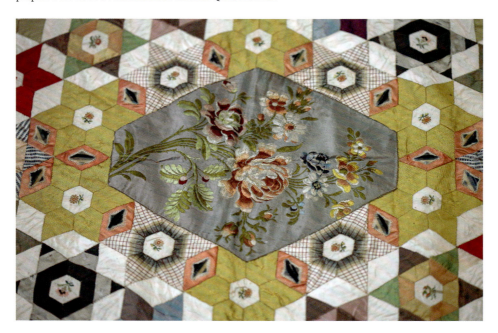

Figure 0.5B. Detail of figure 0.5A.

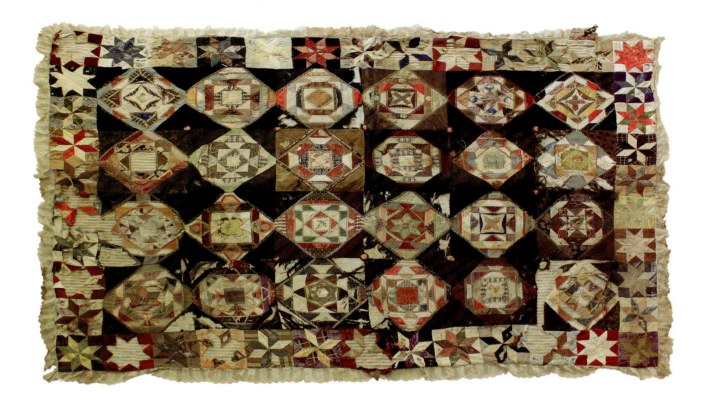

Figure 0.6.
Pieced, embroidered bedcover of satins, corded silk, and velvet brocade by an unidentified artist, c. 1867, 64.56 in. wide × 77.95 in. long. Ladybrand, Free State, South Africa.
Collection of the National Museum of Bloemfontein, donation of P. H. Sevenster. Photograph courtesy the National Museum of Bloemfontein.

Although fabric and needles became increasingly more easily available in the more settled areas of South Africa, in the more isolated interior and especially among the Voortrekkers, it was very difficult to obtain cloth, patterns, and thread. In 1915, Hendrina Joubert, who participated in the Great Trek as a young girl, reminisced, "Sometimes salesmen from the Cape or overseas would travel with the trekkers, and a small packet of needles would cost half a crown. It was the same with thread. We had to carefully pull old threads out of old clothing, in lovely long strands. And the needles . . . A woman would only have one needle, and that would have to last her six months or longer. If the point of a needle broke, we carefully sharpened it again on a stone. We worked with a needle until there was nothing left except the eye."[26] It is likely that in rural households or in those where cloth was economically constrained, cloth and skins were combined to construct bed coverings.

Quilting and Clothing

The use of quilting in clothing can be traced in South Africa to the early eighteenth century. Clothing historian Daphne Strutt observed that "quilted petticoats, very fashionable between 1710 and 1740, of plain silk or satin were often made by their owners but could be bought ready made for about R3.50. Their making was a favourite hand-work and patterns were bought or designed by the maker. They were usually white, greenish-white, green or yellow."[27] Women wore these petticoats for comfort and warmth and "at the same time, men wore quilted banyans, also for warmth."[28]

The Border 9

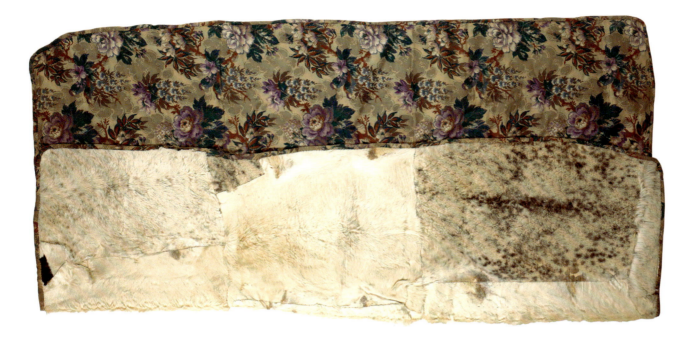

Above, **Figure 0.7A.**
Pieced bedcover of cotton and animal skins.
Collection of Museum Africa.
Photograph courtesy of Museum Africa.

Right, **Figure 0.7B.**
Detail of figure 0.7A.

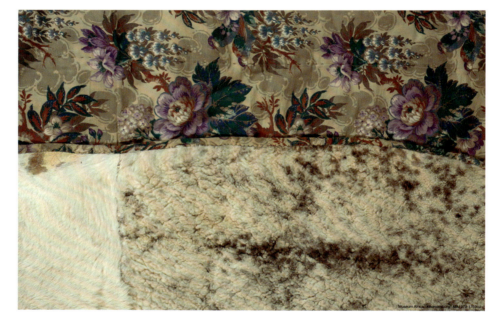

The one item of quilted apparel associated with colonial-settler history that became especially popular in the early nineteenth century is the kappie (Afrikaans for bonnet) made and worn by the Voortrekker women.[29] Often made of elaborately embellished corded one-color cotton, the kappie became a symbol of Afrikaaner heritage and, at of the beginning of the twenty-first century, is still worn at Afrikaaner festivals and by historical reenactors at Afrikaaner events. Most museums in South Africa that are dedicated in part or wholly to preserving settler history have kappies in a variety of colors and styles in their collections.

Late Nineteenth-Century Quiltmaking and Quilts

The discovery of diamonds and gold in the late nineteenth century dramatically altered South African history and attracted thousands of more settlers from Great Britain. The making and use of quilts was already a part of middle-class experience of women in Great Britain during that time, so it is no wonder that quilts were included in the settlers' attempts to retain a semblance of their cultural customs within a new land. Historical quilts preserved in public and private collections are primarily from this era. When compared with those of the same period recorded in quilt history documentation projects in Australia, Canada, Britain, and the Eastern Seaboard states in America, quilts documented in the South Africa Quilt Heritage Project reveal the use of similar techniques, patterns, and fabrics. The quilts provide visual verification of the distribution of goods and cultural knowledge from Great Britain to other countries with governmental and trade ties to the British Empire.[30]

There are few extant quilts of simple patchwork designs. Whether or not this paucity of examples in collections is because more simple ones were just used up or because examples of more complex patterns were more valued by the makers and their families is unknown. Many examples of quilts in star, log cabin, and mosaic designs as well as in the crazy-quilt style can be found in cultural heritage collections. Few of the historical patchwork quilts in South Africa were quilted, likely because the weather conditions were milder than in Great Britain and possibly because padding or batting was not as easily attainable. However, they were often "lined with a patchwork lining, probably because large pieces of fabric were rather used to make dresses."[31]

Reminiscences and Literature about Quilting in South Africa

The existence of numerous nineteenth century and early twentieth century quilts in museums and private collections provides documentation that the making and use of quilts continued in some contexts in South Africa up until present day. This is supported by recorded reminiscences as well as references in South African literature. In her writing, noted South African feminist and author Olive Schreiner provided acute observations of the prevalence of textile making and use, including of quilts. In describing the lives of settlers and farmers of colonial South Africa, Schreiner often refers to the importance of textiles connected to immigrants and their families. "All her life she had dreamed of having a dress made of thick black silk, with large blue daisies with white centres embroidered in raised silk work all over it at intervals. Her mother had had such a bit of silk in a patchwork quilt she had brought from England with her."[32] Schreiner also recognized textiles as both art and text. "The poet, when his heart is weighted, writes a sonnet, and the painter paints a picture, and the thinker throws himself into the world of action; but the woman is only a woman, what has she but her needle? . . . Has the pen or pencil dipped so deep in the blood of the human race as the needle?"[33]

A reminiscence by Eliza Butler, writing in 2003, noted the financial costs and familial connections of quilts: "I have heard my mother say in her mother's time

print was often used for wedding dresses & cost as much and more than 3/6 per yard. Pieces would be exchanged between friends to help towards a wonderful patchwork quilt to be handed down one or two generations, and quilting these quilts was quite an art and industry."[34]

South African author Pauline Smith based many of her poems and short stories on her memories of her childhood. References to quilts are sprinkled through her work and one poem is devoted to the patchwork dress worn by a domestic worker named Katisje. In the line "Of many a print the dress was made (all sizes were the pieces)" and the one revealing Katisje's knowledge of the sources of the pieces, "An' dese from oubaas Daanie's vrouw [these from old boss Daanie's woman]," Smith provides both a physical description of patchwork and a sense of the meaning that the dress had for the wearer.[35] In her book *A Quilt of Dreams*, South African novelist Patricia Schonstein uses quiltmaking as a metaphor for piecing together culturally disparate lives over generations.[36]

Factors Impacting Engagement in Quiltmaking

As can be seen from previous sections of this introduction, the presence of quilts and quiltmaking in South Africa stems primarily from the time of the colonial settlements of the seventeenth century, and the evolution of its history has been heavily conditioned by economic and racial factors as well as opportunities to learn the art. First, since the art form is associated with a colonial rather than Indigenous heritage, quiltmaking in South Africa gained widespread popularity predominately within populations of western European descent. South Africans of Indian descent made, and still make, quilted comforters with tops typically rendered in one whole cloth and not in pieced or appliquéd designs. Black South Africans typically had only intermittent exposure to quilts and quiltmaking, largely through their employment as domestic workers in White South African households or, later, as participants in job creation projects. Second, the costs associated with quilting also limited engagement in some forms of the art. Although quilts can certainly be made with recycled fabric and the basic tools of thread and needle, costs can add up for artists who choose to buy new fabric or use sewing machines to create more sophisticated patterns.[37]

In other parts of the world, especially the United States, Canada, Great Britain, Australia, and other western European countries, the acquisition of quiltmaking skills historically happened at home or with community groups. In South Africa, most women learned to sew as a young person, typically being taught by their mother or another female relative or by instructors in home economics-type courses. The making of quilts, however, was not part of these early learning experiences. In South Africa, quiltmaking was not associated with the kind of familial, social, and religious contexts in which the art was learned in other countries. The structural societal support systems that encouraged engagement in quiltmaking did not really exist until the late twentieth and early twenty-first centuries with the formation of the quilt guilds and textile arts organizations.

The cultural boycotts and restrictions on trade and communication under apartheid also impacted the growth of interest in quiltmaking in South Africa. As quilt history publications, how-to books and periodicals, exhibitions, and

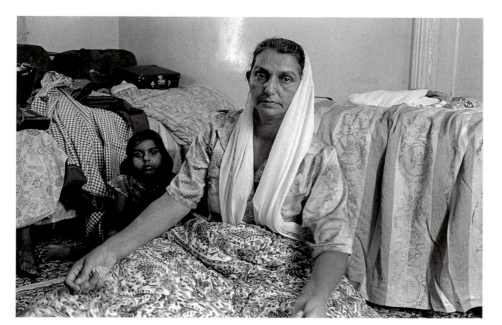

Figure 0.8.
Woman and her quilt, Durban, ca. 1970. Photograph by Omar Badsha, image used by permission of the photographer.

even television and radio shows devoted to quilts proliferated in the United States and elsewhere, these resources rarely found their way to South Africa until the new democratic government was established in 1994. It was not until 1982 that the first quilt history or how-to publication was produced in the country.[38] The end of apartheid meant the opening up of communication channels and increased travel opportunities. Coupled with the establishment of and growing access to the internet, by the end of the twentieth century South Africans could more easily access new materials and information about quiltmaking worldwide.

Quiltmaking and Related Textile Production as Crafts-Based Economic Development

Under the democratic government established in 1994, there was an explosion in economic development initiatives targeted especially for black South Africans in rural and disadvantaged communities. The majority of these were led by the national and provincial governments, nongovernmental organizations, and religious and service organizations. Some were led by artist-activists and often guided by trained textile and graphic designers. All aimed to tap women's traditional skills, especially in sewing and beadwork, to develop marketable products for income generation for the artists. Those efforts resulted in the production of embroidered, patched, and appliquéd bedcoverings and wall hangings.

All of the groups have struggled to develop markets for their work; attention to these textiles has been aided immeasurably by academic scholars, artist-activists, museum curatorial staff, quilting groups of colonial-settler heritage, and tourism workers who have documented and written about these groups, shown their work in exhibitions, and acquired examples for museum collection.[39]

The Mapula Embroidery Project was founded in 1991 as part of an initiative by Soroptimist's International to provide economic upliftment to women in

The Border

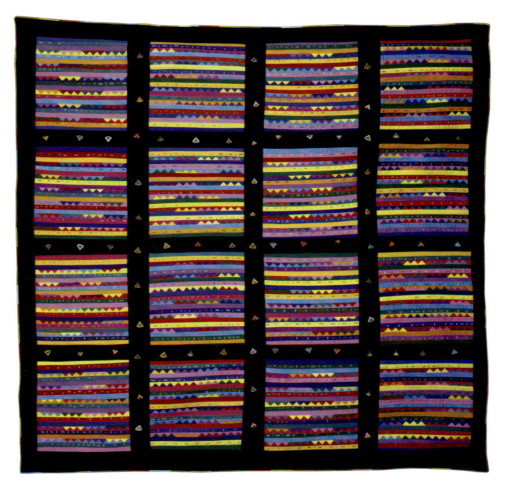

Figure 0.9.
Untitled Quilt by the members of the Ilingelihle Women's Sewing Group Project, Alice, Eastern Cape Province, South Africa, 2002. The project is part of the Adult Basic Education Program of the University of Fort Hare, one of South Africa's historically underserved universities. The women use a technique referred to in the United States as "Prairie Points" in which small, folded pieces of fabric are sewn into strips. "We call it 'Tsolwane,'" says Nomtandazo Mpathi. "It means 'sharp edges.'" Michigan State University Museum Collection: 2002:58.3. Brochure, IIlingelihle quilt acquisition records files, Michigan State University Museum, n.d.

Winterveld, located in the North West Province.[40] The group Isiphethu (from the Zulu word meaning "fountain"), began in 1999, under the aegis of the Carnegie Art Gallery, in Newcastle, South Africa, as a project to create embroidered and appliquéd pictorial pieces for Women's Day. Subsequently their work was sustained by grants from, among others, the South African National Arts Council, the Natal Arts Trust, and the Newcastle Municipal Council.[41]

The University of Fort Hare in Alice, South Africa, is the first institution of higher education established expressly for Black South Africans and is one of South Africa's historically underserved universities. It has prepared many Black South Africans, including Nelson Mandela, for careers that helped them transform the country. The Ilingelihle Women's Sewing Group Project is part

of the university's Adult Basic Education Program and is designed to assist unemployed women living in the Eastern Cape Province. Members of the group make bed-sized pieces, cushion covers, bags, and placemats by sewing together strips of "prairie points" in bright colored, solid cotton fabrics. The strips are then embellished with beadwork and embroidery. Margaret Gidi, a member of Ilingelihle, says: "This job helps us to buy something for our children, some food and you can take your children to school with the little bit of money you get, and you can come to work with the little bit of money."[42]

The Intuthuko (which means "to progress") Embroidery Project is a group of women who use embroidery as a means of building community, raising money, and telling their own stories of life during and after apartheid. Located in Etwatwa, Gauteng Province, the project was established in 2002 "as a community empowerment initiative which seeks to provide poverty alleviation alternatives for 'previously disadvantaged women.' The women make various embroidered products (e.g., conference bags, cell phone pouches, placemats, laptop bags, etc.) which they in turn sell to make a living. Their products/embroideries depict

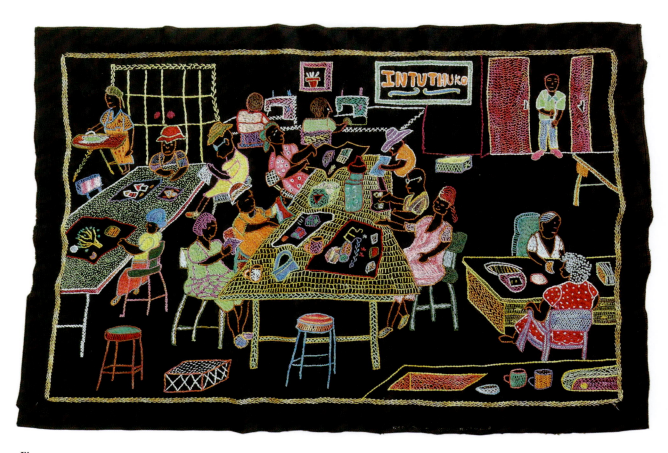

Figure 0.10.
Intuthuko Group Self-Portrait, by members of the Intuthuko Embroidery Project, Etwatwa, South Africa, made of cotton backing and detailed with cotton embroidery thread, 29 in. × 20 in. Made by the women as a gift to Valerie Hearder in appreciation for her selling their art and writing about them. Lesgo (back right), is a young artist who contributed drawings that the women embroidered. Michigan State University Museum, Valerie Hearder Collection 2024:7.12.1. Valerie Hearder, typescript document provided to the author, April 2023.

The Border

their everyday experiences, reflections on the environment, and stories about their surroundings."[43]

The Kaross Workers Embroidery Group was founded in 1989 in the Northern Province by Irma van Rooyen. Two artists, Solomon Mohati and Winnie Makhubela, designed most of the cloth to be embroidered by other members. It was a rare individual group member who is able to secure full-time employment in these projects and the income generated by sales of textiles typically serves as but one source of income. "It is not an uncommon sight to see a woman sitting in her spaza [small store] shop, embroidering a Kaross Workers cloth in between selling phone cards or to see Johannes Mhlongo, a tractor driver, embroidering during his lunch break."[44] In the Kaross Workers project, as in many of the other of the craft-based economic development projects, the textile artist is the sole breadwinner for her immediate and extended family.

The Tambani textile project was founded by Ina le Roux, whose doctoral research centered on traditional stories of the Venda peoples of the North West Province. "Overwhelmed by the lack of economic opportunity in the area she came up with the idea of embroidering the folk tales on quilts, wall-hangings, etc."[45] She got a number of women started on making the textiles and then returned to her home in Johannesburg, where she was able to regularly supply women with fabric and threads, to find markets for the work, and to send badly needed funds back to the women. She found not only was there a limited market for the work in South Africa, but also that the market consisted largely of quiltmakers. At the suggestion of one South African quilt artist, she took work to a large quilt show held annually in Paducah, Kentucky, where Tambani work was so well-received that she began annually attending the show and then added another US quilt show, held in Houston, Texas, as a second annual marketing outlet.[46]

Another project that focused on using pictorial quiltmaking as a means to share traditional stories to foster income generation is the Pomegranate Quilters of the Bethesda Arts Centre in Nieu Bethesda.[47] Led by poet activist Jeni Couzyn and her artist daughter Tarot Couzyn, the project built on the artistic and oral traditions of the San peoples. A permanent display of their work can be found at the Bushman Heritage Museum and examples of their work have been

Facing, **Figure 0.11.**
A Child of Clay, Tambani Embroidery Project, North West Province, c. 2010, 34¾ in. × 62 in. The inscription on the quilt reads, "Once upon a time, there was a Venda potter. She had no children. She made a child of clay. He took the cattle out to graze. You must never get wet my son. Mbungwa, child of clay. Come home quickly and see the clouds. see the clouds! Run faster. He ran to his mother. One day he Mbungwo was too slow . . ."

According to a card accompanying the textile, "My name is Sani Mudau. When my husband passed away in 2005 life became very difficult. Eni told me not to despair but to come and join her embroidery group. We sit and embroider and get paid for work. That is wonderful for the work to come to us here in the bush. Now that I am the only breadwinner, I place hope on the embroidery. Collection of Michigan State University Museum 11.0015. Photo by Pearl Yee Wong https://quiltindex.org //view/?type=fullrec&kid=12-8-5892. Printed information card, acquisition files, Michigan State University Museum.

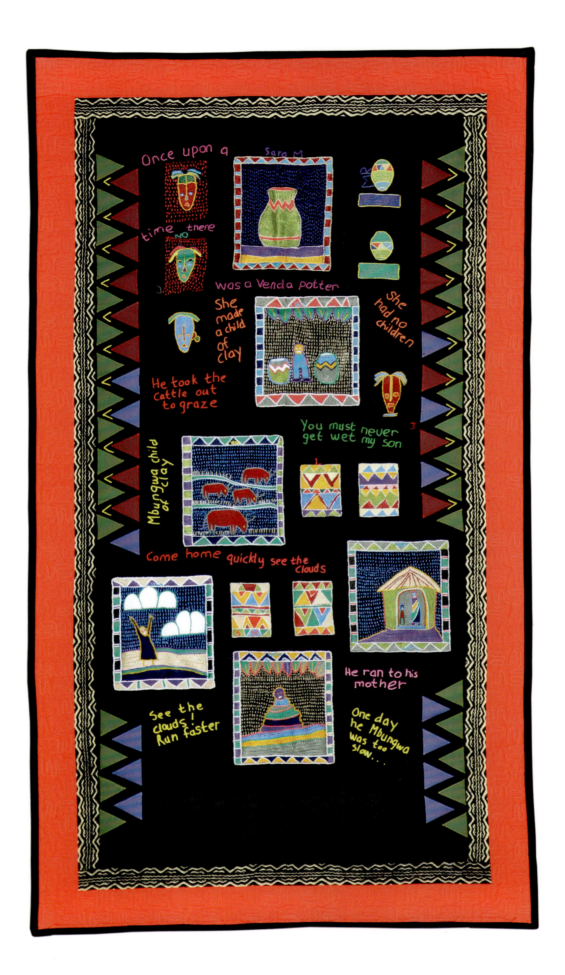

commissioned for the Constitutional Court Building, the British Museum, and Michigan State University Museum.

The Keiskamma Art Project, headquartered in Hamburg, South Africa, also got its start in 2002 with a focus on embroidering historical stories of importance to Xhosa-speaking peoples as well as the role of cattle in their culture. Founding leader, artist, and medical doctor, Carol Hofmeyr oversaw the organization's vision "of building healthy communities in all respects . . . and encouraging hope and support for the vulnerable while working to address issues of poverty through comprehensive programs and partnerships."[48] As the embroiderers expanded their markets and their work received awards, participation in the project by community members grew. With their own increased capacity and with assistance from others, they were able to take on major commissioned work. The project has had a significant impact on alleviating poverty in the Hamburg region and of building the healthier community that Hofmeyr envisaged.

The Zamani Quilting Sisters, based in Soweto, is a rare example of Black South African women who organized and ran a self-help organization and women's resource center largely on their own initiative and with critical but little help from outsiders. Begun in 1987, members were able to secure their own building and sewing machines and have since enabled scores of women to learn and earn income from sewing.[49]

Many quilt guilds of colonial-settler heritage have outreach programs for social good as part of their guild missions. To foster job creation and skill building for economically disadvantaged women, guild members have dedicated time and energy to teaching sewing skills, donating fabric for project members, and including the results of their projects in annual local and national quilt exhibitions.

The Mzansi Zulu Quilt Center, in Merrivale, Kwa-Zulu Natal, is perhaps the only known example of a project established specifically for a group of Zulu women and men to make quilts for income generation. Elisabeth and Rick Baratta, both members of a local Rotary club, started the Rotary Sweetwaters Quilting Guild in 2002. According to Elisabeth, "it gradually grew until we moved from the township to Mzansi Centre. We started with donated fabric and hand and treadle sewing machines. Rotary grants provided electric machines and funds to train more students. Eventually we acquired a long arm quilting machine and went on from there."[50] The Barattas worked tirelessly to promote and market the work; as Elisabeth said, "Over the years we sold hundreds of quilts and wall hangings locally and internationally."[51] The Barattas moved to the United States in 2012 and, without their passionate dedication to market the quilts, the Mzansi Centre folded.

Building Communities of Quilt Artists

Two groups of fiber artists in South Africa have been driving forces in the expansion of interest in the making and appreciation of quiltmaking. The South African Quilters' Guild (SAQG), whose membership of over five thousand largely comprises White South Africans, was founded in 1989, and has twelve affiliated regional guilds. Members stage major regional and national exhibitions, offer instructional workshops—especially in informal communities—maintain

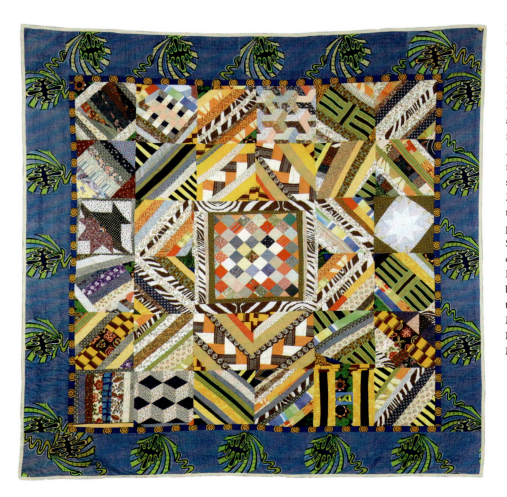

Figure 0.12.
Quilt of various cottons, machine pieced and quilted, Martha Thembiswe Mbanjwa, Merrivale, South Africa, c. 2011. Mbanjwa lives in the Umbulu area of Sweetwaters, a community near Pietermaritzburg. Although she sewed for years for her family, she did not sell her work until she joined Mzansi Zulu Quilt Centre. She then discovered her talents and produced and sold many items. She also became a teacher at the center.
Private collection, photograph by Pearl Yee Wong, courtesy of the Michigan State University Museum. Biography of Elisabeth Baratta, interview with author, March 8, 2011.

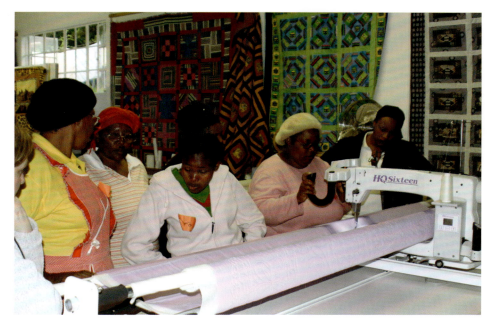

Figure 0.13.
Mzansi quilt workers practice running a longarm quilting machine.
Linda Taylor, email communication with author, July 5, 2022. Photograph by Laurel Barrus. Image courtesy of Linda Taylor.

website resources, and conduct studies and documentation of historical quilts. Fibreworks, formed in 1997, likewise had a tremendous influence on quiltmaking activities, particularly in the acceptance of quilts within the realms of the fine arts market, curatorial, and scholarship world.[52]

In addition to building communities of fiber artists within South Africa, both Fibreworks and the SAQG have fostered connections to quilt artists and organizations around the world. They have brought to South Africa well-known US quilt artists/teachers and have sought opportunities for members to show their work in exhibitions in the United States, South America, Japan, and Europe. Some South African quilt artists hold memberships in such organizations as the US-based Studio Art Quilt Associates. These connections have led to international collaborative exhibitions of work by American and South African quilt artists, notably one in honor of Desmond and Leah Tutu and another in honor of Nelson Mandela.[53]

Although numerous exhibitions in museums and galleries of national crafts have featured work emanating from the aforementioned drafts-based economic development projects, few artists making quilts, whether in traditional or innovative designs, have been shown in these venues. One quilt artist, Margie Garratt, is credited with addressing the need for art quilt exhibitions. Beginning in 1996, she curated Innovative Threads, which she said "serves to educate both the quiltmakers and the public. It encourages quiltmakers to take their art seriously. We demand attention for our art, and we are slowly changing the perception that quiltmaking is only women's work."[54] Curated exhibitions of quilt art were held at a large gallery structure that was part of Nova Constantia Cellars, one of the finest examples of South Africa's early Cape Dutch architecture and which was owned by the Garratt family. Thousands of individuals viewed the quilts, many artists were able to sell examples of their work, and art historians and critics began to view the work as serious craft, if not art.

Quiltmaking Fabrics: Isishweshwe and African Prints

Patchwork and appliquéd textiles can be made, of course, out of many different types of fabric, be it intentionally purchased for the purpose, recycled clothing, or even portions of old quilts. Fabrics from around the world can now easily be purchased online, in fabric stalls at markets or vendor booths at quilt shows, or at any number of fabric stores or quilting shops that can be found across South Africa. When the years of apartheid meant that quiltmakers in South Africa did not have access to the range of fabrics available to textile artists elsewhere in the world, it also meant that quiltmakers were forced to be more inventive with the cloth that they were able to access. Two fabrics, *isishweshwe* and African wax print, became especially favored by contemporary South African quiltmakers.

Isishweshwe, produced in South Africa and marketed around the world, has a long history in clothing traditions in the country.[55] A South African manufacturer of the cloth, Da Gama Limited, located in King William's Town in the Eastern Cape Province, found a new audience among quiltmakers and has expanded its fabric lines to meet this new market. Textile historian Sarah Fee observes that another fabric that gained popularity not in Europe but in Africa

in the second half of the nineteenth century was industrial, imitation Indonesian batik produced by Dutch and British manufacturers and that, much later, in the 1960s, "newly independent African nations established their own cotton-printing factories, so that 'African prints' became widely accepted as a sign of national or African identity."[56] While the wax prints have been more popular in West Africa, these fabrics are also regularly used by South African textile artists, as well as by textile artists in other parts of the world—especially by African Americans—to evoke visual connections with the African continent. As Fee points out though, "while many people today consider industrial prints 'traditional' African [when used in] dress, some studio artists, most famously Yinka Shonibare MBE, question the cloth and use it as a medium to critique the nexus of consumption, enslavement, and imperialism that is bound up with the origins of African prints."[57]

Quilts, Historical Memory, and Activism

Because textiles have been overwhelmingly produced by women, they are sometimes one of the most widespread forms of expression that women have used to record their experiences, feelings, and memories. In countries—like South Africa—where women's access to written literacy was not historically a given, women have sometimes made and used quilts and related textiles for sharing their stories, ideas, and beliefs about histories from the very personal to those that have had widespread, even worldwide impact. Individual tragedies, global pandemics, wars, and political protests are among the events recorded in South African quilts.

The material evidence of experience with historical events in South Africa can be seen in quilts dating back to the late nineteenth century. Several quilts were made by soldiers from Great Britain and Australia who served in the Boer War in South Africa from 1899 to 1902 or who fought in the Anglo-Zulu War of 1879, between the British Empire and the Zulu Kingdom. Similar to other quilts made by soldiers in other wars, they were fashioned out of small patches from the woolen military uniforms, and the quilts were typically of geometric patterns.[58] One, attributed to Millist Vincent, of Tasmania, evokes his experience in the Boer War. It was made of over seven thousand squares.[59] Vincent was one of over sixteen thousand Australians who served in the Boer War.

Another soldier, whose identity remains unknown, created a remarkable quilt depicting the events of the Zulu war.

> This extraordinary woolen military quilt, with thousands of tiny patches, was made in the 19th century from military uniforms and is all hand-sewn. The double edging is "pinked" and the inner squares of tiny diamonds have embroideries of British crowns and flags. Several other embroideries show native huts, spears and shields, a drum and anchors.
>
> Because all of the embroidery refers to the Zulu War, one can assume it was made on site or later when the soldiers reached home. The Zulu warriors' equipment was the shield and the stabbing spear on the quilt.
>
> The Zulu War in Zululand, South Africa in 1879 was notable for a battle at Isandlwana which stunned the world. It was unthinkable that a "native" army,

The Border

Figure 0.14.
Boer War quilt, hand pieced of 7,800 pieces of fabric cut from uniforms of injured soldiers by Millist Vincent II, Tasmania, Australia, 1905, 54 in. × 54 in. (including fringe). Vincent was one of over sixteen thousand Australians who served in the Boer War.
Collection of the Tasmanian Museum and Art Gallery, Hobart. Photography courtesy of the Tasmanian Museum and Art Gallery, Hobart. Notes provided by the Tasmanian Museum and Art Gallery.

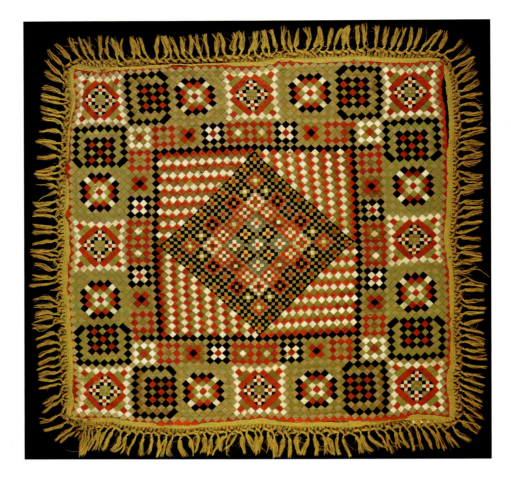

armed substantially with stabbing weapons, could defeat the troops of a western power (the British, 1st Battalion, 24th Foot) armed with modern rifles and artillery, let alone wipe it out.

The news of the disaster and the complete loss of a battalion of troops, was sent by telegraph to Britain, transforming the nation's attitude to the war.[60]

Australian Kate Rodds, reminiscing about her grandmother's home, recalled a couch with "a patchwork cover made of small squares, red, white, and blue scraps from the makings of the dress uniforms of the officers in South Africa."[61] A quilt of a similar technique and materials is associated with the Anglo-Zulu War. The Durban Local History Museum has in its collection an unfinished hexagonal medallion patchwork table cover of Melton wool. According to information provided by the donor, Miss Fanny Pease, who lived in Surrey, United Kingdom, it was made by a soldier from uniforms of men who served in the Anglo-Zulu War and its date was estimated as 1879.[62]

Two other quilts provide visual and textual information about the Boer Wars. An older one, dated 1900, was made by a textile artist only known as M. Bimsom. It carries embroidered inscriptions, words, and depictions of individuals associated with the Second Boer War between Great Britain and the then South

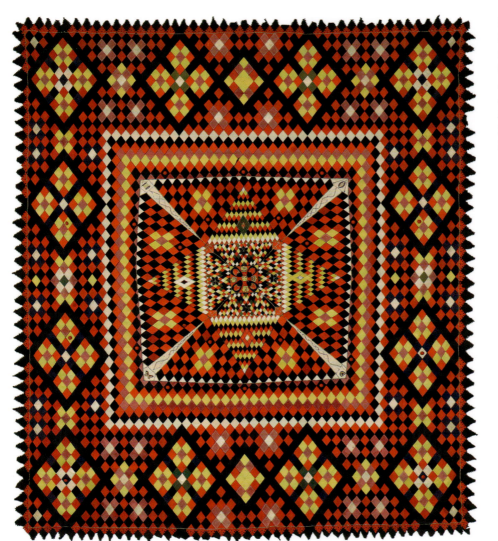

Figure 0.15.
Zulu War Army Quilt, maker unknown, Britain, late nineteenth century, 88 in. × 35 in. Annette Gero, *Wartime Quilts: Appliqués and Geometric Masterpieces from Military Fabrics* (Roseville, Australia: Beagle Press, 2015), 38.

African Republic (see fig. 4.1).[63] A more recent quilt carries visual information pertaining to the Anglo-Boer War of 1899–1902. The War Museum of the Boer Republics, located in Bloemfontein, South Africa, commissioned Naomi Moolman to make it in 2010. Rather than a first-person account of the war, Moolman has curated a visual textile story of it.[64] She drew on historical photographs, owned by the museum and in private collections, of women who did have experience with the conflict as well as of objects affiliated with it (see fig. 3.1.).

One quilt, made by local beginner quilters under the leadership of Susan Sittig commemorates the Sharpeville uprising against the Pass Laws on March 21, 1960, in which the police fired on a crowd of Black protesters, killing sixty-nine people. The quilt now hangs in a church near Sharpeville.[65]

Sally Scott, a well-known South African textile artist, pulled from her own experience with conflict and the experiences of others to produce several works. Her *In Memoriam* visually conveys her reflections on the impact of war on

The Border 23

Facing, **Figure 0.16**
In Memoriam, photographs on canvas and cotton fabric, by Sally Scott, Grahamstown, South Africa, 2010m 6.5 ft. × 30.32 in., 91.34 in. × 30.32 in. Collection of Sally Scott. Photograph courtesy of Sally Scott.

humankind. Scott was born in Rhodesia, now Zimbabwe, and had firsthand experience with the Rhodesian Bush War (1968–80). During a trip with friends to the ruins of Fort Wilshire, she encountered a graveyard that contained the remains of British soldiers and their families. "In January 2010 some friends and I . . . visited Double Drift Fort and went on to explore the now largely disintegrated and overgrown ruins of Fort Wiltshire, the site of a battle during the frontier war of 1818–19." There she saw a graveyard containing the remains of British soldiers and their families. "On inscriptions on the tombstones, I was struck by the intensity of emotion that was etched so deeply into the stones, and found myself reflecting on the meaning of it all." This led her on a journey of writing and, eventually, to expressing her feelings about her own experiences with conflicts and war in general in this textile work. One of the two panels is dedicated to those who died in battle and the other to those who lived. . . . Whichever side of the battle they were on, people were damaged, one way or another. . . . Onto the surface of one panel, Scott embroidered an abridged version of the 1954 poem "Soldiers Bathing" by F. T. Prince. For all men who go to war, an acknowledgement of their sacrifice, both final and ongoing . . . (with special dedication to the men of the Rhodesian Light Infantry).

It is no surprise that members of some of the craft-based economic development projects drew inspiration for their textile work from memories of their own lived histories with the oppressive and human rights–violating laws put into place against South Africans of color by the apartheid government. Art historian Brenda Schmahmann, speaking of such textiles produced in the Mapula Embroidery Project, observed that they "couple high levels of technical and visual artistry with topics that speak eloquently of public histories as well as women's personal experiences."[66] For instance, even though Mapula Embroidery Project members were not personally involved in the student uprisings in Soweto on June 16, 1976, they were aware of the tragedy. They made several pieces based on Sam Nzima's widely circulated photograph of the body of murdered twelve-year-old Zolile Hector Pieterson Hector being carried by Mbuyisa Makhubo that day.

The Amazwi Abesifazane (Voices of Women) Project was established intentionally in 1999 to capture, through oral and textile narratives, the lived experiences of over two thousand rural, mainly disadvantaged, and often illiterate women. Project personnel visited the women; gave them cloth, beads, and thread; and asked them to respond to the prompt "Please tell me about a day you will never forget." The resulting pictorial memory, or story cloths, speaks of harassment by police, domestic brutality, economic hardships, and more.[67] South African scholars Anthea Josias and Ria van der Merwe refer to the Amazwi Abesifazane Project collection of hundreds of cloths as a community archive of remarkable content, one that provides an invaluable historical record of the lives of women during and after apartheid in South Africa.[68] Scholars Puleng Segalo, Einart Manoff, and Michelle Fine suggest that attention to the artists' engagement in this kind of tactile storytelling is a means to understanding the social and psychological landscapes the women occupied. "By using this art-form, the women embarked on a decolonial project where they could tell a narrative in an

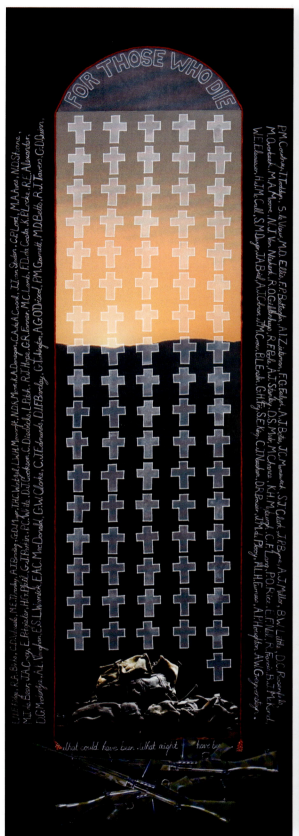
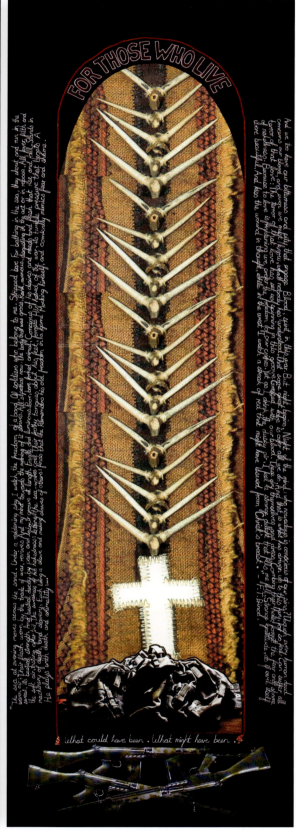

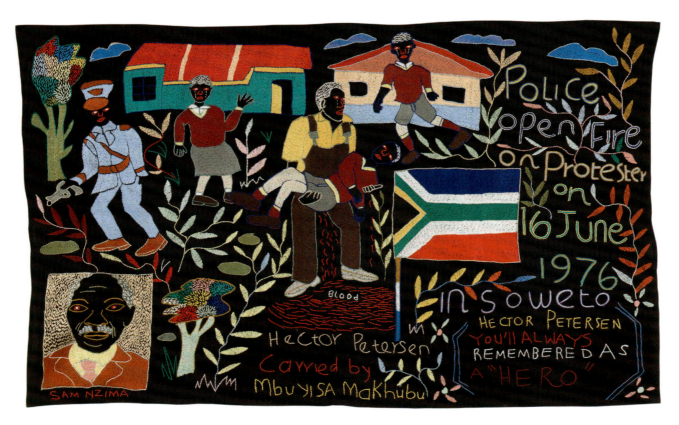

Figure 0.17.
Hector Pieterson—Blood in Soweto, Mapula Embroidery Project, Winterveld, Gauteng, South Africa, c. 2000, cotton, 34 in. × 55 in. Members of the Mapula Embroidery Project, captured in needlework the murder of Hector Pieterson during the student uprisings in Soweto on June 16, 1976. Collection of Fowler Museum at UCLA: X2011.8.3. Gift of William H. Worger and Nancy L. Clark. Photograph by Don Cole, 2016.

artistic and visual way that allows for multiple interpretations of their experiences, thereby negating the notion of a single story that does not acknowledge multiple perspectives and contexts. Using embroidery was a way in which the women could use a skill they already had to break the silence."[69]

Two extraordinary pictorial textiles titled *Journey to Freedom* were produced in 2004 especially for an event at the University of South Africa (UNISA) to mark the tenth anniversary of the new democratic South African government and to reflect on the end of apartheid. Under the direction of UNISA faculty Gwenneth Miller and Wendy Ross and professional artists Erica Luttich, Celia de Villiers, and Sonja Barac, members of the Intuthuko Embroidery Project and the Boitumelo Sewing Group created two embroidered memory quilts. Each square represents one woman's memories. The first panel (see fig. 0.18) depicts such events as the Sharpeville Massacre of 1960, in which the police fired on a crowd of Black protesters, killing sixty-nine, and the student uprising and massacre in Soweto in 1968. The figures with tires around their necks are being "necklaced" (burned to death when gasoline is poured on the tire and ignited)

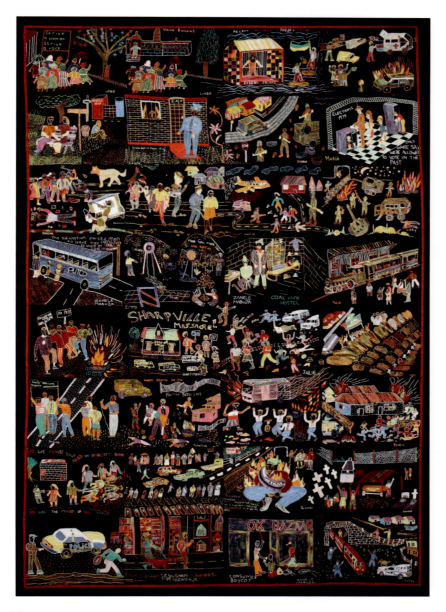

Figure 0.18.
Journey to Freedom, Memory Quilt, Boitumelo Sewing Group, South Africa, 2004, 61½ in. × 90 in. One of two panels made especially for an event at the University of South Africa that reflected on the demise of apartheid. Coordinated by UNISA faculty Gwenneth Miller and Wendy Ross. Each square represents one woman's memories. This panel depicts such historical events as the Sharpeville Massacre of 1960, in which the police fired on a crowd of Black protesters, killing sixty-nine, and the student uprising and massacre in Soweto in 1968. The figures with tires around their necks are being "necklaced" (burned to death when gasoline is poured on the tire and ignited) on the suspicion of collaborating with the authorities.

 Erica Luttich was the professional artist who facilitated and mentored the following individual artists in Boitumelo Sewing Group: Flora Raseala, D. Emmah Mphahlele, Lilian Mary Mawela, Ammellah M. Makhari, Martinah P. Mashabela, Naledzani R. Matshinge, Gloria Melula, Elisa D. Mahama, Linda Mkhung.

Collection of University of South Africa. Photography courtesy of University of South Africa. *Journey to Freedom: Narratives* (Pretoria: University of South Africa, 2007).

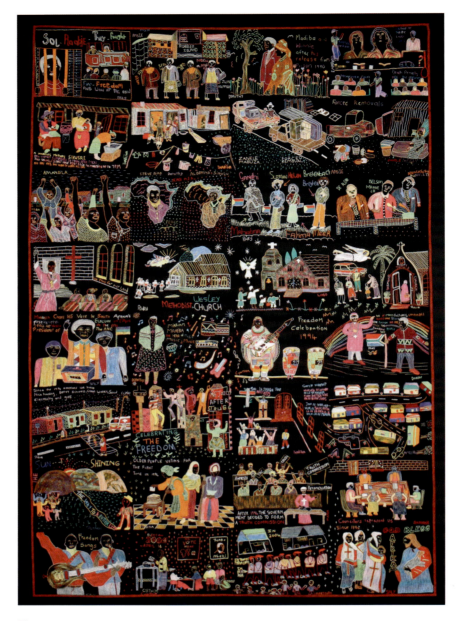

Figure 0.19.

Journey to Freedom, Memory Quilt, Intuthuko Embroidery Project, Etwatwa, South Africa, 2004, 61½ in. × 90 in. One of two panels made especially for an event at the University of South Africa that reflected on the demise of apartheid. Coordinated by UNISA faculty Gwenneth Miller and Wendy Ross. Each square represents one woman's memories. This panel depicts such historical events as the celebrations surrounding the release of Nelson Mandela from prison, the first elections under the new democratic government, and the Truth and Reconciliation Commission hearings.

Celia de Villiers and Sonja Barac were the professional artists who facilitated and mentored the following individual artists in the Intuthuko Embroidery Project: Pinky Lubisi, Thembisile Mabizela, Zanele Mabuza, Angie Namaru, Lindo Mnguni, Julie Mokoena, Salaminha Motloung, Angelina Mucavele, Thabitha Nare, Nomsa Ndala, Maria Nkabinde, Cynthia Radebe, Sannah Sasebola, Rosinah Teffo, Lizzy Tsotetsi, Dorothy Xaba.

Collection of University of South Africa. Photography courtesy of University of South Africa. *Journey to Freedom: Narratives* (Pretoria: University of South Africa, 2007).

on the suspicion of collaborating with the authorities. The second panel (see fig. 0.19) shows events as the celebrations surrounding the release of Nelson Mandela from prison, the first elections under the new democratic government, and the Truth and Reconciliation Commission hearings.[70]

The South African Constitutional Court, located in Johannesburg, commissioned artists affiliated with the Nieu Bethesda Art Center to make two quilts based on the theme of justice. One quilt depicts the biblical healing pool of Bethesda, after which the village of Nieu Bethesda was named. The stirring of the water in the center is Nelson Mandela. The first ripple shows human rights, the second the democratic election, the third is the tenth anniversary of Freedom Day being celebrated in Nieu Bethesda.[71]

Figure 0.20.
Remember Our Fallen Comrades VI for Chris Hani, Sandra Kriel, 1993.
 Felt, embroidery thread, photocopies, beads, plastic, soft drink cans, buttons, 37 in. × 37 in. Collection of Stellenbosch University Museum. Photograph courtesy Stellenbosch University Museum

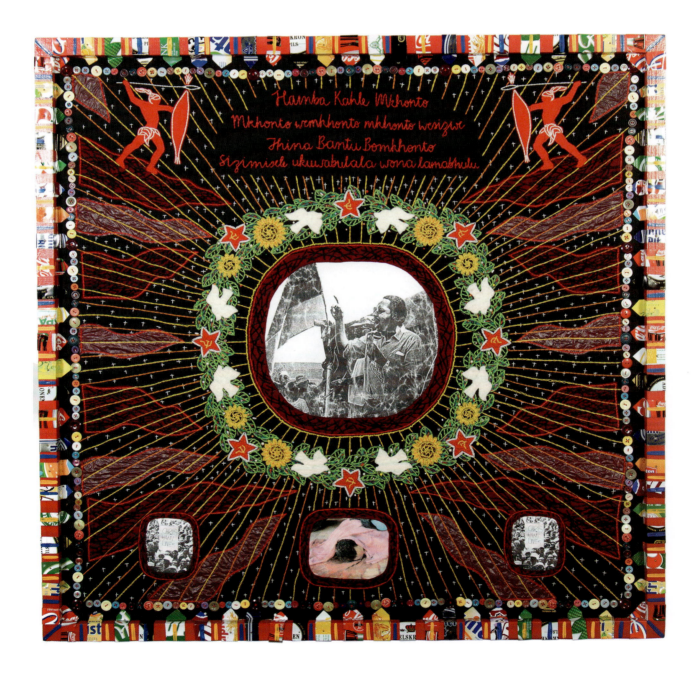

The Border

White South African women artists who supported the anti-apartheid movement and the establishment of a new democratic government also made textiles to express their support. For instance, textile artist Sandra Kriel used phototransfer, piecing, and appliqué techniques to make pictorial statements regarding the activist heroes and critical events, including the Soweto uprising, the Cradock Four, and other critical moments in anti-apartheid history.[72] Likewise, ten years after the 2002 establishment of the new democratic government, Odette Tolksdorf made a quilt celebrating the 1994 democratic election and, as she said, "marking my feelings about this milestone in the country of my birth."[73]

On the tenth anniversary of this historic day, Tolksdorf created another celebratory quilt.

> The tenth-year anniversary of democracy in South Africa motivated me to create this work and voice my feelings about this milestone in the country of my birth. Several years ago I attended a lecture in America by the quilt historian Barbara Brackman. She showed a small banner that had been used in a parade celebrating the Union victory in the USA in 1865. The banner belongs to the Smithsonian Institution and contains the words I have used on my quilt. These words remained in my mind for a long time and they wonderfully expressed my feelings in 2004 about "the new South Africa".
>
> The fabrics I used have historical and political significance in South Africa and added meaning to this work for me.[74]

Although many associate quilts with building a sense of comfort and caring in home and community, these soft fabric creations also can be used for social activism. American quilt artist, historian, and activist Carolyn Mazloomi has noted how quilt artists, especially African American quilt artists, have long used needles as a weapon to combat human and civil rights violations. Through their textile art, quiltmakers have been effective in drawing attention to local and global issues such as xenophobia, racism, land claims, terrorism, and poverty.

Cynthia Msibi (see fig. 0.22) is a member of Isiphethu (Zulu word meaning "fountain"), a craft-based economic development sewing project. Isiphethu began in 1999 when some women from the communities of Madadeni and Osizweni came together to embroider and appliqué images for a Woman's Day project organized by the Carnegie Art Gallery in the nearby town of Newcastle. A formal workshop program was launched in 2000 under the umbrella of the gallery and members of the group are encouraged to attend mentorship programs on business development and quality control.

They have exhibited their work nationally and internationally and won many awards. In 2010, Msibi had this to say about her textile: "Here people are seen rescued by the police after the angry community members attacked them, here the shops have been closed because they've been broken into. And the women and their children have ran [sic] to the police for some help as the other community members approach. The police tried so hard to calm the situation as the members of the community are angry saying that the foreigners are taking their jobs from them causing them to be poor so they must be sent back to wherever they are coming from."[75]

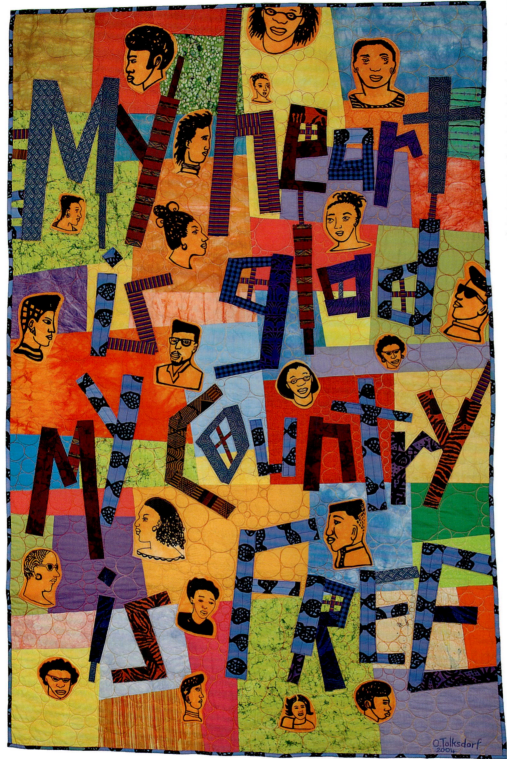

Figure 0.21
My Heart Is Glad, hand-dyed and screened fabrics from Rorke's Drift in rural KwaZulu-Natal and commercial shweshwe prints, featuring machine piecing, fusible web applique, machine top-stitching, and machine quilting. Machine quilted by Bev Essers to Odette Tolksdorf's design, 2004, 65 in. × 38 in. (top) / 43 in. (bottom).
Photograph by Christopher Baker, courtesy Odette Tolksdorf.

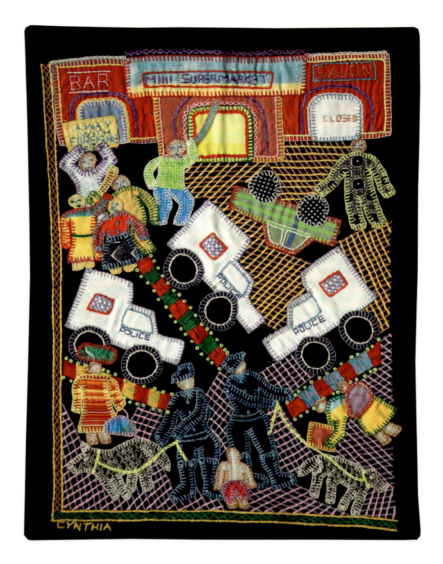

Figure 0.22
Xenophobia Memory Cloth, Cynthia Msibi, Newcastle, KwaZulu-Natal Province, South Africa, 2010, 12½ in. × 16¾ in.

Msibi is a member of Isiphethu (Zulu word meaning "fountain"), a craft-based economic development sewing project. Isiphetu began in 1999 when some women from the communities of Madadeni and Osizweni came together to embroider and appliqué images for a Woman's Day project organized by the Carnegie Art Gallery in the nearby town of Newcastle. A formal workshop program was launched in 2000 under the umbrella of the gallery and members of the group are encouraged to attend mentorship programs on business development and quality control.

 They have exhibited their work nationally and internationally and won many awards. In 2010, Msibi had this to say about her textile: "Here people are seen rescued by the police after the angry community members attacked them, here the shops have been closed because they've been broken into. And the women and their children have ran [*sic*] to the police for some help as the other community members approach. The police tried so hard to calm the situation as the members of the community are angry saying that the foreigners are taking their jobs from them causing them to be poor so they must be sent back to wherever they are coming from."

Cynthia Msibi, interview with author, Newcastle, South Africa, 2011. Collection of Michigan State University Museum: 2010:123.1. Photograph by Pearl Yee Wong, courtesy the Michigan State University Museum.

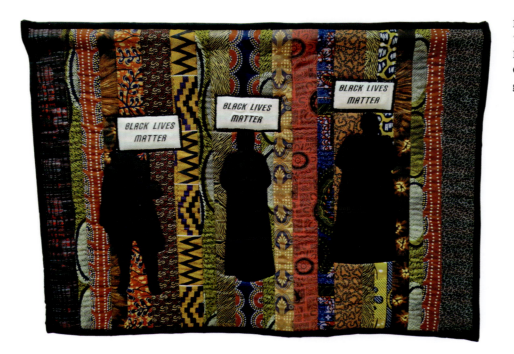

Figure 0.23.
Tribute to George Floyd, Felicity Khan, Cape Town, South Africa Collection of the artist. Photograph courtesy of the artist

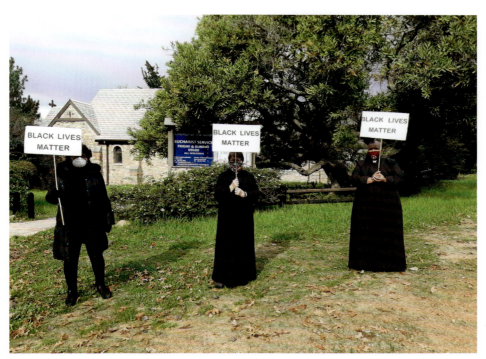

Figure 0.24
Left to right are Felicity Khan, Reverend Jo Tyers, and Reverend Nobuntu Mageza, all of Cape Town. They stand outside along the roadway in Cape Town holding signs protesting the killing by police of George Floyd in Minneapolis, Minnesota. Khan documented this scene in a quilt. Photograph courtesy of the artist.

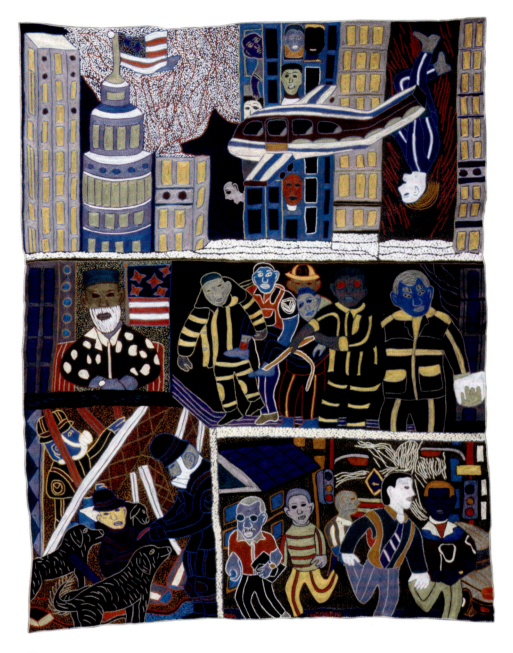

Figure 0.25

9/11, unidentified artists from the Kaross Workers, Letsitele, North Province, South Africa, 2002. Cotton cloth with embroidery, 41 in. × 54 in. In 1988, White South African artist Irma van Rooyen organized the Kaross Workers, a project to provide regular employment for wives of male workers—mostly Tsonga or Venda speakers—on the farm run by her husband in the Northern Province. Five women participated at first, and as of 2004, the number has grown to over four hundred and now also includes a few men. This piece shows the destruction of the World Trade Center in September 2001 and illustrates the access via media that artists, even in remote areas, have to events that resonate around the world.

Collection of the Michigan State University Museum, acc.#2002:58.2. Photograph by Pearl Yee Wong, courtesy Michigan State University Museum

South African quilters have not limited their activism to domestic issues: Cape Town quilter Felicity Khan has called out through her work and art for justice for the murder of Minnesota resident George Floyd by Minneapolis police officer Derek Chauvin (see figs. 0.23 and 0.24). In 1988, White South African artist Irma van Rooyen organized the Kaross Workers, a project to provide regular employment for wives of male workers—mostly Tsonga or Venda speakers—on the farm run by her husband in the Northern Province. Five women participated at first, and as of 2004, the number had grown to over four hundred and included a few men. One important piece by the Kaross workers shows the destruction of the World Trade Center on September 11, 2001, illustrating the access via media that artists, even in remote areas, have to events that resonate around the world (see fig. 0.25).

One quilt with an unusual story of activism against apartheid was gifted to Winnie Mandela. Made by a group of women in West Virginia, it was signed by twenty-six US representatives and senators and then sent to Helen Suzman, who presented it to Winnie Mandela, whose own bedspread had been taken from her while she was under house confinement (see fig. 10.1).[76]

Nelson Mandela and Quilt Tributes

Numerous quilt artists have paid tribute to individuals who were heroes of the struggle for democratic freedom. For instance, Fina Nkosi and Vangile Zulu, two sisters from Soweto, have made several versions of a quilt with fabric portraitures of Black South African women activists and a quilt depicting the ten men sentenced to prison for their political activism at the Rivonia Trial (fig. 0.26).

The Rivonia Trial was held from October 9, 1963, through June 12, 1964. Twelve of thirteen African National Congress leaders accused of treason against the South African government were convicted of sabotage and sentenced to life imprisonment. The trialists included Nelson Mandela, Walter Sisulu, Govan Mbeki, Raymond Mhlaba, Andrew Mlangeni, Elias Motsolaledi, Ahmed Kathrada, Billy Nair, Denis Goldberg, Lionel Bernstein, Bob Hepple, Arthur Goldreich, Harold Wolpe, and James Kantor. All but Nair and Hepple are depicted on the quilt. Rivonia refers to the location of the Liliesleaf Farm, where most of the accused were caught.

Harold Wolpe's nephew, Howard Wolpe, was a US representative from Michigan. A strong anti-apartheid worker, Howard was a primary sponsor of the Comprehensive Anti-Apartheid Act of 1986, which imposed sanctions against American companies doing business in South Africa.

Nkosi and Zulu's quilt is a duplicate of one commissioned of the sister artists by Marsha MacDowell and C. Kurt Dewhurst as a present from Michigan State University to Ahmed Kathrada on the occasion of his eighty-fifth birthday, August 26, 2014.

Nelson Mandela especially inspired quilt artists in South Africa and in countries to make textile pieces that visually honored his sacrifices and leadership in creating a new democratic South Africa. When news of his release from imprisonment was announced in 1990, numerous individuals celebrated by making quilts. Lucille Chaveas, whose husband, Peter R. Chaveas, was United States consul general, principal officer, in Johannesburg, South Africa, from 1988 to

Figure 0.26
Rivonia Trialists, Fina Nkosi and Vangile Zulu, Soweto, Gauteng Province, South Africa, 2014, 67 in. × 73 in. Michigan State University Museum Collection: 2014:24.2. Photograph by Pearl Yee Wong, courtesy Michigan State University Museum.

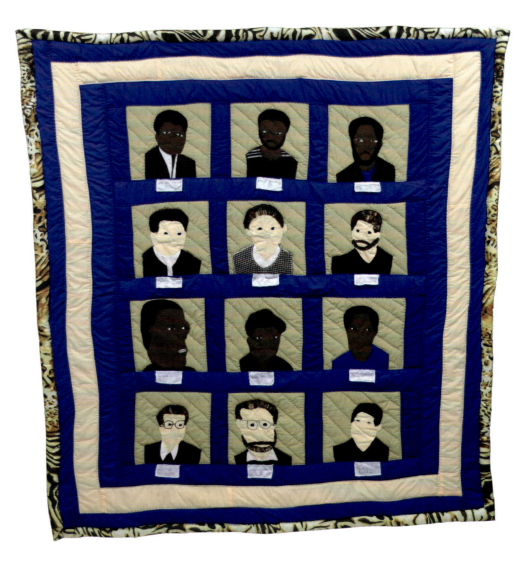

1990, "presented Mandela with, a quilted pillow in the ANC [African National Congress] colours in a variation of the Rocky Road to Kansas pattern which I called the Rocky Road to Freedom."⁷⁷ Lucille, who also regularly visited Helen Joseph, a friend and fellow anti-apartheid activist of Mandela, made a quilt in the same colors: "I have a photograph of Helen using the quilt at the annual Christmas Day toast to the Movement held to honor all those who had died, or were in jail or exile. These gatherings were against the law at the time. Helen died in 1992 at the age of 85 and I have no idea where that quilt might be nor the pillow for Mandela."⁷⁸

Many African American women in the United States also celebrated the occasion by making quilts. Beverly White, an African American woman from Pontiac, Michigan, says of her *Mr. Mandela* quilt, "The inspiration for the *Mr. Mandela* quilt came from the very strong emotions of elation and relief I experienced when he was released from his years of captivity in South Africa."⁷⁹ Carole Harris, of Detroit, Michigan, was inspired to make a quilt she titled *Reclamation*.

She says it was "an expression of the feelings of pride that I and others felt upon seeing Mandela stride out of that prison gate, reclaiming his freedom, our history, ourselves."[80] Hilda Vest, also of Detroit, responded to the news of Mandela's release from prison by making a quilt. As Vest explains, "fascinated by African fabrics since discovering the joys of quilting, I was auditioning scraps of brilliant

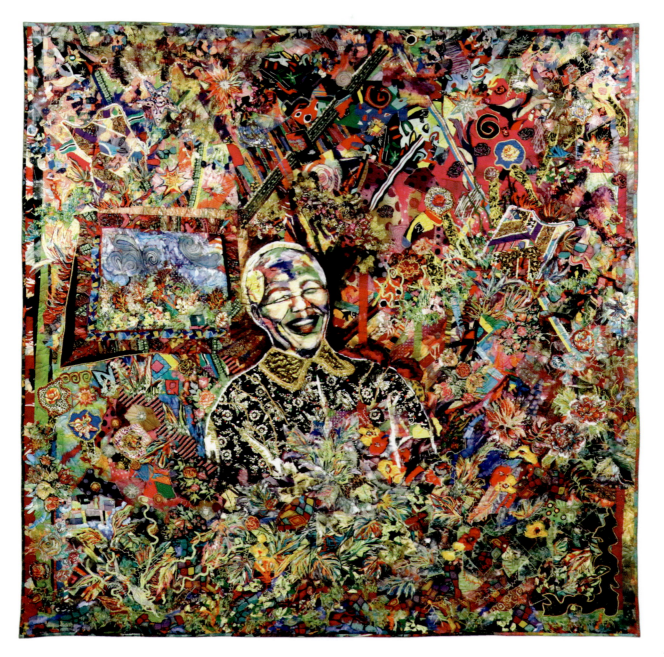

Figure 0.27
Madiba: Prince of Freedom, Roy Starke, Pretoria, Gauteng Province, South Africa, 1995–97, 112 in. × 97 in.
Michigan State University Museum Collection: 2018:49.1. Photograph by Pearl Yee Wong, courtesy Michigan State University Museum.

The Border

colors when news of Nelson Mandela's release from prison flooded the airwaves. How timely, I decided it would be, to fashion the King's X pattern I had already chosen into a humble 'monument' dedicated to his survival after twenty-seven years as a political prisoner. African symbols were incorporated into the quilting, and I proudly embroidered *MANDELA FREED 2-11-90*."[81]

When Nelson and Winnie Mandela came to the United States in 1990 for the first time in what was called the Freedom Tour, they were showered with gifts, including quilts, at each of the venues they visited. The quilts included many made and presented by Native Americans and members of Canada's First Nations. Carolyn Mazloomi, founder of the US-based Women of Color Quilters Network, also made a gift to Mandela of one of her most unique quilts, a quilt that was valued at the time at over $15,000.[82] According to Narissa Ramdhani, formerly Nelson Mandela's personal archivist, she and fellow anti-apartheid activist Irene Menell, founding member of the Liberal Party in South Africa, unpacked 150 quilts in the boxes of presents given to Mandela.[83]

Long after Mandela's release from prison and his Freedom Tour, he continues to be a source of inspiration to textile artists. Textile artist Roy Starke of Rietfontein, who created *Madiba: Prince of Freedom* (fig. 0.27) in 1997, said, "This quilt was inspired by President Mandela of South Africa who spent the best years of his life as a political prisoner on Robben Island."[84] Deeply moved by the freeing of Nelson Mandela from prison, his country's transition to a democratic government in 1990, and Mandela's election as president, Starke made several quilts to express his feelings about these events. In those quilts, he used rainbow colors, referencing the Rainbow Nation and the colors of the South African flag. Of *Madiba: Prince of Freedom* he said, "The joy in creating these quilts is intensely emotional and disturbing . . . the colors, image, and general composition is suggestive of his [Mandela's] 'cosmic' importance." Starke was committed to pushing the notion of quilts as art: "The surface and meaning of the art quilt must be supremely individualistic, passionately expressive and deeply dramatic—the stuff life is made of." [85] Starke's individualistic style included the heavy use of torn fabrics, layered embroidery, and riotous colors. He worked for many years as a flight attendant for South Africa Airways. He took his sewing machine and fabrics with him on long-distance flights around the world, and during the several days of layovers between flights, he would use his hotel rooms as temporary art studios.

In 2016, just three years after Mandela's death, over eighty artists from the United States and South Africa made quilts for an exhibition, *Conscience of the Human Spirit: The Life of Nelson Mandela, Tributes by Quilt Artists from South Africa and the United States*, held in Johannesburg, and a portion of the exhibition showed later at Michigan State University Museum in East Lansing, Michigan.

Several quilts have connections to the custom-made shirts designed by Desré Buirski that Nelson Mandela began wearing in 1994; Buirski eventually branded these as the Presidential Shirt after they become colloquially known as such.[86] The initial one, made of viscose material, was auctioned in 1994 to pay for the ANC's election campaign phone bill in the Western Cape. The shirt fetched ZAR

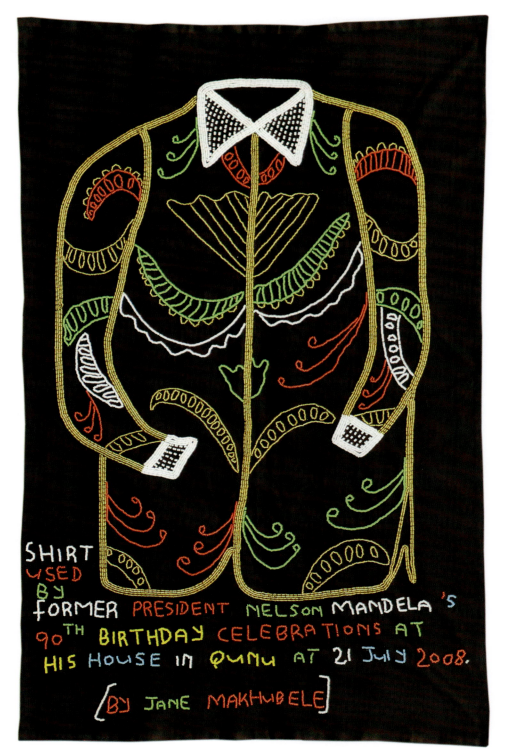

Figure 0.28
Madiba Shirt, Jane Makhubele, Limpopo Province, South Africa, c. 2008, cotton, beads, embroidery thread, with beading and embroidery
Collection of Michigan State University Museum. Photograph by Lynne Swanson, courtesy of Michigan State University Museum

Figure 0.29
Madiba Led the Way, Jenny Williamson and Pat Parker, Johannesburg, Gauteng Province, South Africa, 2012, 60 in. × 45 in. Michigan State University Museum Collection: 2012:127.1. Photograph by Pearl Yee Wong Courtesy Michigan State University Museum.

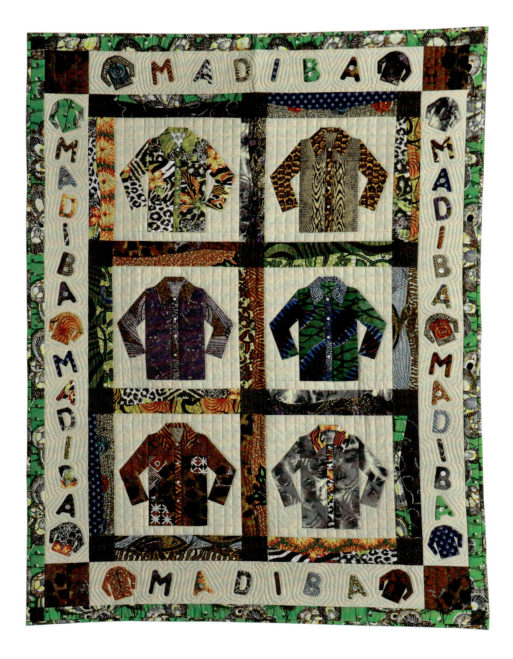

16,000 in the successful auction bid by Jannie Momberg, South Africa's ambassador to Greece.[87] Buirski met with Nelson Mandela for the first time in 1995, and he requested that she make shirts of silk, rather than viscose, for him; subsequently she made well over 120 of these hand-painted silk shirts for Mandela.

As she made each shirt, she kept the scraps of silk leftover and, eventually, patched those bits together into two quilts that she presented to Mandela. Her idea was that the quilts could be auctioned off for the purpose of raising funds for his charities, so she asked him to autograph the quilts to both authorize them and to increase their potential monetary value. In 2007, Buirski was invited to go to Monaco to attend a gala dinner and auction hosted by Prince Albert of Monaco and Nelson Mandela at Hotel de Paris. One of the quilts was auctioned

off at the event; it fetched EUR 36,000, which, at that time, was ZAR 3.6 million.[88] The funds raised were given to the Nelson Mandela Foundation, the Nelson Mandela Children's Fund, and the Mandela Rhodes Fund.[89]

So closely is the Presidential Shirt style identified with Mandela that hundreds of individuals have purchased and worn the shirt in conscious tribute to him. So iconic did the image of Mandela in one of these shirts become that the shirt—by itself—stood for Mandela. Numerous artists began to render just the shirt when they wanted to evoke Mandela. For instance, Billy Makhubele, Jane Makhubele, and Jamina Makhubele design and make modern versions of traditional beaded cloths, known as Minceka, made by the Tsonga-Shangaan people of South Africa, that are based on historic events that have occurred in South Africa. Several of their works feature renderings of a specific Mandela shirt accompanied by embroidered text noting the historical event Mandela attended when wore he it.

The iconic shirt design found its way into quilts. In 2004, South African textile artist Jenny Williamson created a *Steps to Freedom* quilt; in each block of the quilt, she rendered the Presidential Shirt design in different African prints.[90] Jenny's sister Pat Parker drafted a pattern called *Mandela Leads the Way* and published it in one of their jointly authored quilt pattern books.[91]

Sisters Jenny Williamson and Pat Parker are two of South Africa's best-known quiltmakers of the early twenty-first century. The duo have created numerous original quilt patterns, including *Madiba Led the Way* (fig. 29), which pays tribute to the distinctive quilts of colorful African fabrics that were worn by Nelson Mandela (also often referred to as Madiba, his clan name) after he was released from prison. The pattern of the *Madiba Led the Way* quilt is a variation of one Parker and Williamson created and published in their book *Quilts on Safari* (Cape Town, South Africa: Triple T, 1998).

Quilts, Health, and Well-Being for Individuals and Communities

Quilts in South Africa have been made as a means of fostering well-being and health for individuals and for communities. Numerous individuals have made quilts to cope with living with an illness, the loss of a loved one, or dealing with personal tragedy or a negative situation. Individuals and groups have made quilts to comfort or memorialize those suffering with disease or illness or to raise public awareness about health education needs.

Personal narratives of quiltmaking being an activity critical to well-being and healing abound. As but one example, Moira MacMurray, owner/manager of a B&B guesthouse in Parkview, made patchwork curtains for her living quarters. She told the story of how one of her neighbors, afflicted with Alzheimer's, regularly came over to help her with the patchwork. Her neighbor's task was to hold the pins and hand them to MacMurray as needed and she was proud to claim her role as a quilter even though she did not take a stitch. For her, it was meaningful work; she was needed.[92]

One quilt, in the collection of the Drosdty Museum in Swellendam, was made by women during the Boer War when they were held in an internment camp outside Bloemfontein; museum collection records reference that making the quilt was an effort to raise the imprisoned women's morale.[93] Decades later, Barbara

Hogan made a quilt to also cope with incarceration. Hogan was the first White woman to be tried for treason under apartheid and the first individual in South Africa to be tried for treason in a case that didn't involve violence against the state. After her first year of solitary confinement, during which she was allowed only a Bible and a book of poetry, Hogan was allowed to take a correspondence study course from UNISA, to read other books, and to take up a craft. She taught herself how to quilt in the English pieced-paper method, using torn out pages from her correspondence study books for the backing of the pieced blocks. Her warders chose and delivered fabric to her. She was imprisoned for seven years, until 1990, when the South African government lifted the ban on involvement in the ANC and she was unexpectedly released from prison. At the time, she was working on a quilt that she never finished, and she kept the unfinished pieces in an envelope that was addressed to her in prison. When asked about her quilt, she said, "I think I would have gone crazy all those years in prison if I did not have my quilting." The fact that Barbara made this statement speaks volumes about the importance of textiles and their stories in telling South Africa's history.[94]

The AIDS Memorial Quilt is the world's largest quilt project as an intentional means of raising awareness about the AIDS pandemic and the need for more research to find cures, memorializing those who died of the disease, and promoting safe health practices. Although the project started in the United States, efforts were made in other countries, including South Africa, to participate in the AIDS Memorial Quilt Project.[95]

While some individuals did make panels, the project often found resistance, largely because of taboos in traditional communities around talking about sex and the fact that families wanted to hide the source of illness or death from others. Artists affiliated with some craft-based economic development groups such as Keiskamma and the Mapula Embroidery Project depicted individual and

Figure 0.30
This quilt was made in a concentration camp close to Bloemfontein by a group of ladies in an effort to lift their morale.
Collection of the Drosdty Museum, Swellendam, South Africa, http://www.goodhopequiltersguild.org.za/swellendam-drostdy-museum-5. Photograph courtesy the Drostdy Museum.

Figure 0.31
Prison Quilt, Barbara Hogan, Pretoria, South Africa, cotton and paper; pieced, 78¾ in. × 59 in. "I think I would have gone crazy all those years in prison if we did not have our quilting," said Hogan, activist, former political prisoner, and member emeritus of the South African parliament in an interview with author (Johannesburg, June 2007).
Collection of the artist. Photograph by Pearl Yee Wong. Courtesy of Michigan State University Museum.

community impacts of HIV and AIDS as they increasingly brought depictions of daily life into their visual repertoire.

Decades after AIDS swept across the country, the COVID-19 pandemic also prompted the making of quilts, mainly by those who had the financial means to do so, for health-related activism, education, and memorialization. When there was a shortage of manufactured masks to address the health protection needs caused by the virus, nearly everyone with a sewing machine, access to fabric, and sewing skills began making masks for themselves, for family and friends, and for health care providers. Quilters were especially generous with their skills, time, and materials in constructing these desperately needed items.

The Border

Figure 0.32
Calm in the Corona Chaos, Felicity Khan, Cape Town, South Africa, 2020

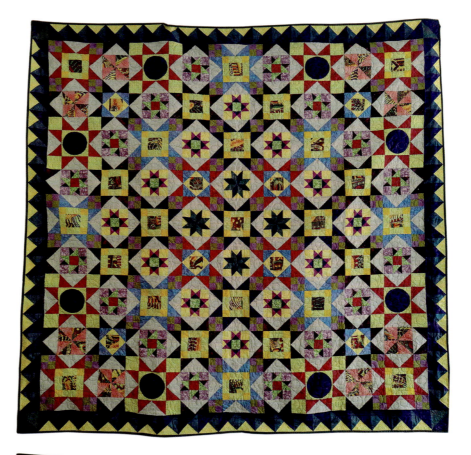

Figure 0.33
"Vaccination Is Very Important," Selinah Makwana, Winterveld, South Africa, 2022, cotton embroidery on cotton cloth, 38.5 in. × 41.75 in. Selinah Makwana, a member of the Mapula Embroidery Project, is one of many project artists who have made cloths depicting aspects of the COVID-19 pandemic. Collection of the Michigan State University Museum, 2024:7.2. Photograph by Lynne Swanson, courtesy of the Michigan State University Museum.

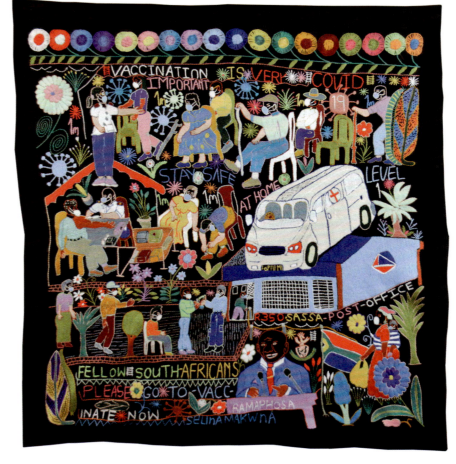

Craft-based economic development groups also engaged in making textiles that reflected the COVID-19 epidemic, chronicling in thread the disruptions to daily living and the loss of loved ones—with scenes of mask wearing, food distribution, greetings with elbows, and outdoor funerals. Individual quilt artists documented their own experience with the virulent disease. For instance, Felicity Khan of Cape Town made a quilt (fig. 32) as a means of coping with the anxieties about getting COVID-19 and the disruptions to life the pandemic created.

The SAQG vigorously encourages its member guilds to undertake projects that will meet the physical and economic health and well-being needs of members of their communities. "We encourage all our guilds and groups to make a difference—one stitch at a time."[96] In their efforts to help generate income for members of economically disadvantaged communities, guild members typically volunteer time in some of the larger crafts-based economic development projects or work with local agencies serving disadvantaged women. Quilt guild members donate hours teaching basic sewing and patchwork and appliqué skills, and they raise funds to buy sewing machines, scissors, notions, and fabric. In the various exhibitions that guilds showcase their own member's works, they also showcase the quilts and other textiles created in these community projects, sometimes in regional and national exhibition sections devoted to the work of the outreach programs. Occasionally some community members become members of the quilt guild.

Like other guilds elsewhere in the world, those in South Africa are committed to actively supporting the health and well-being of the communities in which they live. "We support and encourage our local guilds to extend a helping and supporting hand to people in need. This can range from knitted and crocheted items, to collecting personal care items people may need. Items include scarves, baby clothes, hats, and anything you can think of, to be handed out to groups of people. These acts of kindness and care are completely voluntary, and each guild has their own groups and projects they support."[97] South African quilt guilds provide quilts, clothing, teddy bears, caps, and blankets to maternity and children's hospitals and organizations addressing specific illnesses or health-related needs. Many guild members report that these outreach programs go beyond assisting with sewing skills or donating quilts and blankets to those with illnesses. They have benefited guild members by increasing their awareness of community needs; providing guild members, mostly women, a mechanism to address those needs; and, importantly, fostering cross-cultural friendships.

Quilting in the Twenty-First Century

As of the beginning of the twenty-first century in South Africa, there is a robust network of guilds, regular exhibitions of quilts, and quilt fabric and equipment shops. Some South African quilt artists are beginning to become independent artist entrepreneurs and finding markets, though still limited, for their quilts and quilted items. For instance, Namukolo Mukutu and her family work together on quilts, placemats, and other items that they sell at a booth at the Rosebank Sunday Craft Fair in Johannesburg.[98] Nearby at the same fair, Edith Gardiner and Patience Matigimu, sell bed-sized quilts in modern graphic designs of their own. A few aisles away, Onice Malekhwekhwe and Dina Tsibogo Makola sell

Below, **Figure 0.34**
Namukolo Mukutu and her family work together on quilts, placemats, and other items that they sell at a booth at the Rosebank Sunday Craft Fair in Johannesburg. Photograph by C. Kurt Dewhurst, November 17, 2019.

quilts of isishweshwe fabrics in the strong colorways that are being produced for the fashion and quilt designers.⁹⁹

Historically, quilts were made as bed covers, but some quilts are now also being considered art. Individuals who intentionally made quilts to be hung on walls as art and previously could only show their work in quilt shows organized by guilds or quilt businesses or in the textile arts exhibitions put on by groups such as Fibreworks now have opportunities for displaying their work in exhibitions organized by curators and art dealers in art galleries and museums. Their work is being written about by art critics and historians. Artists who do not label themselves as quilters or quilt artists are also incorporating patchwork, appliqué, and quilting techniques in the construction of their work. For instance, in 2022 the Iziko National Gallery featured a piece made twenty years earlier by Fatima February. Titled *District Six, Where We Lived*, the piece portrays places and people important to February's experience growing up in District Six, a mixed-race community that was demolished during the forced removals enacted by the apartheid government. On a base of appliqué and piecework, February incorporated embellishments using beads, seeds, wooden pieces, string, and lace materials. Three-dimensional doll-like figures are attached to the center of the quilt and the edge is adorned with fabric three-dimensional roses.

Figure 0.35
Edith Gardiner and Patience Matigimu sell quilts of their own design at Rosebank Sunday Craft Fair in Johannesburg. Photograph by Marsha MacDowell, November 17, 2019.

Figure 0.36
Onice Malekhwekhwe and Dina Tsibogo Makola sell patchwork bedcovers and clothing made of ishweshwe fabrics at the Rosebank Sunday Craft Fair in Johannesburg.
Photograph by C. Kurt Dewhurst, November 17, 2019.

Figure 0.37
District Six, Where We Lived, Fatima February, Cape Town, 1992. Collection of the Iziko National Gallery. Photograph courtesy of the Iziko Museums.

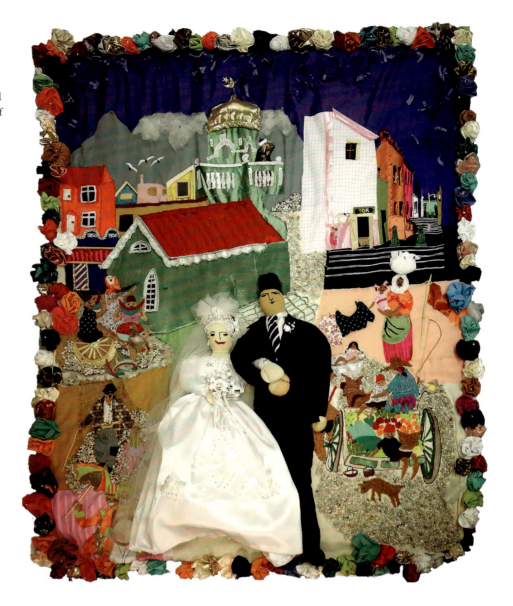

In another example, Laura de Harde of Pretoria, produced a body of work in 2020 and 2021 that was inspired by objects she observed in both home and museum collections. Laura asked her mother, quilt artist Tilly de Harde, to render her quilting designs on paper rather than cloth. Laura would then "collect the stitched sheets of paper from her, return to my studio, and imprint onto the stitched paper my renditions of digital copies of photographic portraits I had taken in storerooms and archives."[100] The resulting work highlights the distinctive quilting patterns of Tilly and the interpretative reflections of collections imagined by Laura.

Sometimes artists are using quilt-related techniques with unusual materials. Pieced and quilted art has been made out of everything from used tea bags to slabs of rubber tires. For instance, the work of contemporary South African artist Bert Pouw has been featured in several museum and gallery exhibitions, including in the *Matereality—A Testament to the Challenge of Tradition* show

Figure 0.38
Compact, Bert Pauw, Cape Town, 2020, plastic and thread, 55.12 in. × 40.16 in. Photograph courtesy of the artist.

held in 2020 at the Iziko South African National Gallery. Pouw has made a series of works called Rescue Remedy in which he has pieced and quilted the cheap and ubiquitous plastic shopping bags used throughout South Africa. It is the ordinary and ubiquity of the bags that attracted Pouw. Art critic Ashraf Jamal, writing about the artist, says that "what Pauw finds disconcerting is the way we 'look past the intended function of things, our failure to grasp the life of things beyond their utility and disposability.' That said, Pauw is not fueled by a green logic. Rather, it is the existential lives of inanimate things that compel him."[101]

Igshaan Adams is another artist who makes patchwork pieces of fabrics sourced from everyday life. In his case, he has used prayer rugs from family and friends who are followers of Sufism. Art historian Winnie August, who has worked closely with Adams, shared that "some have been used for decades and bear traces of their owner. Igshaan sees the rugs as BEING their owners."[102] In 2022, a body of his work was shown at the Art Institute of Chicago, and in an interview associated with the exhibition, Adams said, "The prayer rugs carry evidence of the body's imprint, where the feet and knees touch and especially where [one's] head lightly bleaches the top of the fabric."[103] A gay, practicing

The Border

Right, **Figure 0.39**
Eenheid, Igshaan Adams. Bonteheuwel, South Africa. 2014. Assorted fabrics and embroidery.
Photograph courtesy of the artist and blank projects, copyright Igshaan Adams, 2014.

Facing top, **Figure 0.40**
Kawuuwo, Hellen Nabukenya, 2019, various fabrics, many of used clothing, hand piecing.
Photograph by Erhardt Thiel courtesy of the photographer

Facing bottom, **Figure 0.41**
Kawuuwo, Hellen Nabukenya, 2019, various fabrics, many of used clothing, hand piecing. Hellen Nabukenya of Kampala, Uganda, designed two major patchwork installations for the Stellenbosch Triennial. One was draped over the exterior historic Voorgelegen building on Dorp Street in Stellenbosch
Photograph by Erhardt Thiel courtesy of the photographer.

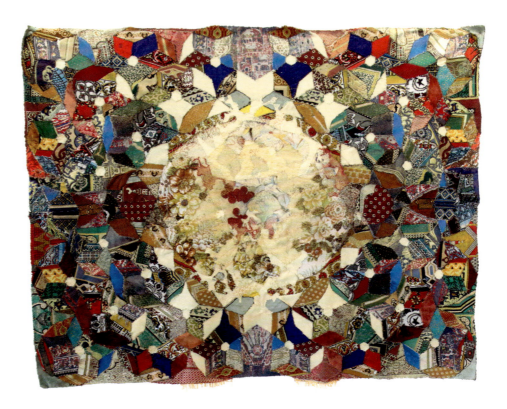

Muslim, Adams grew up in a predominantly working-class township in Cape Town that was founded in the 1960s as part of the forced segregation during the apartheid era. Adams sees his textile work related to family. "His mother worked in a textile firm. She and his grandmother also made quilts for personal use—partly because of what income the family had."[104]

With the textile work of Hellen Nabukenya of Kampala, Uganda, patchwork has moved completely out of the bedroom and even out of the gallery. In the 2020 Stellenbosch Triennale, Nabukenya designed two major patchwork installations, one of which was draped over the exterior historic Voorgelegen building on Dorp Street in Stellenbosch. "The title of the 22-metre-wide textile tapestry is [*Kawuuwo*] a Luganda word for the leaf used to cover the traditional matooke plantain dish while cooking." Nabukenya explained the artwork speaks to the valuable history of the building, once nearly destroyed but now preserved: "The process of gathering and stitching textile offcuts into an installation that is draped on the building represents the collecting and recording of its history."[105] The second piece, titled *Agaliawamu*, was made for the launch of the Triennale and was constructed with the help of women of the Love2Give organization in Kayamandi, a township close to Stellenbosch. The Triennale information book stated that the word "Agaliawamu comes from a Ugandan proverb that translates into 'the teeth that are together can bite the meat.' The artist says it is a call for people to work together to overcome challenges."[106]

It is perhaps fitting to close this introduction by calling attention to two instances of textiles that convey the complex and evolving place of quilts and

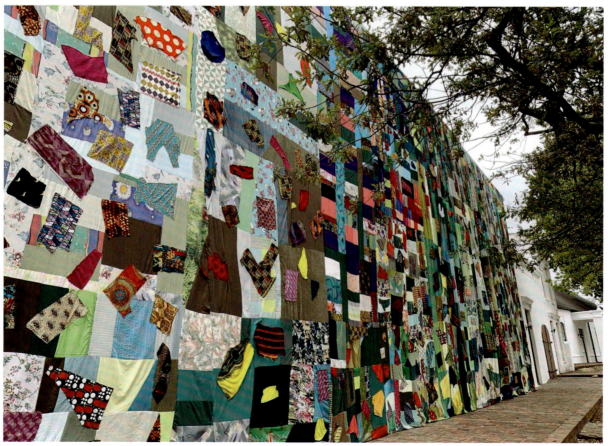

Figure 0.42
The Grand Quilt, Achmat Soni, designer; Shabodien Roomanay, initiator; Zaitoonisa Soni-Abed, project coordinator; Sheila Walwyn and Lorraine Bode, quilters; Zaitoonisa Soni-Abed, Gori Lombaard, Fareida Salie, Farhana Randeree, and Gadija Somsodien, embroiderers; Achmat Soni, Raffiq Desai, and Farhana Randeree, painters; Gadija Somsodien, Zaitoonisa Soni-Abed, Farhana Randeree, Belinda Wightman, and Norma Simons, beadworkers; Hadet Embroidery, embroidery for the calligraphy. Wynberg, South Africa, 2021, 6.5 ft. × 6 ft.
Private collection. Photograph courtesy Zaitoonisa Soni-Abed.

patchwork in South Africa. The first example is found among the Nama, an Indigenous pastoral ethnic people who, prior to the arrival of the Portuguese and Dutch in the seventeenth century, lived and farmed in small communities throughout the Cape area. Europeans soon confiscated their traditional lands and cattle, introduced diseases that decimated Nama populations, and killed or enslaved many Nama. Though Nama resisted, over time they were overpowered and eventually the majority of those remaining were forcefully relocated to regions now known as Namibia and Botswana. A small group lives in South Africa in the Richtersveld National Park located in South Africa's Northern Cape Province.

Wherever they live, the historically marginalized Nama strive to sustain traditional ways of life and have distinctive music, foodways, language, architecture,

and clothing. Patchwork is dominant in both men and women's clothing used in both daily wear and for festive occasions, including weddings and performances of the Nama Stap dance. Some Nama women also wear kappies. In some Nama communities, bedcovers, bags, table runners, and other items are made for both domestic use and to be sold to others. Although both the patchwork and the kappies were introduced into Nama culture by the same western Europeans who nearly decimated them, the use of patchwork has become an important element of Nama identity and a small part of income generation.[107]

The second example is a quilt made in 2021 titled *The Grand Quilt*. The idea for the quilt arose in a meeting of members of the South Africa Foundation for Islamic Art. Well-known Islamic artist Achmat Soni, whose calligraphy adorns the domes and walls of over sixty-six mosques throughout South Africa, created the basic design, which "represents the past history and the present-day South Africa."[108] Zaitoonisa Soni-Abed then led a group of men and women, talented in a variety of artistic skills, in the production of it. Among the group were two white quilt artists: Sheila Walwyn and Lorraine Bode.

The design of *The Grand Quilt* is complex and filled with symbolism. It incorporates the ninety-nine significant attributes of Allah as enshrined in the Holy Quran, a scene of importance to South African Islamic history, and iconic South African visual images, such as the protea flower and Table Mountain. Within the design is a map of South Africa rendered in different colors to depict the Rainbow Nation. Isishweshwe cloth was used in one section because it was a cloth produced in South Africa and beads were used in other sections because "they have been an integral part of African history. . . . They functioned as money, they possess power, they indicate wealth, they are spiritual talismans and they form coded messages."[109] Soni-Abed reported that it took nearly a year for the group to complete the quilt and although there were challenges along the way, "this incredible work of art made it all worth it. . . . It became almost an obsession to see this quilt take shape and grow into an artistic and heritage product that is unique both in its creation, depiction and size."[110] The finished work was first shown at the Islamia Library in December 2021 and is now part of the art collections of the Iziko Museum.

Zaitoonisa Soni-Abed provided the following description of the quilt:

A MAP OF SOUTH AFRICA
The different colors depict the Rainbow Nation—a term coined by Archbishop Desmond Tutu to describe apartheid that capitalized on differences and separation of the different races, culture. It was finally abolished in 1994, and a new post-apartheid South Africa was introduced after the country's first fully democratic elections in 1994.

THE 99 NAMES (ATTRIBUTES) OF ALLAH
As enshrined in the Holy Quran

THE DROMEDARIS SHIP
On April 6, 1652, Jan Van Riebeeck landed at the Cape with three ships: the *Reijer*, the *Dromedaris*, and the *Goede Hoop*. He was accompanied by eighty-two men and eight women, including his wife of two years, Maria.

THE KRAMAT OF SHEIKH YUSUF AL-MAKASSARI
The sheikh, who was exiled by the Dutch in 1694, was dispatched to the Strand area by the governor of the day and made this his final resting place.

TABLE MOUNTAIN
Table Mountain is the most iconic landmark of South Africa and one of the natural wonders of the world. It is also the country's most photographed attraction, and the mountain's famous cable car has taken millions of people to its top.

THE PROTEA FLOWER
The king protea (*Protea cynaroides*) took the title of South Africa's national flower in 1976. The king protea, so called because of its resemblance to a crown, is the largest of all proteas and is found in the Cape Floristic region.

THE AFRICAN BEADS
Beads are an integral part of African history from time immemorial. They functioned as money, they possess power, they indicate wealth, they are spiritual talismans, and they form coded messages.

THE SEA
The sea is depicted in shweshwe material. Shweshwe, also known as shoeshoe or isishweshwe, is a printed cotton fabric that is manufactured in South Africa. The formal name for shweshwe is indigo-dyed discharge printed fabric designs indigenous to the Eastern Cape of South Africa. It is printed onto cotton, which is grown locally, also in the Eastern Cape.[111]

Hellen Nabukenya's art and *The Grand Quilt* embody the increasing cultural diversity of quilt artists and the movement of quilting techniques into new spaces and across geographic and cultural borders. They also represent engagement in collective activity to overcome challenges and realize visions. These are fundamental elements that characterize the art of quiltmaking.

Summary

As this overview has indicated, the techniques associated with making quilts and the making of quilts themselves has a long history in South Africa and the meanings and traditions associated with the objects and the practice are varied and can be complex. Whether or not one works alone or is part of a group, there is a sense of community among those who make and use quilts; the tactile nature of working by hand with thread, needle, and fabric connects quilters over time and around the world. Those who study art are also a community, bound across time, space, and shared interest in the material cultural histories of the world. The study of the history and meanings of the making of quilts and related textiles is still in its infancy; there are so many dimensions of this art to yet be explored and reported on. As more members of the worldwide community of scholars engage in studying, analyzing, and writing about quilting in South Africa, this particular and enduring aspect of art will be better understood as part of the complex history of African art.

Notes

1. Backwell, D'Errico, and Wadley, "Middle Stone Age Bone Tools," 1566–80; Henshilwood et al., "Early Bone Tool Industry"; Hanon et al., "New Evidence of Bone Tool Use."
2. Dingaan and Preez, "Vachellia (Acacia) Karroo Communities."
3. Wood, *Natural History*, 20.
4. Wood, *Natural History*, 20.
5. Wood, *Natural History*, 21.
6. Wood, *Natural History*, 22.
7. Wood, *Natural History*, 24.
8. Mrs. Peiterson in Butler, "Reminiscences of Cradock."
9. Van Riebeck, *Journal*, 13.
10. For two excellent resources tracing the international textile trade before the twentieth century, see Fee, *Cloth That Changed the World*, and Peck, *Interwoven Globe*. For a good resource about South African connections to Indian trade goods, see Kaufmann, *Patterns of Contact*.
11. Malan, "Households of the Cape," 183.
12. Crill, "Revolution," 107
13. Crill, "Revolution," 108.
14. Crill, "Revolution," 108.
15. Crill, "Revolution," 113.
16. Woodward, "Interior," 100.
17. Woodward, "Interior," 99.
18. Woodward, "Interior," 107.
19. Iziko Museum catalog records, Item #SACHM 65/870, Cape Town.
20. See the holdings of several museums in the South Africa Quilt History Project collection in the Quilt Index (https://quiltindex.org/view/?type=docprojects&kid=31-81-1), choose "View all records in this project" and then use the sort-by-date tool located on the top right-hand side of the display page.
21. Briedenhann, "Van Schouwenberg Quilt," 37. For more on this work, see Myra Briedenham, "The Van Schouwenburg Quilt," *CULNA Magazine of the National Museum, Bloemfontein* 48 (April 1995): 37.
22. Typescript notes sourced from catalog records at the Drostdy Museum, Swellendam, South Africa, provided to the author by Wilma Havenga on May 16, 2020. Typescript paper by Ronel Pristorius prepared for 2021 South African National Quilt Festival.
23. Burden, "Beds at the Cape in the Old Cape Furniture Period."
24. "Great Trek 1835–1846," *South Africa History Online*.
25. Anne Marie Carrelsen, interview by Marsha MacDowell, Pretoria, South Africa, 2011.
26. Pretorius, *Die Geskiedenis*, 97–98.
27. Strutt, *Clothing Fashions*, 78.
28. Strutt, *Clothing Fashions*, 225.
29. For further information on kappies see chapter 3, by Vicky Heunis, in this volume; "The White Kappie" (225–39) and "The Coloured Kappie or Bonnet" (224–25) in Strutt, *Clothing Fashions*.
30. The Quilt Index (www.quiltindex.org) includes many of the US quilt documentation project records and tools for searching, sorting, and comparing quilts from different projects but similar time frames, including the South African Quilt Heritage Project.

31. "History—Quilting in South Africa," Quilts of South Africa.
32. Schreiner, *From Man to Man*, xi.
33. Schreiner, *From Man to Man*, 187.
34. Butler, "Reminiscences of Cradock."
35. Smith, "Katisje's Patchwork Dress," 221–225.
36. Schonstein, *Quilt of Dreams*.
37. MacDowell, "Quilts: Unfolding Personal and Public Histories," 5.
38. Schwellnus and Schwellnus, *Las met Lap Stap vir Stap*.
39. For an excellent overview of the Mapula Embroidery Project, Kaross Workers, and Simunye projects, see Schmahmann, "Making, Mediating, Marketing: Three Contemporary Projects," 119–36.
40. See especially Schmahmann, *Mapula*.
41. Typescript document provided to author by Judy Jordan, director, Carnegie Art Gallery, Newcastle, 2011.
42. Ilingelihle, Brochure, acquisition record files.
43. Intuthuko Embroidery Project, South Africa," Artivism.
44. *FNB* [First National Bank] *VITA Craft NOW 2000*, 18.
45. Undated brochure, collected from Ina le Roux by author on March 3, 2011.
46. "About Timbani," Tambani.
47. See chapter 15 in this volume, by Jeni Couzyn et al.
48. Keiskamma, "About Us." See also chapter 14 in this volume, by Brenda Schmahmann.
49. See chapter 9 in this volume, by Marsha MacDowell.
50. Baratta, LinkedIn profile.
51. Elisabeth Baratta, Etsy.
52. See the chapters in this volume on the SAQG, by Elsa Brits, and on Fibreworks, by Jeanette Gilks.
53. MacDowell and Mazloomi, *Conscience of the Human Spirit*; MacDowell and Brown, *Ubuntutu*.
54. Margie Garratt in Slabbert, *Passion for Quiltmaking*, 27.
55. See chapter 5 in this volume, by Juliette Leeb-du Toit.
56. Fee, "Flowering Family," 166.
57. Fee, "Flowering Family," 166.
58. For a thorough study of military quilts, see Gero, *Wartime Quilts*.
59. Rolfe, *Australian Quilt Heritage*, 41.
60. Annette Gero, *Wartime Quilts: Appliqués and Geometric Masterpieces from Military Fabrics* (Roseville, Australia: Beagle Press, 2015), 38.
61. Kate Rodd, quoted in Rolfe, *Australian Quilt Heritage*, 41.
62. Quilt Index, "Hexagon Stars."
63. See chapter 4 in this volume, by Michael Walwyn.
64. See chapter 3 in this volume, by Vicky Heunis.
65. Quilts of South Africa, "Sharpeville Memorial Quilt."
66. See Gillespie, *Innovative Threads*, 90; Schmahmann, "Stitches as Sutures," 52–65. See also Schmahmann, *Mapula*.
67. For more on this project, see chapter 12 in this volume, by Coral Bijoux.
68. Josias, "Methodologies of Engagement"; McEwan, "Building a Postcolonial Archive?," 747–53; Van der Merwe, "Stitching the Lives of Marginalized Women," 268–82; and Van der Merwe, "From a Silent Past to a Spoken Future," 1–20.
69. Segalo, Manoff, and Fine, "Working with Embroideries and Counter-Maps," 345.
70. *Journey to Freedom: Narratives* (Pretoria: University of South Africa, 2007). Individual artists in the Intuthuko Embroidery Project: Pinky Lubisi, Thembisile Mabizela, Zanele Mabuza, Angie Namaru, Lindo Mnguni, Julie Mokoena, Salaminha

Motloung, Angelina Mucavele, Thabitha Nare, Nomsa Ndala, Maria Nkabinde, Cynthia Radebe, Sannah Sasebola, Rosinah Teffo, Lizzy Tsotetsi, and Dorothy Xaba. Individual artists in Boitumelo Sewing Group: Flora Raseala, D. Emmah Mphahlele, Lilian Mary Mawela, Ammellah M. Makhari, Martinah P. Mashabela, Naledzani R. Matshinge, Gloria Melula, Elisa D. Mahama, and Linda Mkhungo.

71. Albie Sachs, conversation with author. See also the Bushman Heritage Museum website, https://bushmanheritagemuseum.org.

72. Author observation of textile on view at the Mayibuye Center on May 24, 2002.

73. Tolksdorf, "Africa Design Sources."

74. Tolksdorf, *My Heart Is Glad*, Odette Tolksdorf, artist website, http://www.odettetolksdorf.co.za/africa-design-sources.html.

75. Cynthia Msibi, interview with author, Newcastle, South Africa, 2011.

76. See chapter 10 in this volume, by Dawn Pavitt. The quilt was illustrated on page 25 in Pimstone, *Helen Suzman, Fighter for Human Rights*. It was also reported in Pavitt, "A Lone Star in Africa." At the end of her article, Pavitt thanks the US Information Service, Senator Nancy Kassebaum's office and Senator Paul E. Tsongas. See also "Quilt Shows Support for Black Nationalist," *Capper's Weekly*, Topeka, Kansas, April 12, 1983. Kyra Hicks, author of *Black Threads*, reported to the author that her grandfather US representative George William Crockett Jr. of Detroit was one of the signers.

77. Chaveas, pers. comm.

78. Chaveas, pers. comm.

79. White, Michigan Quilt Project Inventory. See also Marsha MacDowell, *African American Quiltmaking in Michigan*, 30. White donated the quilt to the Michigan State University Museum. Images and data can be accessed at the Quilt Index. See videotape interview with Beverly White from the Michigan State University Museum *Quilts and Human Rights* exhibition.

80. Harris, artist statement.

81. Vest, Michigan Quilt Project Inventory Form. See videotaped interview with Hilda Vest from the Michigan State University Museum *Quilts and Human Rights* exhibition. It is worth noting that Vest was a student at Michigan State University in the 1950s, an era when only one in a hundred American students enrolled at the university were African American.

82. Mazloomi, pers. comm.

83. Ramdhani, pers. comm.

84. Slabbert, *Passion for Quiltmaking*, 16.

85. Roy Starke, interview with author, Pretoria, South Africa, February 24, 2011; Roy Starke, artist statement, acquisition records, Michigan State University Museum.

86. Buirski, *Mandela's Shirts & Me*, 27-35; Buirski, *President, My Path, and The Patchwork*, 39-44.

87. Buirski, *President, My Path, and The Patchwork*, 43.

88. Presidential Shirt, "Our Story."

89. Buirski, *President, My Path, and The Patchwork*, 88.

90. Williamson and Parker, *Quilt Africa*, 79–82.

91. Williamson and Parker, *Quilts on Safari*, 36–39.

92. MacMurray, interview.

93. Good Hope Quilters Guild, "Swellendam Drostdy Museum."

94. Hogan, interview.

95. See chapter 13 in this volume, by Marsha MacDowell.

96. South African Quilters' Guild, "Community Projects."

97. South African Quilters' Guild, "Community Projects."

98. Mukutu, interview.

99. MacDowell, field notes.

100. De Harde, *Objects on Life-Support*, 94.
101. Jamal, "Country of Last Things." See also Wixsite, "Bert Pauw."
102. August, Correspondence.
103. Adams in Solomon, "For His First U.S. Museum Show, Igshaan Adams Creates Tapestries."
104. August, email comm.
105. Nabukenya, in Stellenbosch Triennale, "Triennale 2020."
106. Nabukenya, in Stellenbosch Triennale, "Triennale 2020."
107. *Nambian*, "Keeping Culture Alive Through Fashion"; Jones, *Nama Marks and Etchings*; Caley, *Study of Vakwangali Traditional Clothing for Fashion Creation in Namibia*.
108. Soni-Abed, interview. See also Soni-Abed, *Portrait of an Islamic Artist*.
109. Soni-Abed, "Grand Quilt Story."
110. Soni-Abed, "Grand Quilt Story."
111. Zaitoonisa Soni-Abed, The Grand Quilt—A SA Foundation for Islamic Art World First, 2022.

Traditional Bedding and Cloak-Blankets of the Indigenous People of South Africa

MENÁN DU PLESSIS

ARCHAEOLOGISTS BELIEVE that swaths of burned, compacted sedges discovered in Sibudu Cave near Durban, South Africa, may be the oldest remnants of bedding material found anywhere in the world, having been dated to as long as seventy-seven thousand years ago.[1] This ancient mattress material of reeds and grasses seems to have been mixed in some cases with leaves of *Cryptocarya woodii*, a plant that may have helped keep insect pests at bay. Of course, we cannot know the identity of the very early people who collected the rushes to make these beds, just as we cannot know what almost unimaginably old language, belonging to what unknown ancestral family, they may have spoken.

It is only from considerably more recent times that we have any detailed knowledge of the kinds of traditional bedding—bases, mattresses, and coverlets—formerly used by the diverse people who make up the modern Indigenous inhabitants of the southern African region. These Indigenous communities include speakers of languages that belong to the diverse families collectively referred to as Khoisan as well as speakers of various languages belonging to the immense Bantu family.[2]

Despite great differences in their languages, and in some cases differences in their economic and material cultures, the various original societies of South Africa had a significant amount in common. Among the customs shared universally was the use of an animal skin as a cloak by day and a blanket by night. Indeed, in most languages of the region, the same general term was (and still is) used for both "cloak" and "blanket." William Burchell, who traveled in the interior of South Africa between 1810 and 1812, described a simple item of basic clothing still worn in the early nineteenth century by many of the Khoi men in the rural interior of the country and added: "This is all the usual and constant covering of the men; besides the *Kaross*, which they have in common with all South Africans, who may literally, if not legitimately according to classic

Figure 1.1.
Kaross (cloak-blanket), Cape region, Southeast Africa, made of hides sewn together with beaded decoration. South African National Gallery 2005–121. Photograph courtesy of South African National Gallery

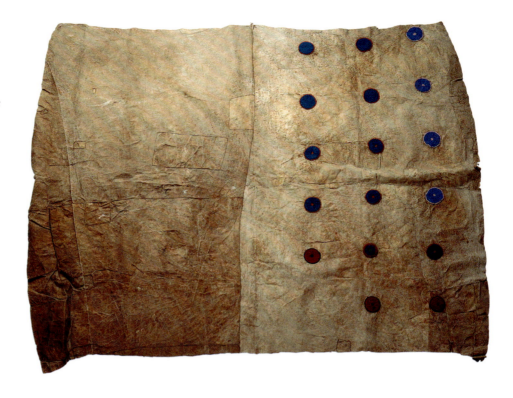

interpretation, be termed the *gentes togatae*; since the *Kaross* is, in fact, nothing else than the *toga* in its simplest and rudest, and perhaps original, form."[3]

This said, it is equally clear that the quality of this versatile covering could vary from one community to another and from one social level to another within more stratified communities. Variations included the particular type of animal skin from which it was made and the amount and quality of workmanship that went into shaping and ornamenting it. Some of the different kinds of cloaks are depicted in the rock art of the region, where it is possible to distinguish plain leather cloaks, cloaks made from leopard skins, and even cloaks of the more sumptuous type made from the painstakingly pieced-together pelts of numerous small animals.[4] The various kinds are also frequently commented on and described by foreigners who traveled through the country in the early days.[5]

Blanket-Cloaks of the Khoisan People

The first communities with whom mid-seventeenth-century Dutch settlers at the most southern region of the African continent referred to as the Cape (named after the Cape of Good Hope, the promontory in the region which marks the junction of the Atlantic and Indian Oceans), came into regular contact were nomadic herders. These herders were organized into different clans but came to be known to the settlers by various general names, including Khoikhoi, Khoekhoen, or Khoi. The word used by the Cape Khoi for the ubiquitous multipurpose cloak, which in their case was often made of sheepskin, was recorded early on as *karos*, *kaross*, or *kros*—a term that has entered into the vocabularies of both Afrikaans and South African English. Somewhat oddly, though, the general word for a cloak in both Nama and Kora is in fact ǂnammi.[6] The source of the

MENÁN DU PLESSIS

word *kaross* may have been a local equivalent of the modern Nama word *kharos*, which really refers to "a sleeping place (on the ground)."⁷

Willem ten Rhyne, who visited the Cape of Good Hope in 1673, observed: "The clothing of the men, . . . whether chiefs or commoners, is exclusively of skin, and consists of a *colobium* or blanket made of the hide of ox or sheep, and called by them *karos*. This supplies the place of a bed, of a box, and of almost all furniture. With it they protect themselves from the rain or from the cold. The garment is sometimes made from panther [?] or goat-skin; and whereas the common folk cover their loins with fox-skin, the chiefs use otter or badger."⁸

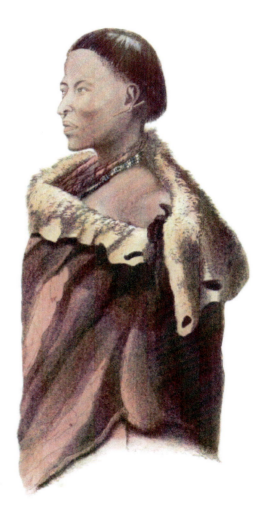

Above, **Figure 1.2.**
The sheepskin kaross is seen in this partially colored sketch by the English painter Samuel Daniell, who was the official artist for the Truter-Somerville expedition 1801–2. Plate from John Barrow, *Travels into the Interior of Southern Africa*, vol. 1 (London: T. Cadell and W. Davies, 1806), pp. 108–9.

Right, **Figure 1.3.**
"Portrait of Mahútu, one of the wives of Chief Mattivi [Matheebe]. Burchell noted that 'her *kobo*, or cloak, is of that kind which has been described . . . as composed of a great number of skins of small animals of the weasel, or cat, genus.'" Originally illustrated in William Burchell, *Travels in the Interior of Southern Africa*, 2 vols. (London: Longman, Hurst, Rees, Orme, Brown, and Green, 1824), plate between pages 494 and 495.

Traditional Bedding and Cloak-Blankets of South Africa

A century later, the kaross was still commonly in use, as observed, for example, by Anders Sparrman, a Swedish naturalist who made his voyage to the Cape of Good Hope in the late eighteenth century:

> In fine, the garment worn by the [Khoi] for covering their bodies is a sheepskin, with the woolly side turned inwards; this pelisse, or else a cloak made of some smaller fur, is tied forwards over the breast. When the weather is not cold, they let it hang loose over their shoulders in a careless manner, when it reaches down to the calves of the legs, leaving the lower part of the breast, stomach, and fore part of the legs and thighs bare; but in rainy and cold weather they wrap it round them; so that the fore part of the body likewise, is in some measure covered with it as far as below the knees. As one sheepskin alone is not sufficient for this purpose, there is a piece sewed, or rather fastened on with a thong, sinew or catgut, to the top on each side. In warmer weather they wear this cloak sometimes with the hairy side outwards, but in that case, they often take it off entirely and carry it on their arms. In general, the [Khoi] do not burden themselves with a great many changes of these cloaks or *krosses* (as they call them in broken Dutch) but are content with one, which serves them at the same time for clothing and bedding; and in this they lie on the bare ground.⁹

Sparrman was not the only traveler to suggest that the Khoi simply slept under their cloaks "on the bare ground"—and perhaps this was genuinely the case on isolated occasions, such as when a small group of Khoi guides were accompanying a traveler and had to improvise their own accommodations at night. It is clear, however, that under normal circumstances, in their own homes, the Khoi preferred to use bed mats, not only for comfort but probably also for protection against thorns and scorpions.

Although the general Khoekhoe word for a hide or skin is *khōb*, the specific Nama term for a "sleeping-rug or mat made from goat skins" is ǂgoab.¹⁰ It is notable, though, that just as the coverings the nomadic Khoi used for their easily dismantled, lath-framed dome houses could be either skins or reed mats, so could the bed mat be made from either. This is obliquely suggested, at least, by remarks such as Jan Engelbrecht's note that the Kora word *bubudu* referred to a brittle species of reed sometimes used for "those mats on which very small children slept."¹¹

As for mattress material, we receive a glimpse of the use of vegetation in the account left by another Swede, Hendrik Wikar, who spent several years during the 1770s in self-exile from the Cape and became well-acquainted with the numerous Nama- and Kora-speaking Khoi clans then living along the banks of the Gariep (or Orange River). On one occasion, he said his "Bushmen" companions prepared a warm bed for him: "First they made a huge fire on the sand, and when that had burnt out, they dug a trench in the warm sand just long enough for me. They placed grass and bushes in the trench and then I went to lie in it, covering myself with more grass and bushes. . . . A bed like this [*zo een kooy*] they call *eykaro*."¹²

Wikar's *kooy* is still used in Afrikaans today as a colloquial expression for "bed" and comes from the Dutch *kooi*, meaning a "berth" or "hammock." The

Afrikaans word *kooigoed*, which literally means "bed stuff," is one of the folk names for the semi-succulent *Helichrysum* species *odoratissimum* and *petiolare*, once popular for stuffing mattresses. Both shrubs, which have a scent reminiscent of hazelnut and mocha, are known in the Nguni languages as *imphepho* and are famed for their medicinal properties.

Henry Lichtenstein, who traveled in southern Africa between 1803 and 1806, encountered people who seem to have spoken one of the N|uu-like varieties from the !Ui sub-group of the Tuu languages. In the |Xam-like varieties once spoken south of the Gariep, terms for cloaks recorded by Wilhelm Bleek and his sister-in-law Lucy Lloyd in the late nineteenth century included !nuing for a large kaross and !woba or !aba for a smaller mantle or cape.[13]

No matter what languages people spoke, it seems to have been the case that in all early South African communities, it was the men who were solely responsible for the making of cloaks and other skin garments—and indeed, leatherwork in general.[14] In response to a direct question about whether men or women made the karosses, a !Xoon speaker interviewed in the twentieth century by Louis Maingard affirmed that it was the men (*taa'a*) who shot the game, scraped the skins, and sewed the cloaks (*sebi*).[15] This speaker explained that he prepared and sewed the small skins of the steenbok to give to his wife. On being asked whether he would make a cloak from the skin of a gemsbok, he confirmed that his people made cloaks from gemsbok skin (!kx'am *tam*), and in answer to a question about whether he also made small cloaks, he said that small ones were made from duiker skin (ʘhã *tam*).[16]

A firsthand account of the making of the sheepskin kaross was also given to Louis Maingard by two elderly Korana men who still spoke, in the first part of the twentieth century, a variety of their original Khoekhoe language.[17] These two men, Pakapab and Kleinjaer, explained that the skin (*khōb*) of a "baster" sheep (*baster gū*) was taken and, in the first stage, was wet through thoroughly and left to soak. On the second day, once the skin was soft, it was rubbed until pliable and then finished off by smoothing it with a type of stone called *witklip*, "white stone" in Afrikaans and |kx'oms in Kora. For a large kaross, six skins were used and for a smaller kaross, four; however, sometimes only two skins were needed. Finally, on the third day, the prepared skins were sewn together using a needle or awl (ǂ'oros). The needle used for the sewing (ǂ'om) was made from bone (ǂxoba). Engelbrecht gave further details about the cutting and sewing of the skins, noting that the tailor (!ao-kx'aob) was specially trained to perform this work.[18]

It was customary among the Korana—just as much as it was among other South African communities, such as the Xhosa people—to present boys and girls with a set of new clothes and other essential items on their entry into adulthood. The gift always included a new cloak.[19] Later, during courtship, a young man would present his intended wife with gifts that similarly included clothing.[20]

It seems fitting that the humble cloak-blanket—so fundamental to the most elemental aspects of its wearer's existence, through day and night, from birth to the onset of adulthood—should, at least in some communities, also have been taken into the grave. The Kora speaker Piet Links, who worked with Lucy Lloyd in the late nineteenth century, said that when a person died, the body

was wrapped in a kaross and bound by a cord (*thurib*) before being put into the grave.[21] Some of the Bloemhof Korana interviewed in the early twentieth century, several generations after they had become Christianized, also still recollected a traditional type of burial (specifically of a chief). Teteb and Iis, for example, described how a reed mat (|harub) was spread out, and then the dead body, wrapped in a kaross, was laid there.[22]

Cloak-Blankets in Other Indigenous Communities

After the handover of the Cape to the British at the beginning of the nineteenth century, many new expeditions were made into the interior, and a number of detailed accounts have come down to us from the travelers who explored South Africa during the early years of colonial occupation—which is to say when the social and economic circumstances as well as aspects of the material culture of the Indigenous people were still relatively unchanged. Written and pictorial accounts of the making and use of cloak-blankets among Xhosa-speaking people and related communities of the east coast and speakers of various Sotho-Tswana languages in the central and northern interior regions were recorded by, among others, Henry Lichtenstein, William Burchell, Ella Margaret Shaw, and Nicolaas Jacobus van Warmelo.

The Xhosa language preserves a rich vocabulary of specialized terms for different kinds of cloaks. Some of these words refer to traditional skin garments, and others to those made from introduced textiles (in the case of which certain specific colors and designs were preferred).[23] Lichtenstein distinguished between the Xhosa word *ingubo*, which was, he said, "a mantle of oxhide," and the *uneebe*, which was "a mantle of a wild animal's skin."[24] Shaw and Van Warmelo, however, in their encyclopedic work on the material culture of the Xhosa people, note:

> Before the eighteenth century, a cloak, *ingubo*, was evidently made as frequently of the skins of wild animals, which were very numerous, as of oxhide, but in the eighteenth and part of the nineteenth centuries, cloaks for both sexes were made primarily of oxhide. . . . Cloaks of calf, antelope or the variegated skins of small animals were then considered especially fine, *umgqwetho* or *umnweba*, and were worn at parties. Sheepskin cloaks are first mentioned in 1832. Cloaks of the chief and royal family, and sometimes of the chief's councillors and favourites to whom old ones were given, were either made entirely of leopard skin or faced with it round the edges. . . . A chief, however, often wore a cloak of ordinary oxhide, or calf or wild animal skin.[25]

Burchell distinguishes between the Khoekhoe and Sichuana language terms used for a blanket-cloak and provides further elaboration of materials used to make them and the seasons in which they are worn:

> I may here remark that *kaross* and *kobo* are but two words for the same thing; the former belonging to the [Khoekhoe] and the latter to the Sichuana, language. They signify the skin-cloak . . . and may be used indifferently, although the latter is more proper to express the Bichuana cloak, which differs in fashion a little from the other, as it does also in materials; the *kaross* being

generally made of sheep skin with the wool on, and the *kobo*, either of the fur of various small animals, or of some larger skin made into leather.

The latter sort, called *kobo-kaama*, because most commonly made of the skin of the *kaama* antelope, is there more properly intended for summer; but the fur-cloaks, called *kōsi-kobo*, being very expensive to purchase, or very difficult to procure, on account of the number of animals required in making it, poverty obliges the greater part of the nation to wear their leathern cloaks at all seasons, though they are considerably colder than those of fur.[26]

Concerning the use of the cloak-blanket referred to as *imbeleko*, Shaw and Van Warmelo note that the skin of the goat slaughtered to celebrate the birth of the child was then "used for it to sleep on," which is to say, as a kind of portable cradle or baby sling.[27] Much as was the case among the Khoi, it was customary to present young Xhosa initiates on their graduation with new clothes, including a cloak. Similar gifts were made on other special occasions, such as weddings.

As for the sewing up of the garments, Lichtenstein observed that, much as the Korana men used a type of bone awl for the same purpose, the Xhosa-speaking peoples "sew the skins with thread made of the sinews of the oxen, piercing the holes to put it through with an iron punch, something like a bodkin, in the place of a needle."[28] Burchell provided some further information about the use of the iron implement:

> The *thūko* (*tóoko*) or needle, is a very usual appendage; it belongs exclusively to the men, and is one of which great use is made. It is always kept exceedingly sharp, and may more properly be named an awl. . . . The work which they perform with this instrument, although proceeding very slowly, is admirably neat and strong, two qualities in which it far excels all which I have seen of European sewing. Their thread is the divided sinew of animals; than which, no fibre possesses greater strength. Their manner of sewing is; to place the two edges of the leather to be connected, close by the side of each other, and, if fur, to place the hairy sides together; a hole, barely large enough to admit the thread, is then, with the utmost precision, pierced with the *thuko*, and the sinew inserted with the hand. The durability of these seams consists not only in the strength of thread, but in each stitch being fastened; so that the breaking of one does not affect any of the others: they are also rendered impervious to the wind, by the care with which they take to make the holes no larger than the thread.[29]

Shaw and Van Warmelo note: "The cloak was probably the first of the garments of either sex to be altered by contact with Europeans, and the nearer the Colony the earlier. By 1835 men, and one author suggests that it was the lower ranks first, began to use woollen blankets as cloaks, and women followed suit a little later for all but festive occasions."[30] From this point on, while the *concept* of the item remained firmly in place, its *material form* began to change, and the traditional cloak-blankets once hand-tailored from skins were increasingly replaced by factory-made blankets.

In contemporary South Africa, much as citizens once paid tribute to their king by bringing him the most prized animal skins, so the gift of preference for senior dignitaries and patriarchs is now—by way of continuity—the blanket, and

it is not uncommon in television news coverage of special events to see the formal handing over of such an item, which must be the most luxurious one obtainable, with a high wool or cashmere content, and a fitting elegance of design. To the present day, moreover, the blanket-cloak is still widely worn, particularly on celebratory occasions such as coming-of-age ceremonies and weddings, and many younger South Africans are increasingly proud to wear modern textile versions of the original kaross, *kobo*, or *ingubo* as a symbol of national identity and heritage.

Notes

1. Wadley et al., "Middle Stone Age bedding," 1388–91. Thanks to Anne Solomon for mentioning this paper to me.

2. It may be useful to keep in mind that neither "Khoi" nor "San" refers to a language grouping. The term "Khoisan" also does not refer to a single language but is used by linguists as a convenient umbrella term for at least three different families of languages in southern Africa, of which the largest, and probably the oldest, is the Khoe family. The many languages that make up the Khoe family are divided into a number of subgroups, and while the languages of the Khoekhoe branch were mostly spoken in the past by herding communities identified as the Khoi (also Khoikhoi or Khoekhoen), the numerous varieties within the Kalahari branch were (and still are) spoken by people sometimes referred to by the Khoekhoe term, San. Note, however, that some San communities of western Botswana, eastern Namibia, and southern Angola speak entirely different languages belonging to either the Tuu (originally !Ui-Taa) or Ju families. The four hundred to six hundred languages of the Bantu family (itself only a subdivision of just one branch of the Niger-Congo superfamily) are distributed throughout more than half of Africa, from the Congo River to the Cape. The family is represented in South Africa by languages of the Nguni and Sotho-Tswana subgroups, as well as Venda, and in the far northeast, the Tswa-Rhonga subgroup.

3. Burchell, *Travels*, 397–98.

4. The African Rock Art Digital Archive (ARADA) (https://africanrockart.org/rock-art-gallery/south-africa/) houses a searchable collection of more than 270,000 images. On the ARADA website, image RARI CT 01 70HC is of a painting from Zimbabwe that appears to represent a person wearing a cloak of the kind made from multiple small pelts. The wearer was almost certainly a person of substance and is unlikely to have come from any community fitting the generic description of "San." On the ARADA website, the image labeled RARI HPC 01 127HC shows a person wearing a red-colored cloak of the kind that fully envelopes the body. It may have been made from the skin of a hartebeest or was perhaps smeared with a commonly used mixture of fat and ochre, which kept the leather supple and also gave it a red coloration.

5. A number of rock paintings were reproduced by Joseph Orpen to accompany his paper "A Glimpse into the Mythology of the Maluti Bushmen," 1–10. One of these depicts dancing figures wearing spotted garments that appear to be leopard skins dangling down behind their backs.

6. The *-mi* in ǂnammi is a variant of the masculine singular suffix *-bi or -b*.

7. The *-s* in Kharos is the feminine singular suffix. See Haacke and Eiseb, *Khoekhoegowab Dictionary*, 70.

8. Dapper, Ten Rhyne, and De Grevenbroek, *Early Cape*, 117.

9. Sparrman, *Voyage*, 187. It is not clear what the basis could have been for Sparrman's belief that the word *kaross* (sometimes pronounced with a reduced first vowel as *kros*) had its origins in Dutch. He was perhaps simply following Ten Rhyne, who made a similar unsupported claim in Dapper, Ten Rhyne, and De Grevenbroek, *Early Cape*, 155, identifying karos, "a wrap," as just one example of "'corrupt Dutch words' that were 'too numerous to mention.'"

10. Haacke and Eiseb, *Khoekhoegowab Dictionary*, 393.

11. Engelbrecht, *Korana*, 94.

12. Mossop, *Journal of Hendrik Jacob Wikar*, 9.

13. Bleek, *Comparative Vocabularies*, 50.

14. This may have been because working with leather was seen as an extension of working with animals, which involved not only hunting wild ones but also herding and milking domesticated ones and preparing skins. Women, on the other hand, were responsible for any tasks that fell within the domain of working with vegetation, which included collecting edible plants from the veld, cultivating domesticated ones, harvesting, pounding grain, cooking, and making baskets, reed mats, and thatched dwelling structures.

15. Maingard, "Three Bushman Languages," 100–115. Bleek recorded the word *sebi* in related Taa varieties as ʃaabi. Perplexingly, a very similar word (ʃabs) is given for "skin cloak" in an early Khoekhoe word list compiled by Etienne de Flacourt, which he published as chapter 25 in his *Dictionnaire de la Langue de Madagascar*, 54–61. The !Xoon language belongs to the Taa subgroup of the Tuu family and was (and still is) spoken by some of the smaller San communities of the western Kalahari. It is related to the !Ui languages.

16. The larger gemsbok and smaller duiker and steenbok are antelopes found in Southern Africa.

17. Maingard, "Korana Dialects," 61–62.

18. Engelbrecht, *Korana*, 110–12. Engelbrecht also suggested that there was a difference between the kaross used for daily wear and the kaross used as a blanket at night—but seemed to contradict himself when he added that the differences in fact were slight.

19. See, for example, the accounts of initiation customs given by Tabab and Matiti in Maingard, "Studies in Korana," 137–40; the account given by Iis and Meis in the same work, 140–41; and the account given by Andries Bitterbos in Engelbrecht, *Korana*, 157–61.

20. Engelbrecht, *Korana*, 131.

21. Lloyd, "Manuscript Notebooks on !Kora." Originals housed with the Maingard Papers in the Manuscripts Collection of Archival and Special Collections at the Unisa Library in Pretoria; digitized versions available online at http://lloydbleekcollection.cs.uct.ac.za under the heading of "Lucy Lloyd, Kora Notebooks."

22. Maingard, "Studies in Korana," 103–61.

23. Shaw and Van Warmelo, "Material Culture of the Cape," 497. Among some rural people, imported textiles were in the early days still colored red by means of ochre or iron oxide.

24. Lichtenstein, *Travels in Southern Africa*, appendix.

25. Shaw and Van Warmelo, "Material Culture of the Cape," 528.

26. Burchell, *Travels*, 350. The Sotho-Tswana word *kobo*, Venda *nguvho*, and Nguni *ingubo* are all cognate, each one reflecting in its own way a root that linguists have been able to reconstruct for the hypothetical ancestral language, Proto-Bantu. The Tswana form *kobo* may be the source of the Khoekhoe *khōb*.

27. Shaw and Van Warmelo, "Material Culture of the Cape," 520. Some versions of the baby blanket or sling were (and still are) almost universally used by mothers throughout the region, and there is a great diversity of names for it throughout the different languages of southern Africa.

28. Lichtenstein, *Travels in Southern Africa*, 273.

29. Burchell, *Travels*, 576–77. In fact, the Tswana word for a needle is more commonly *lomaô*, while *thokô* is the term used for "sewing." The Xhosa counterpart of the word for "sew" is *-thunga*.

30. Shaw and Van Warmelo, "Material Culture of the Cape," 555–56.

South African Kappies

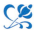

VICKY HEUNIS

THE KAPPIE is an iconic headdress that forms part of South Africa's clothing fashion history and cultural heritage.[1] During the Victorian era in South Africa, a fair complexion was a standard of beauty for women of colonial-settlement heritage. To provide protection from the strong African sun, which would tan their skin, many women wore a South African type of sunbonnet known as a kappie.[2] The term is probably derived from *kapje*, the Dutch word that means small cap or head covering.[3] Clothing historian Daphne H. Strutt confirms this origin: "So it seems that the progenitor of the *kappie* as we know it now evolved from the Dutch hood in combination with the 18th century caps."[4]

Voortrekkerkappie

The earliest versions of the kappie date back to the period from about 1837 to the 1850s. The kappies were referred to as *Voortrekkerkappies*, so named as they were favored by many *Voortrekker* (pioneer) women who migrated between 1835 and 1845 from the Cape Colony to the interior regions of southern Africa during what is known as the Great Trek.[5] Due to its practicality, the kappie was also sometimes worn by women of other racial backgrounds, especially those who lived and worked in farming communities.[6] It was typically considered a work hat, and when leaving the outdoors and entering a building, women either turned the brim of the kappie back or removed it altogether and wore a separate lace or cotton cap.[7]

The prominent shape of the kappie was informed by styles of headdresses favored during the midcentury in Europe.[8] Kappies featured a large brim that was kept stiff and away from the face because it was constructed of heavily starched fabric laced with cording and quilting done in decorative designs. Kappies typically had one or two shorter gathered or box-pleated frills covering the neck. Two loose ribbons were attached to the hat so that they could be tied under the chin to keep the kappie from blowing away in the wind.[9] Based on variations in their construction or shape, kappies were also known as *pofbolkappie* (puffed crown bonnet), *driestuk-kappie* (three-piece bonnet), *rondebolkappie* (rounded crown bonnet), and the *tuitkappie* (poke bonnet). Kappies worn for everyday use were usually made from white linen or cotton material and were colored a cream or biscuit color using dyes made from tree bark or husks.

Figure 2.1 A and B.
White linen Voortrekkerkappie quilted by hand with a flower motif.
War Museum Collection 04314/00002.

The designing, cording, and quilting was done on the individual parts of the kappie before they were assembled. The most outstanding features of the kappie were the beautiful quilted and corded patterns, sometimes known as white work or trapunto, that were painstakingly hand-stitched through the three or four layers of material used to construct the brim. According to quilter and quilt historian Lucille M. Chaveas, the white work quilting technique used on the South African kappie resembles the same technique known as *bourré*, or Marseilles embroidery, practiced in Provence, France, during the seventeenth and eighteenth centuries.[10] Quilting designs were drawn by hand or traced from leather or paper patterns onto the middle layer of material by using the handle of a tin spoon, a slate, or a drawing stone. The design lines were accented with inserted cotton cording obtained from frays of old clothing that were twisted together. The corded designs were then outlined with tiny running stitches through the layers of material so the design would stand out in relief. The open spaces between the corded designs were also filled with fine and even stitches that created a stipple effect. Women designed their own patterns and no two designs looked alike. Plant and flower motifs as well as geometric patterns were used as inspiration. Traditional designs included hearts, circled and stylized flowers, and geometric patterns, such as zigzags, stripes, checks, and diamonds.[11]

The result was a beautiful hand-quilted and corded kappie that displayed the wearer's adroitness for needlework. Strutt concludes that "the women put love and skill into the production of the *kappie*—and turned a utilitarian item into a thing of exquisite beauty, the highlight of a simple ensemble."[12]

Kiskappies and *Smouskappies*

Colored kappies (referred to as *kiskappies*) were usually worn during the first half of the nineteenth century by older women, not for everyday use, but as formal wear for special occasions. Colored kappies had a long crown shape and were usually made from colored cotton and shot silk or satin that could not be washed. Padding or wadding of cloth, but sometimes even of paper, was placed between the layers of material to provide additional stiffness. The brim was quilted and corded in straight thick parallel rows following the line of the edge of the brim arranged in sets with spaces in between. In these spaces the material was often puckered to produce a ruched effect.[13] During the middle Victorian period, around 1860 to the 1880s, colored kappies became more popular since they could be bought from traveling *smous* (traders) and were aptly named *smouskappies*. Because smouskappies were not handmade by the women who wore them or even by others in their community, the use of smouskappies was sometimes frowned on. After the introduction of the sewing machine in South Africa during the 1860s colored kappies were increasingly quilted by machine instead of by hand.[14]

Boerekappie/Sloopkappie

During the late Victorian period, circa 1890–1901, the so-called *Boerekappie* or *sloopkappie* emerged. The brims were often machine-quilted with straight lines and simple geometric patterns. Box-pleats or frills were attached at the point where the brim ended and the crown started. The crown was also gathered in the

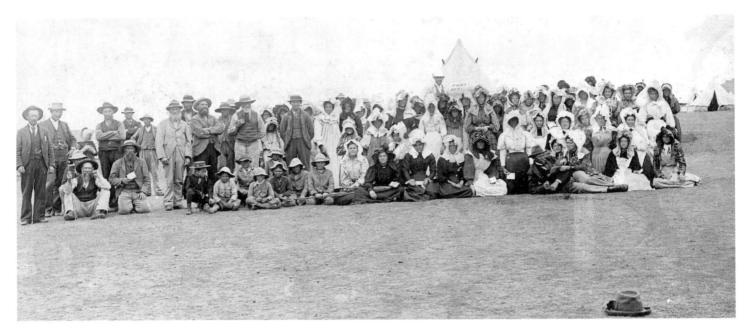

Figure 2.2.
Men, women, and children in an unidentified concentration camp during the Anglo-Boer War.
Note the various shapes, colors, and materials of the kappies that the women are wearing.
War Museum Collection 00794.

Figure 2.3 A and B.
Black satin sloopkappie quilted by machine with geometrical patterns, worn by Mrs. J. M. S. D.
Venter in die Bethulie concentration camp. War Museum Collection 05128/00003.

middle with a drawstring to form the long neck frill that covered the shoulders.[15] Sloopkappies were the style of kappie typically worn by women and children in the concentration camps during the Anglo-Boer War (also known as the South African War) of 1899–1902. The Victorians had a predilection for the color black, which was especially favored by older women, who preferred to wear black cotton or satin sloopkappies.[16] When a loved one passed away, the brims of these kappies were often covered by a layer of crepe as an indication of mourning.[17] With the dawn of the Edwardian era, circa 1901–1914, sloopkappies were made from printed cotton or a German print fabric known as *isishweshwe* with excessive frills attached to the brim.

Summary

The kappie had a revival during the apartheid era in South Africa as the government pressed racial divisions, celebrating and touting the history and culture of White South Africans over that of non-White South Africans. Replicas of traditional Voortrekker clothing, including kappies, were worn during the centenary and commemoration celebrations of the Great Trek in 1938 as well as during the inauguration of the Voortrekker Monument in 1949.[18] Even though the kappie was perceived to form part of the Afrikaner cultural heritage as an iconic headdress, the tradition of wearing kappies also lived on in the Afrikaans-speaking Coloured communities of the Namaqualand in South Africa until recently.[19] Sometimes replicas of kappies are still worn by reenactors for cultural events but most of the original extant headdresses have been preserved in South African cultural history museums as iconic pieces of White South African cultural heritage.

Notes

1. War Museum of the Boer Republics, *Hartskombuis*.
2. Pretorius, *Die geskiedenis*, 223.
3. *Merriam-Webster Dictionary*, s.v. "kappie."
4. Strutt, *Clothing Fashions*, 223.
5. Chaveas, "Study," 2.
6. Pretorius, *Die geskiedenis*, 106.
7. Pretorius, *Die geskiedenis*, 106–8.
8. Pretorius, *Die geskiedenis*, 106–8.
9. Chaveas, "Study," 4–5.
10. Chaveas, "Study," 4, 6.
11. Pretorius, *Die geskiedenis*, 108; Chaveas, "Study," 4–5.
12. Strutt, *Clothing Fashions*, 224.
13. Strutt, *Clothing Fashions*, 225, 239.
14. Pretorius, *Die geskiedenis*, 111–12.
15. Malan, *Kleredrag tydens*, 8–9.
16. Pretorius, *Die geskiedenis*, 112.
17. Malan, *Kleredrag tydens*, 9.
18. Brink, "The 'Volksmoeder,'" 10–11.
19. Litnet, "Die Suid-Afrikaanse ikoon met die pienk Namakwalandse kappie."

The Heritage Quilt

The Anglo-Boer War Women's History Quilt

VICKY HEUNIS

IN 2010, the War Museum of the Boer Republics, located in Bloemfontein, South Africa, commissioned Naomi Moolman of Utrecht, KwaZulu-Natal, to create a quilt to pay homage to the experience of South African women in the country's history from circa 1870 to 1920.[1] Titled *The Heritage Quilt*, the completed quilt intermingles her own personal family history with that of others. While it primarily focuses on the experience of White South African women, the textile presents an innovative way to interpret and narrate history.

Moolman first selected 114 historic photographs from the War Museum and her private collections and then had the photographic images transferred onto plain white cotton material. Next, she cut the images, now rendered on fabric, into squares or rectangular blocks. Following the Attic Window quilt pattern, she arranged and sewed together three rows of three to four blocks that carried images that were connected to one aspect of history. With the addition of window frame sides and a large fabric windowsill to each, Moolman created what she considered a tableau of history or a window into historical experiences of women. After making fifteen such windows, onto the windowsills she appliquéd 163 images of historical objects of personal significance to her family or which represented aspects of women's lives before, during, and after the war. Some of those were drawn from the collections of the War Museum.[2] The finished top was then quilted by Moolman's friends Petro van Rooyen and Magda Kriek.[3]

Each of the three rows of fabric windows portrays different phases of history. The top row of five windows focus on a twenty-year period, from the 1870s to the 1890s, before the onset of the Anglo-Boer War. A description of the contents of one of the windows illuminates how Moolman intermingles her own personal family history with the stories of others in order to convey these periods. The upper right-hand window in the top row features a compilation of family photographs belonging to Moolman as well as images from the photographic collection of the War Museum. The second image in the top row of that window is of an unidentified couple named Botha on their wedding day in 1886. In the row of images below that is one of three nieces of Moolman's mother-in-law; the photograph was from a postcard dated 1898 sent to Theunis Bekker. Moolman

Figure 3.1.
The Heritage Quilt was shown at the National Quilt Festival in South Africa and designer Naomi Moolman was on hand to provide information about the quilt. It was quilted by Petro van Rooyen and Magda Kriek during 2009 and 2010.
Collection of the War Museum of the Boer Republics, 07433/00009. Photograph by Nico Moolman.

added a personal touch with the image of her grandmother Naomi van der Heever (after whom she was named) in the oval frame incorporated onto the right windowsill. The rest of the objects that are appliquéd onto the windowsills are images of family heirlooms belonging to the Moolman family.[4]

The middle row of five windows focuses on the experiences of women during the actual war period, 1899–1902, as well as those who left a remarkable legacy in South African history. As an example, the center window features photographs of nine such women. From left to right are shown Emily Hobhouse (British humanitarian and pacifist), Gezina Kruger (wife of President S. J. P. Kruger), Hendrina Rabie (Boer nurse and writer), Johanna Brandt (Boer nurse, writer, and spy), Olive Schreiner (writer), Jacoba Barret (Boer heroine and fighter), Nonnie de la Rey (wife of General Koos de la Rey), Annie Botha (wife of General Louis Botha), Hendrina Joubert (wife of General Piet Joubert), Marie Koopmans–De Wet (pro-Boer humanitarian), Sarah Raal (Boer heroine, writer, and fighter), and Tibbie Steyn (wife of President M. T. Steyn). In the same window, on the upper right-hand window frame is a photograph, taken circa 1929, of

Figure 3.2.
The Heritage Quilt block 5 illustrates women and objects related to women's experiences before the Anglo-Boer War was declared in 1899.
Photograph by Nico Moolman.

Aia Liesbet and her daughter Martha at a farm called Vleiplaas, located in the Transvaal.[5] When the Boer women and children were taken by English soldiers to the Standerton Concentration Camp, Liesbet and Martha stayed behind at the farm at Vleiplaas where they had lived with a Boer family. At the farm, Liesbet and Martha made handheld brooms containing medicinal plants and herbs like rosemary and wild aloe with items such as a bag of salt or a bottle of Lennon's medicine, which they concealed in the grip of the broom. Liesbet, working as a temporary worker at the Standerton Camp, was able to smuggle these brooms into the camp where the medicines provided aid to the incarcerated sick women and children. Below the photograph of Liesbet and Martha is an appliquéd picture of a traditional handheld broom used by the Indigenous Swazi and Sotho cultural groups; the image portrays the underlying significance and symbolism of Liesbet and Martha's remarkable story.

The bottom row of five windows depicts the period immediately after the war through a period of recovery that lasted well into the 1920s. Homes and farms had been destroyed during the war and Moolman wanted to convey the resilience of

Figure 3.3.
The Heritage Quilt block 8 focuses on the endurance of White South African women during the Anglo-Boer War of 1899–1902.
Photograph by Nico Moolman.

women. As an example, the middle window in the bottom row focuses mainly on the home industries that were established by Emily Hobhouse. She initiated the beginning of various spinning and weaving schools in the former Transvaal and Free State Republics as well as a lace school at Koppies in the Free State. Shown in the left-hand middle row of the window is a beautiful *wag-'n-bietjie bos* (wait-a-bit tree) lace collar that was designed by Emily Hobhouse herself and is now in the War Museum collection. A bottom row left-hand image is of the National Women's Memorial in Bloemfontein that was unveiled on December 16, 1913. It is one of the first monuments in the world to be erected solely to commemorate the suffering of women and children in a conflict situation.[6]

In keeping with the theme of honoring women, *The Heritage Quilt* was unveiled on National Women's Day on August 9, 2010.[7] It has been shown at the 2014 National Quilt Festival but is now periodically displayed at the War Museum where it is considered by visitors as one of their favorite exhibits.[8] During special programs at the museum, Moolman stands near her quilt and tells visitors about the stories connected to the objects and images. For instance, she tells of Elizabeth Lotz (whose photo is shown in the far right-hand bottom row of the window in fig. 3.2). "Elizabeth was a nurse in the Cape Town area. During the Boer War, when she was eight years old, the English came to their farm and shot her father. Her mother was told to dig a grave and bury him. Then she and

Figure 3.4.
The Heritage Quilt block 13 features elements of women's lives in South Africa after 1902. Photograph by Nico Moolman.

her mother were taken away to a concentration camp. Story has it that she was so angry that she kicked and bit a soldier. After the war, she trained as a nurse. When she was offered the position of matron, she accepted on the condition that the nurses be allowed to talk to patients in their native tongue and not just in English. She also insisted that nurses should be trained in Afrikaans as well as English, and she got her way."[9] Through the retelling of Lotz's story, Moolman reveals the experience of just one woman during the war and animates a physical object—the quilt—as a storytelling device.

As one viewer of the quilt stated, "this quilt is an extraordinary testimony to the challenges of everyday life and war in a turbulent period of history. My historical knowledge is poor, and this was a wake-up call, reminding me how fortunate many of us are to live our comfortable lives without the sorts of struggles that these women endured."[10] At one glance the quilt is a meta-object—one object filled with more than a hundred textile objects and stories—all designed to convey understanding of selected elements of South African history. And while Moolman has used the quilt to narrate her personally curated understanding of history, it also serves to remember stories known and evoke awareness of sometimes stories unknown.[11]

The Attic Window quilt pattern creates an optical illusion for the viewer, who, from a present vantage point of safety, looks out through the windows into

The Heritage Quilt

history. His or her gaze penetrates into the historic past of South Africa before, during, and after the Anglo-Boer War of 1899–1902. By looking back at the past, the viewer can see the present in perspective. This quilt design approach provides a catalyst for visitors' own memories and awareness of these extraordinary and sometimes forgotten women. The quilt memorializes their histories for future generations.[12]

Notes

1. The War Museum of the Boer Republics is dedicated to providing an understanding of the background against which the 1899–1902 Anglo-Boer War, also referred to as the South African War, took place. The vision of the museum is "to be an institution of excellence whereby the inclusivity and suffering of all communities during the Anglo-Boer War are depicted, thus propagating the message that negotiation is preferable to war." (See Anglo-Boer War Museum, "Introduction to the Museum.") The institution achieves this aim through long-term and special exhibitions, research, and an extensive and unique collection of objects, photographs, and ephemera.

2. Moolman and Heunis, "Heritage Quilt," 91.

3. The quilt measures 10.96 feet by 20.96 feet. It took approximately twenty-one color ink cartridges, fourteen black ink cartridges, and 280 sheets of transfer paper to print the photographic images onto the cotton fabric. Approximately 158 feet of cotton fabric, 131 feet of wadding (also called batting), and 4.35 miles of thread was used to put components together. It took six months for Moolman, v. Rooyen, and Kriek to complete this masterpiece.

4. Moolman, *Die Groot Kwilt*, 72–83.

5. Moolman, *Die Groot Kwilt*, 114–35.

6. Moolman, *Die Groot Kwilt*, 190–207.

7. Moolman and Heunis, "Heritage Quilt," 20–22; Moolman, *Karren-Melk*, 91.

8. War Museum of the Boer Republics, *Anglo-Boer War in 100 Objects*, 252.

9. Ball, "South African Quilt Festival #7, Heritage Quilt, Dragonfly Quilts."

10. War Museum of the Boer Republics, *Anglo-Boer War in 100 Objects*; Moolman and Heunis, "Heritage Quilt."

11. MacDowell, "Quilts: Unfolding Personal and Public Histories in South Africa and the United States." A version of this was presented at Material Narratives conference, University of Johannesburg, November 18–20, 2019.

12. Moolman and Heunis, "Heritage Quilt."

The Boer War Quilt

Discovering History through Studying a Textile

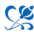

MICHAEL WALWYN

IN 2016, the Michigan State University Museum acquired a remarkable textile linked to South African history.[1] The seller on eBay from whom the museum purchased the textile described it as "a great item from a recent estate [sale]. This beautiful hand-made piece is a memorial quilt featuring participants and events from The Second Boer War (Oct. 1888–May 1902), between Great Britain and The South African Republic. There is a section of the quilt that says 'Worked by hand in 1900 by M. Bimsom.'"[2] The seller provided no additional data.

When the museum staff received the textile, they discovered that it was only a single layer of fabric with no backing, padding, or quilting. It was embroidered with an array of inscriptions and depictions of individuals, horses, and objects, including flags, rectangular containers labeled "shot," two armed female figures labeled "vengeance," and male figures in various types of military uniforms standing or mounted on horseback. In addition, portraits of named officers are presented within embroidered circular or oval frames, with one placed within the center of the textile and the others spaced evenly around three borders of the textile.

Many quilts associated with war have been documented by scholars, but typically these wartime quilts (figs. 0.14, 0.15) were made of military fabrics, sourced from the remnants used in the construction of military outfits or from used outfits, and often rendered in geometric patterns.[3] Two such quilts and one textile made as a table cover are known. All are affiliated with the Boer or Zulu Wars and were made by individuals who served in the Australian and British military.[4] Another quilt affiliated with the Boer War was made by Anglo-Canadians. Fashioned out of woolen army singlets (one-piece undergarments), it is embroidered with the names of over two hundred women as well as the names of British military leaders. It was thought to have been made as a fundraiser to support the Canadian men who served in war as fundraising quilts (quilts carrying the inscribed names of donors of funds) were commonly made in both the United States and Canada.[5]

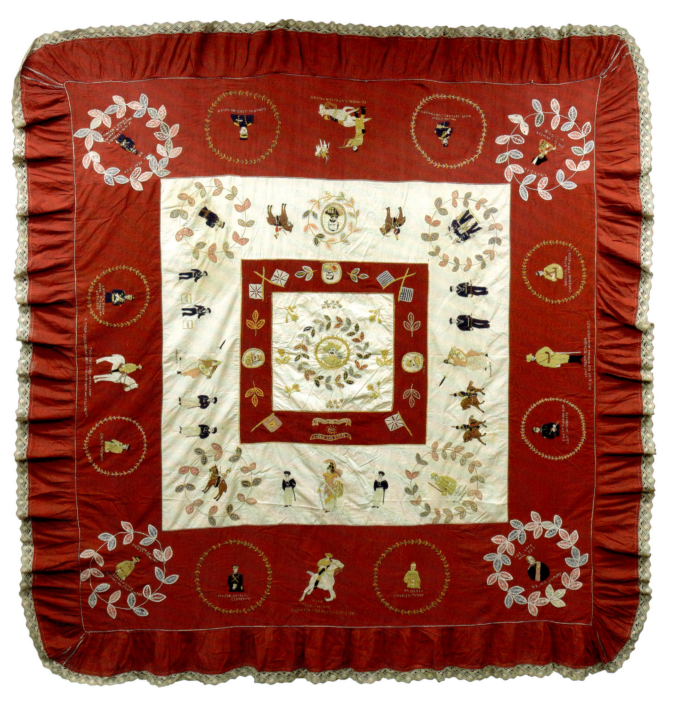

Figure 4.1A.
The South African Boer War Quilt, hand-pieced, hand-appliquéd, and hand-embroidered on cottons by M. Bimsom, 1900, 96 in. × 100 in.
Collection of Michigan State University Museum, 2016:10.1. Photograph by Pearl Yee Wong.

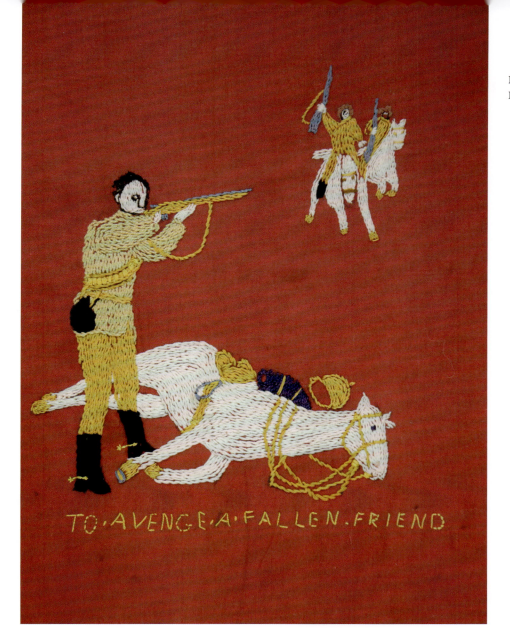

Figure 4.1B. Detail.

Figure 4.1C. Detail.

Figure 4.1D. Detail.

The Boer War bedcover in the MSU collection however is different from the quilts previously described. Instead of being constructed in multiple layers of cloth or with a top made of military fabric pieces in a geometric or block pattern, the MSU textile is one single piece of polished cotton cloth on which the embroidered figures and designs have been rendered.

An Overview of the Boer War

In order to understand how this textile is connected to the Boer War, it is useful to know something about the origins and key elements of the conflict depicted in the quilt. For purposes of examining this textile, it could start with the conflicts between the Dutch (who had settled in the Cape area of southern Africa in 1652) and the first English occupation of South Africa in 1795. The territory was returned to Holland after the Peace of Amiens in 1802 but was again taken by England after the Battle of Blaauwberg in 1806, and their possession was confirmed by the Anglo-Dutch treaty of 1814.

British rule thereafter was a constant irritation to the descendants of the original Dutch settlers, and this culminated in the Great Trek during the 1830s and 1840s, when disaffected Boers left the Cape Colony in search of new territories where they could be free of English rule and interference. Once out of the Cape Colony, they set up a number of small republics, two of which—the South

Figure 4.1E. Detail.

African Republic (Transvaal) in 1852 and the Orange Free State in 1854—were formally recognized by Great Britain. These were regions that were the traditional hunting and gathering territories of the Indigenous Khoisan people.

There followed a period of stability for the next twenty years or so, but the discovery of diamonds at Kimberley in 1871, followed by the gold rush to the Witwatersrand in 1886, changed all that, with the annexation by Britain of the Transvaal in 1877. The Transvaal declared its independence in December 1880, and war broke out.

With the discovery of diamonds and gold came a huge influx of foreigners—*uitlanders* to the Boers—and there was inevitable conflict between them and the republican government. The uitlanders developed many grievances, principally centered on the Transvaal's refusal to grant them the franchise. The perceived plight of the uitlanders provided an ideal justification for the British to pursue their imperial ambitions, not coincidentally coupled with their desire to control the Transvaal gold fields.

Largely instigated by the British, over the next three years a series of impossible demands were made on the Boer government, who made a number of concessions in the process, but eventually the Boers felt they had no option but to initiate war by invading the British-held Natal in the fall of 1899.

The Boers were not a military people. Honed by their exposure to a tough frontier life and surrounded by the threat of a resentful Indigenous population, they had, however, developed a very effective commando system that allowed them to call up and assemble troops at very short notice. In Natal, they faced a British garrison that the Boers, at that point, comfortably outnumbered. The British forces were also not prepared, in terms of their leadership, equipment, and dated military strategies, to fight a modern war. Equipped with modern artillery from sympathetic European nations, the Boers were able to strike and retreat quickly.

At first, the British suffered defeat after defeat, and the war dragged on for three years. Once the Boer capitals of Bloemfontein and Pretoria were taken by the English, the war shifted from traditional pitched battles, to which the English were accustomed, to a guerrilla conflict over huge swathes of territory. To deny support for the Boer army, the British destroyed Boer farms and homes and incarcerated Boer men, women, and children in concentration camps. Peace was agreed to on May 13, 1902, but the conflicts left an enmity between factions that still exists to this day among some descendants of the warring groups.[6]

Presenting Second Boer War History on the Quilt

The quilt holds a tremendous amount of visual data about participants in the Second Boer War. While research has not yet revealed more about Bimsom and his or her connections to the Second Boer War, it is obvious that the maker of this textile knew the countries that provided military personnel; what military personnel of particular nations, rank, and units wore and the type of arms they carried; and the physical appearances and names of important military leaders. A comparison of the embroidered portraits with painted or photographic portraits taken of these individuals during or near the time of the war underscores the skill of the artist in capturing likenesses.

All the named individuals depicted by Bimsom on the textile played critical roles in the Boer War. They are Lieutenant Colonel J. J. Byron; General Lord Methuen; Major Alfred William Robin; Lieutenant General Sir George White, VC; Lieutenant Colonel Otter, Canadian contingent; Lieutenant Colonel Herbert Plumer; Colonel W. H. McKinnon; Major General G. R. P. Woodgate (whose initials are wrong on the quilt—he was actually E. R. P. Woodgate); Major General Sir H. Smith-Dorrien (commanding Australian contingent); Major General R. A. P. Clements; Major General Charles Tucker; and Major General Sir W. P. Symons. Some continued in their military careers after the Boer War. Some returned to their homelands, others stayed in South Africa, where they became businessmen, landowners, and elected government leaders.

Without benefit of knowing more about or from Bimsom, it is impossible to know why the artist included this particular set of individuals and motifs on the quilt, but it might be surmised that the artist was a sympathizer of the British cause—or, perhaps, more accurately of the empire's cause, since all the portraits, bar one unnamed Boer soldier, were identified as being from Great Britain, Australia, Canada, and New Zealand. Regardless, the images and motifs on the textile reflect one individual's personal understanding of and interest in the war.

Most of what is known about the Second Boer War has been constructed from diaries, oral histories, photographs, paintings, archival records, built structures, preserved landscapes, and material objects, such as uniforms, arms, and other items directly connected with war efforts. This quilt is a unique addition to the tangible record of the war and provides a visual prompt to learn more about the Boer War, a period of tremendous change in South African history.

Notes

1. M. Bimsom, Boer War Quilt, 1900, collection acquisition records, Michigan State University Museum.
2. M. Bimsom, Boer War Quilt, 1900, collection acquisition records, Michigan State University Museum.
3. Gero, *Wartime Quilts*.
4. See figures 0.14 and 0.15 in the introduction to this volume, MacDowell, "The Border: Piecing Together a History of Quiltmaking and Related Textiles in South Africa."
5. See Harry Walter Wilton's quilt owned by the National Wool Museum, Geelong Victoria, Australia; Goldi Productions, "Mystery Canadian Boer War Quilt—1900."
6. For more information on the Boer War, see Pakenham, *Great Boer War*; Reitz, *Commando*; Farwell, *Great Anglo-Boer War*; Gardner, *African Dream*; and Cloete, *Rags of Glory*.

Isishweshwe

A Blueprint Fabric in Southern Africa

JULIETTE LEEB-DU TOIT

THE BLUEPRINT indigo cloth known primarily as *isishweshwe* in South Africa is derived from a long history of manufacture, international trade, intercultural borrowings, and various migrations of pre- and postcolonial settlements. It has served as a fabric to construct clothing (from workers' wear to designer fashion) and quilts. As a diasporic cloth, its use over time is a testimony to the ways in which alien objects became part of emergent global relationships among peoples and have served as markers of economic status, cultural identities, social activism, and political affiliations.[1]

Isishweshwe is rooted in several blueprint variants, part of a layered history of intercontinental trade and exchange, initiated probably from as early as the fourteenth century, if not earlier, by African and Arab trade and later by the Portuguese. The latter sourced cotton cloth in India, and it may also have been sourced from here by Arab traders. Isishweshwe was not a distinctive genre initially, reaching South Africa as one of the many variants of indiennes, a collective term used in Europe in the 1700s to denote resist, printed, or painted Indian-derived cloth. The Indian or East Asian prototypes for isishweshwe that entered Southern Africa, were also destined for eventual use in Holland and other parts of Europe, where Indian cloth and designs were emulated by European dye and print workshops. European precedents in linen cloth dyed with woad (a colorant derived from a flower), were to be radically affected by these cotton cloth imports in terms of technologies used in their manufacture, types of design embellishment, and the use of indigo and cotton.

Variants of the cloth, in emulation of Asian and East Asian prototypes, were subsequently produced in small blueprint studios in Europe (initially using woad, later to be replaced by imported indigo) from the seventeenth century, among others in Britain, Scotland, Holland, Belgium, Portugal, Hungary, Czechoslovakia, and Germany and later also in America. European studio-produced resist blueprint was produced by dipping a wood or wood-and-brass-pin designed motif into a paste and affixing this to white cloth, after which the cloth was dyed in an indigo vat, dried and the paste removed, leaving the design motif in white. This hand-printing method, coupled with cheaper access to synthetic indigo by

Figure 5.1.
Indigo blueprint (isishweshwe or sesheoshoe), Durban, South Africa, 2011. Photograph by Juliette Leeb–du Toit.

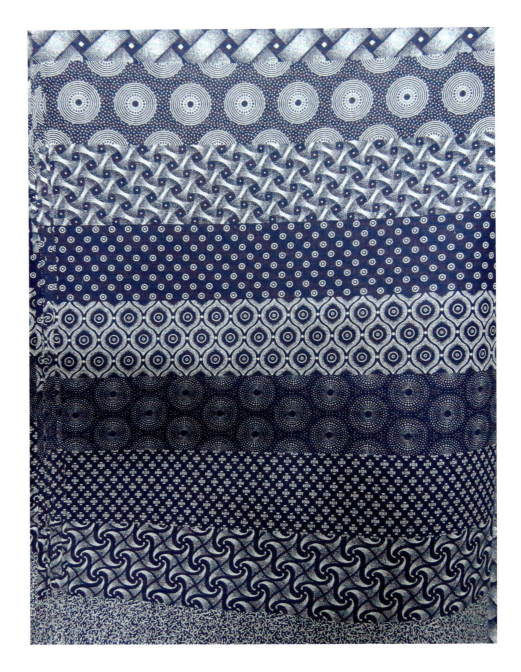

the late nineteenth century and the acceleration of printing by mechanization resulted in the cloth becoming more accessible and cheaper to produce. As a result, it was to become widely used in Europe as working wear and later came to assume national associations with the emergence of proletarianism and emergent (often contested) nationalisms, as occurred in nineteenth-century Hungary and even in Germany.

While Indian derived chintzes and cotton prints were doubtless the main initial source for possible blueprint variants entering the Cape from the seventeenth century, earlier Portuguese indigo trade cloth may have established an important aesthetic preference. The Portuguese had established an entrepôt on the eastern

Indian Ocean seaboard at Delagoa Bay (now Maputo) where similar cloth was probably traded for supplies and slaves. Blueprint was, however, also possibly rooted in the aesthetic of a fifteenth-century indigo slave trade cloth produced in the Cape Verde islands off the West African coast by African weavers, dyers, and slaves employed by the Portuguese. By 1462, African slaves and skilled weavers and dyers were brought to these islands to cultivate cotton and indigo to be used to produce cloth types based on existing and admired African traditions. The cloth produced in Cape Verde included *pano preta*, a deep, almost black, indigo cloth, as well as the *barafula* and *pano de obra*, a woven indigo and white cloth with geometric patterns, widely used as currency by the Cape Verde Portuguese and African settlers, slavers, and traders there.[2]

This would also perhaps explain why blueprint as a product of Indian and subsequent European origin was later well received—it supplemented an already known industry but also primarily a desirable aesthetic.[3] As there was limited African-made indigo-dyed cloth available for use as trade cloth in the lucrative slave trade, Indian and later European cloth variants were attractive alternatives. It is therefore tempting to situate isishweshwe preferences within this historical matrix. Slaves imported to the Cape (west and south coast South Africa) were variously sourced—in East and West Africa and in East Asia. The Asian sourcing of indigo cotton cloth usage is reflected in the 1700s in dress preferences among Middle Eastern slaves at the Cape identified in images from the early nineteenth century. But while imported cotton cloth (as also ceramics, indigo dyes, silver, and silk cloth) in Africa from India and the Arab trade had probably existed for centuries before European contact, cloth from Asia and the Orient began to be actively traded by Europeans from as early as the thirteenth century.

Given a lengthy history of intercontinental contact and trade, cloth became an increasingly important trade commodity as did associated aesthetics and manufacturing skills. Given the role of European traders in contributing to the trade and dissemination of various cloths, they also sought to locate markets en route to absorb the goods acquired in India and the Far East. The centering on one of these cloth types—known as blueprint, now known as isishweshwe, is marked by expansive journeys of exchange, shifting value systems, impositions, acquiescence, and ultimately, indigenization.

Isishweshwe was initially used as serviceable wear in South Africa, sourced predominantly in the White South African and slave and migrant community users' diasporic origins and cultural practice, albeit with cultural and geographic differences, with better variants used for best clothing. In some of these original European contexts, isishweshwe was also associated with proletarian political ascendancy and dissidence.[4] It is significant that some of these aspects also gradually accrued around its usage by both Black and White South Africans. Perceptions of isishweshwe's durability, cost effectiveness, and aesthetic were shared by both settler immigrant and African communities in South Africa. It was therefore not unusual for both white settlers and African women alike to use isishweshwe at the same time, especially in the late nineteenth century.

By the mid-nineteenth century cheaper mass-produced discharge-printed variants (in which designs are bleached out with a paste placed onto pre-dyed

Figure 5.2.
isiXhosa-speaking women of the Uhadi group performing a dance at the Grahamstown Festival, 2009. Photograph by Kirsten Nieser.

indigo cloth) were widely produced in Britain and Europe (Germany in particular), mostly intended largely for the African truck trade in southern Africa. Vast quantities entered this region, especially after the development of a commercially viable synthetic indigo in Europe from 1897 and increased mechanization of both resist and discharge printing. German manufactured blueprint outclassed the British inferior variants at the turn of the nineteenth century, until British variants improved and eclipsed former preferences for German blueprint in South Africa.[5]

In the present, the cloth has become central to seSotho, isiXhosa, and isiZulu speakers throughout the country and most Black South African women have worn it at some stage of their lives, whether in keeping with tradition or currently as associated with ethnic pan-African fashion preferences. Each culturally distinctive group has over time elected to use this cloth in specific dress styles, and these shift and evolve all the time. Some distinctive features and dress types have prevailed, however, such as the *ipinifa* (pinafore), demure necklines and mutton sleeves, the use of logo-displaying inverse pieces of the isishweshwe cloth used for decorative features and for defining necklines and pockets, and the hemline *liteke* (tucks) that are sourced in various prototypes in nineteenth-century Western dress modes. In recent years, the efflorescence of innovative designs has stemmed from pioneering figures in fashion design, such as Amanda Laird-Cherry and Bongiwe Walaza, among many others.

Since the 1970s, the discharge-printed variant of isishweshwe began to be locally produced by Da Gama Textiles Limited in Zwelitsha in South Africa's Eastern Cape Province, together with less desirable but cheaper variants manufactured by both local producers and other competing equivalents more recently

Figure 5.3.
baPedi woman, Polokwane, Mpumalanga, South Africa, 2005.
Photograph by Juliette Leeb–du Toit.

from Pakistan and China.[6] Da Gama has also contributed to innovations in the isishweshwe idiom by producing the cloth in new colorways such as purple, turquoise, pink, and orange (often in combinations of these), some of which has been well received by traditionalists as well as fashion designers and quiltmakers. Here the design idiom describes the cloth as isishweshwe and not the previously limited range of colors in blue, red, and brown (all three sourced in natural or synthetic indigo).

The mission context has been identified as the main source for the imposition of European prototypes that affected changes in dress in southern Africa clothing, as conversion, modesty, and hygiene ironically appeared to converge in the

Isishweshwe

Figure 5.4.
Dress of isishweshwe designed by Cheryl Arthur for an exhibition at the Iziko Museum. Iziko Museums of South Africa, Social History Collection. Photograph courtesy Iziko Museums of South Africa.

eyes of the church. A few images located in the late 1890s reflected the mission context, with Moravians, the London Missionary Society, Lutherans, and the Paris Evangelical Missionary society among the earliest identified instances of blueprint dress usage and absorption. However flawed its intended acculturation and proselytizing, the mission and church provided a new social structure and site of protection for fragmented communities and for those expelled from tribal

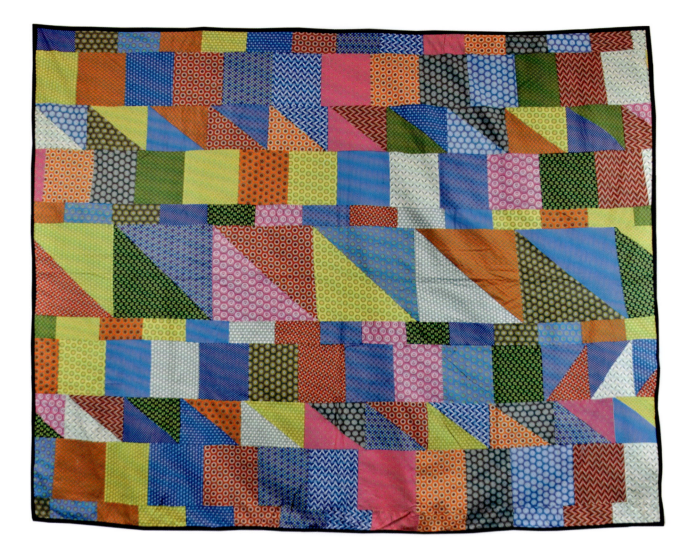

Figure 5.5.
Work by Onice Malekhwekhwe and Dina Tsibogo Makola, Johannesburg, South Africa, 2022, of pieced and unquilted isishweshwe.
Promised gift to the Michigan State University Museum. Photograph courtesy of the Michigan State University Museum

structures.[7] Ironically the sanctioning of cloth usage was supported by the very colonial structures that sought to undermine the cohesion of "tribal" structures and economies in the interest of industrialization and a market economy.

By the early twentieth century, isishweshwe came to express qualities associated with gender decorum among historically "traditionalist" peoples. The widespread wearing of isishweshwe had come to reflect desirable qualities associated with female modesty and decorum, domesticity, marital status, and even religiosity.[8] Importantly both cloth and dress primarily conveyed consensual submission to dress conventions expected of the married woman in traditional contexts. In its association with marriage, the wearing of an isishweshwe garment implicitly protected the female wearer from unwanted male attention, as it betokened the wearer as married and subject to both her husband and by extension his clan. A rural woman wearing isishweshwe was often regarded as being well provided for by her husband, her dress an implicit display of relative wealth. In marriage, too, its wearing also suggested a subscription to modesty

Figure 5.6.
Widow near East London, South Africa, wearing an isishweshwe *ujamani* to indicate she is still in mourning. Photograph by Juliette Leeb–du Toit.

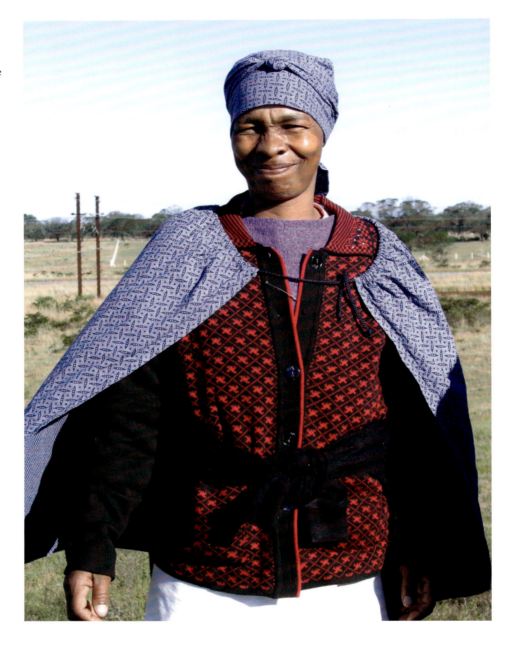

in keeping with expected behavior and the conventions of respect and honoring (*ukuhlonipha*). Attached to all of this was an emerging sense of being differentiated as African and, particularly, South African and Black.

Isishweshwe has assumed pertinence in South Africa to the extent that its earlier colonial roots and associated constraint and imposition, have been eclipsed by culturally condoned applications—to rites of passage and, particularly, to rites associated with marriage, childbearing, and, more recently, to mourning. Isishweshwe has consequently long transcended, but not ignored, its original European and international associations and is worn throughout South Africa as indigenized and culturally relevant. This is especially reflected in the dress

of women, custodians of external reflections of cultural practice and regional distinctiveness, belief systems, hierarchies, and worldviews, although more recently men have begun to use isishweshwe extensively, as signifier of their South Africanness.

Isishweshwe usage also came to reflect the increasing role of industrious women adept at marketing the fruits of their labor in the prolonged absences of their migrant spouses, as it was representative of their thrift and both cultural and personal sartorial pride. As African women acquired sewing skills in missions and schools, the business acumen and entrepreneurial skills as dressmakers that they gleaned from traders' wives resulted in increasing self-sufficiency (and consequently a degree of autonomy) that at times came to be regarded as endangering culturally embraced hierarchical and gendered balances.

But the wearing of isishweshwe and Western dress also, ironically, embodied a partial challenge to the traditional control of women's labor and economy/expenditure. This crucial, seemingly ambiguous development contradicted the perception of women as an underclass in a patriarchal society. Now functioning more freely in vital roles in a post-independent nation, South African women celebrate in their ongoing cultural usage of isishweshwe an acknowledgment that they have surpassed their erstwhile subservience to historically traditional practice and patriarchy as well as their rurality. In this regard, an informant indicated that to her it also signified oppression, as it represented female compliance with male dominance and the relinquishing of her power.

White South African women, many of whose predecessors first wore isishweshwe, have variously utilized and then relinquished their usage of isishweshwe. By the late 1800s rural Boer women upheld ideals of womanhood and domesticity, propriety, and religiosity. They championed these beliefs in the symbolic wear of their Voortrekker predecessors. In post-Trek communities—the members of which are today called "pioneers" by some cultural historians—the Boer woman in her kappie (bonnet) and serviceable dress, both often of *bloudruk*, epitomized the indomitable and steadfast spirit of women in the Anglo-Boer War of 1899–1902. They were viewed as victims of Queen Victoria's indifference, Herbert Kitchener's intransigence, and Britain's ruthless imperialism.

While I have always been aware that some White communities, pre-1960s, wore isishweshwe, it was not until I visited the collections and archives of all South African museums that I located ample evidence, reflected in quilt collections—especially those in Bloemfontein, Pietermaritzburg, Pretoria, and Cape Town—that its use was far more widespread. South African quilts derive from a range of communities and contexts. Initially their making was dominated by White women from various European settler communities; it is also well known that slave and domestic employees produced quilts for their employers and for themselves. The making of quilts from intentionally purchased cloth differed in part from those that were often made from worn clothing remnants or available fabric, in that they reveal quotidian sourcing in everyday available and more readily discarded dress items.

Many quilts located in museum collections testified to the extensive use of bloudruk. Typical of European derived work-wear cloth, this seldom, if ever,

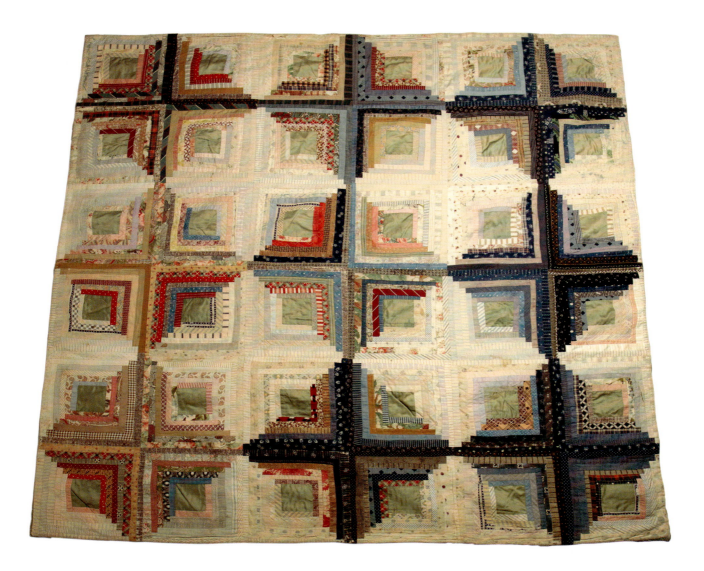

Figure 5.7A
Pieced log-cabin pattern quilt of cottons, including isishweshwe, by an unknown maker, South Africa, nineteenth century. Collection of the Iziko National Museums. Photograph courtesy of the Iziko National Museum

entered museum collections, where preference was rather given to special or significant attire, such as ball gowns, ceremonially specific dress, and "quality" clothing. Were it not for the quilts I found in these collections, evidence of the wearing of isishweshwe would have been very difficult or almost impossible to trace. These finds enabled me to deduce that not only was European blueprint worn and available in South Africa but also that by the late nineteenth to early twentieth century both pre- and post-Trek pioneer women often wore bloudruk, or *blou sis*, a usage they shared with Black South African women and other marginalized groups at the same time. This commonality of blueprint and bloudruk was discarded in the selective and conceptual reconstruction of Voortrekker and pioneer identity after the 1940s, when such dress became conceptualized and sanitized using synthetic cloth and becoming seemingly prescriptive. The neglect of histories of usage and the shared usage of isishweshwe prototypes, in particular, reflect the extent to which a history of cloth usage and preference would have been skewed had not the evidence of quilt insertions of blueprint

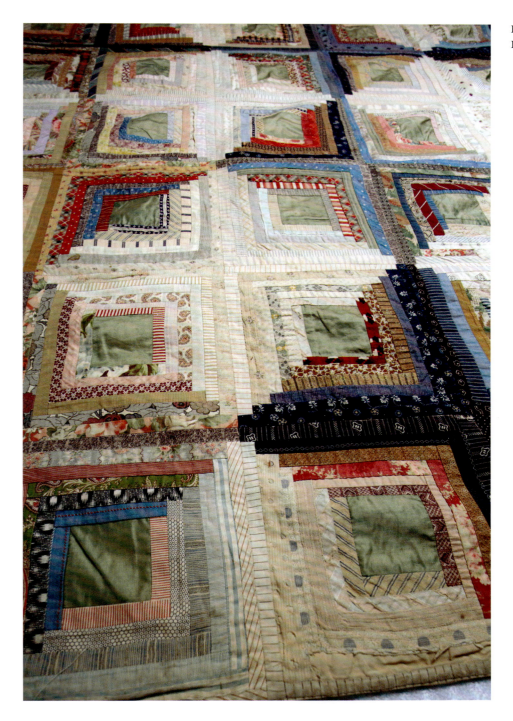

Figure 5.7B
Detail.

not countered a previously myopic and blinkered gaze at cloth preferences and usage.

Coloured communities at Genadendal in the Western Cape and in the greater Kokstad area (bordering present-day KwaZulu-Natal) abandoned their usage of isishweshwe in the late 1940s when their status improved, and Black communities wore the cloth predominantly. Perhaps this abandonment of isishweshwe

Isishweshwe

stemmed from class, racial, and political tensions, or shifts, that emerged increasingly in the postwar period, in conjunction with improvements, economic and educational, in the lives of Afrikaner and, for that matter, Coloured communities.

Cross-cultural dress in South Africa is the outcome of intersecting factors, including desirable individuation, overtures to exotic modernities, and ostensible partisanship and liberalism. It conveys alterity as well as presumed interracial affinity. By the late 1960s the wearing of isishweshwe by "partisan" White women was widespread. It was then perceived as an ideal variant of cross-cultural dressing that marked the renegotiation of self precisely in a context of cultural self-interrogation and intercultural scrutiny. By wearing isishweshwe, these women challenged the specifics of exclusivity in a multicultural context, upholding the porosity of traditional boundaries ostensibly demarcating race, ethnicity, and nationhood. White South African wearers identified the wearing of this cloth as a subversive signifier of opposition, or even resistance, to segregationist policies and implicitly the state.

Not surprisingly, from the 1960s onward, many quilters intentionally included isishweshwe inserts and developed Africanized motifs in their quilts. Isishweshwe inserts in quilts likewise reflected the widespread use of isishweshwe cloth in what was considered "bohemian" or "hippy" clothing. In these contexts, isishweshwe served as a benign signifier of cross-cultural global "resistance" dress.

As South Africa enters a counterrevolutionary phase, new claims as to exclusivity and ownership emerge, extending to colonial-derived items. Postcolonial and decolonization rhetoric has actively sought to selectively reposition and rewrite history. In this context, isishweshwe functions as a significant contextualized facet of history to be explored from racial and economic perspectives.

At the beginning of the twenty-first century, isishweshwe is deeply embedded in the psyche of South Africans—regardless of race—as a cloth steeped in values and associations that transcend its colonial origins. Isishweshwe has expanded its production, retained its local clientele and applications, and reentered the very competitive international markets that desisted in its production pending the social unrest and chaos that was presumed to inevitably ensue after 1994 in South Africa.

Notes

1. In this chapter I have elected to use the cloth's more popular name, derived from isiZulu. The naming of the cloth and its designs reflects the extent of its indigenization. Isishweshwe, said to derive from *seshoeshoe* (seSotho), is seemingly rooted in the name of the first monarch of Lesotho, Moshoeshoe I. Internationally, however, as the precursor of isishweshwe, blueprint was known by various names—for example, *blauwdruk* (Holland), *Blaudruck* (Germany), blueprint (United Kingdom and United States), *kékfestö* (Hungary), and *modrotisk* (Czech Republic). In South Africa a number of vernacular names for isishweshwe emerged over time. They were coined by the cloth's users and often reflected its European origins. Hence "German print" or blueprint (English), *Duitse sis*, bloudruk (Afrikaans), *ujamani, isijalmani, ujeremani, idark, iblu* (isiZulu and isiXhosa, as also used by the amaBhaca, amaNtlangwini,

amaMpondo, amaThembu and amaMfengu), *amatoishi* (sePedi), and *ndoeitji* or *mateis* (seTswana or Herero). Currently the names *isishweshwe* and *blueprint* are most commonly used in South Africa.

2. Jenny Balfour-Paul, personal communication with author, 2016.

3. H. Thomas, *Slave Trade*, 317–20.

4. By 1844, *kékfestö* had become highly significant in Hungary as an adjunct to *Heimatliebe*, a patriotic signifier of one's love for one's country. This trend was instigated by various reforms—political and economic—proposed by the fiery Hungarian leader Lajos Kossuth. His ideals emerged from the 1830s as aspirations to national freedom and as demands for the franchise and other equalities. Under the previous South African regime, White and Black women wore isishweshwe for this very reason. Recent revivals in the use of isishweshwe have shared similar patriotic overtures as wearers identified with the cause of oppressed African women, who also often wore isishweshwe to denote their oppression and declare themselves in their widely recognizable "African" dress.

5. Leeb-du Toit, *Isishweshwe*.

6. Since at least the 1980s, cheaper variants of isishweshwe have emerged in South Africa. These were initially intended to compete with earlier British and European variants and later Da Gama authentic cotton discharge-printed isishweshwe. But as these variants were less desirable to local consumers, they became identified as being inferior and were so designated by their African purchasers. The essential qualities associated with "authentic" (i.e., Da Gama discharge-print) isishweshwe are durability, colorfastness, and design and that the cloth be of a certain weight and only in pure cotton. Many of the "fake" variants are printed (not discharge printed) and are of polyester cotton mixes. Others are regarded as being too heavy and therefore hot and unsuitable for the local climate.

7. To some South African communities, aspects of missionization such as the acquiring of the benefits of Western education was associated with potential power reclamation, with providing a voice to challenge other unacceptable aspects of colonial oppression, such as land deprivation and the imposition of many other legal and mobility restrictions. Acquired colonial "benefits" functioned as some of the "major social and cultural transformations . . . implicated in material substitutions" (N. Thomas, "Case of the Misplaced Ponchos," 79–96). In this regard, both cloth usage and dress based on colonial prototypes came to not only signify modernity, however flawed its associated cultural ruptures, but also contribute to the creation of new social, class, and culturally sanctioned structures that eclipsed and challenged those previously in place.

8. Then known, inter alia, as blueprint, mission print, *jalmani*, *jeremani*, or *ujamani* in reference to the German-produced cloth's origins or merely as prints, calicoes, or indiennes.

Potchefstroom

A Regional Center of South African Quilt History

MIEMS LAMPRECHT

POTCHEFSTROOM, SOUTH AFRICA, has a long history of quiltmaking and use and, because of more recent quiltmaking activities, is considered a place of importance in South African quilt history. Located roughly seventy-five miles west–southwest of Johannesburg, the city grew from one of the earliest settlements of Europeans in the North West Province of South Africa. It was founded in 1838 by the Voortrekkers (pioneers), who, seeking freedom from restrictions of the British-governed Cape Colony on South Africa's western coast, traveled to and settled in interior regions to the northeast, which were the homelands of Indigenous and Zulu-speaking peoples. In 1846 Potchefstroom became the capital of the Zuid-Afrikaansche Republic. The town grew steadily and became a bustling center of trade on a major north–south route for transport wagons. Today, it is a city known for having five tertiary education institutions and numerous museums, including one with an extensive collection of quilts, kappies, and patched clothing. The museum also serves as a hub for a vibrant contemporary quiltmaking community.

The city's quilt-related history can be traced back to the time of Voortrekkers. At the outset of their monthslong, or even yearslong, journeys, Voortrekkers purchased and packed their wagons with the goods necessary for not only the long trek to the north but also to establish homes once they arrived. Supplies packed into wagons included rolls of material such as cotton, linen, silk, gauze (cheesecloth), printed calico, damask, twill weave, velvet, and flannel to make clothes and bed linen. Needles, an especially scarce commodity on the trek, and sewing kits were kept in a safe place such as the wagon chest. Transport riders and traders who periodically visited the isolated farms and far-flung pioneer towns brought with them ready-made clothing from Europe and fabrics. Women availed themselves of the fabrics to make clothing and household items, including quilts.

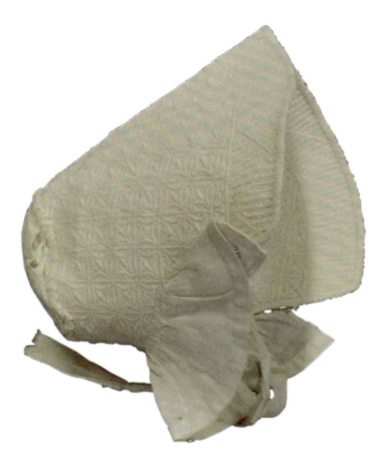

Figure 6.2.
Dorsland *Kappie* (Thirstland Bonnet), 1899–1902, hand-stitched and quilted of plain and printed cotton. The pattern for this kappie was cut in one piece with the round neck frill. An inner lining was provided for the ball (or crown) with a seam for a pull-in ribbon. The broad rim was machine-quilted in numerous patterns and decorated with flat layer pleats on the ball of the bonnet. The bonnet has ribbons that tie underneath the chin.
Collection of Miems Lambrecht (BDR 3). Photograph by Petricia Monchusi, courtesy of the Potchefstroom Museum.

Figure 6.1.
Kappies, Hand-stitched and quilted cotton, 1872. Cecilia Kamfer made these two christening bonnets for her daughter, Hester Gertruida Schwellnus (née Kamfer).
Potchefstroom Museum Collection (11149/11332). Photograph by
Petricia Monchusi courtesy of the Potchefstroom Museum.

Kappies—Bonnets with Quilting

One item of clothing in particular incorporated quilting as an essential feature. Cloth bonnets, called kappies, were favored by the Voortrekkers and Boer settlers, and had brims that were typically quilted in a variety of designs.[1] The patterns employed in the construction of the kappie itself and the quilting designs used on the brims differed from region to region. In the North West Province, a distinctive style, known as the Dorsland kappie, was used for many years by women living on farms and in rural areas. The Dorsland bonnet had a unique construction design—the brim, crown, and neck frill were cut out of one piece of fabric. The Dorsland kappie was named after the pioneers who traversed the Dorsland trail, trekking north through part of what is now called the North West Province through Botswana and Namibia to Angola, where they settled before and after the Anglo-Boer War (1899–1902). Some returned to make their home in South Africa.

Patchwork Mending

As they traveled and settled into new homes, the Voortrekkers wasted no fabrics; worn clothing was patched again and again with the tiniest scraps. A particularly heavy use of patchwork mending occurred during the Anglo-Boer War. During this period, the British War Office introduced a scorched-earth policy, whereby farms and homesteads were burned down and women and children

Figure 6.3. Cotton jacket, unknown maker, 1902, machine- and hand-stitched with applied patches of various materials. This well-patched jacket was worn by a six-year-old Boer boy who was sent with his mother by the British to a concentration camp near Potchefstroom during the Anglo-Boer War (1899–1902). He died in the camp. Potchefstroom Museum Collection (829), donated by Hester Yessel. Photograph by Petricia Monchusi, courtesy of the Potchefstroom Museum.

Figure 6.4.
Cotton dress, unknown maker, 1902, machine-stitched with hand-applied patches. This dress is made of printed cotton with patchwork on the shoulder. The whole dress was dyed with the sap of an indigenous plant, *Eilandsboontjie*, so as not to show the dress' deterioration. The dress was worn by the young daughter of Jacoba and Maurits Jacobus Coetzee during the Anglo-Boer War. Potchefstroom Museum Collection (335). Photograph by Petricia Monchusi courtesy of the Potchefstroom Museum.

sent to concentration (so-called refugee) camps, one of which was located at Potchefstroom. In the camps, where women were cut off from supplies of new fabric, they patched their and their children's clothes with pieces of old clothing.

Historical Patchwork and Quilted Bed Covers

It is known that some Voortrekkers brought handmade patchwork quilts with them on their trek and, as they settled, made more in their new Potchefstroom homes. Some used the Indigenous technique of stitching together pieces of animal skins to make bed covers; others used the patterns and construction

techniques of their own cultural heritage. Although few examples of historical quilts made prior to the Great Trek are extant, even when mass-produced blankets became available, patched, and quilted bed covers were made by Boer settlers and continued to be made by their descendants in and around Potchefstroom.

Among the quilts and quilted items in the Potchefstroom Museum collection are several fragments with well-documented provenance that connect the textiles to regional history. For instance, one made by Balthariena Johanna Grobler (née Wagenaar) circa 1830 has a satin top, sheep wool wadding (batting), and a backing of Irish cotton linen. Balthariena was married to Johannes Hermanus Grobler, the first magistrate of Potchefstroom. The quilt survived the clashes that occurred during the trek between the pioneers and Zulus at Wenen, Moordspruit, and Bloukrans, which can be attested to by the blood spatters still evident on the quilt. Later the quilt was cut into pieces and shared among six granddaughters. Two of them, Bertha and Lina, decided not to cut their share; in 1961, Lina van der Merwe (n–e Grobler) donated her remnant to the museum.

Contemporary Quilting Activities

Up until the 1980s, the making of quilts was primarily an activity learned and practiced in the home. However, one couple—Hettie (née Van der Merwe) and Chris Schwellnus—are credited with initiating new opportunities for learning patchwork and quilting outside the home, for forming groups of quilters, and for instigating exhibitions of quilts not only in Potchefstroom but also across the country. Both were lecturers at the Teacher's Training College (today part of the North-West University) in Potchefstroom and were also deeply involved in local cultural and civic organizations. Hettie liked all forms of needlework, but in 1978, she started to focus on patchwork and quilting. She became one of the first quilt teachers in the region, her work was shown in exhibitions, and she was regularly invited to do demonstrations. Frequently interviewed on television and radio, she became well known throughout the country as a quilting expert. Together the couple coauthored seventeen books, including *Las Met Lap: Stap vir Stap*, one of the first books to pay homage to the history of patchwork and quilting not only locally but also in South Africa as a whole.[2] The publication also contained descriptions of different construction methods and patterns for patchwork. On a local level, both Schwellnuses, but especially Hettie, were instrumental in founding quilting groups, and today there are a number of robust quilt groups in the area.[3] In 2011, Hettie received the Pro Dedicate Award from the South African Quilters' Guild for her work as a quilt artist, author, and a leader in promoting the art of quiltmaking.

The first meeting of the Golden West Quilt Guild, the region's largest quilt guild, was held at the Potchefstroom Museum in 1989.[4] Under the leadership of Hettie Schwellnus, the first exhibition of quilts by guild members was hosted by the museum. The museum now hosts an annual exhibition of quilts organized by the De Oude Molen Gilde; the display of quilts is accompanied by quilting workshops and demonstrations. The museum also supports the outreach activities of

the Golden West Quilt Guild by donating fabrics that can be used in teaching workshops held by the guild for men and women in underserved communities.[5] With strong roots because of its association with its Voortrekker history, quiltmaking is an activity in Potchefstroom sustained by new generations of quilt and patchwork artists.

Notes

1. On kappies, see chapter 3, "The Heritage Quilt," by Vicky Heunis, in this volume.

2. Schwellnus, *Las met Lap Stap vir Stap*.

3. The Golden West Quilters' Guild (formerly called the Northern West Quilters' Guild) is the affiliated umbrella guild for the North West Province and consists of three different regionally based groups, namely: Country Quilters (formerly named Carletonville Quilters Guild), De Oude Molen Quilters (Old Mill Quilters), and Quilting Bees (formerly Klerksdorp). All groups are affiliated with the South African Quilters Guild.

4. The Potchefstroom Museum is part of the Arts, Culture and Heritage Section of the JB Marks Municipality in the southern region of the North West Province, a region that includes the towns of Potchefstroom and Ventersdorp.

5. "Golden West Quilters Guild, Outreach Day," *South African Quilters Guild*.

The South African Quilters' Guild

ELSA BRITS

THE SOUTH AFRICAN QUILTERS' GUILD (SAQG) has played an important role in cultivating communities of practitioners in South Africa. It was founded in 1989 at the Bloemfontein National Quilt Festival with the purpose of fostering a structured environment where all South Africans can reach their full potential in quiltmaking and related textile art, nationally and internationally.[1] The modern history of the SAQG can be traced to the mid-1970s, a period that also saw a revival of quilting arts in the United States and other countries. Because of the political situation in South Africa at that time, possible international teaching, exhibition, and judging opportunities were extremely limited and only a few South African quilters were able to learn about or be engaged in global quilting activities.

One of the first South African textile artists to make connections between quiltmaking activities outside the country to quiltmaking in South Africa was Kaffie Pretorius. In 1976, she traveled to the United States to take a class in patchwork at an art academy in Los Angeles. There she learned to make a "Sampler" quilt, a type of quilt she had not seen made in South Africa. Upon her return to South Africa, she began teaching this style to others and inspired many to start quilting. Some of her students, including, notably, Maretha Fourie and Suzette Ehlers, became well-known quilt artists and were instrumental in founding the SAQG and developing some of its signature programs.

Structure and Membership

As of 2024, the SAQG has approximately two thousand members and is primarily made up of eleven regional guilds. Each regional guild elects a representative who serves on the National Guild's committee. Members of each regional guild are also considered members of SAQG.[2] Additional SAQG member guilds are considered "country groups" and can access the benefits offered by SAQG. These are groups or guilds functioning on their own and usually situated far from the large regional guilds or in neighboring countries.[3] Lastly, SAQG offers individual membership for those living far from any of the regional guilds or country groups.

Figure 7.1.
South African Quilters' Guild Banner
Photograph courtesy South African Quilters' Guild

Programs and Special Projects

The SAQG is engaged in various activities to document and bring recognition to the history of quiltmaking in the country, to support and build awareness of South African contemporary quilt art, and to teach quiltmaking. These activities include a biennial National Quilt Festival (held since 1986), juried traveling exhibitions (begun in 1995), and digital galleries of members' work.

Several recognition programs highlight the contributions of individuals to quilting history. Individuals who have won awards at SAQG's national exhibition and whose work reflects a "consummate level of the quilter's skill in the design, his/her outstanding technical workmanship and the exceptional execution of the quilting in the finished piece" are deemed master quilters.[4] The Pro Dedicate Award program, which began in 2000, is given every other year to an individual in honor of their outstanding service to quilting in South Africa.[5] The Quilters' Hall of Fame program, which began in 2019, "honors the lives and accomplishments of those people who have made outstanding contributions to South African quiltmaking."[6]

One major initiative is the South African Quilt History Project in which SAQG members documented historical quilts made prior to 1960 that were in public and private collections. Each historical quilt was photographed and information about the quiltmaker and the history of the quilt was recorded on

inventory forms. The records of the project are now accessible online through the Quilt Index.[7]

One programmatic area of the SAQG is developing a cadre of individuals who are accredited as quilt judges and who are committed to keeping the quality of quilt work high. Using a judging system developed in the United States by the National Quilting Association (NQA), certified judges bring to their work a broad and deep knowledge of quilting techniques, history, and awareness of the criteria needed to evaluate the work of quilt artists, especially those who wish to have their quilts included in exhibitions, compete for prizes, or sell their work. In 1983, quilt artist Suzette Ehlers became one of South Africa's first accredited quilt judges after completing an NQA accreditation workshop in the United States. Several accreditation courses have since been held in South Africa, and by 2022, there were thirty accredited quilt judges in the country.

In 2013, SAQG embarked on developing an accreditation course for individuals who wish to become quilt teachers.[8] In an effort "to keep the standard of quilt teaching and quilting of the highest quality by training inspiring and professional quilt teachers," SAQG confers recognition on three categories of teachers: SAQG Accredited Quilt Teachers, who have successfully completed a one-year correspondence accreditation course; SAQG Recommended Quilt Teachers, who have been acknowledged as being excellent teachers with a solid record of experience; and SAQG Specialist Quilt Teachers, who are recognized for their unique specialization in a particular aspect of quilting, such as machine quilting, thread painting, or teaching children. Over 160 of such recognized individuals from these three groups are eligible to apply to teach at the National Quilt Festivals.[9]

Almost every guild has at least one charity project that supports other community needs, including many associated with the health and well-being of their communities. Whether it is knitting jerseys (sweaters) for premature babies, teaching skills to women involved in economic development craft programs, or crafting beanies (hats) for those who need warm head coverings, guild members use their fiber skills in benefit of local needs.

The majority of the membership of SAQG are of colonial-settler heritage and are able to source the financial resources to purchase the cloth and equipment needed to create quilt art or to pay for classes in basic quiltmaking and specialized quilt techniques. In recognition of this privileged situation, SAQG member guilds are committed to diversifying their membership, creating access to quiltmaking instruction and to the materials and equipment needed to make quilts and to exhibiting and finding markets for the sale of quilts made by historically disadvantaged South Africans. Almost every member guild conducts ongoing or

Figure 7.2.
Sample images of South African Quilters' Guild activities. Screenshot, South African Quilters' Guild, Facebook page, accessed June 27, 2023, https://www.facebook.com/SouthAfricanQuiltersGuild/photos_albums.

Figure 7.3.
A sampling of the charity projects undertaken by the South African Quilters' Guild. Screenshot, "Community Projects," South African Quilters' Guild website, accessed June 27, 2023, https://www.quiltsouthafrica.co.za/community-projects.

The South African Quilters' Guild

special programs to meet these goals and regularly displays work resulting from these programs in their local guild exhibitions. On the national level, space is dedicated at the biennial SAQG exhibition to showcase work from Black South African quilters.

In addition to these regularly offered programs, SAQG often undertakes special short-term projects in which several artists collaborate on major pieces. Examples include the *Wall of Peace Quilt* on permanent display in Durban, the World Summit on Sustained Development Quilt, and a quilt commissioned from the Golden Rand Guild for Quilters and Protea Quilters as part of the celebration in 2003 of the enthronement of the thirty-sixth king of the Bafokeng.

Summary

With the establishment of the new democratic government and the lifting of the boycotts by other countries, South African quilters, like their peers elsewhere in the world, are free to travel, teach, learn, exhibit, and produce art that sustains traditions of quiltmaking, creates avenues for economic income, and is recognized and awarded internationally. The South African Quilters' Guild has provided an important means for quilt artists to meet and learn from each other, to document and share their work, and to establish standards of quality of craftsmanship and artistry that member artists strive to meet.

Notes

1. South African Quilters' Guild website. Accessed July 27, 2024, https://www.quiltsouthafrica.co.za/.
2. "Regional Guilds," South African Quilters' Guild. Accessed July 27, 2024, https://www.quiltsouthafrica.co.za/the-south-african-quilters-regional-guilds.
3. "Country Groups," South African Quilters' Guild. Accessed July 27, 2024, https://www.quiltsouthafrica.co.za/the-south-african-quilters-country-groups.
4. "Master Quilters," South African Quilters' Guild. Accessed July 27, 2024, https://www.quiltsouthafrica.co.za/master_quilters.
5. "Pro Dedicate Award," South African Quilters' Guild. Accessed July 27, 2024, https://www.quiltsouthafrica.co.za/pro-dedicate.
6. "Quilters Hall of Fame," South African Quilters' Guild. Accessed July 27, 2024, https://www.quiltsouthafrica.co.za/quilters-hall-of-fame.
7. "South Africa Quilt History Project," Quilt Index. Accessed July 27, 2024, https://quiltindex.org/view/view/?type=docprojects&kid=31-81-1.
8. "SAQG Accredited Quilt Teachers," South African Quilters' Guild. Accessed July 27, 2024, https://www.quiltsouthafrica.co.za/saqg-accredited-quilt-teachers.
9. "SAQG Accredited Quilt Teachers," South African Quilters' Guild. Accessed July 27, 2024, https://www.quiltsouthafrica.co.za/saqg-accredited-quilt-teachers.

Fibreworks

A South African Textile Artist Organization

JEANETTE GILKS

FIBREWORKS is an organization developed in 1997 by a group of women friends, all of whom were artists working in textiles.[1] I was a part of the group. While some came from quilting backgrounds and others were trained in graphic design or fine art, we were united in a commitment to promote fiber and textile art as a serious art form.[2] We envisioned creating a group dedicated to promoting change within the existing art and craft platforms in South Africa, generating interaction and critique among fiber artists, and presenting new creations. Group members were particularly interested in work intended as art, to be presented in exhibitions and galleries.[3]

What actually constitutes fiber art? For members of Fibreworks, it is defined as follows: "Fiber art is an art form that encompasses a very large range of techniques, materials and approaches that give the fiber artist possibilities to explore and expand the art form in almost unlimited ways."[4] Each incoming member of Fibreworks is given a copy of "Fabulous Fibres!," an unpublished document that describes fibers as "materials that are made up of continuous filaments or elongated pieces similar to lengths of thread." The document also contains statements of encouragement to artists to explore a variety of techniques, including those used in making quilts, and styles when working with fibers.[5]

Many Fibreworks members are internationally renowned artists and teachers whose artworks are in private and public collections in South Africa and abroad. Fibreworks member artists are not required to work wholly in textiles. We welcome anyone to the group whose work incorporates the use of fiber, however tenuous that might be. New members submit applications for membership that are juried by existing Fibreworks members. While we seek excellence in members' work, we embrace all manner of art media and take pride in how member artists creatively and ingeniously incorporate fiber into their work. We encourage Fibreworks members to comment and reflect in their work on the traditional nature and purpose of textiles, on what constitutes "women's work," and the evolving nature and purpose of these long-standing "craft" practices. Our fiber/textile shows consequently do uphold some of the ancient techniques of stitching, embroidery, weaving, and the like, but they also demonstrate a

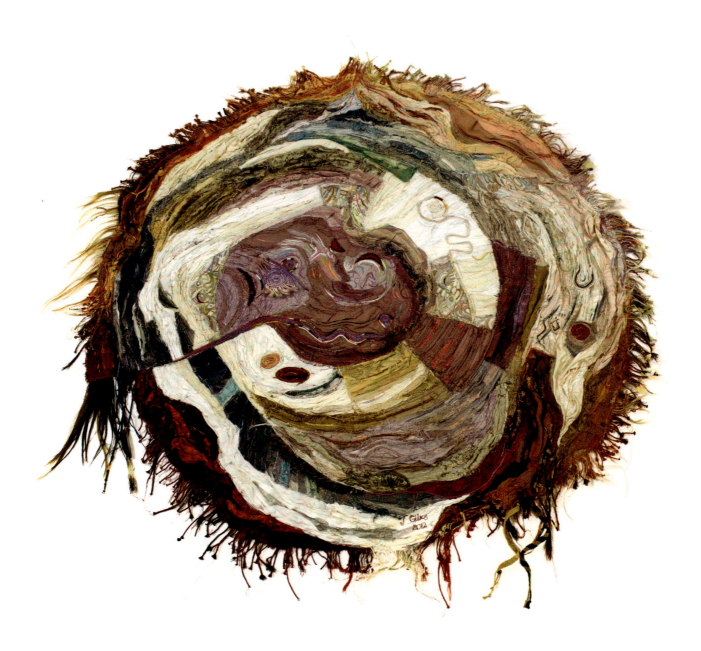

Figure 8.1.
Spirit of the Plianesburg, by Jeanette Gilks, of commercial fabrics and ready-made objects. Assegai, KwaZulu-Natal, South Africa, 2012, 44.88 in. × 44.88 in. Photo by Mickey Burnett.

transformation of many of these traditions. Fibreworks member Celia de Villiers humorously described members of the organization as "ex-centrics" since we created a fiber-related organization with foci distinctly different from more traditional fiber groups, such as quilt groups or lace guilds. Our fiber creations demonstrate our quests to challenge traditional definitions of fiber art.

From my own perspective, I believe that the medium of any artwork is a transformative device that lies between imagination and manifestation, between the idea and the act. While some Fibreworks artists choose to work within the limitations of the medium, others try to extend these limits. I believe that the most exciting textile work dances on this edge, between the known and the unknown, between the familiar and the mysterious. I also believe that successful

fiber artwork compels the viewer to engage with and be moved by the art. As can be seen in two works here, one of my own and one by fellow Fibreworks member Gina Niederhumer, we use a variety of techniques and types of fibers to intentionally convey ideas and to evoke feelings and responses by viewers.

My own work, *Spirit of the Plianesburg* (see fig. 8.1), describes one such artistic confluence. The Pilanesberg is a well-known game reserve in the northern territory of South Africa. The reserve is a roundish shape, as it follows the ancient and much eroded footprint of an extinct volcano. Whilst visiting the game reserve, some years ago, I came across a geological map of the site, and I became intrigued by the diversity of rocks found in the area and the various colors these rock formations had been assigned in the map.

In order to pay homage to this deceased volcano—indeed to pay homage to *all* glorious earth beneath our feet—I decided to make a circular artwork using colors and textures and found objects that I felt evoked both the primordial and the more recent history of the area. In addition, I had never made a circular artwork before, so believed this would be an interesting challenge. It was!

The title of the work conjures up all kinds of spirits. There are the spirits of all animals—past and present—that have ever lived and died there; the hand-made fringe around the edge of the work recalling whiskers, fur, prickles and tails. Actual feathers, collected from the area, possibly suggest the continuous physical presence of the abundant bird life in the reserve. Other parts in the artwork suggest a human presence. Some of the lines and shapes could represent drawings on rocks or symbols scratched into rock surfaces. The quilt's cloth itself might be a shaman's kaross (a rug or blanket sewn of animal skins) or blanket. Finally, I hope that the heavily folded, textured materials I've used suggest the spirit of the volcano's original eruption as it disgorged its hot insides across the land.

Gina Niederhumer describes her quilt *Cobwebs in the Corners of My Mind* in similarly evocative and personal terms:

> The work *Cobwebs in the Corners of My Mind* (2014) was made in an attempt to visually define the concept behind my artistic process, which is the ongoing attempt to understand my life, the choices I have made and how to live with them . . . mend what is in need of repair in me.
>
> In hand and machine embroidered texts I have transcribed entries from my journals onto small fabric pieces in red threads and stitched these onto mull cloth. Some of the fabrics are remnants from my mother and grandmother's household linens. The open weave of the mull cloth is suggestive of a net or a veil, which could be read as something being hidden or trapped . . . but also as providing possibly a safety net. This ambiguity fits well into the concept of locating the uncertainty within my search. A softer version of mull cloth was also used as wound dressings when I grew up, which offers a pertinent metaphor for attending to the search for the wounded places inside me.
>
> Tightly wrapped bundles and stitched figurines are hinting at the past and influences I have no control over. The photocopies of winter landscapes represented a longing in me that I could initially not place, which is symptomatic of how this intuitive process of collecting objects, such as these postcards, led me one step at a time toward the next associative memory, which eventually revealed some inner "truth" and gave me a sense of understanding the larger

Figure 8.2.
Detail from *Cobwebs in the Corners of My Mind*, by Gina Niederhumer, Cape Town, 2014, .94 in × .49 in. Made of found objects, photocopies, fabric, thread, and mull cloth. Photo by Vanessa Cowling

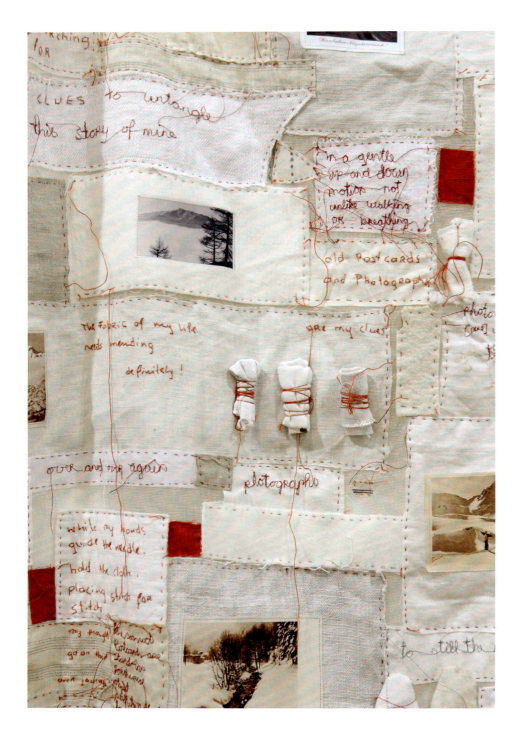

connections within my personal narrative. Jung described this intuitive process as "unconscious knowingness."

My quest is a kind of Parzival journey through which I am trying to find answers within me.[6] *Cobwebs in the Corners of My Mind* maps out the unattended residues of unresolved themes that occupy my thoughts. The work in its unfinished state is symbolic for the never-ending task to mend and repair the fabric my life.

At the first meeting of the nascent Fibreworks group, it was decided that we would hold a biennial exhibition of members' work in South Africa. As of 2022, we have had eleven such exhibitions, showcased in some of the most prestigious art museums and galleries in South Africa. Fibreworks has also mounted five "Major Minors" exhibitions featuring small works, sized 9.84 inches by 9.84 inches, that traveled to various venues in Europe, Australia, and the United States.[7] With these exhibitions, we have been able to extend public awareness of forms of fiber arts that were not typically included in quilts or other art exhibitions.

I have found it interesting that textile art exhibitions generally attract larger numbers of people than do exhibitions of other media. Maybe it is the tactile element that people find fascinating. Viewers of our work seem genuinely intrigued by the time and minute attention that is demanded in making hand-crafted things. Perhaps they perceive that, in a fast-paced digital world, the very slow actions needed to physically join fiber materials together have purpose. In a world obsessed with instant gratification, something that has taken months to complete is incomprehensible, even absurd perhaps, especially considering that artists might do art for reasons other than income.

The Fibreworks organization has been an important organization in providing intellectual stimulation as well as building and sustaining a community of artists. Like other South African organizations devoted to fiber arts, such as the South African Quilters' Guild, Fibreworks seeks to nurture the artistic growth and recognition of textile artists. Through its work, Fibreworks has brought national and even worldwide attention to a community of arts practitioners who love working in media that includes thread and threadlike materials.

Notes

1. Fibreworks Art, "Homepage."
2. The British English spelling of *fibre* is used in the organization's name. Otherwise, the American English *fiber* is used throughout this article.
3. For this essay, I have relied on digital and print resources generated by Fibreworks. For instance, Fibreworks generated a quarterly newsletter that included all the minutes from our Fibreworks meetings, information such as exhibition dates and venues, notes on significant achievements of members, and articles submitted by members.
4. "Fabulous Fibres!," unpublished document. This document is one of several given to all new Fibreworks members.
5. "Fabulous Fibres!"
6. Parzival: a literary story of the quest and inner travail of the knight Parzival. Written by the German Poet Wolfram von Eschenbach (1170–ca. 1220). Richard Wagner later based his opera *Parsifal* on the original medieval story. See Michael McGoodwin, "Wolfram von Eschenbach: *Parzival (Parsifal)*," summary, last updated November 12, 2022, Michael and Rebecca McGoodwin Family website, www.mcgoodwin.net/pages/otherbooks/we_parzival.html.
7. Where possible, a color-illustrated catalog was produced to accompany the exhibition.

Zamani Quilters of Soweto

MARSHA MacDOWELL

FOR WOMEN WHO LIVE in Soweto (short for South Western Township), located eighteen miles outside of Johannesburg, opportunities to earn a living are limited. Most commute daily to the city to work, largely in low-paying jobs as domestics or in factories. Sewing, typically learned at home, is a skill that helped secure them those jobs. Soweto resident Florence M'Kasibe, was once such a woman. Deirdre Amsden, who later worked with M'Kasibe and interviewed her, wrote of her friend:

> Florence M'Kasibe learned to sew by hand when she was a child. When she eventually went to work in a dress factory, she bought herself a sewing machine so that she could continue to sew at home for herself and her children. She recalls, "I used to get up in the morning at 3 o'clock to prepare everything for my children. . . . I'd leave at 5 o'clock to catch the train at 5:40. . . . We started work at 7:30, worked for eight hours and knocked off at 4 p.m. I'd get home at 7 o'clock exhausted. . . . To pay the installment on that machine I'd sew, sew, sew until midnight. I'd sleep three hours and wake up to begin again."[1]

The uprisings in 1976, in Soweto in particular, and the general unrest and violence across the country meant that M'Kasibe, like many of her family, friends, and neighbors, lost her job. Meeting in informal clubs and working out of garages and church halls or in their homes, sewers across the country used their own sewing machines to make clothes full time.[2] In 1978, Betty Wolpert, a London resident born in South Africa, visited these women. Inspired by their industriousness, Wolpert helped small groups of them buy some fabric and sewing machines, which could be used by those who did not have their own. Wolpert also taught them the basic techniques of making quilts.[3] Soon after, these separate groups formed one large group that they named the Zamani Soweto Sisters Council (Zamani SSC). With Wopert's assistance in writing grants, Zamani SSC received some initial organizational and financial support from the local Maggie Magaba Trust. In 1980, at the invitation of Wolpert and with the support of

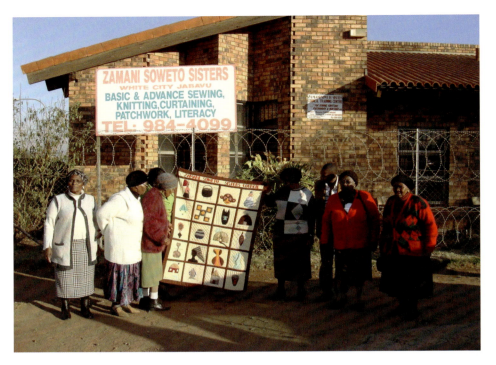

Figure 9.1.
Zamani Soweto Sisters Council members.
Photograph by Marsha MacDowell, Soweto, South Africa, June 17, 2007.

the trust, two of the women, Florence M'Kasibe and Marie Hlomuka, went to England.[4] There they took classes for six weeks in literacy, sewing, and patchwork, including classes taught by Deirdre Amsden at the Patchwork Dog and Calico Cat. They also met with members of the Quilters' Guild, who organized an exhibition of the quilts of the Zamani SSC in 1982 at St. James Church, Piccadilly, London.[5] M'Kasibe and Hlomuka returned to Soweto to teach others, and Amsden, supported by the trust, traveled in 1982 to Soweto, where she spent three weeks teaching the women patchwork and quilting skills.[6]

At the time the women were working out of Soweto's Young Women's Christian Association (YWCA) building, the Dube Centre. Amsden reported that it was challenging to teach in the center:

> Working conditions were not ideal. The back room of the YWCA is about sixteen feet wide and twice as long and usually houses a dozen knitting machines and half as many treadle sewing machines. There is little storage space, only one power outlet for the iron, and the lighting is poor. We pushed all of the machines, except for two of the treadles, to one end of the room and arranged three tables down the center, ready for work. . . . The Zamani Soweto Sisters made their own quilting frame, planing and sanding locally purchased rough timber, tacked webbing onto the two rails and used four "C" clamps to hold it rigid. The first week we worked on pieced patchwork, both by hand and by machine, also strip patchwork in all its variations from Log Cabin to Seminole and Quilt Methods. . . . The second week we concentrated on hand

and machine methods of applique. By the end of the three weeks, the far wall of the room was covered with samples of their work and a group hanging was almost quilted.[7]

Though the quilts made by the Zamani SSC were done in patterns that they had learned from the British quiltmakers, they used the blue, red, and brown "German" (*isishweshwe*) cloth they preferred for making their own everyday dresses. However, they found that customers preferred quilts in red and blue isishweshwe rather than in brown.[8] Even though the women learned traditional patterns and techniques for quilts, they were eager to make individual, original designs, "because they believe everything made should have a meaning."[9] Zamani quilter Maria Hlomuka created a textile she called "Piano of Struggle," which she said demonstrates "that black and white are inseparably entwined.... From a country where the white man too often spells barbed wire and bullets, that's hope."[10]

In a letter to quilt scholar and pioneer of African American quilt studies Cuesta Benberry, Hlomuka wrote "my colleagues are not too keen on my work, they feel it is too explicit and so unhealthy for our political consumption. I am also adamant for it is the only way I could express my feelings and explain the events of our time. I do this in writing and patchwork."[11] Benberry understood and appreciated Hlomuka's unique quilts, saying of her life and work, "I had written and become friends with Zamani prior to my meeting with them in London in 1986. I especially admired Maria Hlomuka because she was a poet as

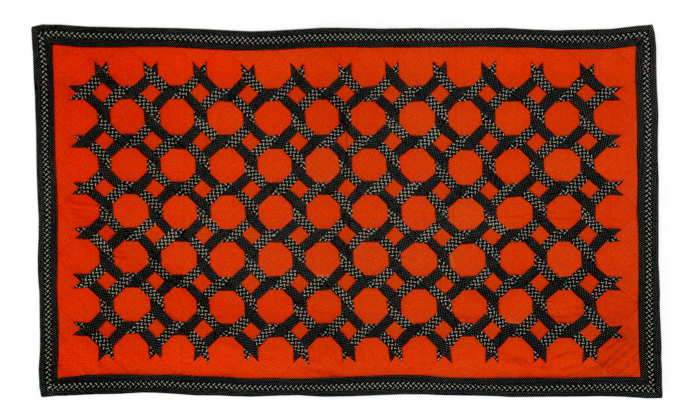

Figure 9.2.
Nine Patch and Snowball, cotton fabrics, machine-pieced and quilted by Maria Sera, White City Jabavu, South Africa, 2007, 35½ in. × 56¾ in. Sera's quilt is of blue and black isishweshwe materials, fabric favored by the Zamani SSC. The pattern is from Trudie Hughes, *Template-Free Quiltmaking* (Bothell, WA: Martingale, 1986).
Collection of Michigan State University Museum, acc.#2007:124.7.1

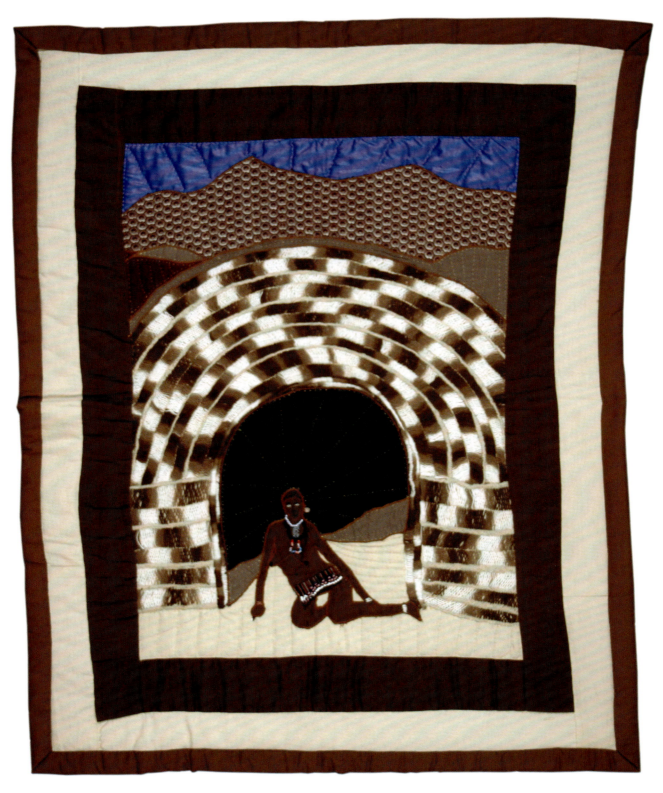

Figure 9.3.
Intombi, by Maria Hlomuka, 1986, Soweto, South Africa, 29 in. × 38 in. Machine pieced and appliqued, embroidered, and hand quilted of cotton or cotton or polyester blends.
Collection of Michigan State University Museum, #2008:119.7

well as a creative quiltmaker. In London, I spent the most enjoyable three weeks with Zamani that I can remember. I bought the 'Intombi Quilt' not only for its beauty but also to have a Maria Hlomuka work, a Zamani work, something unlike any other piece in the world."[12]

In 1985, Amsden returned to Soweto for three weeks to teach additional patchwork techniques as well as how to publish a newsletter that would have sections on recipes, patchwork, dressmaking, history about Zamani SSC, and poetry. The Zamani SSC invited local social workers, teachers, and members of other organizations, including the YWCA and the Black Consumer Union, to join the instructional sessions. About fourteen individuals were present each day.[13] The resulting quilts were numerous and beautiful, the poetry flowed, and a first newsletter was produced that included the following poem, illustrated by photographs of the Zamani sewers at work.

Zamani

Zest, zest with alarming force
Besieged by some women,
Yesteryear in troubled Soweto
Like zephyr it did
And zippy, zippy it crawled
Oh! Zamaniii

Away loneliness, away,
Away frustration and devastation
Accompany your friends in hell,
Accept defeat as sportsmen,
Away tears, away ignorance.
Zamaniii the Answer.

Mutuality the cornerstone,
Mother, daughter, we call,
Move, move to liberty
For managers, authorities are numb.
Many envy your guts,
When uttered Zamaniii.

Awareness the theme, of course,
Are you near or afar?
Awake for time is come,
Ability is your will,
Ameliorate your skill.
Go to Zamaniii.

None will disown your wealth,
None will bar your pleasure,
Now is the harvest time,
No to hunger, no to non-confidence,
Nurture, three all in One,
All in Zamaniii.

> In a dark corner of Soweto
> I was hurt and injured once
> In spirit rather than body,
> I searched comfort, day and night,
> Interest, compassion prompted me,
> To find Zamaniii.
>
> —Maria Hlomuka[14]

By 1986 the women had enough quilts for a second exhibition, and again Zamani members—this time Elizabeth Mpenyana, Lilian Nchang, and Thandi (unrecorded last name)—traveled to London for three weeks for activities related to the exhibition, which was to be held at the Brixton Art Gallery in London from May 24 to June 14, 1986.[15] A series of workshops, lectures, poetry readings, music performances, a puppet show, an auction of a quilt to support the Zamani SSC, and other events, including a visit to quilt collections at the American Museum in Bath, were planned by the gallery and the Brixton Quilters' Guild. On this trip, the Zamani artists were the teachers for three of the workshops. Cuesta Benberry, because of her intrepid research on African American quilt history, had already known about the Sowetan quilters and had been corresponding with Zamani SSC member Maria Hlomuka, As a result, she was invited to come to London at the time of the exhibition and to give a lecture.[16] In her diary, Benberry wrote about being with Mpenyana and Nchang on June 16, the tenth anniversary of the youth uprising against oppressive apartheid practices in Soweto. As the three watched televised images of students being shot and killed on that day ten years earlier, Benberry recorded that the images brought back sharp personal memories that Mpenyana and Nchang shared with her.

The meetings between the Zamani quilters and Cuesta Benberry were to have lasting impacts. Benberry purchased a quilt by Hlomuka for her personal teaching and research collection, and the two continued to exchange handwritten letters and poems, including the following one by Benberry.[17] After returning home, she began giving lectures on the patchwork quilts of the Zamani SSC and its members' antiapartheid struggle.

> *To Zamani*
>
> We are kindred souls, you and I,
> Oh, Zamani,
> Though separated by time and space,
> 'Tis true, Zamani,
> Yet our hearts are meeting, touching,
> Defying the barriers of distance between us,
> Dear Zamani.
>
> Distance is as nothing,
> Oh, Zamani.
> I hear your lilting songs, still.
> Sing on, Zamani!

I see you smile and dance the "La-La,"
I feel pain as quietly you speak of troubled Soweto,
All is embedded in my memory of you,
Forever, Zamani!

—Cuesta Benberry, St. Louis, Missouri, October 1986[18]

These new international connections helped attract more donors to support the Zamani SSC, and in 1987 the members were able to secure a building of their own at the corner of Mlangeni and Letaba Streets in White City Jabavu, Soweto. There they were able to make everyday clothes, quilts, school uniforms, and other items.[19] As of 2007, there were approximately twenty-four quilters who were active with the Zamani group.[20]

Since its founding, the Zamani SSC has been critical to scores of women learning skills that would provide a source of income. Some stayed closely affiliated with the group; others launched independent entrepreneurial enterprises. Two such individuals were sisters Fina Nkosi and Vangile Zulu, who started quilting at Zamani in 1985 but as of 2020 work as a team out of a space in downtown Johannesburg. While the two used their sewing skills to make school uniforms, clothing for all ages, placemats, pillow covers, and quilts in the traditional designs they learned at Zamani SSC, they also became known for their pictorial quilts. As Nkosi said, "I started making quilts with faces in 1989 to encourage storytelling."[21] The pair have since made many quilts with facial portraits

Figure 9.4.
Fina Nkosi and Vangile Zulu in their workplace, Johannesburg.
Photograph by Marsha MacDowell, March 13, 2014.

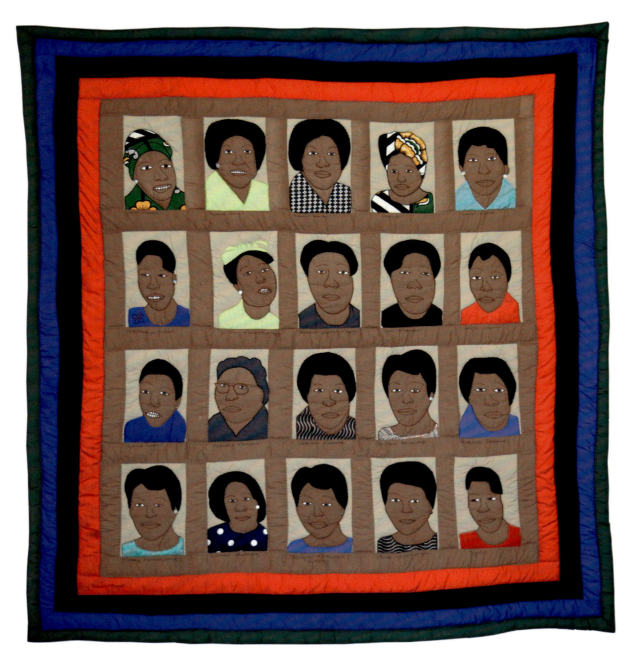

Figure 9.5.
South African Black Women Anti-Apartheid Heroes, Fina Nkosi and Vangile Zulu, Soweto, South Africa, 2004, 77½ in. × 83 in. Cotton, cotton or polyester blends, machine piecing, machine applique, attachments (beading, charms, buttons, etc.), and hand quilting. The quilt incorporates portraits of Black South African women who the artists felt were instrumental in the struggle for freedom in South Africa. Depicted, left to right and with artist's original spelling in parentheses, are (*row one*) Winnie Mandela, Albertina Sisulu, Adelaide Tambo (Addelatte Thamo), Lindiwe [no last name give but likely Lindiwe Nonceba Sisulu], Thandi Modise; (*row two*) Nokukhauya Huthuli, Lillian Masediba Ngoyi (Lillian Mosediba Ngoyi), Princess Constance Magogo (Princess Contance Magogo), Dudu Masondo, Stella Sigcau (Stell Sigcawu); (*row three*) Dipuwo Hanni, Florence Mkhize (Florance Mkmize), Charlotte Maxeke, Dr. Ellen Khuzwayo, Princess Irene (Princess Irene); and (*row four*) Marry [*sic*] Nontolwane, Lillian Ntshang, Felicia Mabuza-Suttle, Rose Givamanda, and Kate [no last name given but likely Kate Molale].

of South African individuals of national and international renown, including Nelson Mandela, Xokani Nkosi Johnson, the Black South African women leaders of the antiapartheid movement, and the 1964 Rivonia Trialists (one version of which was presented as an eightieth birthday present to Ahmed Kathrada, one of the trialists who was convicted and served eighteen years in prison on Robben Island; see figure 0.26).[22] A small quilt by the sisters depicting Mandela at four different stages of life was included in an international exhibition in Johannesburg in 2016.[23] Their quilt of Black South African women leaders of the antiapartheid movement (see fig. 9.5) was displayed in a 2004 exhibition of the Craft Council of South, Johannesburg, South Africa, and in the 2008 *Quilts and Human Rights* exhibition at Michigan State University Museum, East Lansing, Michigan.

Work produced by women affiliated with the Zamani SSC has been shown in several exhibitions in South Africa, Britain, and the United States, and examples of their work can be found in numerous private and public collections. The Zamani SSC has provided a platform where women of South Africa, through their creativity, needlework skills, and entrepreneurial experience, have been able to combat the double exploitation of racism and sexism they faced. Just as the women produce unique quilts because they believe everything made should have a meaning, Zamani SSC has provided agency and meaning for a group of Sowetan women.

Notes

1. "Zamani Soweto Sisters: A Patchwork of Lives," 48–49. According to a note at the end of the article, the text was based on materials provided by Deirdre Amsden.
2. "Zamani Soweto Sisters Council Case Statement," unpublished document.
3. Sera, interview.
4. The Maggie Magaba Trust was established to promote self-help groups, provide support for educational opportunities, and to give aid to destitute families. It was initiated by Betty Wolpert, a white woman living in England, but was run entirely by Black South African women.
5. Amsden, "Quiltmaking around the World," 28, 38. The Quilters' Guild is a membership organization of quilt artists and scholars in the British Isles.
6. The author is indebted to Deirdre Amsden for donating a trove of newspaper clippings and ephemera related to her work with the Zamani Soweto Sisters. These documents are in the Amsden Papers in the Cuesta Benberry Collection at Michigan State University Museum.
7. Amsden, "Quiltmaking around the World," 28, 38.
8. Sera, interview.
9. Starsmore, "Foreign Correspondence."
10. Unattributed clipping, Amsden Papers in the Cuesta Benberry Collection.
11. Hlomuka, letter.
12. Benberry, undated paper, Cuesta Benberry Collection.
13. Amsden, "My Trip to Soweto," 2.
14. Hlomuka, *Zamani*, typescript document in the Cuesta Benberry Collection of African American Quilts and Quilt History Research, Michigan State University Museum.

15. "Soweto: The Patchwork of Our Lives," press release.

16. Amsden, "Cuesta Benberry."

17. After Benberry's death in 2007, her family gifted the Cuesta Benberry Collection of African American Quilts and Quilt History Research in 2008 to the Michigan State University Museum, where it continues to be used for research, teaching, exhibitions, and educational programs. See text for exhibition at Flickr, "Unpacking Collections: The Legacy of Quilt Scholar Cuesta Benberry."

18. Cuesta Benberry, *To Zamani*, typescript document, Cuesta Benberry Collection of African American Quilts and Quilt History Research, Michigan State University Museum.

19. "Zamani Soweto Sisters Council Case Statement," unpublished document.

20. Sera, interview.

21. Nkosi, interview.

22. Born HIV-positive, Xokani Nkosi Johnson died of AIDS in 2001 at the age of twelve, when research on HIV/AIDS was still in its infancy. His mother gave him up for adoption when she, debilitated by the disease herself, was no longer able to care for him. After he was initially not allowed to attend school because of his HIV status, Nkosi became the face of the impact of the HIV/AIDS crisis on children and regularly gave testimonies about his experiences as an advocate for increases in HIV/AIDS research and education.

23. MacDowell and Mazloomi, *Conscience of the Human Spirit*, 78.

A Lone Star in Africa

DAWN PAVITT

IN JANUARY 1983, Helen Suzman went to visit Winnie Mandela in Brandfort, South Africa, where she had been confined under a banning order for over five years. Under the order, Mandela was only allowed to see one person at a time, and if that person was White, they had to have a permit to enter the town. Suzman visited Mandela on three occasions to see for herself the conditions under which she was forced to live. During one of those visits, she witnessed a raid by the Security Police. Shortly thereafter, Suzman wrote an article entitled "Dropping In in South Africa: Your Hostess' Bedspread May Be Subversive," published in the *Washington Post* on January 14, in which she recounted the bizarre event she had witnessed. Her story was run in a number of media outlets. According to one published version, "[Suzman] saw to her astonishment that the tiny house was full of large white men. . . . a raid by the Security Police was in full swing."[1] She reported that since Mandela had to be present while her home was being searched, the two women sat "on a sofa in the living room [and talked]. . . . The men took books from shelves and posters from the walls" and "every now and then ask[ed] Mandela to sign for an article they were taking away—books, documents, papers]. . . . [They also took] a framed certificate . . [and] her crocheted bedspread—it was made up in yellow, green and black, the colors of the African National Congress—a subversive bedspread undoubtedly!"[2]

An imaginative response to this act of harassment was quickly initiated by a member of the United States Senate Committee on Foreign Relations, Senator Paul E. Tsongas, who invited fellow senators and congressmen to join him in sending an autographed quilt to Winnie Mandela as a replacement for her abducted bedspread. As Tsongas stated in a letter to President Ronald Reagan, "The quilt is a symbol of our concern for her safety and a measure of our opposition to the systematic denial of civil liberties to people of color in South Africa."[3]

The quilt is a Lone Star pattern, made by a group affiliated with the West Virginia Department of Culture and History. In early February, in the United States Capitol Building it was publicly signed by twenty-six US congressmen and senators. On March 18, 1983, under the heading "Banned S. African Receives Bedspread from Capitol Hill," journalist Allistair Sparks reported on the previous

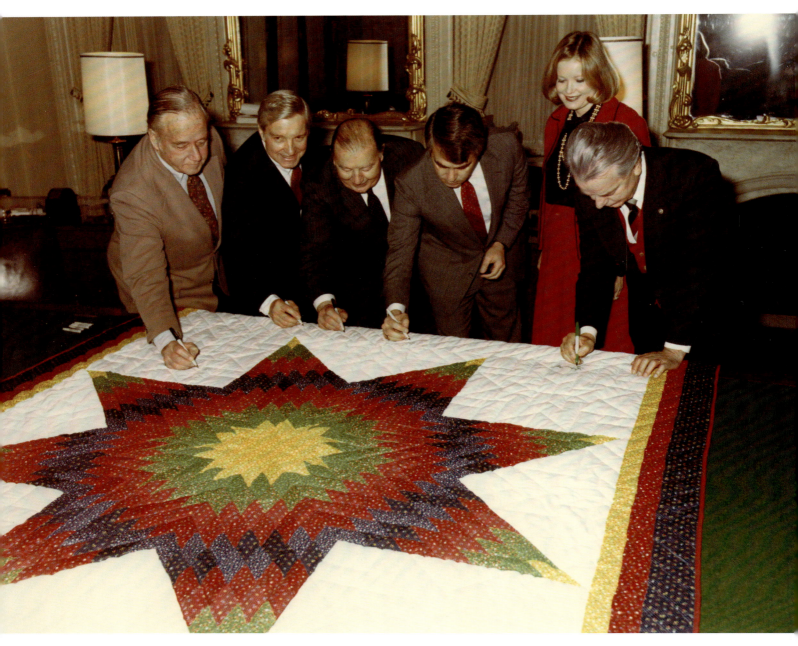

Figure 10.1.
"Signing of Winnie Mandela's Quilt," Paul Tsongas Digital Archives, accessed May 11, 2023, https://ptsongasuml.omeka.net/items/show/5258.
University of Massachusetts Lowell University Library Center for Lowell. History Paul E. Tsongas Congressional Collection Box 95A, Folder 13, Item 1 O.

day's ceremony in Brandfort, where, under a willow tree near her house, with an audience of half a dozen reporters, Winnie Mandela received her new quilt from Helen Suzman. Subsequently the BBC's *World at One* program reported the difficulties Allistair Sparks was experiencing from the South African police as a result of his coverage of this story.[4]

Notes

1. Helen Suzman, "Dropping In in South Africa."
2. Suzman, "Dropping In in South Africa."
3. Paul E. Tsongas, Letter to Ronald Reagan.
4. The editor wishes to thank the British Quilters' Guild for giving permission to reprint, in this volume, this article by the late Dawn Pavitt that appeared in the *Quilters' Guild Newsletter*, issue 16, Autumn 1983. The article has been modified slightly here to include references to the original article written by Helen Suzman and the letter written by Paul Tsongas. The quilt was illustrated on page 25 in Pimstone, *Helen Suzman, Fighter for Human Rights*. It was also reported in Pavitt, "Lone Star in Africa." At the end of her article Pavitt thanked the US Information Service, Senator Nancy Kassebaum's office, and Senator Paul E. Tsongas. See also *Capper's Weekly*, "Quilt Shows Support for Black Nationalist": "Winnie Mandela, Brandfort Township, South Africa, a banned black nationalist, recently received a red and green quilt signed by 26 members of the U.S Congress who oppose South Africa's apartheid policies. The quilt replaces a black, gold, and green bedspread seized by security police last January because it bore the colors of the African National Congress, of which her imprisoned husband, Nelson Mandela, is the leader."

11

The Empowering Stitch

SANDRA KRIEL

AS DO OTHER COUNTRIES around the world, South Africa has a centuries-old tradition of hand-stitching to construct and embellish clothing and objects that are functional or purely decorative. Artists have created visual expressions of personal and communal experiences; illuminated historical and contemporary stories, events, and issues; and portrayed concepts, ideas, and beliefs.

Until very recently in South Africa, the art establishment (critics, historians, gallery owners, collectors, and museum curators) considered the production of textiles by hand as craft rather than art, and craft work was viewed as less important or even inferior to other art forms, such as paintings and sculpture. Craftwork, including textile products, were largely collected, studied, and exhibited as ethnographic material. I think my embroideries, because of their imagery, artistry, and content, were the first in South Africa to blur this division and challenge the hierarchy of genres. My work questions the status of craft and contributes to the art versus craft debates, ultimately demanding a new appreciation for the place of textile work in the history of visual arts production. My work is not only beautiful, descriptive, and decorative but also critical, defiantly exposing atrocities and denouncing and charging the brutally oppressive South African apartheid regime.

At a very early stage in my life, I discovered that I enjoyed doing needlework, and I learned to sew, crochet, and knit. At school I did, among other subjects like mathematics and science, needlework and art. With that combination of home-based instruction and school-based coursework, one of the obvious careers to pursue was fashion design. But I had very little interest in designer clothing, so I studied painting. Very quickly my love of needlework entered into my art production, and I began to use cloth to create a relief design that I then painted. Later I used appliqué, embroidery, beading, and general mixed media to create works on fabric using no paint. Because there was a bias in the art world—a predominantly male world—against needlework, I mounted my early pieces on hardboard and framed them so they would be considered art. I was pleased when my work *Why Are You Afraid?* won a prize at the 1991 Cape Town Triennial. After this, I presented my work on cloth unframed and without any hardboard support.

The 1980s in South Africa was a painful time of struggle for the many who endured and fought against the illegitimate minority apartheid regime. Even though I had a full-time teaching job, I was also active in political, educational, and cultural organizations. I spent much of my time in meetings where revolt and mass action were defiantly discussed and planned. I had no time to isolate myself in a studio to paint, so I started doing embroidery in these meetings. The ideas and emotions flowed through my fingers into my art. This creative outlet helped me process the personal and social trauma of the time. I felt empowered as an activist and as an artist in effecting the transformation of the country. I felt I was doing something meaningful as I patched and embroidered the narratives of the anti-apartheid movement into the fabric. I was commemorating and validating the struggle. I was dedicating every stitch to those who were giving their time, and often their lives, to fight for a free and democratic South Africa.

Why Are You Afraid? consists of three 3.2- square-foot separately framed pieces that are hung horizontally, very close together. Composed of intense violet velvet, rich and delicate, it is decorated with bright cotton thread, photostats, beadwork, plastic appliqué, and embroidery. The cloth is mounted on hardboard and then framed with wooden, carved, and painted frames. The frames are further decorated with cuttings from empty soda tin cans. The work is very decorative and richly textured. The piece took me nearly two years, an average of five hours a day, to make. It was a very time-consuming and labor-intensive process.

The title of the work is embroidered on the cloth. On the first piece I embroidered the words WE WERE NOT BORN TO BE RAPED AND DESTROYED; on the second, WE WERE NOT BORN TO CONTROL AND DESTROY; and on the third, WHY ARE YOU AFRAID?. The text refers to destructive power relations and the violation of basic human rights. Marion Arnold, a chronicler of women's art in South Africa, wrote about this work: "Kriel's narrative, ending on an interrogative note, draws attention to the gendered spectator and the role of gender in determining responses to womanhood. It also raises the issue of victimization and the capacity of people to resist or succumb to societal pressures."[1] I felt the work offered a critique of the sociopolitical conditions, and it communicated and validated the interests of women as the most oppressed group of people in our society. By using visual images of dehumanization and death, I was expressing not only my abhorrence of an unjust apartheid system but also my belief that empowerment can transform reality and instill hope. Art historian Kim Miller also commented on how my work conveys this empowerment of women: "Importantly, Kriel addressed this issue by depicting women not as victims of violence, but as empowered survivors: the images show women organizing together in collective resistance and political collaboration."[2]

The piece on the left portrays three women holding hands to form part of a supportive human chain in action and protest against oppression and violence. In this piece I express and question issues of power relations, control, and domination. I empathize with and celebrate the role that women played in South Africa's struggle for liberation. Although the production and circulation of T-shirts with political iconography was banned at the time, I depict women defiantly and proudly wearing them. In the upper part I placed stars and a half circle moon representing darkness and night. In the half circle, I depicted a male

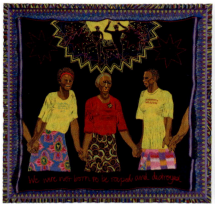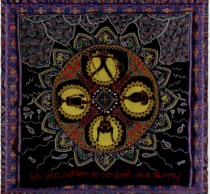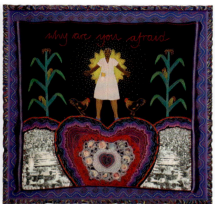

and a female; the male has an erect penis and hands held threateningly in the air, the female tries to cover and protect her naked body. Ynestra King says of this piece, "Each woman has her own personality and presence; she is a human being with rights, not a sexual object to be used and abused by social practices which violate nature."[3] Through involvement in political action, these women gain agency and empower themselves. Often survivors of violence, they fight for a society where there is equality and justice for all and a better future for their children.

I incorporated an ecofeminist narrative into the central piece of the triptych. There is a big circle that radiates like the sun (life), with petals like a sunflower and a central point with a cross indicating the four directions of the wind, with water and little white clouds surrounding it (earth). From this center circle grows four brown tree trunks with green leaves and red fruit (growth and productivity). Inside four circles placed between the trees are four more suns with four female figures involved in different activities: reading a book, cleaning the house, carrying food supplies, and giving birth. I placed real plastic toy figures of soldiers with guns (hate and destruction) on the outside of the big circle. In the petals of the sunflower, I surrounded the soldiers with embroidered barbed-wire motifs. In the top half of the background, I placed factories with smoke stacks filling the air with pollution, and in the bottom half, I depicted land and sea animals. It was important to me to show that human beings and nature are interdependent, and men are delusional in believing they can control the world, as well as women, who are often viewed by men as inferior and weak. "For men raised in woman-hating cultures, the fact that they are born of women and are dependent upon nonhuman nature for existence is frightening. Men perpetuate the process of objectification, of the making of women and nature into 'others' to be appropriated and dominated. They forget that they were born of women, were dependent on women in their early helpless years, and are dependent on non-human nature all their lives, which allows first for objectification and then for domination."[4] In this piece I critique and question man's power over women and nature.

As a central image in the third panel of this triptych, I placed a female figure dressed in the overalls of a domestic worker with a piece of dusting cloth in her

Figure 11.1.
Sandra Kriel, *Why Are You Afraid? Part I, II and III*, 1990. Embroidery and paint on hardboard, 40.16 in. × 40.11 in. each. Collection of the Rembrandt van Rijn Art Foundation, Rupert Museum RVR6, Stellenbosch, South Africa

The Empowering Stitch

pocket. Behind her is a radiating sun that suggests her warmth and generosity. Her arms are stretched out in a welcoming manner, vibrant, active, and dignified. She is asking the question *WHY ARE YOU AFRAID?* Fear was the most common emotion of the time and nearly everybody, but especially women of color, had a reason to experience intense fear. She is smiling and is placed firmly with her feet apart on a pulsating heart to represent love; within the middle of the heart, I used pictures of different stages of the developing fetus to convey life. To convey death, I incorporated, on the right and left of the heart, photocopies of pictures taken at mass funerals of people killed by the regime. "Indeed, funerals were banned in part because they were utilized as political tools to elevate martyred leaders and to further galvanize the resistance movement. They were acts of defiance that drew public attention to the government's human rights abuses."[5] The woman challenges her fear by suggesting that although she is poor, she has resilience through working and growing food to be independent and to provide for her family, even being able to invite others to share in the little she has. She is a protector of plants and animals, life transforming and life sustaining. She has striven beyond pain to stand proud as an empowered survivor of oppression and injustice.

I believe that if people can only love and stop fearing each other, there will be peace and happiness. When the work was on exhibition in the national pavilion at the 1993 Venice Biennial, I arrived at my exhibition space one morning and saw a group of Italian cleaning women gathered in front of this work talking and laughing enthusiastically. They noticed the central figure of a South African domestic worker dressed as they were, and they were obviously very surprised and charmed by the fact that their job was represented in one of the works.

Although my work has the decorative and beautiful quality of traditional embroidery, my pieces offer a strong critique of racial and gender politics, and they promote social justice. The content, inspired by my deep convictions, makes them objects of resistance and defiance and weapons of the struggle. They subvert the idea of embroidery done by women as a symbol of feminine subjugation, and they are not purely decorative to embellish and give pleasure. I intend for my work to invite and challenge viewers to position themselves in terms of the work's content. Where do you stand? What are you going to do? Through my work I wish to validate and empower people by remembering the pain and suffering of the past, to move from feelings of hopelessness to courage and to reimagine and transform the present with the hope of building a free and just future.

Notes

1. Arnold, *Women and Art in South Africa*, 138.
2. Miller, "Interweaving Narratives of Art and Activism," 106.
3. King, "Ecology of Feminism and the Feminism of Ecology," 22.
4. King, "Ecology of Feminism and the Feminism of Ecology," 22.
5. Miller, "Interweaving Narratives of Art and Activism," 109.

12

Amazwi Abesifazane— Voices of Women

A Textile History Collection

CORAL BIJOUX

THE AMAZWI ABESIFAZANE—VOICES OF WOMEN PROJECT was initiated in 1999 by artist-activist Andries Botha to promote healing and reconciliation following the traumatic apartheid era.[1] He held "that a traumatic history can only be transcended by making visible an under-disclosed past."[2] Botha and his team—which included, among others, his assistant Janine Zagel and facilitators Leonard Zulu, Eunice Gambushe, and Tholakele Mdakane—sought to collect stories from rural Black South African women whose apartheid-era experiences were not being recorded through other documentation efforts. Project team members traveled to rural areas where they sought out women who wanted to tell their stories. In one-on-one situations and in workshop contexts where several women met with a project facilitator, each woman willing to do so was asked to tell their story of "A Day I Will Never Forget." Team members photographed the storyteller and, when possible, wrote out the story in the teller's mother language (which sometimes was later translated to English). Then each storyteller was given a small (approximately 10 inch by 12 inch) piece of cotton fabric, thread, and colored beads so that she could record her story in textile form. Each artist signed her work. Typically rendered in a riot of colors, the memory cloths were often of racism, police brutality, domestic violence, beatings and murders, violations of human rights, physical and emotional hardships, death and dying, living with HIV/AIDS, and loneliness and loss. Seldom are there memories of joy, seldom of love, and seldom about dreams. One such memory cloth, currently housed at Michigan State University, was created by Lobilile Ximba in a workshop hosted by the African Art Centre in Durban in 2000 (see fig. 12.1). According to a paper attached to the piece, the story embroidered on the cloth in Zulu translates to English as "There is something I shall not forget, the enemies were here at home to kill us."[3]

In another piece, titled *A Day I Will Never Forget*, created by Marthie Bothma in a workshop conducted by Amazi Abesifazane in association with the North West University (see fig. 12.2), the artist expresses a difficulty she faced as a mother raising a child in the digital age:

My story is not just a day, but eighteen years as a mother. My oldest son is ADHD and technology, computer, TV and Playstation were the best "babysitters," because they had such stimulating and fast action. It started with him doing educational games, then he turned to adventure and Lego-building type games, and eventually to war and occult games.

As he watched more regularly and with more complex and aggressive games, his personality began to change. He became completely addicted to online games, so much so that he wanted to do nothing but sit in front of his computer. He had little physical energy and everything else in life was just conflicting with his addiction. Our house had no peace; just aggression, conflicts, and sadness.

I took note of an American Brad Huddelston talking about the dangers of technology and invited him to South Africa. He made me aware that my son indeed had a physical, literal, and emotional addiction to online games.

With the new information, I was able to help my child onto the difficult path to getting rid of the addiction.[4]

The initial project ran for nearly ten years, and nearly three thousand story cloths were produced. The entire collection is an invaluable archive of historical, authored, records of the lived experiences of individuals who were marginalized

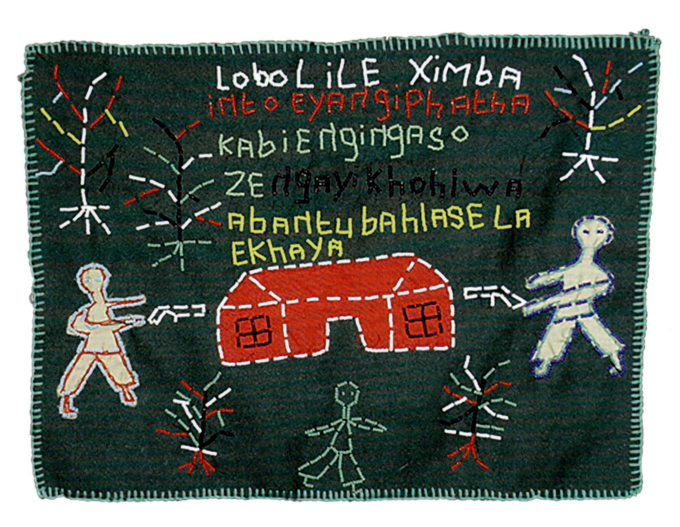

Figure 12.1.
Memory cloth, appliqué and beadwork by Lobilile Ximba, Durban, South Africa, 2001. Collection of the Michigan State University Museum, 2001:150.4.

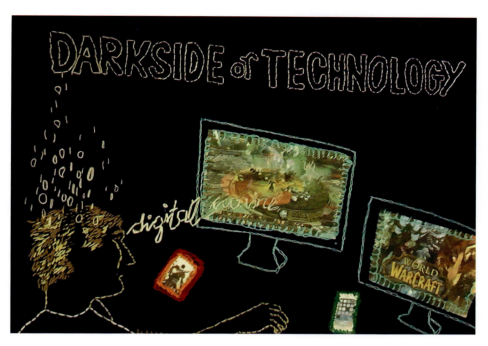

Figure 12.2.
A Day I Will Never Forget, Marthie Bothma, North West Province, South Africa, 2015.
Appliqué and embroidery on cloth.
Collection of the Amazwi Abesifazane-Voices of Women Trust

through history. Each story cloth and narrative from these many women are histories in themselves. Today the collection is held by the Voices of Women Museum in Durban, South Africa, for the past ten years; I have had the privilege of serving as the curator of the collection. I seek opportunities to showcase the collection and to interrogate the many issues highlighted in the collection. Together with Tholakele Mdakane, I oversee the physical care of the collection and seek partnerships to preserve it physically and digitally. To diversify the stories documented, I mobilize workshops for other groups of women to share their memories of a day they will never forget.

The Voices of Women project continues to construct workshops for sharing stories and making memory cloths. The workshops provide safe spaces for women to speak their own truths and to bear witness to others who speak about loss or their daily concerns and heartache or simply to dream openly and without shame. The workshops are places where *there will be no silence* and where women freely share stories through symbols and thread, stitches of color and texture, regardless of differences in language, class, race, or cultural background. To speak and share a moment in life in this way is tantamount to power.

The visual and textual narratives reflect broader contexts of gender disparity and unequal treatment experienced by women/womxn, abuse, and the many violations of women's rights. The narratives now also capture stories of both major and minor challenges women face as they navigate life—from becoming adults to coping with parenthood or job issues and addressing health issues.

Issues of representation permeate not only the development of the project but also now the Voices of Women Museum. Over my tenure, I have actively worked to ensure that the archive is a more inclusive representation of women in South Africa. As a result, the collection now includes memory cloths by Afrikaner, South African Indian, and Coloured women from the Cape and elsewhere. I have led efforts to conceptually reframe how the memory cloths are made accessible to the public, to emphasize the individual authorship of each cloth, to reconsider the processes used in collecting stories, and to fundamentally question what this body of work means. Our quest is to interrogate what is included in the collection, what is omitted or ignored, or what begs for more context. We consider how the responses are documented and presented; should they be presented publicly and to which publics; did the collection and sharing of stories foster reconciliation and healing; what might it mean if you are asked to tell your own story of a day you would never forget, who should ask the question, and should the question even be asked at all?

As I bear witness to the shared memories recorded through this project, "I recognize myself, my mother, my grandmother, our communities' mothers', women's, and girls' stories told through these narratives, over and over again. We know. We see. We hear. The echo of sadness and pain reverberates through these textiles and then through me and speaks for me and me for them. Her. Us. The echo of resilience and strength and mostly, the ability to overcome against the odds."[5] With their needles, threads, beads, and cloth, the Voices of Women participants are telling us what we did not want to hear. *There will be no forgetting here.*

Notes

1. The project was one of several Botha started under Create South Africa, a nongovernmental organization.
2. Botha, *Amazwi Abesifazana*.
3. Lobilie Ximba, acquisition record files, Michigan State University Museum.
4. Marthie Bothma's story provided to author in an email on May 27, 2022; original text in Afrikaans, translated into English with Google Translate.
5. Bijoux, excerpt from curatorial statement, *There Is No Silence Here*.

South Africa, AIDS, and Quilts

MARSHA MacDOWELL

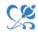

ONE OF THE MAJOR challenges facing South Africa since the establishment of the new democratic government in 2004 has been the HIV pandemic. As of 2020 the country has the largest AIDS epidemic: 20 percent of all people living with HIV in the world are in South Africa and 20 percent of new HIV infections occur there.[1] Fighting AIDS within South Africa presents many challenges. Even though antiviral treatments are now available, strongly maintained traditional practices and beliefs, especially related to gender roles and communication, have inhibited conventional approaches to AIDS education and treatment.[2] The creation and dissemination of arts have been important in "breaking the silences," fostering education of individuals about the realities of the HIV/AIDS epidemic and inspiring action about the HIV/AIDS epidemic.

Long before the word *craftivism* became popularized, artists across the country made work that documented the devastation, promoted health education and awareness, told personal stories of living with HIV/AIDS, and often incorporated the red ribbon symbol for AIDS.[3] One challenge to AIDS education in traditional Black African culture has been the respectful practice, known as *hlonipha* in Zulu, that forbids open communication about issues of sex or the relationships between men and women. People have been immediately shamed and ostracized by family and friends in some communities if they revealed themselves as HIV positive. The silence and stigmas have meant unnecessary death for countless uninformed people. Fiber artist Margie Garratt, creator of *Angry about AIDS* (see fig. 13.1), says her piece was "piece born out of total frustration and disillusionment at the prospect of millions of lives being lost. The political inaction, the misinformation is nothing short of culpable homicide."[4]

Many artist-activists, health professionals, educators, and community activists worked closely with individuals and groups of traditional artists, especially in communities in which the disease particularly took its toll, to use their traditional sewing, beadwork, embroidery, and wirework skills to not only promote discussion about and educate individuals about HIV/AIDS but also to create new products as a source of income generation.[5] Some of these projects, begun in the late 2000s, have endured, and the work produced by these artists and artist collectives remain relevant to address the ongoing health crisis.[6]

Figure 13.1.
Angry about AIDS, Margie Garratt, Constantia, South Africa, 2001, 17.5 in. × 12 in. Private collection. Photograph courtesy of the artist.

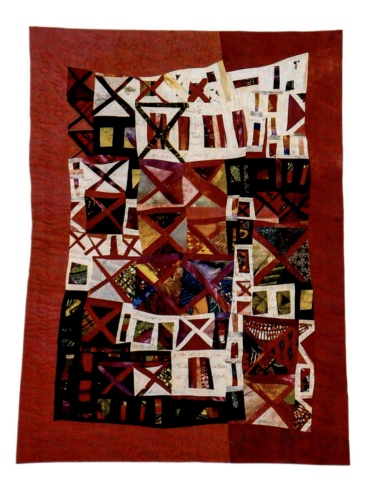

Perhaps the most well-known AIDS-related art project in the world is the NAMES Project Foundation's AIDS Memorial Quilt, an enormous textile work intended to "remember, in perpetuity, the lives lost, [to] . . . offer healing and hope to survivors, . . . and inspire generations of activists in the fight against stigma, denial, and hate for a just future."[7] Called the world's largest quilt, it consists of over 48,000 panels sewn into blocks of twelve panels when spread out together on the ground forms a quilt that is 1.2 million square feet (over 110,000 square meters) and weighs more than fifty tons.[8] Each panel, made sometimes by just one person or by a group of individuals, is three feet by six feet (the approximate size of a grave) and represents at least one person but sometimes many who have died of AIDS. The panels are sent to the NAMES Project Foundation, where six or seven panels are stitched together to form twelve-by-twelve-foot blocks. These blocks are loaned out, especially on December 1, World AIDS Day, to organizations around the world to continue bringing attention to this pandemic.[9]

According to a report written by Louise M. Bourgault, an evaluator of the South African AIDS Quilt Project initiative in South Africa, "The South African AIDS Memorial Quilt was brought to this country in 1989 by Carroll Jacobs. As a theology student studying in the United States, Jacobs was inspired by the healing potential and the calming effect she thought AIDS quilt panels were

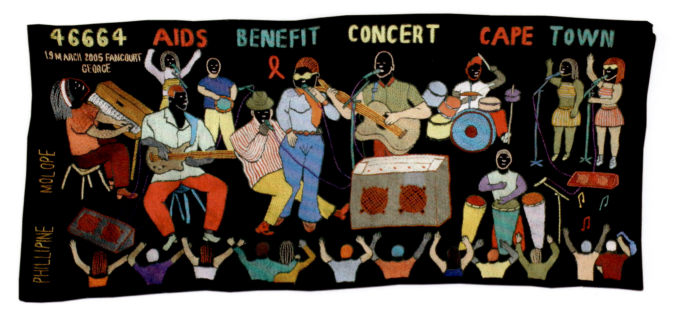

Figure 13.2.
AIDS Benefit Concert Cape Town, Philippine Molope / Mapula Embroidery Project, Winterveldt, North West Province, South Africa, 2005, 16 in. × 36 in. Philippine Molope is affiliated with the Mapula Embroidery Project, a crafts-based economic development project for rural women. *Mapula* means "Mother of Rain" in Tsonga. The concert, scenes of which are depicted here, was actually held in George (a town east of Cape Town), South Africa, on March 19, 2005, as a fundraiser for South Africa AIDS education and health care. The number "46664" refers to Nelson Mandela's prison number.
Michigan State University Museum Collection: 2005:34.3. Photograph courtesy of Michigan State University Museum.

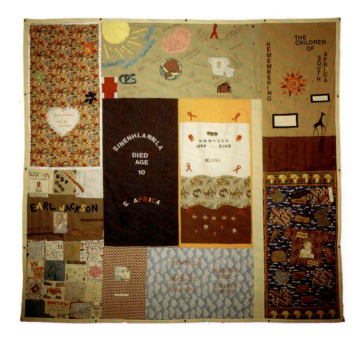

Figure 13.3.
Remembering Children of South Africa (Block 5714). This block can be seen in the context of the entire AIDS Memorial Quilt at https://www.aidsmemorial.org/interactive-aids-quilt. Photograph courtesy of the National AIDS Memorial.

making on the families and friends of the deceased. . . . Jacobs decided to take the craft project back to South Africa."[10] Bourgault described that while some individuals in South Africa made memorial panels, it was not "until late 1998 that the South African quilt initiative would achieve 'project' status . . . and the first panels produced by the project were made in early 1999. By October 1998, there were more than 300 panels."[11] Often the panels incorporated traditional Black South African textile and beading techniques and designs, and some panels were sent to the United States to become part of the AIDS Memorial Quilt.[12] Stories of those who made the quilt panels were often collected and the example here illustrates both the prevalence with which HIV/AIDS existed in South Africa and the sadness experienced by those whose lives were touched by loss because of the disease.

We dedicate this message to all those who have lost their loved ones because of AIDS. We as the South African youth want to put an end to the spread of AIDS and HIV. So let us join hands and fight because together we stand and divided, we fall. We dedicate our quilt panel to our loved ones and to all South Africans, black, white, coloured or Indian who have passed away because of AIDS. We are saying we miss you; we love you and you will always be in our memories and our prayers. The cross in our quilt symbolizes holiness in our memories and the condom stands for our hope that we as youth will practise safer sex and that they will rest in peace.[13]

Figure 13.4.
Archbishop Tutu (c) blesses a panel of the AIDS Memorial quilt panel as cathedral dean Reverend Michael Weeder (r) delivers it to US consul general Erica Barks-Ruggles, June 22, 2012.
Photograph courtesy of the US Embassy of South Africa.

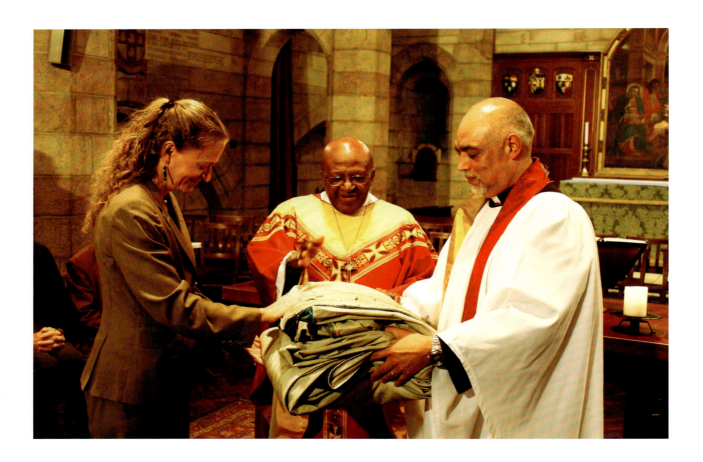

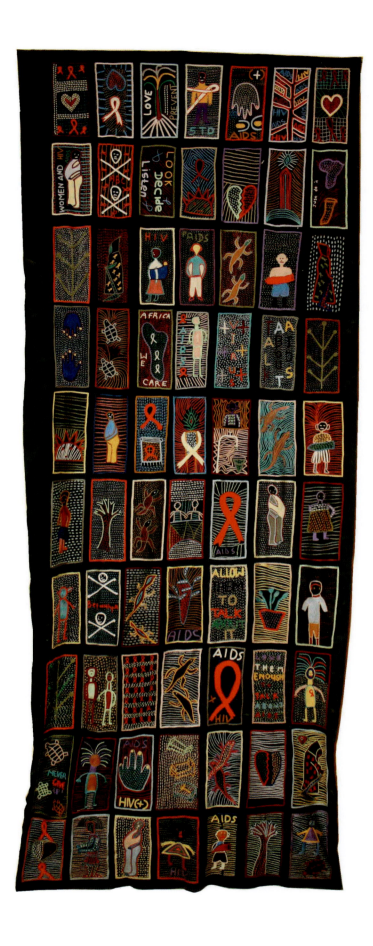

Figure 13.5.
Paper Prayer. Cotton embroidery on cotton fabric. Collection of Brenda Schmahmann. Photograph by Paul Mann.

It is no surprise that when the thirteenth World AIDS Conference was held in Durban in 2000, panels made in memory of South African victims were displayed outside the conference site. Blocks of the AIDS Memorial Quilt, often containing South African–made panels, have been sent back to South Africa on a number of occasions and shown in multiple venues, including several times at the St. George's Anglican Cathedral, home church of the late Archbishop Desmond Tutu in Cape Town.[14]

The Paper Prayer project was one notable South African project in which participants produced small, embroidered, rectangular cloth panels that were sewn together into quilt-like wall-hangings. The project was initiated by artist Kim Berman, who founded the Artist Proof Studio in Johannesburg after she witnessed the display of the AIDS Memorial Quilt on the National Mall in Washington, DC.[15] Originally the Paper Prayer project engaged individuals in making prints on handmade paper as a means of income generation and of discussing their own experiences with HIV/AIDS issues. "The Paper Prayers project expanded its focus on printmaking to the use of found and recycled materials and extended its range to the making of embroidered cloths with AIDS messages. Some women's collectives were taught textile printing, batik, and embroidery, while other collectives were taught papermaking."[16] Berman describes the project, a regularly programmed activity of the Artist Proof Studios, as "not only [a] response to the HIV and AIDS crisis but also . . . a tool to counter social injustice generally. Self-funded through commissions and sales of craft products such as embroidered cloths, quilts, and soft toys, Paper Prayers has, over the years, generated livelihoods for about 40 women infected or affected by HIV."[17]

Quilts and quiltmaking in South Africa continue to play important roles in impacting changes in HIV/AIDS-related health education and research. They also memorialize and honor those who fell victim to the disease, provide comfort and healing for those living with the disease, provide sources of income for those whose livelihoods were eliminated or reduced because of the disease, and, importantly, create a space where difficult or silenced stories can be told.[18] The quilts provide material testaments to the power of creativity to positively address health and well-being for individuals and communities.

Notes

1. Allinder and Fleischman, "World's Largest HIV Epidemic in Crisis." HIV stands for human immunodeficiency virus. AIDS is acquired immune deficiency syndrome

2. Wells et al., *Siyazama*, 13–27.

3. See Coombes, "Positive Living," 143–74; Roberts, "Break the Silence," 36–49; Nattrass, "South African AIDS Activism, Art, and Academia; Mills, "Art, Vulnerability and HIV in Post-Apartheid South Africa," 175–95; Allen, "Art Activism in South Africa," 396–415; Morgan, *Long Life*; Wells et al., *Siyazama*; Schmahmann, "Materialising HIV/AIDS in the Keiskamma Altarpiece," 45–71; Schmahmann, "Patching up a Community in Distress," 6–21; Schmahmann, "Stitches as Sutures," 52–65.

4. Margie Garratt, quoted in Gillespie, Liza. *Innovative Threads: A decade of South African Fibre Art*. Cape Town: Innovative Threads, 2006:55.

5. Wells et al., *Siyazama*, 145–59.
6. Schmahmann, "Patching up a Community in Distress," 6–21.
7. AIDS Memorial, "About," National Aids Memorial website, accessed July 28, 2024, https://www.aidsmemorial.org/about.
8. Weems, MacDowell, and Smith, "Quilt."
9. "AIDS Quilt Touch."
10. Bourgault, *South African AIDS Memorial Quilt Project*, 3.
11. Bourgault, *South African AIDS Memorial Quilt Project*, 3.
12. AIDS Memorial, "Search the AIDS Memorial Quilt," accessed July 28, 2024, https://www.aidsmemorial.org/interactive-aids-quilt
13. Bourgault, *South African AIDS Memorial Quilt Project*, 24–25.
14. United States Embassy and Consulates in South Africa, "Desmond Tutu Blesses Panel from AIDS Quilt Returning to Washington," June 22, 2012.
15. Berman, *Finding Voice*, 51.
16. Berman, *Finding Voice*, 55.
17. Berman, *Finding Voice*, 71.
18. For an in-depth examination of quilts in health and well-being, see MacDowell, Luz, Donaldson, *Quilts and Health*.

The *Keiskamma Guernica*

BRENDA SCHMAHMANN

THE *KEISKAMMA GUERNICA*, completed midway through 2010, is a work in needlework and mixed media that was made by members of the Keiskamma Art Project. A self-help initiative involving about 120 members from the village of Hamburg and some surrounding settlements in the Eastern Cape of South Africa, the Keiskamma Art Project was founded by artist and medical doctor Carol Hofmeyr in 2000. Modeled after Spanish artist Pablo Picasso's iconic *Guernica* of 1937, the *Keiskamma Guernica* is one of a number of large-scale works by this collective that rework well-known art objects from the West in such a way as to refer to their own circumstances and concerns.[1] In the *Keiskamma Guernica*, Picasso's response to the horrific impact of the bombing of the town of Guernica, Spain, by German forces working in cooperation with the fascist leader, Francisco Franco, is adapted to speak of the devastation wrought by HIV/AIDS on a population rendered vulnerable through an inadequate health service.

As I have argued in a prior more detailed exploration of the work, the *Keiskamma Guernica* might best be seen in light of Linda Hutcheon's definition of parody as a genre involving "repetition with critical distance which marks difference rather than similarity."[2] Qualities that the Keiskamma work has in common with Picasso's *Guernica* would seem to draw attention to the fact that the *Keiskamma Guernica* is about circumstances particular to 2010 rather than 1937, about a devastating disease rather than about civil war, and speaks of paradigms and frameworks of people in South Africa rather those of a Spaniard living in France.

An analysis of the choice and treatment of subject matter and materials in the *Keiskamma Guernica* illuminates how the Keiskamma Art Project artists adapt and rework motifs used in Picasso's *Guernica* and, in doing so, mark "difference rather than similarity." In order to understand how this textile evokes "difference rather than similarity" it is important to provide a brief background about the desperate circumstances that informed an impetus to represent the impact of HIV/AIDS on Hamburg as analogous to the dropping of bombs on a vulnerable civilian population.

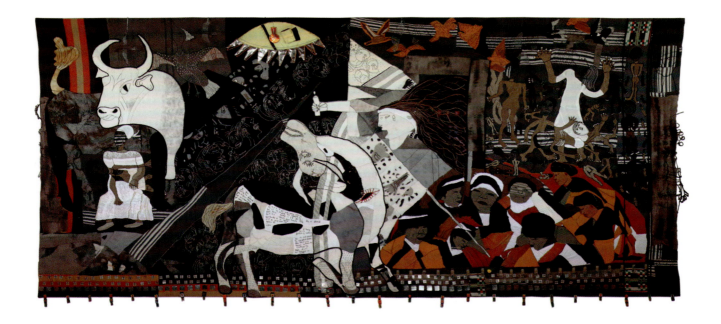

Figure 14.1.
Keiskamma Art Project, *Keiskamma Guernica* (2010), mixed media, 11.45 ft. × 25.5 ft. Collection of the Red Location Museum, Port Elizabeth. Photograph by Paul Mills.

HIV/AIDS and Hamburg

One aspect of the backstory to the *Keiskamma Guernica* is South Africa's inadequate response to the HIV/AIDS virus, which has resulted in 12.2 percent of all South Africans being HIV-positive.[3] More specifically, the work responds to the lack of suitable structures and mechanisms for addressing the impact of HIV/AIDS in Hamburg specifically, and the terrible fatalities that have resulted from this scenario.

When she first settled in Hamburg in 2000, just before setting up the Keiskamma Art Project, Hofmeyr became acutely aware of the shocking effect that an absence of a practicing doctor in the village was having on people's health as well as an increasing number of people who were dying of AIDS-related causes. While she had not practiced medicine for some years, her bringing on board Jacky Downs and, later, Florence Danais to manage the day-to-day running of the art project enabled her to shift much of her energy to medicine. She was thus able to prevent a situation in which people had nobody to attend to them in emergency situations and were obliged to travel to the two nearest hospitals, which were 43 and 106 kilometers away from Hamburg.

In early 2005, prior to government-sponsored antiretroviral rollouts in the area, the Keiskamma Trust—an umbrella entity set up to manage various community initiatives in Hamburg—became part of a program to introduce antiretroviral treatment in the Eastern Cape through the American government–sponsored initiative PEPFAR (President's Emergency Plan for AIDS Relief). The trust founded the Umtha Welanga (Rays of Sun) Treatment Centre as a facility offering personalized care to HIV-positive patients, including providing hospitalization for the very ill. In 2007, having discontinued its relationship with the local nonprofit organization through which it had been receiving antiretroviral

treatment from PEPFAR, the trust was initially allowed to continue to care for and initiate treatment of patients in the district. However, in 2009, largely because of financial contingencies and because the government health service required that all South African–manufactured antiretroviral treatment be distributed through government hospitals and clinics, the trust was obliged to phase out these activities.

Besides presenting challenges to people who lacked funding to spend on transport to get to hospitals, the new arrangements appear to have divested residents of Hamburg and surrounding villages of proper care. People in Hamburg with whom I have spoken indicate that many of the staff in hospitals are insensitive in their responses to HIV-positive patients, failing to provide necessary counseling and support.[4] Additionally, as Hofmeyr observes, prior to the making of the *Keiskamma Guernica*, there were several incidents in which local people suffering from AIDS-related illnesses had died through neglectful treatment. She cites, for example, the case of an HIV-positive woman who, suffering from tuberculosis and in a partially conscious state, suffocated to death because her medication was syringed into her mouth rather than via a nasogastric tube.[5]

Imagery and Materials in the *Keiskamma Guernica*

For Hofmeyr, the bombing of the town of Guernica was analogous to the devastation caused by AIDS in Hamburg because both tragedies spoke to ordinary citizens' lack of agency. As was the case for townspeople when Guernica was bombed, people in Hamburg "were left to suffer because of some political decisions that are outside of their experience or ability to change."[6]

Although Hofmeyr came up with the idea of making a work referring to concerns about HIV/AIDS modeled on Picasso's *Guernica*, the production of the *Keiskamma Guernica* did not involve project members simply realizing a fully developed concept. As Nokuphiwa Gedze, one of the project members who handles drawing and design, indicates, "we discussed it and then we thought of the images we are going to use. Each artist drew on paper whatever picture he or she was doing to symbolize something. And then we put that together."[7]

In Picasso's painting, the horror of what was the first systematic dropping of bombs on a civilian population by a military air force is invoked in part through references to the bullfight. For example, the work includes a bull on the top left, a central horse who has been stabbed during the bullfight, and a figure on the bottom left whose amputated hand still holds a lance and who seems to be an allusion to a matador or picador who has lost his life in the ring. Also at play in the Picasso prototype, however, are allusions to Christianity. The upraised arms of the woman falling from the burning building on the top right of the work, for example, might be understood as a reference to the Crucifixion, as indeed might the image of the horse at the center of the work.[8]

On the top right of the *Keiskamma Guernica*, in parallel to Picasso's depiction of the woman falling from the burning building, the Keiskamma Art Project artists have represented Hofmeyr herself; she is seemingly caught in a swamp and surrounded by people who are either struggling to survive or who have died. This image of Hofmeyr as a defeated and desperate savior is reiterated through

the image of the woman holding out a light at the center of the work. This second portrait, an adaptation of a woman holding out a light in the Picasso painting, invokes a sense of Hofmeyr being on call at all hours of the day and night.

Another woman—this time a generic figure—appears on the left of the painting. In parallel to the Pieta-like woman in *Guernica* who holds her dead baby on her lap, this work represents a woman holding her adult child and thus refers to the fact that it was primarily young adults in Hamburg who were dying of AIDS-related illnesses.

The *Keiskamma Guernica* imitates the bull at the top left of Picasso's *Guernica*. But the South African work also extends focus to cattle by translating the wounded horse that the Spanish artist represented in the center of his painting into a bull. Implied to be stabbed with a spear within a sacrificial ritual rather than in a bullfight, the animal has been overlaid with a transcription of a text message to Hofmeyr—a desperate plea for help from the sister of an AIDS sufferer just before he died.

Historically, cattle assumed a central importance within isiXhosa-speaking communities, where they were associated with, for example, the accumulation of wealth. But while the bull on the left offers a generic reference to cattle, the sacrificed animal in the center of the work may be associated more specifically with the young prophetess, Nongqawuse, whose millenarian vision in 1856 had been invoked in prior works by the project. Influenced by Nongqawuse's vision that her community should kill their cattle and refrain from cultivating crops in preparation for a re-creation of the world, many thousands had died or lost capacity to fend off colonial pressure on their lands by being drawn into migrant labor in a desperate attempt to save themselves and their families from starvation.[9] Viewed in light of these events, the sacrificed bull that is represented in the *Keiskamma Guernica* may suggest that, as in the mid-nineteenth century, the early twenty-first century is witnessing a catastrophe with momentous import for isiXhosa speakers—in this instance, death through AIDS-related causes.

On a more immediate level, the central bull would seem to allude to sacrifices undertaken to negotiate the impact of AIDS. Cattle may be sacrificed in mortuary rituals for men but such sacrifices may also be undertaken in an endeavor to secure healing for a sick individual or for communities suffering the impact of disease.[10] Noseti Makubalo, a project member, views the motif as a plea for help from the community: "We were crying to the Department of Health, to our government. . . . We were showing them how people die. . . . That cow was slaughtered to speak to the ancestors. In our culture that is a way of begging our ancestors for help."[11]

The dead figure that Picasso represented at the bottom left of his *Guernica* has not been substituted by, for example, the representation of a single AIDS victim. Rather, the *Keiskamma Guernica* includes a series of small metal panels arranged on bands at the bottom of the work. The origins for these were masses of temporary metal gravestones that appear on graves in the Eastern Cape. Having spotted these when driving past the graveyard in Motherwell, Hofmeyr was struck by not only the number of fatalities but also how, in catching the light, they created a sense of a shimmering otherworldliness.[12] In the *Keiskamma*

Guernica, these have been inscribed with initials of people in Hamburg and its immediate surrounds who died of AIDS-related causes—but without full names so that confidentiality is sustained. These are placed immediately below a group of women whose representation was based on a photograph taken at the funeral of an AIDS victim in the village.

Important also to meaning within the *Keiskamma Guernica* is the choice of materials for inclusion in the work. Unlike previous artworks in needlework, which were constructed from fabric that had been specifically acquired for use, this work incorporates some "found" materials. While on one level a money-saving device as well as a signal about consciousness of environmental imperatives to recycle rather than simply dispose of used items, this reuse also allows materials within the work to function as a literal physical trace or index of the community and its engagement with AIDS.

A key component of the work is various blankets that were retrieved from the Umtha Welanga Treatment Centre before it closed down. Constituting the backdrop for the crucified Hofmeyr, they also provide a face and background to the woman with her deceased child on her lap as well as reiterating the rows of grave markers. Indicators of a no-longer operative treatment center, they speak of healing that has ceased.

Also important is clay-colored fabric used in the work. Constituted from old skirts that Hofmeyr collected, they allude specifically to customary forms of dress. As Anitra Nettleton and others have observed, isiXhosa speakers in the Eastern Cape have a long history of using red ochre in garments.[13] First being used to stain skins, clay was subsequently deployed to dye imported blankets and cloth. Besides being a marker of locale and place, these elements are evocative. Somewhat faded, they seem to invoke a sense of a medical system that is itself eroded and worn out. The sun enclosing a bulb, which Hofmeyr constituted from old overalls that she persuaded a project member to donate, extends this evocation of the dilapidated and frayed—by implication, speaking of a health system that is itself in tatters.

Previous works by the Keiskamma Art Project had included beadwork elements. The *Keiskamma Guernica* is different only in the sense that rather than incorporating beads that had been specially acquired for it, the work includes small, beaded AIDS ribbons that were leftovers from a prior initiative and were being sold in the Keiskamma Art Project's shop in Hamburg. Placed beneath the metal plates derived from grave markers, they make evident that these are deaths from AIDS-related causes.

Conclusion

Exhibited for the first time at the 2010 National Arts Festival, a large-scale festival held annually in Grahamstown, a town in South Africa's Eastern Cape Province, the *Keiskamma Guernica* was acquired thereafter by the Red Location Museum in Port Elizabeth, South Africa, who put it up on permanent display. While this purchase brought much-needed income to and portended wider exposure for the Keiskamma Art Project, difficulties subsequently arose with the museum. In late 2013, shortly after the work had returned to the Red

Location Museum from being on loan for an exhibition at the South African National Gallery in Cape Town, the Red Location Museum was forced to close its doors because of tensions between the museum and local community members. When it returned from Cape Town a couple of months before the closure of the museum, the *Keiskamma Guernica* needed repair and had consequently been placed in storage rather than displayed. Activism in the area prevented the museum being accessed, and it was only in late 2016 that the Keiskamma Art Project could retrieve the work to mend it. Given the difficulties surrounding the Red Location Museum, it is unclear when (or even if) this magnificent work by the Keiskamma Art Project will once again be able to be viewed there.

Notes

1. The Keiskamma Art Project's first large-scale work was the *Keiskamma Tapestry* in 2004. Reworking the Bayeux Tapestry's representation of the Norman conquest of England to instead show Britain's own occupation of South Africa via the Frontier Wars fought in the Eastern Cape, the work was purchased by Standard Bank in South Africa and is on permanent loan to Parliament in Cape Town.

2. See Hutcheon, *Theory of Parody*, 6; Schmahmann, "Patching Up A Community in Distress," 6–21; and Schmahmann, *Keiskamma Art Project*.

3. See Shisana et al., *South African National HIV Prevalence, Incidence and Behaviour Survey*.

4. Author interviews with numerous project participants.

5. Danais and Hofmeyr, interview.

6. Danais and Hofmeyr, interview.

7. Gedze, interview.

8. The literature on *Guernica* is vast. See Russell, *Picasso's Guernica*, for an analysis of references to the bullfight and Christianity.

9. See Peires, *The Dead Will Arise*.

10. See Mvunabandi, "The Communicative Power of Blood Sacrifices."

11. Makubalo, interview.

12. Hofmeyr, interview; Danais, interview.

13. Nettleton, Ndabambi, and Hammond-Tooke, "Beadwork of the Cape Nguni," 40.

The Tapestries of the Bushman Heritage Museum, Nieu Bethesda

JENI COUZYN AND ARTISTS FROM THE BUSHMAN HERITAGE MUSEUM, NIEU BETHESDA

Jeni

If you travel into the heart of the Great Karoo in the Eastern Cape of South Africa, you will come to the Sneeuberg Mountains, with Compassberg, the tallest peak in this semidesert, often capped with snow. Nestled in a valley in the foothills of the Sneeuberg is the village of Nieu Bethesda. Here in a crowded, poverty-stricken township live the scattered mixed-race descendants of the |Xam, a once proud people, hunter-gatherers, cave painters, and, above all, stories people. Severed from their roots, they cling by a thread to a sense of community, identity, and even existence as a people.

Leaving the township with your back to the mountain, walk down a wide dirt road till you come to the police station (usually closed), the post office (usually closed), and then a giant white church whose congregation on a Sunday might be a dozen farming families. Cross the road, pass under a rough stone arch, and you'll find yourself in a different world. You might hear singing. The river stones in the large round courtyard gleam. Someone comes out to welcome you. This is the Bushman Heritage Museum, home to three galleries of giant tapestries exploring the powerful and rich |Xam mythology. On the back wall of the largest of the galleries, covering the whole wall, is the newest of the tapestries. It is called *These Are Our Stories*.

The stories we tell define us. ||Kabbo, a |Xam shaman, one of a handful of extraordinary people who saved |Xam mythology from extinction when the |Xam were wiped out in the nineteenth century, explained of the |Xam, "Stories travel on the wind. We are stories people." It was through the process of telling and listening to wisdom stories that the |Xam felt connected to the earth, to each other, to the past and future. I love these teaching stories, where four distinctive archetypes of the feminine emerge, shaping all creation. In these stories,

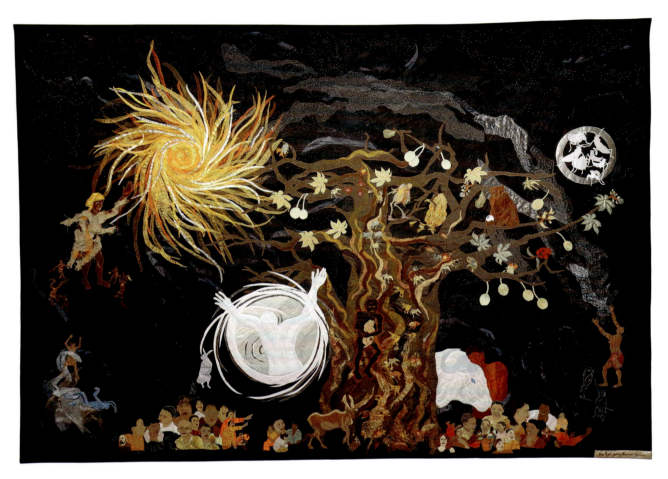

Figure 15.1.
These Are Our Stories.
Photograph courtesy of the Bethesda Heritage Museum, Bethesda Foundation.

the wonder of consciousness awakening, the abundance of fertility, the danger of trying to dominate the wind or turn a lion into a dog, the incomprehensible doings of the trickster energy in the world—all create, through powerful symbolism, a vision that seems to me as fresh and relevant in our struggling world as it must have been ten thousand years ago when the stories were first told. The |Xam have much to teach us about ourselves that we desperately need to know. Through exploring and expressing these stories in tapestries and other artwork, ancient life-giving connections are being restored.[1]

Sandra

We always sing when we are working. When we sing, we feel happy. It is joining us as one, and through that we connect. I really like the tapestry "These are our stories." On the tapestry we have a lot of the stories. For me the tree in the center is connecting us with our roots. Also at the bottom of the tapestry we have the faces of our ancestors—my grandfather is there—and also the faces of all of the artists who made the tapestry. On the one side, it's all about the sadness

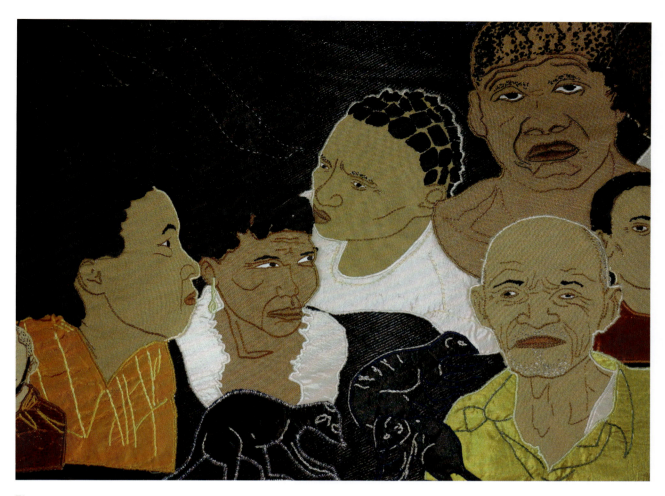

Figure 15.2.
Detail of "These Are Our Stories," showing portraits of the Nieu Bethesda artists. Photograph courtesy of the Bethesda Heritage Museum, Bethesda Foundation.

that we lost our culture and, on the other side, the happiness of reconnecting to our culture.

We didn't know the stories. Our director, Jeni Couzyn, introduced the stories to us about our ancestors. She first read the stories to us and then explained what the stories meant. Then we did some role-playing with the stories, talked about their meanings, and connected them to our own lives. It feels like the stories are about us. We draw the figures, moving our own bodies to feel the movement. We make beautiful clothes for them and play with the figures to tell each story. We make a background for texture and depth. When we start stitching the figures we sometimes use free machining. To stitch a line we use chain stitch and blanket stitch to stitch on the clothes. We also use seeding, trapping the fabric, tacking stitch and satin stitch. We look at our own hair and do different hairstyles for the people.

When we sat around the fire recently telling the stories to our community, I started to get the feeling of how it used to be, with fire on everyone's faces, and

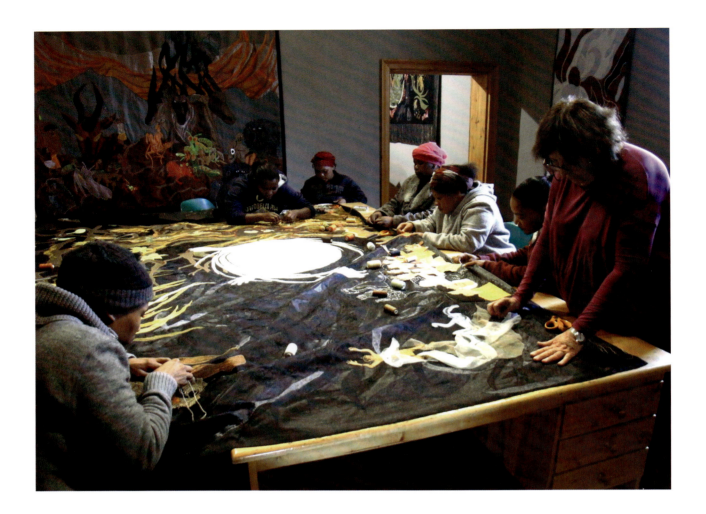

Figure 15.3.
Nieu Bethesda artists working with Jeni Couzyn on a tapestry. Photograph courtesy of the Bethesda Heritage Museum, Bethesda Foundation.

everyone sitting quietly listening to the stories, and the darkness all around us, and you heard the noise of the fire and the wood—that shooting sound, and the sky was full of stars—it was a lovely feeling. My ancestors were also there.

Some visitors to the museum get very emotional when we show them the tapestries and they cry, and we cry with them. They also feel that the tapestries are talking to them even though our ancestors could not be heard; they are now speaking through the tapestries. One visitor was crying. She said that our ancestors weren't heard when they were alive, but they are speaking to us now through the tapestries, and she believes they were awesome people, pure of heart. She said they cared so much for nature, and she is proud of us and of Jeni. We are keeping the channel open for our visitors for the ancestors to speak. Through the museum there are people whose lives will be changed.

Now, when we tell our stories, I feel as if I'm singing. I feel complete.

Felicity

For me it is exciting working on the tapestries—singing and working together, and through the tapestries we learn the stories. Working with the sunset colors is the feeling of Nieu Bethesda and also putting the mountains like we are surrounded with and it is lovely putting them into our tapestries. Wednesday night

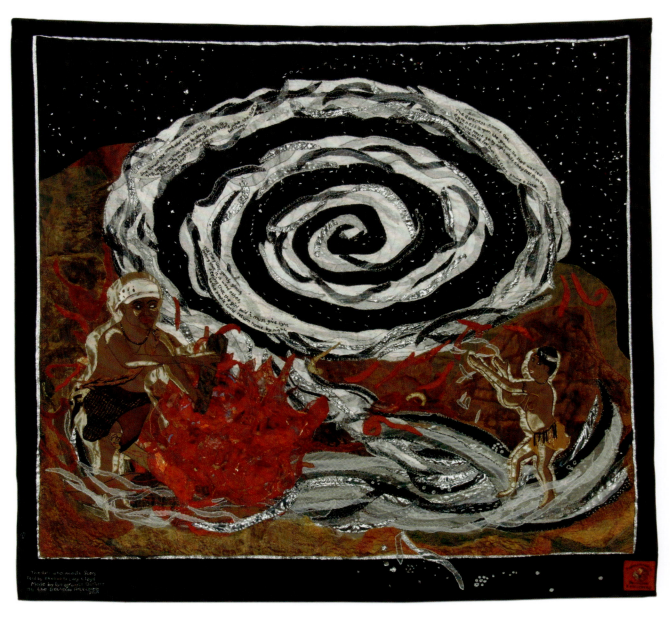

Figure 15.4
In this depiction of the story of "The Girl Who Made Stars," a young woman throws wood ash into the sky, where it forms into the Milky Way. In the center, the great spiral of the Milky Way dominates the sky. Words from the story, as told by //Kabbo, are embroidered in the left-hand lower corner. The textile was made in 2005.
Private collection. Photograph courtesy of the Bethesda Heritage Museum, Bethesda Foundation.

the Milky Way was lying very beautiful in the sky, and Yvonne and I were feeling like the old Nieu Bethesda. The tourists were loving it, and I was explaining to them, this is the Milky Way, and the Seven Sisters, and Orion's Belt. We worked with SKA (Square Kilometre Array) in the past, and they showed us some of the things at Carnavon.[2] When we started coming to the center, at the beginning we didn't have the meaning, and our director was teaching us the meaning of

The Tapestries of the Bushman Heritage Museum, Nieu Bethesda

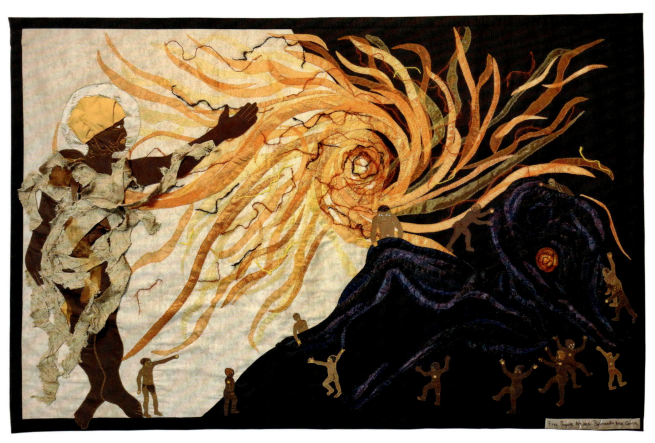

Figure 15.5
Nieu Bethesda artists have made two textile versions of "The Creation of the Sun" story. In this version, the wise old woman is huge and powerful, and the sleeping sun is almost made of darkness. But his heart has a burning center. The Old Woman has commanded the children to throw him up into the sky, so he can shine for the whole world. Because children represent new life, each child also has a spark of fire in his hands or heart. The creation of the sun is about the awakening of consciousness in humanity.
Photograph courtesy of the Bethesda Heritage Museum, Bethesda Foundation.

things. I love working on the plants and also on the faces and facial expressions. That tapestry is the best of the best. It reminds me of our place in Nieu Bethesda. In the wintertime the stars are more visible to see. I love the way we did it in the tapestry. It feels like the sky. I also love the sun—you can see the warmth in the sun. The hardest part when we started making that tapestry was putting on the backing and learning how to make the sun look warm. It was also hard to learn how to make the backing of the tapestry and how to prevent the organza from fraying. Also when you put on the drawing, if one line is wrong the whole thing is wrong. When you draw, you must put your feelings into the drawing; then you get the expression right. During the night when we put the border on and it is crooked, then we must put it again. With the singing, when we sing it feels that you work faster, and you feel joy, and you can also put that joy into the tapestry. You can see the joy in the tapestry—the bright colors join together.

Yvonne

All of us come together to make life drawings and choose colors for the tapestry. The best part is when we lay out the colors, we are all singing. That is very powerful when we are singing and dancing around the tapestry. Everyone knows how we have to work very neatly, because when you work, the love has to come out of your heart. The tapestries are all about the Bushman stories, because Jeni told us about our culture. That is different from making cushion covers or other artwork. So, when we draw, it is something like a miracle because it is from your own culture. That is how it feels.

Gerald

With me it was a great challenge because not only did I have to change the people around me but also I had to break the pattern inside me because I also strongly believed that sewing was just for women. Now I understand, after long talks and training through the Arts Center, knowing that humans are made up of both masculine and feminine sides and understanding the power of the feminine. Now I can proudly say I am a textile artist. My family knows that, and my girlfriend knows that, and they understand. There is nothing to be ashamed of about it. I love designing and sewing with the machine. Hand embroidery is still a bit of a struggle. It has nothing to do with not wanting to be seen. It is about it being hard, the needle hurts and pushes back into your fingers. Using a thimble is even harder—it slows you down. Sometimes our fingers actually bleed, and you can see the marks on our fingers.

Naasley

When we do tapestries it feels like we make history complete with the stories and pictures. The stories feel empty for me without the pictures. We get to our ancestors through the pictures and the stories. It feels great for me, because even when life goes downward, you can still feel there is support from someone above you, that there are unseen structures that through connection talk to us. When we do the quilting and the stories, that is the connection with our ancestors.

 I feel like I am with our ancestors when I draw a picture. I ask them and it feels to me the drawing comes straight from them; so I start to do some lines, and the images come out of the lines. What I like about *These Are Our Stories* is that it can tell us deep about life today. It also feels for me like the |Xam bible, because I can see the sun, but this is the deeper meaning about the sun. I can feel the wind, and I become familiar with the mother of nature, the feminine side of nature. These stories are deeper than just stories. First when we made it, it was hard to see it, but when we started to put color on, the tapestry started to become alive. The main thing for me was the time when we hung it up. After all the hard work, and all the things we have gone through, that is the best for me, you can see the smile on everyone's faces. When we do the tapestries, the singing, the voices, it is a magical moment.

 It is amazing for me when I show the tapestries to visitors in the museum. It feels like I am taking them on a journey of wisdom stories. And sharing it with the people, like there is a fire, and the ancestors are with me when I share it. I

also tell them that these stories are healing stories, and the people say to me that they are feeling heavy when they go in, but they feel relief when they come out—maybe they were stressed or faced a difficult time—but hearing the stories takes everything away.

I feel great that we have a museum in Nieu Bethesda with our stories. It is a big thing for us as the |Xam, to have a museum here with us. This is the museum of the First People and sometimes I tell my friends, we don't just sew lappies [patchwork] together, we are sewing the world together. We had a woman from Cradock who wanted us to come and tell the stories at her school. I loved telling the stories—the people hang on to your lips even if they can't understand all the words. When I am telling the stories it feels for me that I am not Naasley anymore. It is my ancestors talking through me. I can live in these stories. They are the bridge between me and my ancestors. I love to do it.

Notes

The authors of this chapter are all affiliated with the Bushman Heritage Museum, Nieu Bethesda, South Africa (www.bushmanheritagemuseum.org). Jeni Couzyn is the founder/artistic director. Telling their stories here are community members Sandra Sweers, lead artist; Felicity Tromp, Yvonne Merrington, and Gerald Mei, textile artists; and Naasley Swiers, artist.

1. Dingaan and Preez, "Vachellia (Acacia) Karroo Communities in South Africa."

2. The Square Kilometre Array (SKA) project is an international effort to build the world's largest radio telescope . . . [to]conduct transformational science to improve our understanding of the Universe and the laws of fundamental physics, monitoring the sky in unprecedented detail and mapping it hundreds of times faster than any current facility. See SARAO, "About the SKA," accessed July 28, 2024, https://www.sarao.ac.za/about/ska/.

Defining a South African Quilt Aesthetic

MARSHA MacDOWELL

IN 1995, the Smithsonian Institution sponsored a two-day research forum in which speakers gave presentations on identifying and analyzing characteristics of quilt regionality that drew from systematic studies of quiltmaking in Germany, England, Wales, France, and the United States, specifically Rhode Island, New Jersey, Pennsylvania, West Virginia, and Kansas. As the presentations and the breakout discussions documented in the proceedings revealed, regionality was very difficult to discern. Certainly particular patterns, techniques, color palettes, and uses of quilts could be situated as traditions bound to specific ethnic, religious, or geographic areas or, as in the United States, could sometimes be traced to the source countries from which immigrants hailed. But largely, the conference exposed the difficulties that were inherent in determining a quilt's place of origin without the provenance being written on or accompanying a piece.[1] The evidence provided by typical provenance—who, when, and where the textile was made—are indeed key elements to understanding the history of a quilt. Through ethnographic and historical research, such documents as artist statements, collector or marketplace accounts, estate and auction documents, church records, and similar documentation impart additional evidence about why the quilt was made and used.

Historical and contemporary quilts made and used in South Africa reflect the diverse techniques, materials, styles, and uses of textiles among Rainbow Nation's Indigenous, settler, and immigrant ethnic and cultural groups. The quilts reflect a variety of major influences, including international, continental, and regional trade in goods; immigration to and migration of peoples within southern Africa; trends in fashion; changing roles of women in society; income-generation needs; and disruptions from pandemics, wars, and political unrest.

Some of the earliest quilts known to exist in South Africa date to the first decade of the nineteenth century. Some were brought as treasured objects to South Africa by western European immigrants; others were shipped to immigrants by families and friends in their home countries. Those historical quilts known to be made by immigrants from western European countries mirror patterns and materials of those that were being made by their families and

communities in their place of origin. Indian immigrants to South Africa introduced their textile traditions into the cultural mix; patched and appliquéd spreads are traditionally used in some South African Indian homes.

Eventually the design and execution of some quilts began to take on characteristics that reflected local cultures, the environment, and available materials as well as global design influences.[2] During the economic, communication, and cultural boycotts of the apartheid era, South Africans did not have access to the explosion of commercially available quilt patterns and how-to publications that were generated in other countries, particularly in the United States. Chris and Hettie Schwellnus, of Potchefstroom, authored the first book on quiltmaking in South Africa.[3] This was soon followed by a number of how-to publications by South African quilters and textile designers, including Maretha Fourie, Lesley Turpin-Delport, Martini Nel, and the sisters Jenny Williamson and Pat Parker. South African craft magazines such as *Stitches* began to regularly feature quilt patterns and pattern instructions. These publications made patterns and general how-to information more accessible to South Africans, but designers of most published South African patterns only subtly tweaked or adapted the traditional patterns used extensively in Great Britain, the United States, and other western European countries. Williamson and Parker were in the forefront of designing patterns and whole quilts, which strongly encouraged the use of African prints and design motifs even when working in a structural quilt format that retained its connections to those used in the colonial past.

Contemporary art in South Africa, whatever the media, often features vibrant colors and a fusion of traditional and modern elements. South African artists borrow, in form, structure, and content, from the aesthetic traditions of Indigenous people, settlers, and immigrants who have populated the country; their individual and collective histories are evidenced in South African art. South African artists have drawn on personal and collective experiences and the impacts of living in a country where multiple wars have been waged between different Indigenous and settler factions, Indigenous and settler factions have been forced to relocate, racial restrictions were imposed on majority populations by a minority government, racial freedom and a new democratic government were fought for, the AIDS pandemic raged and took thousands of lives, and there are still challenges of addressing systemic inequities in economic opportunities, health, housing, and education. Artists also draw on new symbols developed in the postapartheid era to cultivate a shared sense of national identity. For instance, a new national flag created in 1994 intended to represent all, not just some South Africans; its red, black, green, yellow, and blue design became ubiquitous in material culture—whether manufactured or hand-fashioned—and quilts are no exception. The red AIDS ribbon symbol was also incorporated into many forms of art, including quilts; the inclusion of the symbol conveyed that all South Africans were needed to fight the health crisis.

It is no surprise that one finds contemporary quilts with color palettes that evoke the oceans, savannahs, and mountains and imagery of the flora and fauna as well as urban vistas that are familiar to South Africans. A particular element might be used to anchor the design of the work, but sometimes many of

the elements are mixed together to even more strongly "fix" the piece as South African.[4] Quilt artists in South Africa also frequently use South African isishweshwe fabric or African prints to construct their quilts. Some contemporary quilt artists forgo the typical rectangular shape of a quilt to render pieces that are in the shapes of the mirror cloak blankets of hide worn by the San peoples or the beaded clothing of the Ndebele, Zulu, or Xhosa women. Some quilts incorporate actual beadwork or have leather pieces attached, further connecting the piece to the cultures and resources of the land.

Most contemporary South African quiltmakers, when asked if there is a distinctive South African quilt aesthetic, quickly respond that their work reflects the cultural and natural diversity of the nation. The sampling of work included in this volume demonstrates that construction techniques, designs, color palettes, subject matter, and fabric choices exude a strong sense of place and of connectedness to the country's unique natural and cultural history.

Notes

1. *What's American about American Quilts?*, conference proceedings.
2. MacDowell, "Textiles and Quiltmaking in a Rainbow Nation," 295; MacDowell, "Quilts: Unfolding Personal and Public Histories in South Africa and the United States."
3. Schwellnus, *Las met Lap*.
4. Specific visual elements used by South African quilt artists that firmly places their work as South African include plants such as proteas (also known as the sugarbush in South Africa and considered the country's national flower), fynbos (a distinctive type of vegetation found only on the southern tip of Africa), mountain aloes, conebushes, and aloe; trees such as acacia or baobab; birds such as the guinea hen, yellow-billed hornbill, lilac-breasted roller, southern carmine bee-eater, secretarybird, southern red bishop, knysna loerie, and narina trogon; reptiles and animals such as nyala, cattle, crocodiles, zebras, baboons, monkeys, cheetahs, giraffes, impala, meerkats, hippopotamus, springboks, oryx, and the "Big Five" (lions, leopards, elephants, African water buffalo, and rhinoceroses); urban and natural landscapes such as Cape Town's Tabletop Mountain, the skyline of Johannesburg with its the Hillbrow Tower (also known as the Telkom Tower), and Robben Island; architecture such as the Cape Dutch style in the Western Cape, the painted homes of the Ndebele, the windmills of Cradock, the rondavels of the Eastern Cape, the Art Deco buildings and mosques of Durban, and the usually one-story metal-roofed homes in townships ingeniously constructed of many different materials; and the traditional clothing and design motifs of the material culture of Voortrekker, Zulu, Hindu, Xhosa, and other individuals.

Figure 16.1.
Sunbonnet Sue Goes on Safari, Parker and Williamson, Johannesburg, South Africa 1998, 56 in. × 68½ in.
Private collection. Photograph by Rob Williamson. Jenny Williamson and Pat Parker, *Quilts on Safari* (Cape Town, South Africa: Triple T Publishing, 1998), 44–47.

Figure 16.2.
Church, Betty Mgidi, Johannesburg, Gauteng Province, South Africa 2014, 47 in. × 27 in., cottons and leather.

Betty Mgidi worked as a housekeeper in the home of two Johannesburg artists, one of whom was a textile artist who supported Mgidi's interest in quilting. A deeply religious person, Mgidi might have depicted here the facade of the Roman Catholic church in her Ndebele home community of Mabhoko, Mpumalanga Province, South Africa. The facade of that church was painted by Francina Ndimande, a famous Ndebele artist.

Just as Ndebele women decorate their community buildings with painted geometric designs, Mgidi has used fabric paint or markers for the church in this wall hanging. She has also incorporated other traditional Ndebele textile techniques—beadwork and leatherwork—in this work here. Mgidi used quilting stitches to depict trees, clouds, and mountains in the background. (Betty Mgidi, interview with author, Johannesburg, South Africa. February 24, 2011.) Michigan State University Museum Collection: 2014:52.1. Photograph courtesy of Michigan State University Museum.

Figure 16.3.
Port Elizabeth—Legacy of Settlers, Marilyn Pretorius, Port Elizabeth, South Africa, 2011, 59.05 in. × 51.18 in. Satin stitch, raw edge appliqué, machine and hand embroidery, fabric painting and machine quilting

In this quilt, Pretorius represented historical civic buildings, all declared national monuments, in Port Elizabeth. They include the city hall (cornerstone laid in 1858), public library (completed in 1901), Grey Institute (later became Grey College, cornerstone laid in 1856), Holy Trinity Anglican Church (completed in 1866), and Campanile (built to commemorate the centenary of the arrival of the 1,820 British Settlers). The Cape Receife Lighthouse, No 7 Castle Hill (first a house, now a museum with a quilt collection), Pearson Conservatory in St. George's Park and sections of other buildings were quilted onto the border. Pretorius also used a quilting design based on a wrought-iron fence similar to the one encircling the church where a memorial service was held for a dear friend's deceased son.

The quilt won best machine workmanship at the 2011 National Quilt Festival in Stellenbosch (Marilyn Pretorius, email communication with Marsha MacDowell, July 8, 2022). Collection of the artist. Photograph courtesy of the artist.

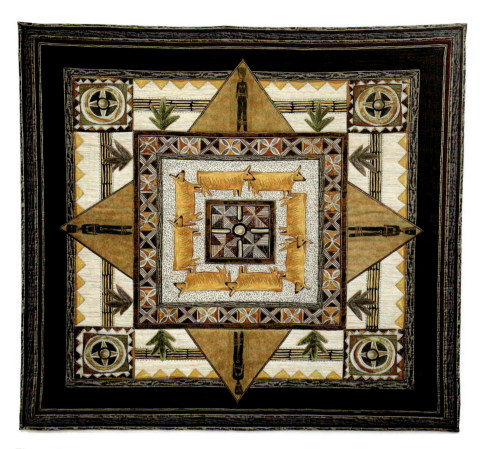

Figure 16.4.
The Sound and Silence of the Mission Station, Norma Slabbert, Hamilton, New Zealand, 1998.

During the spring of 1996, I went back to my childhood home, Groothoek Mission Hospital in the former Lebowa—thirty years after I had left. Driving away after an emotional visit, I had the title for a quilt come to mind. The sounds at the hospital were exactly as I remembered them: a symphony of silence backed by the church bell, a penny whistle, chirping cicadas, and the quiet voices of patients. The mission church on the premises had a great influence on my life because in a strange twist of apartheid, the White staff at the hospital were not allowed inside the church. As a child, I was very confused by the exclusion, and I was violently drawn to the forbidden church when the bell tolled. I used to sneak into the churchyard and sit under the window, enthralled by the singing of the Black nurses and patients. This was my religious education.

Looking at the quilt again in 2022, Slabbert shared that "the quilt mostly talks about my struggle with religion—or rather church—with its conflicting messages, corruption, and human made constraints, especially on women. And of course, my conflicting feelings on the idea of colonial missionaries 'interfering' with deeply felt indigenous beliefs." She placed aloes in the corners of the quilt; her grandmother used them for medicinal purposes. The windmill in the center references the one on the farm where she grew up, and "it was our only source of drinking water in a hot and barren place. I could stare at it for hours. It took me to far away places."

Slabbert also stated that the inclusion of cattle was "my reference to my roots, my early years on a cattle farm, and the deep meaning and value that cattle have in Africa. The cattle was also done with a bit of defiance—after a very famous U.S. quilt maker (or artist) proclaimed that, whatever you do, never put a cow on your quilt. Well, if you grow up in Africa and on a cattle farm, that is part of your daily life. Your sense of place. Of course you are going to put a cow in your quilt!" (Norma Slabbert, email communications with author, July 10, 2022; Norma Slabbert, *The Sound and Silence of the Mission Station*, Series: Stitched Stores, Norma Slabbert Quiltmaker website, https://normaslabbert.com/early-work/; Norma Slabbert, *A Passion for Quiltmaking: Leading South African Quilters Show and Tell* [Pretoria: J. P. van Der Walt, 1998], 98).

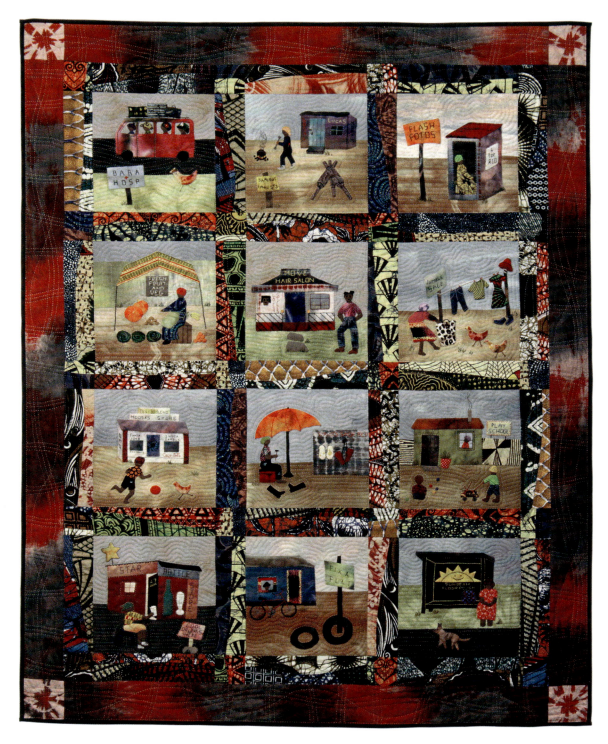

Figure 16.5.
Every Picture Tells a Story, Jenny Williamson and Pat Parker, Johannesburg, South Africa, 2004, 43 in. × 52 in.

According to the artists, "this quilt depicts urban life as seen around us at the present time. Small business is the order of the day and budding entrepreneurs are everywhere to be found" (Jenny Williamson and Pat Parker, *Quilt Africa* [Highlands North, South Africa: Wild Dog Press, 2004], 8). Collection of the artists, photograph by Rob Williamson

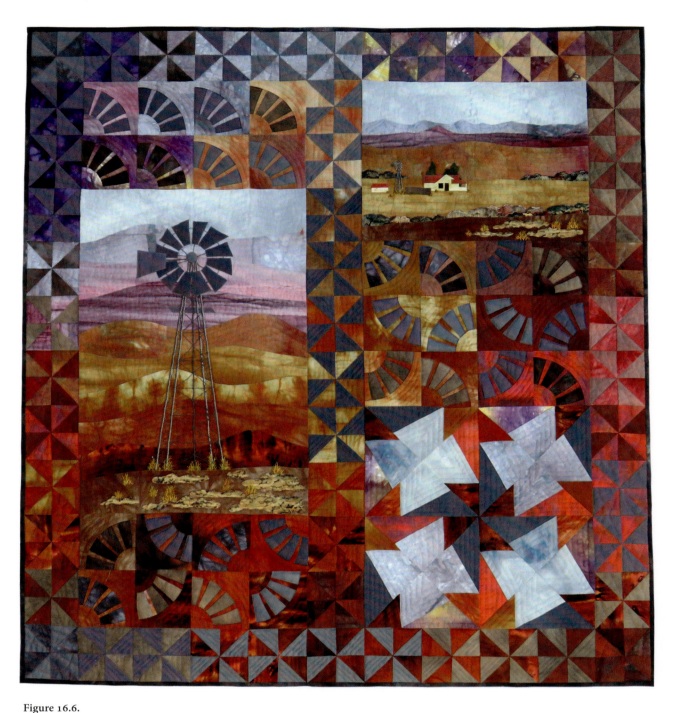

Figure 16.6.
Windmills on My Mind, Pat Parker, Johannesburg, South Africa, 2004, 43.30 in. × 51.18 in., hand-pieced, machine-appliquéd, and quilted

Along the Karoo, windmills dot the flat landscape and models of windmills are made of tin and wire by artists and sold in formal galleries as well as at informal artist stands along the road, at gas stations, and near tourist sites. Parker states that "I continue to be fascinated by the many windmills that form an integral; part of the Karoo landscape." (Jenny Williamson and Pat Parker, *Quilt Africa* [Highlands North, South Africa: Wild Dog Press, 2004], 26).
Collection of the artist. Photograph by Rob Williamson.

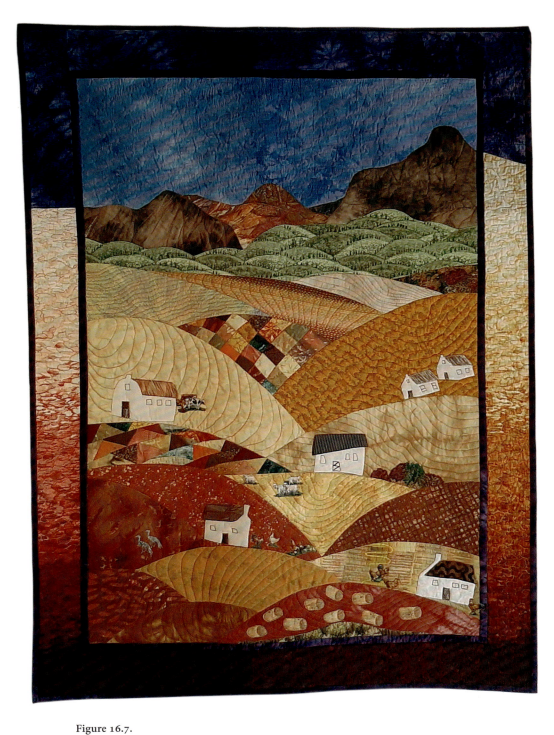

Figure 16.7.
Overberg, Bettie van Zyl, Hermanus, South Africa, 2002, 1 m × 1.35 m 3.3 ft. × 4.4 ft.

"For fifty-five years I traveled the 1,400 kilometres from Johannesburg to Hermanus for our annual summer holiday. As I was teaching at the 2002 National Quilt Festival in Cape Town, I decided to put that precious memory into a quilt. I tried to portray the feeling of 'coming home' as I emerged from the mountains at Villiersdorp and seeing the endless 'Ruêns' (round hills) of the Overberg, my mother's birthplace, again. I could swear that I could smell the sea air from there" (Bettie van Zyl, email communication to author, June 9, 2023).

Private collection. Photograph courtesy of the author.

Figure 16.8.
Drakensberg Dreams, Helga Beaumont, Kloof, South Africa, circa 1999, 29.53 in. × 36.61 in. Hand-dyed fabrics, printed and stamped, netting, machine embroidery, machine-appliquéd and machine-quilted.

"Having majored in anthropology, I have always been fascinated by the Indigenous peoples around the world. The vivid photography in John Hone's *Bushman Art of the Drakensberg* inspired the central machine embroidered medallion. The background is what I visualized as the caves of the Bushmen and their beautiful paintings on the rocks" (Helga Beaumont, email communication with author, June 28, 2022).

Figure 16.9.
Infanta Hills, Margie Garratt, Nova Constantia, South Africa, 2005, 36.61 in. × 47.24 in. Hand-dyed and commercial fabrics, machine-pieced and quilted.

"My family has owned a farm on the Southern coast of South Africa for the past forty years. It is a place of peace and refuge for us all. Filled with natural unspoiled elements and offers the mental space to simply be creative using the flowers, birds, beasts, and beautiful environment. The protea is uniquely South African, and we find them quite remarkable blooms and in winter they burst from the dry hills of the summer sun. Once again, I used my own photographs as a basis for the machine drawings. Carefully piecing the flowers trying to re-create the shapes using slashing and piecing methods, both commercial and home-dyed fabrics were used extensively in this work"
(Margie Garratt, email communication with author, June 15, 2022).
Photograph courtesy of Margie Garratt

Figure 16.10.
Ingubo Entle (Xhosa for *A Beautiful Blanket*), Jo Crockett and Nomawethu Bebeza, Langa Township, Cape Town, South Africa, 2008, 52 in. × 74 in.

 White South African quilter Jo Crockett collaborates on textile projects with Black South African women artists, most of whom, like Nomawethu Bebeza are Xhosa and live in Langa, a community just outside of Cape Town. They often produce a style of quilts that has become quite popular among textile artists, particularly those involved in economic development projects and seek to sell their work in shops catering to tourists.

 This style of quilt is generally constructed of African fabrics and incorporates "typical" images of South African natural landscapes, and urban and rural life as well as objects and images of the African continent. Included on this quilt are renderings of elephants, cheetahs, lions, snakes, a soccer ball, a bus, a person carrying water, and a map of Africa.
Collection of Michigan State University Museum. Photo by Pearl Yee Wong
courtesy of Michigan State University Museum.

Figure 16.11.
Grounded I, Rosalie Dace, Durban, South Africa, 21.2 in. × 15 in., 2013. Hand-dyed, hand-screened, and commercial cottons; hand-dyed and commercial silk; taffeta, thread, beads and buttons. Machine- and hand-pieced, appliquéd, quilted embroidered and embellished. Collection of the artist. Photograph courtesy of the artist.

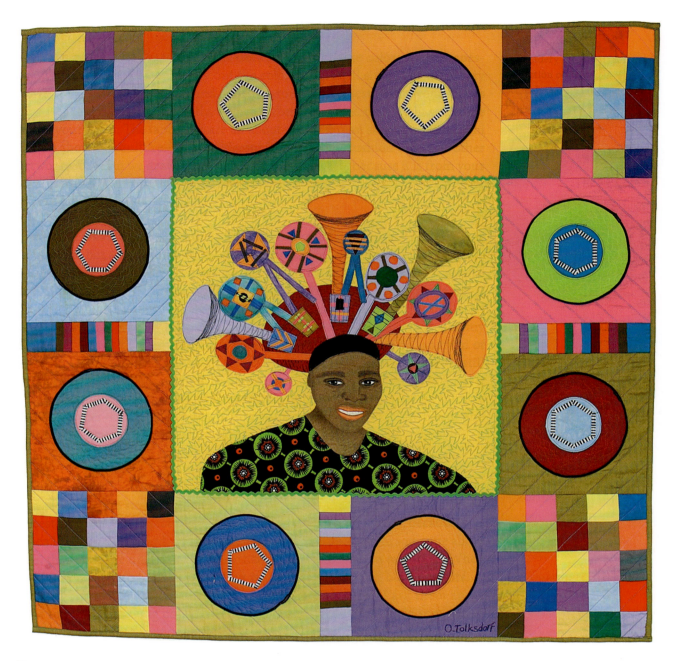

Figure 16.12.
Vuvuzela Madonna (Musical Instrument), Odette Tolksdorf, Durban, South Africa, 2010, 41.33 in. × 41.33 in. Hand-dyed and commercial cotton fabrics, soutache cord, and ric-rac braid.

"Even though I generally have very little interest in sport, it was almost impossible not to get caught up in the excitement of the 2010 football World Cup held in South Africa. Vuvuzelas were everywhere—not just at the football matches—and I even bought one! I saw some Zulu women's hats decorated with beadwork and vuvuzelas which looked just wonderful, and I thought it was a good use for the noisy vuvuzelas!" (Odette Tolksdorf, email communication with author, June 13, 2022). Private collection. Photograph by Christopher Baker courtesy of Odette Tolksdorf.

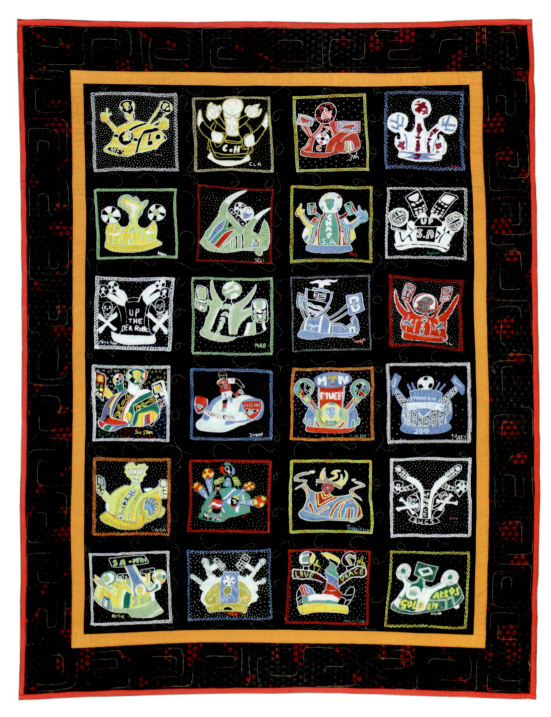

Figure 16.13.
Makarapa Quilt, Intuthuko Embroidery Project, Etwatwa, Gauteng Province, South Africa, circa 2010, 37¾ in. × 50¾ in.

 This textile of embroidered squares was made by the women in the Intuthuko Project (a women's upliftment project) of Etwatwa, located east of Johannesburg, in the Gauteng Province. Each of the panels on this textile depict a different makarapa (the name of the plastic helmet that is sculpted and decorated and worn by fans in support of their favored soccer teams). This piece was made to celebrate South Africa's hosting of the 2010 FIFA World Cup Soccer Tournament.
Collection of Michigan State University Museum 11.0016. Photograph by Pearl Yee Wong.

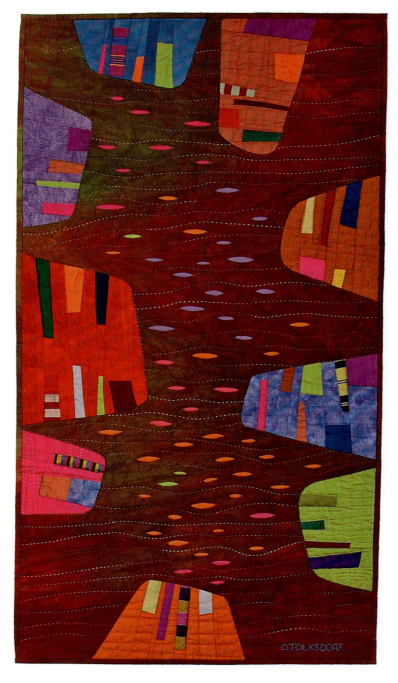

Figure 16.14.
ON THE EDGE NO. 3—Zulu Headrest Series, Odette Tolksdorf (designer); Inge Lailvaux (quilter), Durban, South Africa, 2001, 22 in. × 40 in. Hand-dyed and commercial cottons and silks, pieced and quilted.

"The spark which started the idea for this series was the carved design on an old wooden Zulu headrest. I was intrigued that the carved designs were only around the edge of the rectangular format and the center was left as a blank space. This appealed to me as a design challenge – to emphasize the edges instead of the center of the composition while integrating the whole surface" (Odette Tolksdorf, email communication with author, June 13, 2022; "On the Edge," Odette Tolksdorf website, accessed June 24, 2023, http://www.odettetolksdorf.co.za/on-the-edge.html). Collection of the artist. Photograph by Christopher Baker courtesy of Odette Tolksdorf.

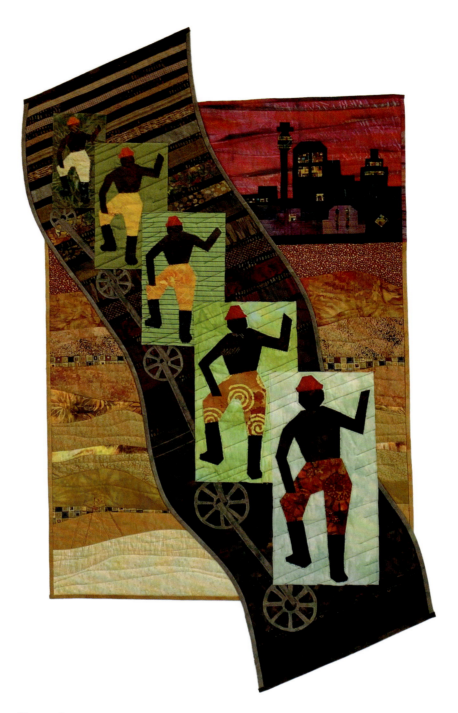

Figure 16.15.

Egoli, Sheila Walwyn, Cape Town, South Africa 2008, 26 in. × 35.4 in. Cotton fabrics, machine-pieced, appliquéd, fused, and hand-embroidered.

"This quilt was made as part of a theme of 'Shosholoza,' meaning a traditional African song favored by men whose work it was to lay railway lines. Meaning to push forward, endeavor or strive, it evokes a sense of pride. Gumboot dancers and steam trains are portrayed, with Egoli, or Johannesburg, in the background as the hub of employment opportunities." The quilt was exhibited in the National Quilt Festival in 2008 (Sheila Walwyn, "Sheila Walwyn," Fibreworks website, accessed June 20, 2023, http://www.fibreworksart.com/Walwyn.html).

Collection of the artist. Photograph by Diana Vandeyar courtesy of the artist.

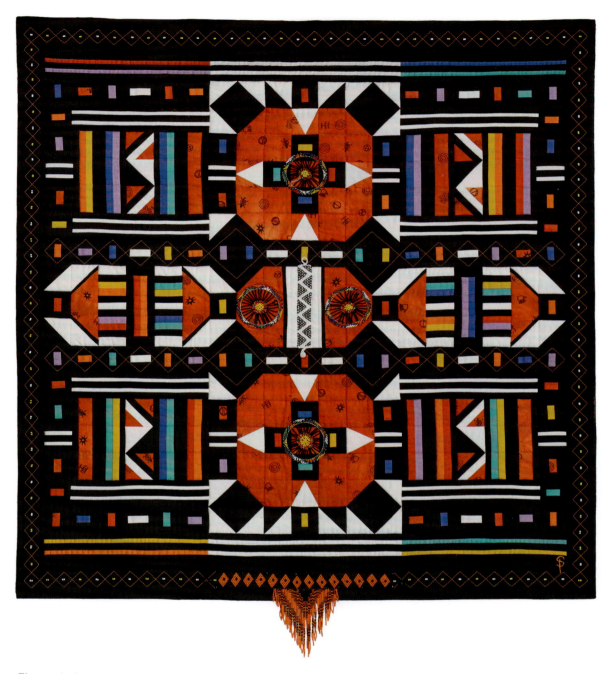

Figure 16.16.
Cultural Diversity: Isiphephetu Apron, Paul Schutte, Potchefstroom, South Africa, 2015
Cotton fabrics and glass beads, machine-pieced and quilted with beading by hand in the border.

"Three diverse South African cultures converge in this piece: An elderly married white man constructed a piece inspired by a Ndebele apron which is traditionally given to an unmarried girl by her mother (symbolizing her ascent from childhood to womanhood), while Zulu artifacts, made by elderly Zulu women were incorporated into the realization and construction of the work" (Paul Schutte, documentation form, Quilts and Related Textiles of South Africa files, 2023). The quilt won first prize in the Challenge category at the 2017 South African National Quilt Festival in Port Elizabeth.
Private collection. Photograph courtesy of the Rembrandt van Rijn Foundation, Rupert Museum, Stellenbosch, South Africa.

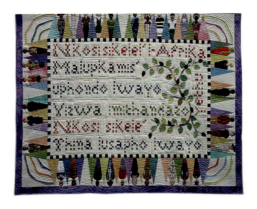

Figure 16.17.
Sanbonani eThekwini (Hello Durban), Odette Tolksdorf, designer: Grassroots Quilters Guild, piecers and quilters, Durban, KwaZulu Natal Province, South Africa, 1999, 70.07 in. × 53.15 in.

According to the artist, "participating group members were each given a 'paper doll' to dress, representing the wide variety of people living in Durban" (Odette Tolksdorf, email communication with author, June 13, 2022; see also Lisa Gillespie, *Innovative Threads: A Decade of South African Fibre Arts* [Cape Town: Innovative Threads, 2006], 32). Collection of the Durban International Convention Centre (Durban ICC). Photograph courtesy of Odette Tolksdorf.

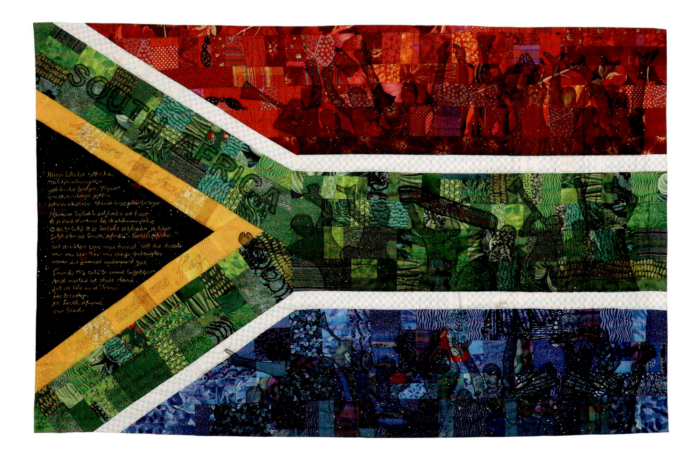

Facing, **Figure 16.18.**
One Flag-Many Fans, Jenny Hermans, Cape Town, South Africa, 2010, machine-pieced, machine-appliquéd, and quilted.

Hermans made this quilt in 2010, the year that South Africa hosted the World Soccer Cup "as part of an exhibition—*Images of Sport*. In that year South Africa hosted the Fifa Soccer World Cup and the time leading up to and including these sport events and opportunities across the land, helped to bring together our diverse communities, cultures and beliefs and we were proud and, somehow, I thought the flag was a symbol that united people of SA."

According to Hermans, quilted on the flag are the following words (in italics):

God Bless Africa. Guard her people. Guide her rulers and give her peace: the prayer for Africa.

Madiba magic: Nelson Mandela our much-loved father of the nation instills pride and his own special magic in the hearts of the people of the south and of the world.

Shosholoza, Viva, Halala

Gees, Bokke, Proteas, Banyana

Ayoba, laduma, olé

Players and fans united under one flag

South Africa

Cradle of Humankind

Peace in our land

Have faith, be proud, be free

Rainbow Nation

Take care of life. HIV & Aids

Ubuntu: "One of the sayings in our country is Ubuntu—the essence of being human. Ubuntu speaks particularly about the fact that you can't exist as a human being in isolation. It speaks about our interconnectedness. You can't be human all by yourself, and when you have this quality—Ubuntu—you are known for your generosity, for standing together and being united and supportive."—Desmond Tutu.

The players' pledge is said, in one form or another, characterizing the spirit of sportsmanship and fair play. *I pledge to play the game with respect, commitment and fairness, displaying my skill and passion. I will be gracious in defeat and humble in victory.*

The South African National Anthem: This stirring anthem set to a beautiful tune, brings together two anthems, five languages and over 49 million people in South Africa.

Nkosi sikelel' iAfrika

Maluphakanyisw' uphondo lwayo,

Yizwa imithandazo yethu,

Nkosi sikelela, thina lusapho lwayo.

Morena boloka setjhaba sa heso,

O fedise dintwa la matshwenyeho,

O se boloke, O se boloke setjhaba sa heso,

Setjhaba sa South Afrika - South Afrika.

Uit die blou van onse hemel,

Uit die diepte van ons see,

Oor ons ewige gebergtes,

Waar die kranse antwoord gee,

Sounds the call to come together,

And united we shall stand,

Let us live and strive for freedom,

In South Africa our land.

(Jenny Hermans, email communication with the author, June 13, 2022.)

Collection of the artist. Photograph by René Hermans courtesy of Jenny Hermans.

Common Ground, Building Bridges

The Women of Color Quilters Network and South African Quilt Artists

MARSHA MacDOWELL, CAROLYN MAZLOOMI, AND PATRICIA TURNER

DURING THE YEARS of South Africa's apartheid government, there were international embargos on communications with South Africans as well as bans on cultural exchanges. As a result, there were very few visits by South African quilt artists to the United States or vice versa, and it was only White Americans and South Africans, not Black Americans or South Africans, who made the trip. In addition, only a few of the enormous number of American quilt books and magazines reached South African audiences, and again, these were publications featuring White quilting traditions.[1]

Many African Americans were, however, deeply aware of the plight of Black South Africans and their fight for freedom from oppressive racial laws. Like other artist-activists around the world, African American quilt artists used their needles and thread to draw attention to South African apartheid. Members of the US-based Women of Color Quilters Network (WCQN) were among those who made quilts. WCQN members had long been active in making quilts that chronicled past and current injustices and paid tribute to those who made a difference.[2] Although on different continents, African Americans and Black South Africans share a history of racial oppression and a quest for democratic changes in their countries that foster nonracialism.

In the early 1980s, renowned quilt scholar, Cuesta Benberry, provided the first introduction of the WCQN to the work of some Black South African quilters. Benberry had visited London with members of the Zamani Soweto Sister Council, purchased one of their quilts, and, upon her return to the United States, began to give lectures on the quilts of the Sisters Council and the plight of their members in South Africa. WCQN members attended her lectures and were mesmerized; they not only admired the beauty of the quilts made by the Sisters Council but also felt a kindred and spiritual connection because both shared common ground in the political struggle for racial equality.

When Nelson Mandela was released from prison, it was worldwide news. Artists, including African American quilters, celebrated and marked the occasion.

In 1990, Nelson and Winnie Mandela came to the United States for the first time in what was called the Freedom Tour. They were showered with gifts, including quilts, at each of the venues they visited. Sadly, the locations of the over 150 quilts—including one by Carolyn Mazloomi—known to have been made as formal presentations to Nelson Mandela, the man, or Nelson Mandela, the president, are unknown.[3]

For decades, the WCQN wanted to participate in an exhibition of quilts in South Africa, as well as travel the country. That opportunity arose in 2013 when friends and colleagues Mazloomi and Marsha MacDowell thought there should be an exhibition of quilts newly made in Mandela's honor. Quickly, they found an organization willing to host the exhibition—the International Quilt Convention Africa, which was to be held July 24–26, 2014, at the Emperor's Palace, Johannesburg.

At first the concept was to invite only WCQN members to submit work, but soon the determination was made to extend the invitation to South African quilt artists. Jenny Hearn, a White South African artist who was well-connected in the South African Quilters' Guild and had shown work in the United States, was brought on board to help recruit South African participation. Patricia Turner, a scholar of African American quilts, agreed to contribute an essay to the exhibition catalog.

For Black South African quilters, the circumstances surrounding the life of Nelson Mandela were their own. The trajectories of their lives are tightly woven with those of the man so many of them called "Madiba." If they were alive when he was in prison, they too were ensnared in an intractable caste system in those days before democracy. When he was free and a constitution based on human equality was established, their liberation was also at hand. For White South African quilters, the exhibition posed an opportunity to state their own perspectives on the apartheid system and to pay tribute to a man they admired, a man who became a symbol of a new, nonracial democratic existence.

Some quilt artists recalled when Nelson Mandela, the African National Congress freedom fighter, was first sentenced in 1964 and reflected on the years when anti-apartheid struggle was a defining component of their own political awakening. For slightly younger quilters, the release of Mandela from prison was etched in their minds, the famous image of the gray-haired man in the dignified suit walking with his then wife, Winnie, with their fists clenched and raised in the air. For even younger quilters, Nelson Mandela may have always been an avuncular elder statesman, garbed in a colorful shirt. Yet they understood he had played a critical role in world history and had undergone great personal sacrifices on behalf of democracy and non-racialism.

When the culminating exhibition—titled *Conscience of the Spirit: The Legacy of Nelson Mandela, Tributes by American and South African Quilt Artists*—was launched in Johannesburg, it showcased thirty-three quilts made by WCQN members and thirty-four by both Black and White South African quilt artists. In addition to essays by Mazloomi, Turner, and MacDowell, the accompanying exhibition publication included images of each work and the artists' own descriptions of their work, all presented in alphabetical order by the last name of

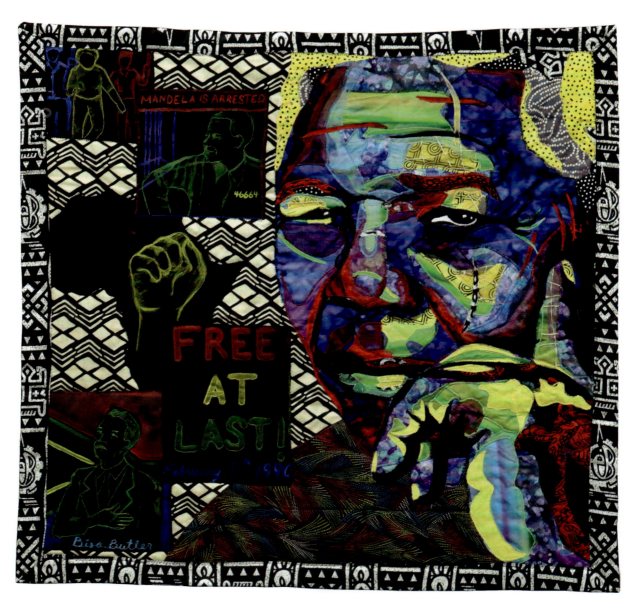

Figure 17.1
Free at Last, Bisa Butler, West Orange, New Jersey, USA, 2014. Cotton, chiffon, netting, and acrylic paint, machine quilted and appliquéd.

"The debt we all owe Nelson Mandela as human beings cannot be quantified. He fought for the rights of all people, he fought for a free and democratic South Africa without apartheid. Mandela was and is the physical embodiment of the struggle and triumph of good against evil.

"Mandela is literally and figuratively depicted here as one with his beloved country. As a man of the people, he is made of the very fabric of the South African flag—the green, black, and yellow of the African National Congress, and the previous red, white, and blue of the former South Africa. He brought all of South Africa together and focused on healing rather than hate.

"I call my quilt *Free at Last* because not only did Mandela prove to the entire world that as long as your mind is free, so will you be, but also [because] he is now soaring with our great ancestors like Malcolm X, Mahatma Gandhi, and Martin Luther King. Martin Luther King gave the phrase 'free at last' worldwide recognition in a speech, and I found it perfectly fitting here"
(Bisa Butler, artist statement, Mandela Quilt Exhibition Files, Michigan State University Museum). Collection of the artist. Photograph courtesy of the Michigan State University Museum.

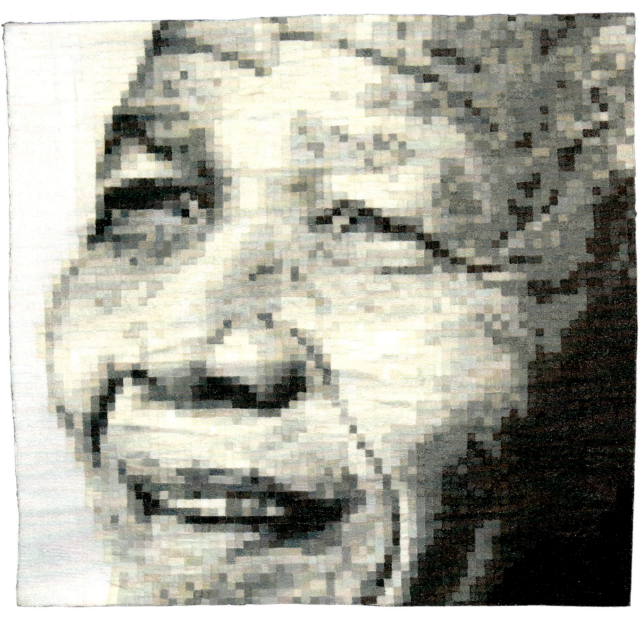

Figure 17.2
My Mandela, Dana Biddle, Heidelberg, South Africa, 2014, 28.5 in. × 29 in. Cottons, pieced and embroidered (Dana Biddle, artist statement, Mandela Quilt Exhibition Files, Michigan State University Museum).
Collection of Michigan State University Museum, 2017:45.1, https://quiltindex.org//view/?type=fullrec&kid=12-8-6817. Photograph courtesy of the Michigan State University Museum

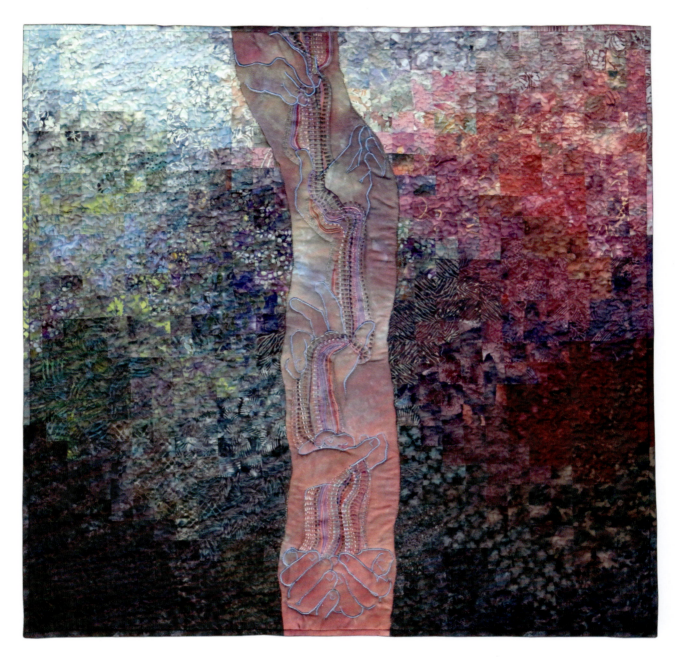

Figure 17.3.
It Is in Your Hands Now, Jenny Hearn, Johannesburg, South Africa, 2014, 29¾ in. × 29¾ in.

"I saw a billboard with Mandela's face and the words 'It's in your hands now.' The embroidery in my quilt implies that he held the different threads of this diverse nation together from 1992 to 1994, when the nation was very apprehensive about the future and was on the brink of civil war. The nation has now passed from one leader to another and it is up to all South Africans to hold true to his legacy" (Jenny Hearn, artist statement, Mandela Quilt Exhibition Files, Michigan State University Museum).
Collection of Michigan State University Museum. Photograph courtesy of the Michigan State University Museum.

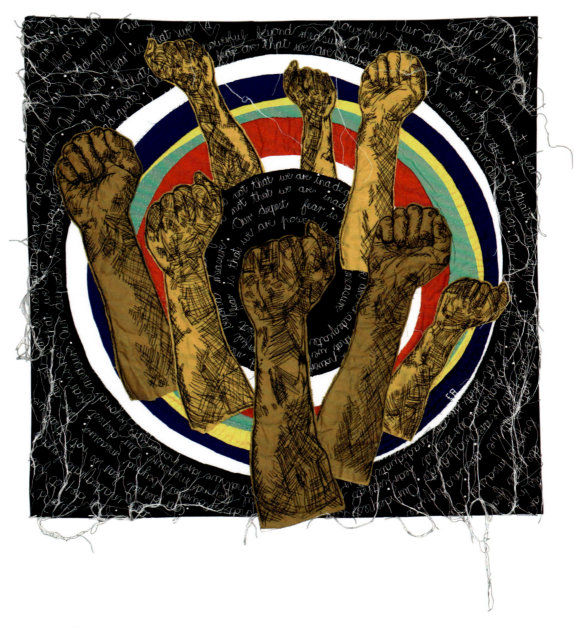

Figure 17.4.
Amandla!, Elaine Barnard, Newcastle, KwaZulu-Natal, South Africa, 2014. Cotton and polyester fabrics, appliqué and free-style machine embroidery, hand-quilted and tied.

"I grew up in South Africa under apartheid. We were never allowed to see any image of Mandela. The very first time I saw him, and I believe the rest of South Africa, was when he walked out of Victor Verster prison, raising his fist above his head. That fist was what I wanted to portray in my quilt—freedom! Amandla!

"In this quilt I used the colors of our national flag to symbolize our rainbow nation after the release of Mandela. I also used the words Mandela quoted from Marianne Williamson in his inaugural address in 1994: 'Our deepest fear is not that we are inadequate. Our deepest fear is that we are powerful beyond measure. It is our light, not our darkness that most frightens us.'"

(Elaine Barnard, artist statement, Mandela Quilt Exhibition Files, Michigan State University Museum).
Collection of the Michigan State University Museum. Photograph courtesy of the Michigan State University Museum.

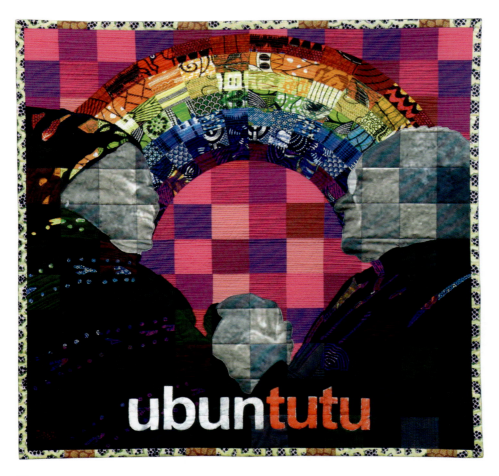

Figure 17.5.
Ubuntutu, Diane Vandeyar, Cape Town, Western Cape, South Africa, 2016. Cottons, linens, synthetic and silk fabrics, photo transferred, pieced, quilted.

Vandeyar has lived in both South Africa and the United States. "The title combines the term Ubuntu, which is a South African philosophy and phrase which translates as 'human kindness' or 'human-ness,' combined with the name Tutu, to form "Ubuntutu." This quilt was made for the traveling exhibition Michigan State University Museum organized to honor Archbishop Desmond Tutu, which is titled after this quilt. The quilter made the quilt in Oakton, Virginia.

Ubuntu is a Southern African philosophy which states "I am because you are." It encompasses the human virtues of compassion and humanity, which are exemplified by Leah and Desmond Tutu's life mission. When contemplating the word Ubuntu, the synergy and connection between the Tutus and Ubuntu became very apparent to me—and so it befitted that the two be merged and hence "ubuntutu."

Benny Gool's photograph of the Tutus was the perfect focal point for my quilt. I used a photo transfer technique to print the images of the hands and faces onto different individual pieces of fabric, this carried over to the theme of squares throughout the quilt.

The rainbow over the Tutus was made with African fabrics. It is a tribute to all the people of the South African "Rainbow Nation," a phrase coined by Archbishop Tutu to describe post-apartheid South Africa. I also used the rainbow colours as highlights in the head wrap and clothing to further connect the Tutus with the "Rainbow Nation."

A large portion of the quilt uses liturgical colours, such as purple, violet, rose and pink, representing Archbishop Tutu's devotion to the clergy.

(Diane Vandeyar, artist statement, Mandela Quilt Exhibition Files, Michigan State University Museum. Photographer Benny Gool gave Diana Vandeyar his permission to use his photo in this quilt.)
Collection Michigan State University Museum. Photograph courtesy of the Michigan State University Museum

the artists.[4] It was almost impossible to tell by just looking at the textile whether the maker was from South Africa or from the United States; the demarcations between the ages, races, religions, and citizenships were blurred not only through similar expressions of admirations for Mandela but also through the artists' use of similar textile construction techniques and materials. Indeed, American artists incorporated African fabrics, even South African isishweshwe, into their work; meanwhile, South African artists used fabric imported from the United States or patterns and techniques linked to specific American quilt artists.

The textiles that materialized Mandela's life story are as varied as the makers of the work. Some are very explicit in their visual narrative or in the text that is written, embroidered, and painted on them. Others give very few, if any, visual clues that they are connected to Mandela's story or South Africa. Yet it is in the artists' stories of why they made these textiles that we learn of their deep connections to South African history, to their own personal stories, and to Nelson Mandela.

A group of WCQN members traveled to South Africa for the opening of the exhibition. For many, it was a once-in-a-lifetime trip to Africa. Many South African quilt artists also were present at the opening, and it was a delight to see so many artists signing each other's catalogs and taking pictures of each other and of the exhibition. One of Nelson Mandela's grandsons attended and spoke glowingly of the collective work.

The Nelson Mandela Museum in Mthatha is touring the Mandela quilt exhibition fabricated on panels, and the museum collaborated with the Cape Town–based design firm Dreamfuel on a multimedia *Legacy of Light* version of the exhibition that can be shown outdoors, with images projected against exteriors of structure. The *Legacy of Light* exhibition debuted in 2019 in Qunu, the village in which Mandela went to school as a young boy.

Most of the artists involved in the Mandela quilt exhibition participated in a second binational quilt exhibition, this time paying tribute to the late Archbishop Desmond Tutu and his wife and comrade Leah Tutu.[5] The exhibition, with the archbishop and Leah in attendance, opened at the Nelson Mandela Gateway Center/Robben Island Museum and then traveled to the Stellenbosch University Museum.

The quilts and their associated stories that were part of both exhibitions are now digitally accessible through the Quilt Index.[6] Several of the South African and American quilts made for each of the exhibitions were subsequently acquired by the Michigan State University Museum and have been showcased in exhibitions at the museum and loaned to other museums. These activities continue to convey the enduring connections between South African and African American quilt artists.

With their needles and cloth, quilt artists build bridges across time, space, and cultures. The connections between African American and South African quilters who share a sense of common heritage are historically special; today, a new common ground is being built among all American and South African quilters through their shared engagement in this textile art form.

Notes

1. Johnson, "Quilting Links U.S. and Africa: A Tradition Come Full Circle."

2. Since its inception in 1986, under the leadership of Carolyn Mazloomi, WCQN has been a force in connecting African American quilt artists, conducting professional development workshops for artists, offering quilt lessons and educational programs for youth, and developing exhibitions of work that have been presented in many museums and quilt festivals in the United States as well as some in other countries. For more about the origins and activities of the WCQN, see German, "Surfacing," 137–68.

3. According to Narissa Ramdhani, formerly Nelson Mandela's personal archivist, she and Irene Menell unpacked 150 quilts from the boxes of presents given to him. The quilts included many made and presented by Native Americans and members of Canada's First Nations.

4. This article draws from the essays by Marsha MacDowell, Carolyn Mazloomi, and Patricia Turner in MacDowell and Mazloomi, *Conscience of the Spirit*.

5. MacDowell and Brown, *Ubuntutu: Life Legacies of Peace and Action*.

6. Quilts included in the *Conscience of the Spirit: The Legacy of Nelson Mandela, Tributes by American and South African Quilt Artists* exhibition can be seen in the Quilt Index. Those included in *Ubuntutu: Life Legacies of Peace and Action; Quilt Tributes to Desmond and Leah Tutu* can be seen in the Quilt Index at https://quiltindex.org/view/?type=exhibits&kid=50-147-2.

The Quilt Index

South African Quilt History, Preservation, and Access

MARSHA MacDOWELL

THE QUILT INDEX is an open access, digital repository of thousands of images, stories, and information about quilts and their makers drawn from hundreds of public and private collections around the world. As a digital humanities research and education project of Matrix: The Center for Digital Humanities & Social Sciences at Michigan State University, the Quilt Index represents the work of thousands of community-based and independent scholars, digital humanists, and professionals in libraries, archives, and museums who are dedicated to preserving quilt history and making it accessible.[1]

The object- and artist-focused data in the index is enhanced with the inclusion of journals, digitized quilt ephemera and publications, essays, online galleries, and lesson plans. Quilt Index tools include those to search (e.g., by key words, maker, location of origin, date, fabric, color, pattern, and technique), sort (e.g., by date range, region, title), and the capacity to enlarge or compare images side by side.

From the outset of the Quilt Index, as textile historian and former Quilt Index team member Mary Worrall observed, the Quilt Index "used a broad definition of the term quilt which could accommodate inclusion of quilts and quilt-related textiles deemed important to be documented and digitally preserved by those who made, collected, and studied them."[2] Thus, textiles that are of pieced or patched tops only but not quilted, fragments of quilts, and clothing or other items that employed patchwork, piecework, and quilting techniques in their construction, are included in the Quilt Index.

The Quilt Index was originally launched in 2003 with the records of four pilot quilt collections. As Worrall described, "the first body of documentation housed in the Quilt Index stemmed from a revival of interest in quiltmaking and quilt study by artists and scholars in the late twentieth century particularly in the United States. During this time, an increasing number of individuals became interested in quilts as works of art, historical documents, and sources for academic research. Through state and regional quilt documentation projects, largely run by dedicated volunteers, individuals were encouraged to bring quilts they made or owned to community sites where physical descriptions, photographs and histories of quilts, and biographical details about their makers were

Figure 18.1.
Home Page, Quilt Index (www.quiltindex.org).

Figure 18.2.
Screenshot of sample display page, South African Quilt History Project. https://quiltindex.org/results/?collection=South%20Africa%20Quilt%20History%20Project.

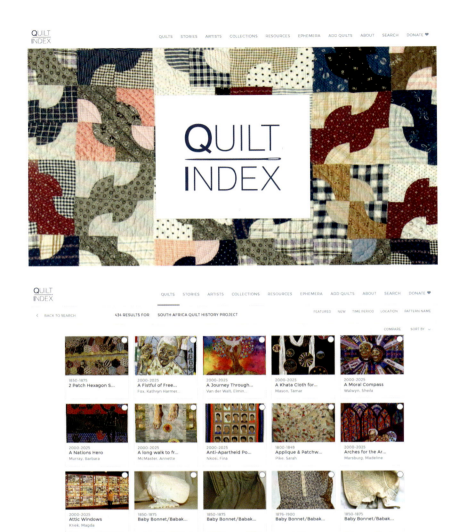

recorded."[3] Tens of thousands of quilts were documented by primarily grassroots community historians. The Quilt Index continues to add the records from these American quilt documentation projects as well as the documentation records of quilt collections held by museums and private individuals.

As quilts and quilt-related techniques can be found throughout the world, the Quilt Index project team began to develop strategies to include quilts with origins from outside the United States. Efforts were first directed to selected American museums, notably the International Quilt Museum at the University of Nebraska–Lincoln and the Michigan State University Museum, which held examples of such quilts in their collections. Subsequently records of two Canadian province-wide quilt documentation projects as well as the holdings of the TRC Leiden Museum in the Netherlands have been added, and discussions with individuals associated with Australia's National Quilt Register project and the British Quilt Heritage Project have taken place.[4] Three research projects— each consisting of collaborations of multiple individuals and institutions—have

further expanded the internationalization. These included the Black Diaspora Quilt History Project (which, in addition to African American quilts and quilt artists, focused on those in Liberia, the Egyptian makers of *khayamiya*—appliqued cloths originally made as panels for tents, and Indian-African Siddi quilt art), the quilts of Southwest China, and South African quilt history.[5]

In 2011, South African Quilters Guild partnered with the Quilt Index project team at Michigan State University to add the digital photographs and records of the guild's Heritage Quilt Search to the Quilt Index.[6] At the same time, I was conducting independent research on quilt history with a focus on visiting over twenty museum collections, attending quilt exhibitions, giving presentations at quilt guilds, and interviewing contemporary quilt artists.[7] In discussions I had with curators, artists, and cultural heritage workers, it became evident that the museums contained amazing quilt and quilted textile collections little known across South Africa, let alone around the world. I encouraged them to add their collections to the index. As of 2022, the Quilt Index holds images and records of textiles from thirteen museums, and four more are planned to be added by 2025.[8] Not only does the Quilt Index serve as a means of digitally preserving this data and making it accessible to a world audience, it simultaneously increases awareness of the existence of the museums. For instance, the inclusion of records of one South African museum in the Quilt Index has been profiled in an article published in *The Quilter*, a journal of the Quilters' Guild of the British Isles.[9] One unexpected quilt donation to a museum occurred as a result of a local news article about a museum joining the South African Quilt History Project and the Quilt Index; the No. 7 Castle Hill Museum in Port Elizabeth received a quilt that belonged to Sir Percy Fitzpatrick, world-renowned for his book *Jock of the Bushveld*, written in 1907.[10]

The records of the South African Quilters Guild's Heritage Quilt Search, the records of the quilts from South African museum collections, and the documentation from my own research is presented in the Quilt Index under the South Africa Quilt History Project. Two binational exhibition projects have also increased the inclusion of South African quilts in the Quilt Index. Both projects involved members of the US-based Women of Color Quilters Network and South African contemporary quilt artists who made quilts in tribute to Nelson Mandela for one exhibition and to Desmond and Leah Tutu for a second exhibition. The digital images and stories of the quilts created by these artists are preserved and presented in the Quilt Index.[11]

Because of the expansive definition of quilts used for including materials in the Quilt Index, the South African Quilt History materials presented in the index includes images and information about kappies (bonnets with quilted brims), which were especially important to colonial-settler history and remain part of the cultural identity of White South Africans of Boer/Dutch ancestry. Many South African museums have examples of quilts and kappies in their collections.

Through the addition of the data on South African quilts and quilted items in the Quilt Index, researchers are able to more deeply explore in-country quilting histories. They are also able to interrogate the relationship of South African quilts and quilting traditions to those in other countries (including those of settlers' origin or those with similar colonial-settlement histories), the intersections of

Indigenous materials and traditions with quilts, the interrelationships between quilts and world trade, the effect of key designers/authors on quilt styles, and the burgeoning global interest in using quilts as vehicles to champion human rights or as venues for job creation for women.[12] As Worrall observed, "The connections that can be made by viewing quilts made from different times and places are invaluable in stitching together a more comprehensive view of this material culture history and in opening doors of new arenas of inquiry for individuals around the world."[13]

Notes

1. Quilt Index, "Welcome to The Quilt Index," accessed July 28, 2024. https://quiltindex.org/about/welcome/. The author was involved in the planning and development of the index and has served as director of the project since the early 2000s.

2. Worrall, "Quilt Index: Building an International Resource" 51.

3. Worrall, "Quilt Index: Building an International Resource" 51.

4. National Quilt Register, "About"; National Archives, "British Quilt Heritage Project Records."

5. The Black Diaspora Quilt History Project was funded by a major grant from the National Endowment for the Humanities (2022–24).

6. Quilt Index, "South Africa Quilt History Project."

7. A portion of this research was underwritten by a fellowship awarded by the International Quilt Study Center/University of Nebraska–Lincoln. In-kind support was provided by Michigan State University Museum.

8. Museums whose collections are already in the index are the Albany Museum (Grahamstown), Amathole Museum (Amathole), Durban Local History Museum (Durban), East London Museum, Great Fish River Museum, Hout Bay Museum, Macrorie House Museum (Pietermaritzburg), McGregor Museum (Bloemfontein), Msunduzi Museum (Pietermaritzburg), National Museum Bloemfontein (Bloemfontein), No. 7 Castle Hill Museum (Port Elizabeth), Transvaal Museum Services, and the War Museum of the Boer Republics (Bloemfontein). The collections of the Ditsong Museum (Pretoria), Iziko Museums (Cape Town), Museum Africa (Johannesburg), and Drostdy Museum (Swellendam) will be added by 2024.

9. Thomson, "Traditional Quilts in South Africa," 20–21.

10. See Fitzpatrick Quilt, maker not recorded, 1901–1929, from South Africa Quilt History Project (SAQHP), No. 7 Castle Hill Museum, published in the Quilt Index, accessed January 2, 2017, http://www.quiltindex.org/fulldisplay.php?kid=59-9A-3.

11. MacDowell and Mazloomi, *Conscience of the Spirit*; MacDowell and Brown, *Ubuntutu: Life Legacies of Love and Action*. Quilts included in the *Conscience of the Spirit* exhibition can be seen in the Quilt Index at https://quiltindex.org/view/?type=exhibits&kid=50-147-1. Those included in *Ubuntutu* can be seen in the Quilt Index at https://quiltindex.org/view/?type=exhibits&kid=50-147-2.

12. "Quilt Index: Collaborative Planning for Internationalization," grant application, p. 4.

13. The overall South Africa Quilt History Project (SAQHP) was initiated by Marsha MacDowell. Marline Turner provided support for the inclusion of the records of the South African Quilters Guild's Heritage Quilt Search. Mary Worrall, Justine Richardson, and Beth Donaldson assisted in the presentation in the Quilt Index of data collected as part of the SAQHP.

BIBLIOGRAPHY

Websites

AIDS Memorial. "About." National Aids Memorial website. Accessed July 28, 2024. https://www.aidsmemorial.org/about.

———. "AIDS Memorial Quilt." Accessed July 30, 2024. https://www.aidsmemorial.org/quilt.

———. "AIDS Quilt Touch." Accessed July 30, 2024. https://www.aidsmemorial.org/interactive-aids-quilt.

———. "Search the AIDS Memorial Quilt." Accessed July 28, 2024. https://www.aidsmemorial.org/interactive-aids-quilt.

———. "South Africa." Accessed March 12, 2022. https://aidsmemorial.info/memorials/set=country/id=15/south_africa.html.

Amazwi Abesifazane. "Reclaiming Heritage: A Living Archive." Accessed April 4, 2020. https://www.amazwi-voicesofwomen.com/archives.

Amazwi Abesifazane—Voices of Women. Accessed April 4, 2020. https://www.amazwi-voicesofwomen.com/.

Anglo-Boer War Museum. "Introduction to the Museum." Accessed August 14, 2024. https://wmbr.org.za/about-the-war-museum/.

Artivism. "Intuthuko Embroidery Project." Accessed March 20, 2022. https://www.artivismexhibition.com/intuthuko-embroidery-project.html.

Baratta, Elisabeth. LinkedIn profile. Accessed March 30, 2022. https://www.linkedin.com/in/wwwquiltsafariscom/?originalSubdomain=za.

Bushmen Heritage Museum. Accessed February 1, 2022. https://bushmanheritagemuseum.org/.

Etsy. "Elisabeth Baratta." https://www.etsy.com/ca/people/MzansiZuluQuiltCenter. Accessed March 30, 2022.

———. "Mzansi Zulu Quilt Center." Accessed March 30, 2022. https://www.etsy.com/ca/people/MzansiZuluQuiltCenter.

Fibreworks Art. "A Celebration of South African Fiber and Textile Artists." Accessed June 24, 2008. http://www.fibreworksart.com/Garratt.html.

———. "Homepage." Accessed January 25, 2022. http://www.fibreworksart.com/.

Flickr. "Unpacking Collections: The Legacy of Quilt Scholar Cuesta Benberry." Accessed March 10, 2022. https://www.flickr.com/photos/msumuseum/albums/72157701010320045.

Geelong Heritage Collections. "Harry Walter Wilton's Quilt." Accessed March 5, 2022. https://www.geelongheritagecollections.com.au/item/harry-walter-wiltons-quilt/.

Goldi Productions. "Mystery Canadian Boer War Quilt—1900." Great Canadian Heritage Discoveries. Accessed March 15, 2022. http://www.goldiproductions.com/angloboerwarmuseum/Boer4f_fabric_quilt_glencoe.html.

Good Hope Quilters' Guild. "Swellendam Drostdy Museum." http://www.goodhopequiltersguild.org.za/swellendam-drostdy-museum-5.

Google Image Search. "Namakwaland kappie." Accessed March 15, 2022. https://www.google.com/search?q=Namakwaland+kappie&source=lnms&tbm=isch&sa=X&ved=2ahUKEwijnsa8--H2AhXsSjABHX2NBOAQ_AU0Ano ECAEQBA&biw=1583&bih=871&dpr=2.

"Great Trek, 1835–1846." *South Africa History Online.* Accessed July 27, 2024. https://www.sahistory.org.za/article/great-trek-1835-1846#:~:text=The%20 Great%20Trek%20was%20a,homeland%2C%20independent%20of%20British %20rule.

Keiskamma. "About Us." http://www.keiskamma.org/about-us/. Accessed March 30, 2022.

Litnet. "Die Suid-Afrikaanse ikoon met die pienk Namakwalandse kappie." Last modified April 16, 2014. https://www.litnet.co.za/die-suid-afrikaanse-ikoon-met-die-pienk-namakwalandse-kappie.

Merriam-Webster Dictionary. s.v. "kappie." Origin and Etymology. Accessed June 28, 2017. https://www.merriam-webster.com/dictionary/kappie.

National Archives. "British Quilt Heritage Project Records." Quilters' Guild Collection. Accessed January 24, 2023. https://discovery.nationalarchives.gov.uk/details/r/5c79b8da-f7f9-4b8a-aeda-beec118efd7b.

National Fibreworks Exhibition: EDGE. Twentieth Anniversary of South African Fibreworks. KZNSA Gallery. October 9, 2018–November 3, 2018. https://www.kznsagallery.co.za/Exhibitions/View/941/edge.

National Quilt Register. "About." Accessed January 24, 2022. https://www.nationalquiltregister.org.au/about/.

Nelson Mandela Foundation. "Uniting for a Better World," July 31, 2007. Accessed August 14, 2024. https://www.nelsonmandela.org/news/entry/uniting-for-a-better-world.

Planet Patchwork. "Quilting in South Africa." Accessed June 24, 2008. http://www.planetpatchwork.com/safrica.htm.

Presidential Shirt. "Our Story." Accessed July 30, 2024. https://presidentialshirt.com/our-story/.

———. "The Presidential Shirt Story." Accessed June 24, 2008. http://www.presidentialshirt.co.za/shop/default.asp.

———. "Shop Content." Accessed September 10, 2008. http://www.presidentialshirt.co.za/shop/shopcontent.asp?type=thequiltstory.

Quilt Index. "Boer War Quilt." Accessed July 30, 2024. https://quiltindex.org/view/?type=fullrec&kid=12-8-6633.

———. "Hexagon Stars." Record no. 31-27-27. Completed 1879. South Africa Quilt History Project. Accessed May 10, 2020. http://www.quiltindex.org/fulldisplay.php?kid=59-9A-11A.

———. "South Africa Quilt History Project." Accessed July 30, 2024. https://quiltindex.org/view/?type=docprojects&kid=31-81-1.

———. "Welcome to The Quilt Index." Accessed July 28, 2024. https://quiltindex.org/about/welcome/.

SARAO. "About the SKA." Accessed July 28, 2024. https://www.sarao.ac.za/about/ska/.

Ska Observatory. "The Origin of Darkness and the Moon." *Contact*, no. 4 (June 4, 2020). https://issuu.com/ska_telescope/docs/contact_-_issue_04/s/10614588.

Smithsonian Institution National Museum of American History. "The National Quilt Collection." Accessed March 15, 2022. https://americanhistory.si.edu/collections/object-groups/national-quilt-collection.

South African Quilters' Guild. "Community Projects." Accessed March 1, 2022. https://www.quiltsouthafrica.co.za/community-projects.

———. "Country Groups." Accessed July 27, 2024. https://www.quiltsouthafrica.co.za/the-south-african-quilters-country-groups.

———. "Golden West Quilters Guild, Outreach Day." Accessed January 30, 2022. https://www.quiltsouthafrica.co.za/12-53-golden-west-quilters-guild.

———. "History—Quilting in South Africa." Accessed March 30, 2022. https://www.quiltsouthafrica.co.za/9-79-history-of-quilting-in-south-africa.

———. "Master Quilters." Accessed July 27, 2024. https://www.quiltsouthafrica.co.za/master_quilters.

———. "Pro Dedicate Award." Accessed July 27, 2024. https://www.quiltsouthafrica.co.za/pro-dedicate.

———. "Quilters Hall of Fame." Accessed July 27, 2024. https://www.quiltsouthafrica.co.za/quilters-hall-of-fame.

———. "Regional Guilds." Accessed July 27, 2024. https://www.quiltsouthafrica.co.za/the-south-african-quilters-regional-guilds.

———. "SAQG Accredited Quilt Teachers." Accessed July 27, 2024. https://www.quiltsouthafrica.co.za/saqg-accredited-quilt-teachers.

———. "The Sharpeville Memorial Quilt." Accessed May 20, 2020. https://www.quiltsouthafrica.co.za/12-46-the-sharpeville-memorial-quilt.

———. "South African Quilters' Guild." Accessed March 30, 2022. http://www.quiltsouthafrica.co.za/.

Stellenbosch Triennale. "Triennale 2020—Imagining a Future." Accessed March 2, 2022. https://stellenboschtriennale.com/triennale-2020-imagining-a-new-future/.

Storycloth Database. "Resources." Accessed March 1, 2020. http://www.storyclothdatabase.org/resources.html.

Tambani. "About Tambani." Accessed March 30, 2022. https://tambani.co.za/about-tambani/.

Tolksdorf, Odette. "Africa Design Sources." Accessed June 1, 2020. http://www.odettetolksdorf.co.za/africa-design-sources.html.

WikiTree. "Sara Christina (Dreÿer) Munnik (1768–1850)." Accessed May 20, 2020. https://www.wikitree.com/wiki/Dre%C3%BFer-634.

Wixsite. "Bert Pauw." Accessed June 22, 2023. https://pauwbert1.wixsite.com/bert-pauw.

Unpublished Documents

Benberry, Cuesta. *To Zamani*. Typescript document. Cuesta Benberry African American Quilts and Quilt History Research Collection, Michigan State University Museum.

Bimsom, M. Boer War Quilt, 1900. Collection acquisition records, Michigan State University Museum.

Botha, Andries. "Amazwi Abesifazana." Unpublished and undated project history document given to Marsha MacDowell by Janine Zagel, project manager, Voices of Women, 2003.

Burden, Matilda. "Beds at the Cape in the Old Cape Furniture Period." Unpublished manuscript. South African Quilt Research Collection, Michigan State University Museum, 2019.

"Fabulous Fibres!" Unpublished document. Collection of Jeanette Gilks.

Fitzpatrick Quilt. Maker not recorded, 1901–29. South Africa Quilt History Project. No. 7. Castle Hill Museum.

Harris, Carole. Artist statement. Michigan Traditional Arts Research Collection files. Michigan State University Museum.

Hlomuka, Maria. "Zamani." Typescript document. Cuesta Benberry African American Quilts and Quilt History Research Collection, Michigan State University Museum.

Ilingelihle. Brochure. Acquisition files, Michigan State University Museum.

MacDowell, Marsha. "Materializing Mandela's Legacy: Textiles of Activism, Honor, Celebration, and Memory." Unpublished paper. Presented at the Ninetieth Anniversary of Nelson Mandela Colloquium. Critical Reflections on the Legacy of Nelson Mandela: Tracing the Making and Meaning of Liberation Struggles in African Museums and Heritage. Miriam Makeba Auditorium, University of Fort Hare Campus, East London, South Africa, September 24–27, 2008.

Moore, Kathleen L. "Availability of African/S. African Textiles & Quilts: An Annotated Bibliography." Unpublished manuscript prepared for the International Quilt Study Center, University of Nebraska–Lincoln, June 26, 2007.

Msibi, Cynthia. Artist statement. Document files, Michigan State University Museum, 2010.

Pristorius, Ronel. Typescript paper prepared for 2021 South African National Quilt Festival. Collection of Marsha MacDowell.

Soni-Abed, Zaitoonisa. The Grand Quilt—A SA Foundation for Islamic Art World First, 2022. Typescript document. Given by Soni-Abed to Marsha MacDowell, 2022.

Vest, Hilda. Michigan Quilt Project Inventory Form. January 3, 2007. Michigan State University Museum Research Collections.

White, Beverly. Michigan Quilt Project Inventory Form 93.119, Michigan State University Museum Research Collections.

Zamani Soweto Sisters Council Case Statement. Unpublished document. Cuesta Benberry African American Quilts and Quilt History Research Collection, Michigan State University Museum.

Interviews and Correspondences

Areington, Zohra K. Personal communication with Marsha MacDowell. Johannesburg, South Africa. August 26, 2015.

August, Winnie. Email communication with Marsha MacDowell. January 22, 2020.

Balfour-Paul, Jenny. Personal communication with Juliette Leeb-du Toit. 2016.

Baratta, Elisabeth. Interview by Marsha MacDowell. Merrivale, Kwa-Zulu Natal, South Africa. March 8, 2011.

Beaumont, Helga. Interview by Marsha MacDowell. Durban, South Africa, March 3, 2011.

Bebeza, Nomawethu. Copy of handwritten text attached to textile. Collection of Marsha MacDowell.

Berman, Kim. Interview by Marsha MacDowell. Johannesburg, South Africa, February 22, 2011.

Carrelsen, Anne Marie. Interview by Marsha MacDowell. Pretoria, South Africa, February 22, 2011.

Chaveas, Lucille. Personal communication with Marsha MacDowell, March 11, 2009.

Dace, Rosalie. Interview by Marsha MacDowell. Durban, South Africa. March 3, 2011, and March 12, 2011.

Danais, Florence, and Carol Hofmeyr. Interview by Brenda Schmahmann. Hamburg, South Africa. September 15, 2014.

De Villiers, Cecilia. Interview by Marsha MacDowell. Pretoria, South Africa. February 17, 2011.

DeWet, Sandra. Interview by Marsha MacDowell. Johannesburg, South Africa. February 21, 2011.

Faulds, Jutta. Interview by Marsha MacDowell. Durban, South Africa. March 7, 2011.

Garret, Margie. Interview by Marsha MacDowell. Constantia, South Africa. July 7, 2009, and March 7, 2011.

Gedze, Nokuphiwa. Interview by Brenda Schmahmann. Hamburg, South Africa. September 15, 2014.

Gilks, Jeanette. Interview by Marsha MacDowell. Hillcrest, Kwa-Zulu Natal, South Africa, March 2011.

Havenga, Wilma. Email to Marsha MacDowell. April 26, 2020.

Hearn, Jenny. Interview by Marsha MacDowell. Johannesburg, South Africa, September 7, 2013.

Hlomuka, Maria Chinky. Letter to Cuesta Benberry, November 18, 1985. Cuesta Benberry African American Quilts and Quilt History Research Collection, Michigan State University Museum.

Hogan, Barbara. Interview by Marsha MacDowell. Johannesburg, South Africa. December 9, 2007.

Johnson, Carool. Interview by Marsha MacDowell. Swellendam, South Africa. March 10, 2010.

Kruger, Elsa. Communication with Miems Lamprecht. Kammieskroon, Northern Cape.

Le Roux, Ina. Interview by Marsha MacDowell. Parkhurst, South Africa. March 3, 2011.

MacMurray, Moira. Interview by Marsha MacDowell. Parkview, South Africa, April 3, 2011.

Makubalo, Nozeti. Interview by Brenda Schmahmann. Hamburg, South Africa. September 16, 2014.

Malherbe, Leonie. Interview by Marsha MacDowell. Durban, South Africa, March 7, 2011.

Mazloomi, Carolyn. Personal communication with Marsha MacDowell. August 2008.

McMaster, Annette. Interview by Marsha MacDowell. Pietermaritzburg, South Africa. March 7, 2011

Mgidi, Betty. Interview by Marsha MacDowell. Johannesburg, South Africa. February 24, 2011.

Miller, Gwenneth. Interview by Marsha MacDowell. Pretoria, South Africa, February 17, 2011.

Mosoka, Agnes. Interview by Marsha MacDowell. Soweto, South Africa, June 19, 2007.

Mukutu, Namukolo. Interview by Marsha MacDowell. Johannesburg, South Africa, 2011.

Nash, Desré Buirski. Interview by Marsha MacDowell. Cape Town, February 7, 2011.

Nettleton, Anitra. Personal communication with Marsha MacDowell. Johannesburg, South Africa, November 20, 2019.

Nkosi, Fina. Interviews by Marsha MacDowell and C. Kurt Dewhurst. Soweto, South Africa. September 5, 2013. Johannesburg, South Africa. February 27, 2014; March 13, 2014.

Parker, Pat. Interview by Marsha MacDowell. Benmore, South Africa. February 22, 2011.

Ramdhani, Narissa. Personal communication with Marsha MacDowell. November 20, 2008.

Sachs, Albie. Conversation with Marsha MacDowell. Clifton, South Africa. February 16, 2019.

Sera, Maria. Interview by Marsha MacDowell and C. Kurt Dewhurst. Soweto, South Africa. June 17, 2007, and August 2, 2012.

Schmahmann, Brenda. Interview by Marsha MacDowell. Grahamstown, South Africa. February 10, 2011.

Scott, Sally. Interview by Marsha MacDowell. Grahamstown, South Africa. February 10. 2011.

Smith, Margie. Interview by Marsha MacDowell. Grahamstown, South Africa, February 16, 2011.

Soni-Abed, Zaitoonisa. Interview by Marsha MacDowell. Wynberg, South Africa. March 10, 2023.

Starke, Roy. Interview by Marsha MacDowell. Pretoria, South Africa. February 24, 2011.

Tolksdorf, Odette. Interview by Marsha MacDowell. Durban, South Africa. February 12, 2011, March 3, 2011, and March 13, 2011.

Turner, Marline. Interview by Marsha MacDowell. Pietmaritzburg, South Africa. March 8, 2011.

Vest, Hilda. "Quilts and Human Rights, Hilda Vest." Interview by Marsha MacDowell. Michigan State University Museum, January 21, 2008. YouTube. http:www.youtube.com/watch?v=uhG3S00eJRM.

Viles, Hester. Interview by Marsha MacDowell. Johannesburg, South Africa. July 24, 2014.

Viljoen, Enid. Interview by Marsha MacDowell. Pretoria, South Africa. February 24, 2011.

Walwyn, Sheila. Multiple interviews by Marsha MacDowell, July 2009–2024.

White, Beverly. "Quilts and Human Rights, Beverly Ann White." Interview by Marsha MacDowell. Michigan State University Museum, January 21, 2008. YouTube. http:www.youtube.com/v=4L7Eefjr2ts&feature=related.

Williamson, Jenny. Interview by Marsha MacDowell. Benmore, South Africa. February 22, 2011.

Zulu, Vangile. Interview by Marsha MacDowell. Soweto, South Africa. September 5, 2013.

References

Allen, Rika. "Art Activism in South Africa and the Ethics of Representation in a Time of AIDS." *Critical Arts* 23, no. 3 (2009): 396–415. DOI: 10.1080/02560040903251209.

Allinder, Sara A., and Janet Fleischman. "The World's Largest HIV Epidemic in Crisis: HIV in South Africa." Center for Strategic and International Studies, Washington, DC. April 2, 2019. https://www.csis.org/analysis/worlds-largest-hiv-epidemic-crisis-hiv-south-africa.

Amsden, Deirdre. "Cuesta Benberry." *Quilters' Guild Newsletter* 27 (Summer 1986): 9. Cuesta Benberry African American Quilts and Quilt History Research Collection, Michigan State University Museum.

———. "My Trip to Soweto." *Canada Quilts* (September 1985): 8. Cuesta Benberry African American Quilts and Quilt History Research Collection, Michigan State University Museum.

———. "My Trip to Soweto." *Canada Quilts* (November 1985): 2. Cuesta Benberry African American Quilts and Quilt History Research Collection, Michigan State University Museum.

———. "My Visit to the Zamani Soweto Sisters." *Quilters' Guild Newsletter*, Spring 1982 issue. Deirdre Amsden Collection/Cuesta Benberry African American Quilt and Quilt History Research Collection, Michigan State University Museum.

———. "Quiltmaking around the World: South Africa." *Quilter's Newsletter Magazine* 145 (September 1982): 28, 38. Cuesta Benberry African American Quilts and Quilt History Research Collection, Michigan State University Museum.

Appadurai, Arjun, ed. *The Social Life of Things: Commodities in Cultural Perspective*. Cambridge: Cambridge University Press, 1986.

Arnold, Marion. *Women and Art in South Africa*. New York: St. Martin's Press, 1996.

Arnold, Marion, and Brenda Schmahmann, eds. *Between Union and Liberation: Women Artists in South Africa 1910–1994*. Burlington, VT: Ashgate Publishing Company, 2005.

ATKV-DAMES. Exhibition Catalog. Voortrekker Monument. Randburg, South Africa, 2000.

Backwell, Lucinda, Francesco d'Errico, and Lyn Wadley. "Middle Stone Age Bone Tools from the Howiesons Poort Layers, Sibudu Cave, South Africa." *Journal of Archaeological Science* 35, no. 6 (2008): 1566–80. https://doi.org/10.1016/j.jas.2007.11.006.

Ball, Maggie. "South African Quilt Festival #7, Heritage Quilt." *Dragonfly Quilts* (blog), February 28, 2014. http://www.dragonflyquilts.com/weblog/?p=1010.

Baratta, Elisabeth. "The First African Quilting Guild in South African [*sic*]." Rotary Quilts. Accessed February 12, 2009. http://www.rotaryquilts.org/project/Africa_Hilton_Howick.htm.

Barber, Elizabeth. *Women's Work: The First 20,000 Years: Women, Cloth, and Society in Early Times*. New York: W. W. Norton, 1994.

Barrow, John. *Travels into the Interior of Southern Africa*. Vol. 1. London: T. Cadell and W. Davies, 1806.

Becker, Carol. "Amazwi Abesifazane (Voices of Women)." *Art Journal* 63, no. 4 (2004): 116–34.

———. "Amazwi Abesifazane: Voices of Women." In *The Object of Labor: Art, Cloth, and Cultural Production*, edited by Joan Livingstone and John Ploof, 113–30. Chicago: School of the Art Institute of Chicago Press, 2007.

Becker, Rayda. "Southern African." In *The Art of African Textiles: Technology, Tradition, and Lurex*, edited by John Picton, 116–34. London: Barbicon Art Gallery, Lund Humphries Publishers, 1995.

Bedford, Emma. *A Decade of Democracy: South African Art, 1994–2004*. Cape Town: Double Storey Books in collaboration with Iziko Museums of Cape Town, 2004.

Berman, Kim S. *Finding Voice: A Visual Arts Approach to Engaging Social Change*. Ann Arbor: University of Michigan Press, 2017.

Berman, Kim, and Jane Hassinger. *Women on Purpose: Resilience and Creativity of the Founding Women of Phumani Paper*. Johannesburg: DeskLink Media in association with the University of Johannesburg, 2012.

Bijoux, Coral. *There Is No Silence Here*. Excerpt from curatorial statement. Virtual exhibition, 2021. https://artspaces.kunstmatrix.com/en/exhibition/5591271/there-is-no-silence-here.

Black, Bonnie Lee. *How to Make an African Quilt: The Story of the Patchwork Project of Ségou, Mali*. Taos, NM: Nighthawk Press, 2013.

Bleek, Dorothea. *Comparative Vocabularies of Bushman Languages*. Cape Town: University of Cape Town School of African Studies Publications, 1929.

Blum, Annette. "Amazwi Abesifazane and Mapula: Alternative Spaces of Narrative, Disclosure and Empowerment in Post-apartheid South Africa." In *Ethnographic Worldviews*, edited by Robert E. Rinehart, Karen N. Barbour, and Clive Pope, 21–38. Dordrecht: Springer, 2014.

Bourgault, Louise M. *The South African AIDS Memorial Quilt Project: An Evaluation of Phase One*. Pretoria, South Africa: Beyond Awareness Campaign HIV/AIDS and STD Directorate, Department of Health, 1999.

Brackman, Barbara. *Encyclopedia of Pieced Quilt Patterns*. Paducah, KY: American Quilter's Society, 1993.

Briedenhann, Myra. "The Van Schouwenburg Quilt." *CULNA Magazine of the National Museum* 48 (April 1995): 37.

Brink, Elsabé. "The 'Volksmoeder'—A Figurine as Figurehead." In *Reshaping Remembrance: Critical Essays on Afrikaans Places of Memory*, edited by Albert Grundlingh and Siegfried Huigen, 5–14. Amsterdam: Rozenberg, 2011.

Brink, Yvonne. *They Came to Stay: Discovering Meaning in the 18th Century Cape Country Dwelling*. Stellenbosch: African Sun Media, 2008.

Buirski, Desré. *Mandela's Shirts and Me: The Story of the Creation of a Global Icon*. Cape Town: Presidential Shirt, 2010.

———. *A President, My Path, and The Patchwork: The Captivating Story of the Iconic Presidential Shirt*. Cape Town: Presidential Shirt, 2010.

Burchell, William. *Travels in the Interior of Southern Africa*. 2 vols. London: Longman, Hurst, Rees, Orme, Brown, and Green, 1882–24.

Burden, Matilda. *Old Cape Furniture: Studies in Styles*. English version. Stellenbosch, South Africa: Privately published, 2015.

Butler, Eliza. "Reminiscences of Cradock." Rhodes University Cory Library for Historical Research 14,680.2 (TS), Grahamstown, South Africa, 2003.

Botha, Andries. "Amazwi Abesifazane: Reclaiming the Emotional and Public Self." In *The Object of Labor: Art, Cloth, and Cultural Production*, edited by Joan Livingstone and John Ploof, 131–42. Chicago: School of the Art Institute of Chicago Press, 2007.

Broude, Norma, and Mary D. Garrard, eds. *Feminism and Art History: Questioning the Litany*. New York: Harper and Row, 1982.

Caley, Marian A. N. "Finding Healing and Creating Cultural Identities through Textiles: On the Power of Precolonial Aawambo Attire and Traditional Nama Patchwork Practice." Lecture abstract, December 15, 2022. Academy of Fine Arts

Vienna. https://www.akbild.ac.at/en/institutes/education-in-the-arts/events/lectures-events/2022/finding-healing-and-creating-cultural-identities-through-textiles-on-the-power-of-precolonial-aawambo-attire-and-traditional-nama-patchwork-practice.

———. "A Study of Vakwangali Traditional Clothing for Fashion Creation in Namibia." Master's thesis, University of Namibia, 2022.

Campschreur, Willem, and Joost Divendal, eds. *Culture in Another South Africa*. London: Zed Books, 1989.

Chapman, Laura. "Late Bloomer: Quilting Isn't Prevalent in Many African Countries, but the Craft Is Gaining Popularity Quickly." In *Deep: Fabric as Narrative: Constructing a Global Quilting Tradition*, edited by Nancy Anderson and Charlyne Berens, 40–44. Lincoln: University of Nebraska–Lincoln, College of Journalism and Mass Communications, 2008.

Chaveas, Lucille M. "Quilted Links? South African Kappies and French Boutis." *Quilt Journal* 4, no 1 (1995): 20–26.

———. "A Study of the Quilted and Corded 'Kappies' of the Voortrekker Women and Their Resemblance to French White Work Quilting of the 17th and 18th Centuries." *Navorsinge van die Nasionale Museum Bloemfontein* 9, no. 1 (1993): 2–5.

Christopherson, Katy. "Appendices: State Quilt Project Data." In *Gatherings: America's Quilt Heritage*, edited by Kathlyn F. Sullivan, 212–15. Paducah, KY: Museum of the American Quilter's Society, 1995.

Cloete, Kim. "Science, Art Converge in SKA Exhibition." *Engineering News*, September 30, 2014. Accessed February 10, 2022. https://www.engineeringnews.co.za/article/science-art-convergei-n-the-ska-exhibition-2014-09-30.

Cloete, Stuart. *Rags of Glory*. New York: Doubleday, 1963.

Coetsee, Elbé. *Craft Art in South Africa*. Cape Town: Struik Publishing, 2002.

Colchester, Chloë, ed. *Clothing the Pacific*. Oxford: Berg, 2003.

Cole, Desmond T. *Setswana—Animals and Plants*. Gaborone: Botswana Society, 1995.

Comaroff, John, and Jean Comaroff. *Of Revelation and Revolution: The Dialectics of Modernity on a South African Frontier*. Vol. 2. Chicago: Chicago University Press, 1997.

Common Threads Project. "Sew to Speak: Narrative Textiles in Human Rights and Healing Practices." Conference Report. Webster University, Geneva, Switzerland, September 12–14, 2014. https://commonthreadsproject.org/sew-to-speak-story-cloths-in-human-rights-and-healing-practices.

Cooke, Ariel Zeitlin, and Marsha MacDowell. *Weavings of War: Fabric of Memory*. East Lansing: Michigan State University Museum in collaboration with City Lore and Vermont Folklife Center, 2005.

Coombes, Annie E. "Positive Living: Visual Activism and Art in HIV/AIDS Rights Campaigns." *Journal of Southern African Studies* 1, no. 45 (2009): 143–74. DOI: 10.1080/03057070.2019.1567161.

———. *Reinventing Africa: Museums, Material Culture and Popular Imagination*. New Haven, CT: Yale University Press, 1994.

———. *Visual Culture and Public Memory in a Democratic South Africa: History after Apartheid*. Durham, NC: Duke University Press, 2003.

Couzyn, Jeni. "/Xam Quilt Tells the Story of One Earth." *Safcei*, March 26, 2015. https://safcei.org/xam-quilt-tells-the-story-of-one-earth/.

Crill, Rosemary. 2019. "A Revolution in the Bedroom: Chintz Interiors in the West." In *Cloth That Changed the World: The Art and Fashion of Indian Chintz*, edited by Sarah Fee, 107–35. New Haven, CT: Yale University Press.

De Flacourt, Etienne. *Dictionnaire de la Langue de Madagascar, etc.* Paris: Josse, 1658.

de Greef, Erica. "The IsiShweshwe Story: Material Women?" *Textile History* 47, no. 1: 124–28.

de Harde, Laura. "Objects on Life-Support: Items on Pallets and Bundles in Cupboards." In *Inherited Obsessions: Conversations with an Exhibition*, edited by Laura de Harde, 87–99. Pretoria, South Africa: ESI Press, 2022.

Dennell, Robin. "Needles and Spear-Throwers." *Natural History* 90, no. 10 (October 1986): 70–78.

De Oude Molen Gilde (The Old Mill Guild). Booklet. South Africa Quilt Collection document files, Michigan State University Museum.

"Desmond Tutu Blesses Panel from AIDS Quilt Returning to Washington." Press release, United States Embassy and Consulates in South Africa, June 22, 2012. https://za.usembassy.gov/desmond-tutu-blesses-panel-from-aids-quilt-returning-to-washington/.

Dias Quilters' Guild Presents Friendship National Quilt Show. Exhibition catalog. Port Elizabeth, 1998.

Die Suid-Afrikaanse kwiltersgilde. *Laslap en kwilt: Inspirasie uit die verlede.* Pretoria, South Africa: LAPA Publishers, 2013.

Dingaan, Mamokete, and Pieter Preez. "Vachellia (Acacia) Karroo Communities in South Africa: An Overview." In *Pure and Applied Biogeography*, edited by Levente Hufnagel, 109–41. London: IntechOpen, 2017. 10.5772/intechopen.70456.

Donnell, Radka. "Out of Silence: Contemporary Quilts." *Gallerie Women Artists: Contemporary Quilts.* Edited by Caffyn Kelley. Special Issue, no. 9 (1990): 19–21.

Dubin, Steven C. *Transforming Museums: Mounting Queen Victoria in a Democratic South Africa.* New York: Palgrave Macmillan, 2006.

Due-South: Travel Guide to South African Craft Sites. Erasmuskloof, South Africa: Eskom Due-South Craft Route Project, 2006.

du Plessis, Menán. *Kora: A Lost Khoisan Language of the Early Cape and the Gariep.* Pretoria, South Africa: Unisa Press, 2018.

Eddy, Celia. *Quilted Planet: A Sourcebook of Quilts from around the World.* New York: Clarkson Potter, 2005.

Edwards, Elizabeth, Chris Gosden, and Ruth B. Philips. *Sensible Objects: Colonialism, Museums, and Material Culture.* Oxford: Berg, 2006.

Elinor, Gillian, Sue Richardson, Sue Scott, Angharad Thomas, and Kate Walker, eds. *Women and Craft.* London: Virago Press, 1987.

Engelbrecht, Jan A. *The Korana.* Cape Town: Maskew Miller, 1936.

England, Kaye, and Mary Elizabeth Johnson. *Quilt Inspirations from Africa: A Caravan of Ideas, Patterns, Motifs, and Techniques.* Chicago: Quilt Digest Press, 2000.

Farwell, Byron. *The Great Anglo-Boer War.* New York: Harper and Row, 1976.

Fee, Sarah. "The Flowering Family Tree of Indian Chintz: Regional Textile and Dress Arts." In *Cloth That Changed the World: The Art and Fashion of Indian Chintz*, edited by Sarah Fee, 166. New Haven: Yale University Press, 2019.

Ferrero, Pat, Elaine Hedges, and Julie Silber. *Hearts and Hands: Women, Quilts, and American Society.* Nashville, TN: Rutledge Hill Press, 1984.

Fibreworks: Major Minors. South African Fibreworks Exhibition. Exhibition catalog. 2005.

Fibreworks: Major Minors II. South African Fibreworks Exhibition. Exhibition catalog. 2005.

Fibreworks: Major Minors III. South African Fibreworks Exhibition. Exhibition catalog. 2005.

Fibreworks: Major Minors IV. South African Fibreworks Exhibition. Exhibition catalog. 2005.

FNB [First National Bank]. *VITA Craft NOW 2000*. Johannesburg: National Crafts Council of South Africa.

Fourie, Maretha. *Protea Designs for Piecing and Quilting*. Cape Town: Tafelberg, 1984.

Franger, Gaby, and Geetha Varadarajan, eds. *The Art of Survival: Fabric Images of Women's Daily Lives*. Madras, India: Tara, 1996.

Gardner, Brian. *The African Dream*. New York: G. P. Putnam's Sons, 1970.

Gerald, Pamela Fitz. *Warm Heritage: Old Patchwork Quilts and Coverlets in New Zealand and the Women Who Made Them*. Auckland, New Zealand: David Bateman, 2003.

Gerdes, Paulus. *Women, Art, and Geometry in Southern Africa*. Trenton, NJ: African World Press, 1998.

German, Sandra K. "Surfacing: The Inevitable Rise of the Women of Color Quilters Network." In *Uncoverings 1993: Research Papers of the American Quilt Study Group Volume 14*, edited by Lauren Horton, 137–68. San Francisco: American Quilt Study Group, 1993.

Gero, Annette. *The Fabric of Society: Australia's Quilt Heritage from Convict Times to 1960*. Sydney, Australia: Beagle Press, 2008.

———. *Wartime Quilts: Appliqués and Geometric Masterpieces from Military Fabrics*. Roseville, Australia: Beagle Press, 2015.

Gero, Annette, and Katie Somerville. *Making the Australian Quilt, 1800–1950*. Melbourne, Australia: National Gallery of Victoria, 2016.

Giblin, John, and Chris Spring. *South Africa: The Art of a Nation*. London: Thames & Hudson in collaboration with the British Museum, 2016.

Gilfoy, Peggy Stoltz. *Patterns of Life: West African Strip Weaving Traditions*. Washington, DC: Smithsonian Institution Press/National Museum of African Arts, 1987.

Gillespie, Liza. *Innovative Threads: A Decade of South African Fibre Art*. Cape Town: Innovative Threads, 2006.

Gillow, John. *African Textiles*. San Francisco: Chronicle Books, 2003.

Gilson, Pam. *Mzansi Zulu Quilt Centre*. DVD. Merrivale, South Africa.

Gloger, Jo-Ann, and Patrick Chester. *"More to a Needle Than Meets the Eye": A Brief History of Needlemaking, Past and Present*. Redditch, UK: Forge Mill Needle Museum, 1999.

Goggin, Maureen Daly. "Introduction: Threading Women." In *Women and the Material Culture of Needlework and Textiles, 1750–1950*, edited by Maureen Daly Goggin and Beth Fowkes Tobin, 1–10. Surrey, UK: Ashgate, 2009.

Goldblatt, Wendy, and Eugene Hon, eds. *FNB Vita Craft Now 1998*. Johannesburg: Craft Council of South Africa, 1998.

Golden Rand Guild for Quilters. Exhibition catalog. 2000.

Good Hope Quilters' Guild. *16th S.A. National Quilt Festival: Alive With Colour*. Exhibition catalogue. 2011.

Gordon, Beverly. *Textiles: The Whole Story*. London: Thames and Hudson, 2011.

Goue Weste Kwiltersgilde (Golden West Quilters Guild). Booklet. South Africa Quilt Collection document files, Michigan State University Museum.

Grundhauser, Eric. "Found: The World's Oldest Sewing Needle." *Atlas Obscura*. August 24, 2016. https://www.atlasobscura.com/articles/found-the-worlds-oldest-sewing-needle.

Guille, Jackie. "Southern African Textiles Today." In *The Art of African Textiles: Technology, Tradition, and Lurex*, edited by John Picton, 51–54. London: Barbicon Art Gallery, Lund Humphries, 1995.

Haacke, Wilfrid H. G., and Eliphas Eiseb. *A Khoekhoegowab Dictionary, with an English-Khoekhoegowab Index*. Windhoek, Namibia: Gamsberg Macmillan, 2002.

Hahn, Theophilus. *Die Sprache der Nama*. Leipzig, Germany: Barth, 1870.

Hanon, Raphaël, Francesco d'Errico, Lucinda Backwell, Sandrine Prat, Stéphane Péan, and Marylène Patou-Mathis. "New Evidence of Bone Tool Use by Early Pleistocene Hominins from Cooper's D, Bloubank Valley, South Africa." *Journal of Archaeological Science: Reports* 39 (2021). https://doi.org/10.1016/j.jasrep.2021.103129.

Henshilwood, Christopher S., Francesco d'Errico, Curtis W. Marean, Richard G. Milo, and Royden Yates. "An Early Bone Tool Industry from the Middle Stone Age at Blombos Cave, South Africa: Implications for the Origins of Modern Human Behaviour, Symbolism and Language." *Journal of Human Evolution* 41, no. 6 (2001): 631–78.

Heunis, Vicky, and Nico Moolman. "Heritage Quilt at the War Museum in Bloemfontein." *Stitches 'n Bears* 17 (2010): 20–22.

Horner, Lily. "A Brief History of the Sewing Needle." San Francisco School of Needlework and Design. 2018. https://sfneedleworkanddesign.org/a-brief-history-of-the-sewing-needle.

Hunter, Clare. *Threads of Life: A History of the World through the Eye of a Needle*. New York: Abrams, 2019.

Hutcheon, Linda. *A Theory of Parody: The Teachings of Twentieth-Century Art Forms*. New York: Methuen, 1985.

Innovative Threads. Exhibition catalog. Nova Constantia, South Africa, 1999.

———. Exhibition catalog. Nova Constantia, South Africa, 2000.

———. Exhibition catalog. Nova Constantia, South Africa, 2001.

———. Exhibition catalog. Nova Constantia, South Africa, 2002.

———. Exhibition catalog. Nova Constantia, South Africa, 2003.

Innovative Threads Fibre Art. Exhibition catalog. Nova Constantia, South Africa, 2005.

Innovative Threads Textile Art. Exhibition catalog. Nova Constantia, South Africa, 2004.

Jamal, Ashraf. "Bert Pauw: Country of Last Things." *Art Africa*, February 27, 2019. https://www.artafricamagazine.org/bert-pauw-byron-berry/.

Janniére, Janine Bensasson. "An Important Discovery of French Patchwork." *Magazine Antiques* 147, no. 6. (December 1995): 822–27.

Jewels of the Earth. South African Quilters' Guild Seventh National Traveling Exhibition. Exhibition catalog, 2011–2012. South Africa Quilt Collection document files. East Lansing, MI: Michigan State University Museum.

Johnson, Pearlie. "Quilting Links U.S. and Africa: A Tradition Come Full Circle." *International Review of African American Art*, 2012. http://iraaa.museum.hamptonu.edu/page/Quilting-Links-U%3ES%3E-and-Africa.

Jones, Erma Jean Johnson. "Nama Marks and Etchings: Employing Movement Analysis Techniques to Interpret the Nama Stap." PhD diss., University of London, 2009.

Josias, Anthea Patricia. "Methodologies of Engagement: Locating Archives in Post-apartheid Memory Practices." PhD diss., University of Michigan, 2013.

Journey to Freedom: Narratives. Pretoria: University of South Africa, 2007.

Kaufmann, Carol. *Patterns of Contact: Designs from the Indian Ocean World.* Cape Town: Iziko Museums of South Africa, 2014.

King, Ynestra. "The Ecology of Feminism and the Feminism of Ecology." In *Healing the Wounds: The Promise of Ecofeminism*, edited by Judith Plant, 18–28. London: New Society Publishers, 1989.

Kriel, Sandra. "Introduction to My Work." *South African Arts Calendar* 18, no. 2 (1993): 8–11.

LaGamma, Alisa, and Christine Giuntini. *The Essential Art of African Textiles: Design without End.* New Haven, CT: Yale University Press; New York: Metropolitan Museum of Art, 2008.

Lamprecht, Bettie. "Ikoniese materiaal wat geen grense ken" [Iconic material without borders]. 2013. Archived from original on January 22, 2014.

Leeb-du Toit, Juliette. *Isishweshwe: A History of the Indigenisation of Blueprint in Southern Africa.* Pietermartzburg, South Africa: University of KwaZulu-Natal Press, 2017.

———. "Southern Africa." In *Berg Encyclopedia of World Dress and Fashion: Volume on Africa*, edited by Joanne B. Eicher and Doran H. Ross, 157–63. London: Bloomsbury Publishing, 2010. DOI: 10.2752/BEWDF/EDch1084.

Levinsohn, Rhoda. *Art and Craft of Southern Africa.* Johannesburg: Delta Books, 1991.

Lichtenstein, Henry. *Travels in Southern Africa in the Years 1803, 1804, 1805, and 1806.* Translated by Anne Plumptre. London: Henry Colburn, 1812.

Limb, Peter. *The ANC's Early Years: Nation, Class and Place in South Africa before 1940.* Pretoria: Unisa Press, 2010.

Livingstone, Joan, and John Ploof, eds. *The Object of Labor: Art, Cloth, and Cultural Production.* Chicago: School of the Art Institute of Chicago Press, 2007.

Lloyd, Lucy C. "Manuscript Notebooks on !Kora." 1879. Maingard Papers in the Manuscripts Collection. Archival and Special Collections, Unisa Library. Pretoria, South Africa. Digitized versions available online at http://lloydbleekcollection.cs.uct.ac.za under the heading of "Lucy Lloyd, Kora Notebooks."

MacDowell, Marsha, ed., *African American Quiltmaking in Michigan.* East Lansing: Michigan State University Press in collaboration with Michigan State University Museum, 1997.

———. "Folk Arts." In *1999 Michigan Folklife Annual*, edited by Yvonne R. Lockwood and Marsha MacDowell, 24–29. East Lansing: Michigan State University Museum, 1999.

———. "Quilts: Unfolding Personal and Public Histories in South Africa and the United States." *Image & Text: A Journal for Design* 34, no. 1 (2020). Gale Academic OneFile. https://link.gale.com/apps/doc/A666356873/AONE?u=anon~aba1395e&sid=googleScholar&xid=a9b9e733.

———. "South African Quiltmaking: A Beginning Look, A Way Forward." Manuscript, Presentation given at The Global Quilt: Cultural Contexts. *International Quilt Study Center & Museum 4th Biennial Symposium.* April 2–4, 2009.

———. "South African Quiltmaking: Textiles in a Rainbow Nation." Paper given at "Other Views: Art History in (South) Africa and the Global South," an international symposium coordinated by the South African Visual Arts Historians under the aegis of the Comité International d'Histoire de l'Art, University of the Witwatersrand, Johannesburg, January 12–15, 2011.

———. "Textiles and Quiltmaking in a Rainbow Nation." In *Quilts Around the World: The Story of Quilting from Alabama to Zimbabwe*, edited by Spike Gillespie, 294–300. Minneapolis, MN: Voyageur Press, 2010.

MacDowell, Marsha, and Aleia Brown, eds. *Ubuntutu: Life Legacies of Love and Action*. East Lansing: Michigan State University Museum, 2016.

MacDowell, Marsha, and Marit Dewhurst. "Stitching Apartheid: Three South African Memory Cloth Artists." In *Weavings of War: Fabrics of Memory*, edited by Ariel Zeitlin Cooke and Marsha MacDowell, 77–87. East Lansing: Michigan State University Museum in collaboration with City Lore, Inc. and Vermont Folklife Center, 2005.

MacDowell, Marsha, Clare Luz, and Beth Donaldson. *Quilts and Health*. Bloomington: Indiana University Press, 2017.

MacDowell, Marsha, and Carolyn L. Mazloomi, eds. *Conscience of the Human Spirit: The Life of Nelson Mandela, Tributes by Quilt Artists from South Africa and the United States*. East Lansing: Michigan State University Museum, 2014.

MacDowell, Marsha, Mary Worrall, Lynne Swanson, and Beth Donaldson. *Quilts and Human Rights*. Lincoln: University of Nebraska Press, 2016.

Maingard, Louis F. "The Korana Dialects." *African Studies* 23, no. 2 (1964): 57–66.

———. "Studies in Korana History, Customs and Language." *Bantu Studies* 6, no. 2 (1932): 103–61.

———. "Three Bushman Languages: Part II, The Third Bushman Language." *African Studies* 17, no. 2 (1958): 100–15.

Malan, Andre, and Carelsen, Annemarie. *Kleredrag tydens die Anglo-Boereoolog 1899–1902*. Pretoria, South Africa: Protea Boekhuis, 1999.

Malan, Antonia. "Households of the Cape, 1750 to 1850: Inventories and the Archaeological Record." PhD diss., University of Cape Town, 1993.

Mandela, Nelson. *Long Walk to Freedom: The Autobiography of Nelson Mandela*. Boston: Back Bay Books, 1995.

Manier, Martha J. *Sewing Their Stories, Telling Their Lives: Embroidered Narratives from Chile to the World Stage (1969–2016)*. Arcata, CA: Humboldt State University Press, 2019.

Manning, Jenny. *Australia Quilts: A Directory of Patchwork Treasures*. Hunters Hill, Australia: AQD Press, 1999.

Maphangwa, Shonisani. "From Colonial to Post-Colonial: Shifts in Cultural Meanings in Dutch Lace and Shweshwe Fabric." MA thesis, University of Johannesburg, 2010.

Marschall, Sabine. "Positioning the 'Other' Reception and Interpretation of Contemporary Black South African Artists." In *Matatu: Journal for African Culture and Society* 25, no. 1 (2002): 55–71. DOI: 10.1163/18757421-90000419.

Martin, Anthea. 2000. "Textiles in South Africa 2000." In *FNB Vita Craft Now 2000*, edited by Wendy Goldblatt and Eugene Hon, 4–35. Johannesburg: Craft Council of South Africa, 1998.

McEwan, Cheryl. "Building a Postcolonial Archive? Gender, Collective Memory and Citizenship in Post-Apartheid South Africa." *Journal of Southern African Studies* 29, no. 3 (2003): 739–57.

Mdlolo, Florence N. *Ngiyalizwa Izwi Lomntanami: I Could Hear the Voice of My Child*. Musgrave, South Africa: Create Africa South, 2000.

Miller, Kim. "Interweaving Narratives of Art and Activism: Sandra Kriel's Heroic Women." In *African Art Interviews Narratives: Bodies of Knowledge at Work*, edited by Joanna Grabski and Carol Magee, 98–113. Bloomington: Indiana University Press, 2013.

———. "T-Shirts, Testimony and Truth: Memories of Violence Made Visible." *Textiles: A Journal of Cloth and Culture* 2, no. 3 (2005): 250–73.

Miller, Kim, and Brenda Schmahmann. "Women's Cooperatives and Self-Help Artists." In *Berg Encyclopedia of World Dress and Fashion*, edited by Joanne B. Eicher and Doran H. Ross, 533–39. Oxford: Berg, 2011. DOI: 10.2752/BEWDF/EDch1084

Mills, Elizabeth. "Art, Vulnerability and HIV in Post-Apartheid South Africa." *Journal of Southern African Studies* 45, no. 1 (2019): 175–95. DOI: 10.1080/03057070.2019.1569364.

Moletsane, Relebohile, Claudia Mitchell, and Ann Smith, eds. *Was It Something I Wore?: Dress, Identity, Materiality*. Cape Town: HSRC Press, 2012.

Moodie, Donald, ed. *The Record*. Translated by Donald Moodie. Cape Town: A. S. Robertson, 1838.

Moolman, Nico, and Vicky Heunis. *Die Groot Kwilt*. Vanderbijlpark, South Africa: Coral Publishers, 2010.

———. *Karren-Melk vir Ta'Nonnie*. Vanderbijlpark, South Africa: Coral Publishers, 2015.

Morgan, Jonathan. *Long Life . . . Positive HIV Stories*. North Melbourne, Australia: Spinifex Press, 2003.

Mossop, Ernest Edward, ed. *The Journal of Hendrik Jacob Wikar (1779)*. Translated by A. W. van der Horst. Cape Town: Van Riebeeck Society, 1935.

Mothetho, Eunice, Susan Sellschop, and Wendy Goldblatt. *Craft South Africa: Information Directory*. Pretoria: Department of Arts, Culture Science, and Technology, 2001.

Mvunabandi, Schadrack. "The Communicative Power of Blood Sacrifices: A Predominately South African Perspective with Special Reference to the Epistle to the Hebrews." PhD diss., University of Pretoria, South Africa, 2008.

Namibian. "Keeping Culture Alive Through Fashion." July 5, 2019. Updated October 4, 2022.

National Quilt Festival Kaleidoscope. The 17th South African National Quilt Festival. Catalog. Bloemfontein, South Africa, 2013.

Nattrass, Nicoli. "South African AIDS Activism, Art, and Academia: A Memoir from the 2000s." *Journal of Southern African Studies* 45, no. 1 (2019): 215–27. https://doi.org/10.1080/03057070.2019.1559541.

Nel, Martini. *Die volledige Kwiltbook*. Cape Town: Human and Rousseau, 1997.

Nettleton, Anitra, Julia Charlton, and Fiona Rankin-Smith. *Engaging Modernities: Transformations of the Commonplace*. Johannesburg: University of Witwatersrand, 2003.

Nettleton, Anitra, Sipho Ndabambi, and David Hammond-Tooke. "The Beadwork of the Cape Nguni." In *Catalogue: Ten Years of Collecting (1979–1989)*, edited by David Hammond-Tooke and Anitra Nettleton, 39–44. Johannesburg: University of Witwatersrand Art Galleries, 1989.

Nkambule, Nomvula Julia. "What Does Democracy Mean to Me?" Voices of Women National Quilt Project. Parliamentary Millennium Programme, 2008.

Nuttall, Sarah, and Carli Coetzee, eds. *Negotiating the Past: The Making of Memory in South Africa*. Cape Town: Oxford University Press, 2005.

Nuttall, Sarah, and Cheryl-Ann Michael. *Senses of Culture: South African Culture Studies*. London: Oxford University Press, 2000.

Odendaal, Andre. *The Founders: The Origins of the ANC and the Struggle for Democracy in South Africa*. Auckland, South Africa: Jacana Media, 2012.

Olfert Dapper, Willem ten Rhyne, and Johannes Gulielmus de Grevenbroek. *The Early Cape Hottentots*. Edited by Issac Schapera. Translated by B. Farrington. Cape Town: Van Riebeeck Society, 1933.

Orpen, Joseph. "A Glimpse into the Mythology of the Maluti Bushmen." *Cape Monthly Magazine* 49, no. 9 (1874): 1–10.

Oshins, Lisa T. Preface to *Quilt Collections: A Directory for the United States and Canada*. Washington, DC: Acropolis Books, 1987.

Parkenham, Thomas. *The Boer War*. London: Weidenfeld & Nicolson, 1979.

Parker, Roszika. *The Subversive Stitch: Embroidery and the Making of the Feminine*. London: Women's Press Limited, 1984.

Pavitt, Dawn. "A Lone Star in Africa." *Quilters' Guild Newsletter*, no 16 (Autumn 1983).

Pawloska, Aneta. "Transitional Art in South Africa." *Art Inquiry. Recherches Sur les Arts* 13 (2011): 183–202.

Peck, Amelia. *Interwoven Globe: The Worldwide Textile Trade, 1500–1800*. New Haven, CT: Yale University Press; New York: Metropolitan Museum of Art, 2013.

Pheto-Moeti, Mabokang Baatshwana. "An Assessment of Seshoeshoe Dress as a Cultural Identity for Basotho Women of Lesotho." MSc thesis, University of the Free State, 2005.

Peires, Jeff. *The Dead Will Arise: Nongqawuse and the Great Xhosa Cattle-Killing of 1856–7*. Johannesburg, South Africa: Jonathan Ball Publishers, 2003. Originally published in 1989 by James Curry in Britain, Indiana University Press in the United States, and Ravan Press in South Africa.

Pimstone, Millie. *Helen Suzman, Fighter for Human Rights*. Exhibition catalog. Cape Town: South African Jewish Museum with the Isaac and Jessie Kaplan Center for Jewish Studies, 2005: 25.

Pityana, Barney, ed. *Journey to Freedom*. Pretoria: University of South Africa Press, 2007.

Plummer, Cheryl. *African Textiles: An Outline of Handcrafted Sub-Saharan Fabrics*. East Lansing: Michigan State University Press, 1971.

Pretorius, J. Celestine. *Die geskiedenis van Volkskuns in Suid-Afrika*. Kaapstad, South Africa: Laeberg Uitgewers, 1992.

Prichard, Sue, ed. 2010. *Quilts 1700–2010: Hidden Histories, Untold Stories*. London: V&A Publishing.

"The Quilt Index: Collaborative Planning for Internationalization." IMLS National Leadership Grant Application. Museums Library–Museum Collaboration. Collaborative Planning Level II. 2011. https://kora.quiltindex.org/files/1-151-93/2011-QI-IMLS-proposal.pdf.

"The Quilting in America 2017 Survey." ORC International and Advantage Research, presented by the Quilting Company and Quilts Inc., 2017. http://www.quilts.com/news-and-info-qia-survey.html.

"Quilt Shows Support for Black Nationalist." *Capper's Weekly*, 1983. Clipping in Cuesta Benberry African American Quilt History Research Collection, Michigan State University Museum.

Ralfe, Liz. "Love Affair with My Isishweshwe." In *Not Just Any Dress: Narratives of Memory, Body, and Identity*, edited by Sandra Weber and Claudia Mitchell, 211–18. New York: Peter Lang, 2004.

Reitz, Deneys. *Commando: A Boer Journal of the Boer War*. Johannesburg, South Africa: Jonathan Ball, 1998.

Roberts, Allen F. "Break the Silence: Art and HIV/AIDS in KwaZulu-Natal." *African Arts* 34, no. 1 (Spring 2001): 36–49.

Rolfe, Margaret. *Australian Quilt Heritage*. Rushcutters Bay, Australia: J. B. Fairfax Press, 1998.

———. *Patchwork Quilts in Australia*. Auckland, New Zealand: Penguin Books Australia, 1991.

Rossouw, Mandy. "Londen oorrompel deur SA se modes." [London taken over by SA's fashions.] *Beeld*, 2006. Archived from the original on January 22, 2014.

Russell, Frank D. *Picasso's Guernica: The Labyrinth of Narrative and Vision*. London: Thames & Hudson, 1980.

Schapera, Isaac, ed. *Olfert, Dapper, Willem ten Rhyne and Johannes Gulielmus de Grevenbroek: The Early Cape Hottentots*. Translated by B. Farrington. Cape Town: Van Riebeeck Society, 1933.

Schmahmann, Brenda, ed. "Art as Empowerment: Needlework Projects in South Africa." In *Coexistence: Contemporary Cultural Production in South Africa*, edited by Pam Allara, Marilyn Martin, and Zola Mtshiza. Waltham, MA: Rose Art Museum, Brandeis University; Cape Town: South African National Gallery, Iziko Museums of Cape Town, 2003: 41–45.

———. *The Keiskamma Art Project: Restoring Hope and Livelihoods*. Cape Town: Print Matters Heritage, 2016.

———. "Making, Mediating, Marketing: Three Contemporary Projects." In *Material Matters*, edited by Brenda Schmahmann, 119–36. Johannesburg: Witwatersrand University Press, 2000.

———. *Mapula: Embroidery and Empowerment in the Winterveld*. Parkwood, South Africa: David Krut Publishing, 2006.

———. "Materialising HIV/AIDS in the Keiskamma Altarpiece." *Image & Text* 23, no. 1 (2014): 104–30.

———. *Material Matters: Appliqués by the Weya Women of Zimbabwe and Needlework by South African Collectives*. Johannesburg, South Africa: Witwatersrand University Press, 2000.

———. "Patching up a Community in Distress: HIV/AIDS and the Kesikamma Guernica." *African Arts* 48, no. 4 (2015): 6–21.

———. "Stitches as Sutures: Trauma and Recovery in Works by Women in the Mapula Embroidery Project." *African Arts* 38, no. 3 (Autumn 2005): 52–65.

Schonstein, Patricia. *A Quilt of Dreams*. Cambridge: Black Swan, 2006.

Schreiner, Olive. *From Man to Man*. London: Virago, 1982.

Schwellnus, Chris, and Hettie Schwellnus. *Las met Lap: Stap vir Stap*. Pretoria: Femina, 1982.

Segalo, Puleng, Einat Manoff, and Michelle Fine. "Working With Embroideries and Counter-Maps: Engaging Memory and Imagination within Decolonizing Frameworks." *Journal of Social and Political Psychology* 3, no. 1 (2015): 342–64. https://jspp.psychopen.eu/index.php/jspp/article/view/4863.

Sellschop, Susan, Wendy Goldblatt, and Doreen Hemp. *Craft South Africa*. Hyde Park, South Africa: Pan Macmillan, 2002.

Seymour, John. *The National Book of Forgotten Household Crafts*. London: Dorling Kindersley, 1987.

Shaw, Ella Margaret, and Nicolaas Jacobus van Warmelo. "The Material Culture of the Cape Nguni: Personal and General." In *Annals of the South African Museum*, vol. 58, part 4. Cape Town: South African Museum, 1998.

Shisana, O., T. Rehle., L. C. Simbayi, K. Zuma, S. Jooste, N. Zungu, D. Labadarios, D. Onoya, et al. *South African National HIV Prevalence, Incidence and Behaviour Survey, 2012*. Cape Town: HSRC Press, 2014.

"Shosholoza: Patchwork d'Afrique du Sud, 10th European Patchwork Meeting." Exhibition catalog, September 12–15, 2013. St. Croix-aux-Mines, Alsace, France.

Sieber, Roy. *African Textiles and Decorative Arts*. New York: Museum of Modern Art, 1972.

Slabbert, Norma. *A Passion for Quiltmaking: Leading South African Quilters Show and Tell*. Pretoria: J. P. van der Walt and Son, 1998.

Smith, Pauline. "Katisje's Patchwork Dress." In *The Penguin Book of Southern African Verse*, edited by Stephan Gray, 145–46. London: Penguin Books, 1989.

Solani, Noel Lungilezwelidumile. "The Biography of the Liberation Struggle and Public Representation of Its Memory and Heritage: 1994 to 2008." PhD diss., University of Fort Hare, South Africa, 2013.

Solomon, Tessa. "For His First U.S. Museum Show, Igshaan Adams Creates Tapestries That Reflect on South African History." *Art News*, April 5, 2022. https://www.artnews.com/art-news/artists/for-his-first-u-s-museum-show-igshaan-adams-creates-tapestries-that-reflect-on-south-african-history-1234622055/.

Soni-Abed, Zaitoonisa. "The Grand Quilt Story." Handout provided by Soni-Abed to Marsha MacDowell, during visit to her home, Winelands, South Africa, 2023.

———. *Portrait of an Islamic Artist: Achmat Soni*. Cape Town: South Africa Foundation for Islamic Art, 2017.

South African Quilters' Guild. *8th National Travelling Exhibition 2013–2015*. Exhibition catalog. 2013.

South Africa's Participation at the 33rd Smithsonian Folklife Festival. Washington, DC, June 23–July 4, 1999. Johannesburg: National Arts Council of South Africa.

"Soweto: The Patchwork of Our Lives; An Exhibition of Work by The Zamani Soweto Sisters." Press release. Brixton Art Gallery, London, n.d. Cuesta Benberry Collection of African American Quilts and Quilt History Research, Michigan State University Museum.

Sparrman, Andrew. 2016. *A Voyage to the Cape of Good Hope*. Vol. 2. Translated by J. Forster. London: G. G. J. and J. Robinson.

Spring, Christopher. *African Textiles*. London: Studio Gallery, 1997.

———. "Printed Cloth (Kanga)." In *Hazina: Traditions, Trade and Transitions in Eastern Africa*, edited by K. Lagat and J. Hudson, 31–33. Nairobi: National Museums of Kenya, 2006.

———. *Silk in Africa*. Seattle: University of Washington Press, 2002.

Spring, Christopher, and Julie Hudson. *North African Textiles*. London: British Museum Press, 1995.

Starsmore, Ian. "Foreign Correspondence." *Crafts*, no. 76 (September/October 1985). Cuesta Benberry Collection of African American Quilts and Quilt History Research. Michigan State University Museum.

Stowe, Tori, and Jen Rowland. *Catalogue of Eastern Cape Craft*. Grahamstown: NISC South Africa and Eastern Cape Provincial Arts & Culture Council, 2006.

Strutt, Daphne H. *Clothing Fashions in South Africa: 1652–1900*. Cape Town: A. A. Balkema, 1975.

Suzman, Helen. "Dropping In in South Africa." *Washington Post*, January 14, 1983. https://www.washingtonpost.com/archive/politics/1983/01/14/dropping-in-in-south-africa/801bd671-cd45-4328-bd41-116ca9783b35/.

Textile Circulation in the Dutch Global Market, 1602–1795. Digital repository curated by Carrie Anderson of Middlebury College and Marsely Kehoe of Hope College, art historians and scholars of the Dutch West and East India Companies. http://dutchtextiletrade.org/

Thomas, Hugh. *The Slave Trade: The Story of the Atlantic Slave Trade, 1440–1870*. New York: Simon & Schuster, 1997.

Thomas, Nicholas. "The Case of the Misplaced Ponchos: Speculations Concerning the History of Cloth in Polynesia." In *Clothing the Pacific*, edited by Chloe Colchester, 79–96. Oxford: Berg, 2003.

Thomson, Gilly. "Traditional Quilts in South Africa." *Quilter Journal*, no. 133 (Winter 2012): 20–21.

Tobin, Beth Fowkes, and Maureen Daly Goggin. "Introduction: Materializing Women." In *Women and Things, 1750–1950: Gendered Material Strategies*, edited by Beth Fowkes Tobin and Maureen Daly Goggin. Farnham, UK: Ashgate, 2009.

Trowell, Margaret. *African Design*. New York: Frederick A. Praeger, 1960.

Tsongas, Paul E. Letter to Ronald Reagan. February 18, 1983. Paul Tsongas Digital Archives at UMass Lowell. Accessed July 28, 2024. https://ptsongasuml.omeka.net/items/show/4524.

Turner, Marline. "Heritage Quilts." *South African Quilters' Guild*. Accessed June 24, 2008. http://www.quiltsouthafrica.co.za/heritage.php.

Turpin-Delport, Lesley. *Die Suid-Afrikaanse boek van Laslappie-en Appliekwerk*. Cape Town: Struik, 1988.

———. *Quilts and Quilting in South Africa*. Cape Town: Struik Timmins, 1991.

Ulrich, Laurel Thatcher. *The Age of Homespun: Objects and Stories in the Creation of an American Myth*. New York: Alfred A. Knopf, 2001.

———. "Of Pens and Needles: Sources in Early American Women's History." *Journal of American History* 77, no. 1 (1990): 200–207.

Van der Merwe, Ria. "Collections Create Connections: Stitching the Lives of Marginalized Women on the National Memory Canvas." *Museum Management and Curatorship* 3, no. 4 (August 2015): 268–82. https://doi.org/10.1080/09647775.2015.1043022.

———. "From a Silent Past to a Spoken Future: Black Women's Voices in the Archival Process." *Archives and Records* 40, no. 15 (2017): 1–20.

Vandeyar, Diane. "Artist Statement." In *Ubuntutu: Life Legacies of Love and Action*, edited by Marsha MacDowell and Aleia Brown, 1. East Lansing: Michigan State University Museum, 2016.

Van Riebeck, Jan. *Journal of Jan van Riebeck*. Edited by H. B. Thom. Cape Town: A. A. Balkema for the Van Riebeck Society, 1952. Cape Town: A. A. Balkema, 1975.

Venter, Chris. *The Great Trek*. Cape Town: Don Nelson, 1985.

Wadley, Lyn, Christine Sievers, Marion Bamford, Paul Goldberg, Francesco Berna, Christopher Miller. "Middle Stone Age Bedding Construction and Settlement Patterns at Sibudu, South Africa." *Science* 334, no. 6061 (2011): 1388–91.

War Museum of the Boer Republics. *The Anglo-Boer War in 100 Objects: War Museum of the Boer Republics*. Pretoria, South Africa: Frontline Books, 2018.

———. *Hartskombuis: Boerekos van die Anglo-Boereoorlog*. Cape Town: Tafelberg, 2016.

"Ways of Seeing Early Modern Decorative Textiles." Special issue, *Textile History* 47, no. 1 (2016): 124–48.

Webber, Martha. "Crafting Citizens: Material Rhetoric, Cultural Intermediaries, and the Amawzi Abesifazane South African National Quilt Project." PhD diss., University of Illinois at Urbana-Champaign, 2013.

———. "Literacy Intermediaries and the 'Voices of Women' South African National Quilt Project." *Reflections: A Journal of Community-Engaged Writing and Rhetoric* 11, no. 2 (Spring 2012): 68–90.

Weems, Mickey, Marsha MacDowell, and Mike Smith. "The Quilt." *Qualia Encyclopedia of Gay Folklife*. Accessed October 11, 2013. http://www.qualiafolk.com/2011/12/08/the-quilt/.

Weiner, Annette B., and Jane Schneider, eds. *Cloth and the Human Experience*. Washington, DC: Smithsonian Institution Press, 1989.

Wells, Kate, Marsha MacDowell, C. Kurt Dewhurst, and Marit Dewhurst. *Siyazama: Traditional Arts, AIDS, and Education in South Africa*. Pietermaritzburg, South Africa: University of KwaZulu Natal Press, 2012.

What's American about American Quilts? A Research Forum on Regional Characteristics and the American Quilt Legacy Exhibition Case at the National Museum of American History. Conference Proceedings. Washington, DC: Smithsonian Institution, 1995.

Wilkinson, Veronica C. "South African Textile Group Thrives." *FibreArts*, November/December 2005. http://www.fiberarts.com/back_issues/11_05/news_notes.asp.

Williamson, Jenny, and Pat Parker. *Quilt Africa*. Highlands North, South Africa: Wild Dog Press, 2004.

———. *Quilts on Safari*. Cape Town, South Africa: Triple T, 1998.

———. *Quilt: The Beloved Country*. Cape Town, South Africa: Wild Dog Press, 2008.

Williamson, Sue. *Resistance Art in South Africa*. Cape Town: David Philip, 1989.

Women's Work: Crafting Stories, Subverting Narratives. Exhibition. Iziko Museum. https://www.iziko.org.za/exhibitions/womens-work-crafting-stories-subverting-narratives.

Wood, John George. *The Natural History of Man; Being an Account of the Manners and Customs of the Uncivilized Races of Men*. London: George Routledge and Sons, 1874.

Woodward, Carolyn S. "The Interior of the Cape House 1670–1714." Master's thesis, University of Pretoria, 1982.

Worrall, Mary. "The Quilt Index: Building an International Resource." In *Quilts of Southwest China*, edited by Marsha MacDowell and Lijun Zhang, 51–53. Nanning, China: Guangxi Nationalities Museum, Yunnan Nationalities Museum, and Guizhou Nationalities Museum, 2016.

"Zamani Soweto Sisters: A Patchwork of Lives." *Fibre Arts* (March/April 1983): 48–49.

Zamani Soweto Sisters Council Newsletter, Issue No. 1, 1985. Deirdre Amsden Collection/Cuesta Benberry African American Quilt and Quilt History Research Collection, Michigan State University Museum.

Zegart, Shelly, and Jonathan Holstein. *Expanding Quilt Scholarship: The Lectures, Conferences, and Other Presentations of Louisville Celebrates the American Quilt*. Louisville: Kentucky Quilt Project, 1993.

Zeitlin Cooke, Ariel, and Marsha MacDowell, eds. *Weavings of War: Fabric of Memory*. East Lansing: Michigan State University Museum in collaboration with City Lore Inc. and Vermont Folklife Center, 2005.

CONTRIBUTORS

Coral Bijoux is a practicing artist and curator with a background in education, art, and heritage practice (https://coral4art.co.za). Since 2012 she has been engaged in curating exhibitions and developing the Voices of Women Museum.

Elsa Brits is a quilt artist and past president of the South African Quilters Guild (http://www.quiltsouthafrica.co.za). She is acknowledged by her peers as a consistent advocate for documentation of the country's quilt history.

Jeni Couzyn is a poet and the founder / artistic director of The Bushman Heritage Museum, Nieu Bethesda, South Africa (www.bushmanheritagemuseum.org). Born in South Africa, she divides her time between England, Canada, and South Africa.

Menán du Plessis, PhD, is Associate Professor, Department of General Linguistics at Stellenbosch University. Her book *Kora: A Lost Khoisan Language of the Early Cape and the Gariep* was honored with the Hiddingh-Currie Book Prize from the University of South Africa.

Jeanette Gilks is a South Africa–based quilt artist and teacher who is very interested in the therapeutic dimension of art making. She was a cofounder of Fibreworks.

Vicky Heunis, PhD, is a cultural historian and collections manager at the War Museum of the Boer Republics in Bloemfontein, South Africa, and has published articles on various aspects of South African material culture. Her thesis, in Afrikaans, was awarded the Protea Books prize.

Sandra Kriel, MA, is an artist activist whose work focuses on and forms a critique of racial and gender politics. Her art has been shown at many venues, including the 1993 Venice Biennale.

Miems Lamprecht is Senior Cultural Historian at Potchefstroom Museum and in that capacity has been responsible for quilt-based community outreach programs, exhibitions, and collection development. She is also a quiltmaker.

Juliette Leeb-du Toit, PhD, is an art historian and research associate at the University of Johannesburg. Her book *isiShweshwe: A History of the Indigenisation of Blueprint in South Africa* was a finalist for the 2019 University of South Africa Prize in Humanities and Social Sciences.

Marsha MacDowell, PhD, is Professor and Curator of Folk Arts and Quilt Studies at the Michigan State University Museum, Director of The Quilt Index (www.quiltindex.org), and has conducted research on quilts and quiltmaking in South Africa since 1997.

Carolyn Mazloomi, PhD, is an award-winning artist, author, curator, and founding director of the Women of Color Quilters Network (WCQN). In 2014 Mazloomi was honored with the National Endowment for the Arts' Bess Lomax Hawes National Heritage Fellowship for her work on behalf of African American quilt artists.

Dawn Pavitt was a quilt artist known for her optical illusion designs. She was also an active member of The Quilters' Guild of the British Isles and a regular contributor to the guild's newsletter.

Brenda Schmahmann, PhD, is Professor and SARChI Chair in South African Art and Visual Culture at the University of Johannesburg. She has published extensively on South African material culture, including on the work of women affiliated with economic empowerment initiatives.

Patricia Turner, PhD, is Research Professor, Department of African American Studies and World Arts and Culture at the University of California, Los Angeles. Her 2009 book *Crafted Lives: Stories and Studies of African American Quilters* probed the ways in which African American quilts have been depicted, criticized, and characterized.

Michael Walwyn was an independent scholar who specializes in the military history of South Africa.

INDEX

Page numbers in italics refer to illustrations

acacia thorns, 1
activism, 21, 134–36, 138–40; AIDS-related, 42–43, 141–44, *145*, 146, 151–53; against apartheid, 24, 26–30, 35, 185; embroidery and, 134; in global issues, 35; on health and well-being, generally, 41–45, 137–38; Mandela quilt tributes as, 35–41; quiltmaking as, 30–35, *32*, *33*, *34*
Adams, Igshaan, 49–50, *50*
addiction, 138
African American quilt artists, 30, 36–38, 57n81, 121, 124–25. *See also* Women of Color Quilters Network (WCQN)
African National Congress (ANC), 36, 42
African prints, 20–21, 41, 54, 164, 165. *See also* isishweshwe
Agaliawamu (Nabukenya), 50
AIDS. *See* HIV/AIDS
AIDS Benefit Concert Cape Town (Molope), *143*
AIDS Memorial Quilt, 42–43, 142, *143*, 144, *144*, 146
AIDS ribbons, 153, 164
Alexander, Jane, viii
Allah, 99 names of, *52*, 53
Alzheimer's, 41
Amandla! (Barnard), *190*
Amazwi Abesifazane (Voices of Women) Project, 24, 26, 137–40
Amsden, Dierdre, 119, 120, 123, 127n6
Angry about AIDS (Garratt), 141, *142*

animal skins, ix, 1–2, 59–60, 61–62; cloth combined with, 9, *10*; men working, 63, 65, 67n14; methods of preparing, 63, 65; social class and, 61, *61*, 64; types of, 61–62, 63, 64–65, 66n4
antelope, 67n16
apartheid: Black women leaders against, 35, *126*, 127; effects of, on quiltmaking, viii, 12–13, 164, 185; funerals of those killed under, 136; history of, made visible, 137; memory quilts about, 24, 26–29, *27*, *28*; and post-apartheid symbols, 164; Rainbow Nation and, 53; US leaders against, 57n76, 129, *130*; and White exclusion, *169*; White women against, 30–35, 100
Arnold, Marion, 134
Arthur, Cheryl, *94*
Artist Proof Studios, 146
artists of color, viii, 38, 185–86, 192, 197. *See also specific artists*
art versus craft, ix
Asia, cloth from, 89, 90, 91
Attic Window pattern, 79–80
August, Winnie, 49

baby blankets, 65, 68n27
Bantu language family, 59, 66n2
banyans, 9
Barac, Sonja, 26, *28*
Baratta, Elisabeth, 18
Baratta, Rick, 18
Barks-Ruggles, Erica, *144*

Barnard, Elaine, *190*
Barret, Jacoba, 76
Bayeux Tapestry, 154n1
beads and beading, 41, 53, 54, 153, 165, *167*
Beaumont, Helga, *173*
Bebeza, Nomawethu, *175*
bedding: of Khoisan, 62–63; material evidence of, 4, 59; materials for, 2, 9, 62–63, 64–65; servants making, 4–6, *5*; of Voortrekkers, 7, 9. *See also* blanket-cloaks
Benberry, Cuesta, 121, 124–25, 128n17, 185
Berman, Kim, 146
Bernstein, Lionel, 35, *36*
Bester, Willie, viii
Biddle, Dana, *188*
Bijoux, Coral, *139*
Bimsom, M., 22, 81, 86
Black Diaspora Quilt History Project, 197, 198n5
Black South Africans: and quiltmaking, 12, 13–18; rural, income-generating programs for, viii, 13
Black South African women: activism by, 18, 35, *126*; isishweshwe worn by, 91–92, *92*, *93*, 95–97, *96*, 99, 101n4; rural, stories of, 137–40
blanket-cloaks, 59–60; of chiefs versus common people, 61, 66n4; Khoisan, 60–62, *61*, 63–64; in other Indigenous communities, 64–66
Bleek, Wilhelm, 63, 67n15
Bloemfontein National Quilt Festival, 109
bloudruk, 97–98, 100n1. *See also* isishweshwe
blueprint, 89–90, 91, 100n1. *See also* isishweshwe
Bode, Lorraine, *52*, 53
Boerekappies, 71–73, *72*
Boers, 7, 84–86. *See also* Voortrekkers
Boer War concentration camps, 41, 77, 79, 86, 106; children in, *72*, 73, 77, 86, 105–6; deaths in, *105*; kappies worn in, *72*, 73; quilts produced in, 42
Boer War Quilt (Bimsom), 81, *82–84*, 84, 85; visual data in, 86–87
Boer War quilt (Vincent), 21, *22*
Boer Wars, 21, 22, 22–23, 84–86, 105–6; *Heritage Quilt* of, 75–80, *76*, *77*, *78*, *79*; visual data about, 86–87; and War Museum of the Boer Republics, 23, 75, 80n1; women's experiences in, 76–77, *78*, 105–6; women's lives after, 77–78, *79*. *See also* Boer War concentration camps
Boitumelo Sewing Group, 26, *27*
Botha, Andries, 137, 140n1
Botha, Annie, 76
Bothma, Marthie, 137–38, *139*
Bourgault, Louise M., 142, 144
bourré, 71
Brackman, Barbara, 30
Brandt, Johanna, 76
Briedenham, Myra, 6
British settlers, 3, 6, 11, 154n1. *See also* Boer Wars; Zulu War
bubudu (sleeping mats), 62
Buirski, Desré, 38, 40–41
bull and cattle imagery, 151, 152, *169*
Burchell, William, 59–60, *61*, 64–65
Burden, Matilde, 7
burial, 63–64
Bushman Art of the Drakensberg (Hone), *173*
Bushman Heritage Museum, 155
Bushman Heritage Museum tapestries: "The Creation of the Sun," *160*; emotions in making, 156, 160–61; emotions in response to, 158; "The Girl Who Made Stars," *159*; making of, 157, *158*, 160–61; sewing the world together, 162; singing and, 156, 158, 160–61; *These Are Our Stories*, 156–57, *156–57*, 161
Butler, Bisa, *187*
Butler, Eliza, 11–12

Calm in the Corona Chaos (Khan), *44*
Campanile, *168*
Cape Recife Lighthouse, *168*
Cape Town, early history of, 2–3, *4*
Carnegie Art Gallery, 14, 30, *32*
Carrelsen, Anne Marie, 7
cattle, 18, 52, 152; imagery of, 151, 152, *169*
central medallion, 6, *173*
charity projects, 111, *111*
Chaveas, Lucille, 35–36, 71
Chaveas, Peter R., 35–36

Child of Clay, A (Tambani Embroidery Project), 16, *17*
children: in concentration camps, *72, 73,* 77, 86, 105–6; in digital age, 137–38, *139*; loss of, to AIDS, 152, *153*
Christian imagery, 151–52
Christian missions, 93–95, 101n7, 169
Church (Mgidi), *167*
clothing, 2, 103; Christian missions changing, 93–95, 101n6; cross-cultural, 100; and fashion, 89, 92, *94*; patched and patchwork, 53, 105–6, *105–6*; quilted, 9–10; and rites of passage, 63, 65, 96; used in quilt art, 153. *See also* isishweshwe; karosses
Cobwebs in the Corners of My Mind (Niederhumer), 115–16, *116*
Coetzee, Jacoba, *106*
Coetzee, Maurits Jacobus, *106*
colonization, 2–4, 6–7, 11, 154n1; and background of Boer Wars, 84–86; and Christianization, 93–95, 101n7; and decolonization, 24, 26; quiltmaking tied to, 12
Coloured (term), xn4
Coloured communities: isishweshwe in, 99–100; kappies in, 73
Compact (Pouw), *49*
Comprehensive Anti-Apartheid Act of 1986, 35
Conscience of the Human Spirit (exhibit), 38, 186, 192, 193n6
cotton, 54, 91
counterpanes, 4
Country Quilters, 108n3
Couzyn, Jeni, 16, 157, 161
Couzyn, Tarot, 16
COVID-19 pandemic, 43–45, *44*
Cradock Four, 30
craftivism, 141
crafts-based economic development, viii–ix, 13–18, 20, 24–26, 30, 111, 119, *175*, 198; HIV/AIDS-themed work in, 141, 146; SAQG members volunteering for, 45
craft versus art, ix
crazy quilts, 11
"Creation of the Sun, The," 160

Crill, Rosemary, 3–4
Crockett, George William, Jr., 57n76
Crockett, Jo, *175*
Cuesta Benberry Collection of African American Quilts and Quilt History Research, 128n17
Cultural Diversity: Isiphephetu Apron (Schutte), *181*

Dace, Rosalie, *176*
Da Gama Limited, 20, 92–93, 101n6
Danais, Florence, 150
Daniell, Samuel, *61*
Day I Will Never Forget, A (Bothma), 137–38, *139*
decolonization, 24, 26
De Gama Textiles, 92, 101n6
De Oude Molen Gilde, 107, 108n3
Desai, Raffiq, 52
Dewhurst, C. Karl, 35
digital age, raising children in, 137–38, *139*
District Six, Where We Lived (February), 46, *48*
doctors, access to, 150
domestic workers, 135–36
Donaldson, Beth, 198n13
Downs, Jacky, 150
Drakensberg Dreams (Beaumont), *173*
Dreyer (Munnik), Sara Christina, 6–7, *8*
Dromedaris (ship), 52, *53*
Durban, people of, *182*
Dutch East India Company, 2, 3, 6
dyes and dyeing, 3, 69, 89, 91, *106*, 153

ecofeminism, 135
economic development initiatives. *See* crafts-based economic development
Eenheid (Adams), *50*
Egoli (Walwyn), *180*
Ehlers, Suzette, 109, 111
1820 Settlers, 6
embroidery, 26, 133, 134, 136. *See also* Intuthuko Embroidery Project; Mapula Embroidery Project
Engelbrecht, Jan, 62, 67n18
Eschenbach, Wolfram von, 117n6
Essers, Bev, *31*
Every Picture Tells a Story (Williamson and Parker), *170*

"Fabulous Fibres!," 113
fear, 135–36
February, Fatima, 46, *48*
Fee, Sarah, 20–21
feminine, the, 155, 161
fiber art: defining, vii, 113; extending limits of, 114–15; tactile aspect of, 117; viewers' role in, 115
Fibreworks, 20, 113–17; founding of, 113; shows and exhibitions by, 113–14, 117; written resources of, 117n3
Fine, Michelle, 24
First Nations quilt artists, 38
Fitzpatrick, Percy, 197
Flacourt, Etienne de, 67n15
Floyd, George, *33, 35*
football, *177, 178*, 183
Fourie, Maretha, 109
46664 Concerts, *143*
Free at Last (Butler), *187*
Freedom Day, 29
Freedom Tour, 38, 186

Gambushe, Eunice, 137
Gandhi, Mahatma, *187*
Gardiner, Edith, 45, *47*
Garratt, Margie, 20, 141, *142, 174*
Gedze, Nokuphiwa, 151
gender: human rights and, 134, 136; and kaross-making, 63, 65, 67n14; roles, communication and, 141; in textile arts, 161
gender decorum, 95–97
Gidi, Margaret, 15
Gilks, Jeanette, *114*, 115
"Girl Who Made Stars, The," 159
Givamanda, Rose, *126*
ǂgoab (sleeping mat), 62
Goldberg, Denis, *35, 36*
Golden Rand Guild for Quilters, 112
Golden West Quilt Guild, 107–8, 108n3
Goldreich, Arthur, *35, 36*
Gool, Benny, *191*
Grand Quilt, The (Soni et al.), *52*, 53–54
Grassroots Quilters Guild, *182*
Grey Institute, *168*
Grobler, Balthariena Johanna, 107
Groothoek Mission Hospital, *169*
Grounded I (Dace), *176*
Guernica (Picasso), 149, 151, 152

Hadet Embroidery, *52*
Hamburg, South Africa, 149–52
Hanni, Dipuwo, *126*
Harde, Laura de, *48*
Harde, Tilly de, *48*
Harris, Carole, 36–37
healing, 152, 161–62
health and illness, 41–45, 137–38. *See also* HIV/AIDS
Hearder, Valerie, 15
Hearn, Jenny, 186, *189*
Hector Pieterson—Blood in Soweto (Mapula), 24, *26*
Heever, Naomi van der, 76
Hepple, Bob, *35, 36*
Heritage Quilt, The (Moolman), 75, *76*; method of making, 75, 80n3; size of, 80n3; unveiling of, 78; women's experiences depicted in, 75–79, *77, 78, 79*
Hermans, Jenny, *182*–83
Hicks, Kyra, 57n76
historical memory, quiltmaking and, 21–26, 29–35, *32–34*, 79–80, 137–40, *138–39*
HIV/AIDS, 128n22; antiretroviral treatment for, 141, 150–51; education about, *143*, 144; in Hamburg, South Africa, 149–51; *Keiskamma Guernica* and, 149; prevalence of, in South Africa, 141, 164; silence regarding, 141, 146; South Africa's response to, 150–51
HIV/AIDS patients, 151, 152–53
Hlomuka, Maria, 120, 121, *122*, 123–24
hlonipha, 95–96, 141
Hobhouse, Emily, 76, *77*
Hofmeyr, Carol, 18, 149, 150, 151–52, *153*
Hogan, Barbara, 41–42, *43*
Holy Trinity Anglican Church, *168*
Hone, John, *173*
Huddelston, Brad, 138
Hughes, Trudie, *121*
Hutcheon, Linda, 149
Huthuli, Nokukhauya, *126*

Iis, 64
Ilingelihle Women's Sewing Group Project, *14*, 14–15
imbenge, ix
Indian fabrics, 2, 3–4

Indian South Africans, quiltmaking by, 12, 164
Indigenous peoples: quilts celebrating, 173; settler trade with, 3; traditions of, and quilts, viii–ix, 59–66, 198
indigo, 89–90, *90*, 92
Infanta Hills (Garratt), *174*
Ingubo Entle (Crockett and Bebeza), *175*
In Memoriam (Scott), 23–24, *25*
Innovative Threads, 20
International Quilt Convention Africa, 186
International Quilt Museum, 196
internment, 41–42
Intombi (Hlomuka), *122*, 123
Intuthuko Embroidery Project, *15*, 15–16, 26, *28*, 56n70, *178*
Irene, Princess, 126
Isandlwana, battle of, 21–22
Isiphethu, 14, 30, *32*
isishweshwe, 20, 46, 53, 54, *90*, 92; Black South African women wearing, 91–92, *92*, *93*, 95–97, *96*, 99, 101n4; colorways, 93; "fake," 101n6; fashion, 92, *94*; gender decorum and, 95–97; indigenization of, 91, 96–97, 100; kappies made from, 73, 97; mass-produced, 91–92, 101n6; methods of making, 89–90, 91–92; and opposition to apartheid, 100, 101n4; origin and history of, 89, 90–91, 100n1; Portuguese, 89, 90–91; quilts made of, 20–21, 46, 54, 89–93, 97–100, 121, 165, 192; South Africa producing, 92–93; terms for, 100n1, 101n8; White women using, 73, 91, 97–99, 100, 101n4
Islamic art, *52*, 53–54
It Is in Your Hands Now (Hearn), *189*

Jacobs, Carroll, 142, *144*
Jamal, Ashraf, 49
Johnson, Xokani Nkosi, 127, 128n22
Joseph, Helen, 36
Josias, Anthea, 24
Joubert, Hendrina, 9, 76
Journey to Freedom, 26–29, *27–28*
Jung, Carl, 116
Jurgens family, 6
justice quilts, 29

ǁKabbo, 155, *159*
Kamfer, Cecilia, *104*
Kantor, James, 35, *36*
kappies, ix, 10, 53, *104*, 105; colored, 71, *72*, 73; in Coloured communities, 73; definition of, 69; Dorsland, *104*, 105; isishweshwe used for, 73, 97; making of, 71; in Quilt Index, 197; revival in, 73; and *sloopkappies*, 71–73, *72*; styles of, 69; and Voortrekkerkappies, 69–71, *71*
kaross (term), 60–61, 67n9
karosses, 1–2, *2*, 59, *60*; as gifts, 65–66; as grave-clothes, 63–64; makers of, 1–2, 63, 65, 67n14; material form changing, 65; as quilts, ix; terms for, 63, 64–65, 67n15, 67n26; as togas, 60; Voortrekkers making, 106
Kaross Workers Embroidery Group, 16, *34*, 35
Kassuth, Lajos, 101n4
Kathrada, Ahmed, 35, *36*, 127
Kawuuwo (Nabukenya), 50, *51*
Keiskamma Art Project, 18, 42, 149, 153–54, 154n1
Keiskamma Guernica, 149, *150*; cattle in, 152; graves in, 152–53; Hofmeyr in, 151–52; materials in, 153; ownership of, 153–54
Keiskamma Tapestry, 154n1
Keiskamma Trust, 150–51
kékfestö, 100n1, 101n4. *See also* isishweshwe
Kentridge, William, viii
Khan, Felicity, *33*, 35, *44*, 45
Khoisan languages, 59, 66n2
Khoisan people, 59–60; blanket-cloaks of, ix, 60–64, *61*; chiefs of, 61, *61*, 64
Khuzwayo, Ellen, *126*
King, Martin Luther, Jr., *187*
King, Ynestra, 135
kiskappies, 71
Kleinjaer, 63
kooigoed (bed stuff), 63
Koopmans-De Wet, Marie, 76
kooy (bed), 62
Kriek, Magda, 75, *76*, 80n3
Kriel, Sandra, 29, 30, 133–36
Kruger, Gezina, 76

Lailvaux, Inge, *179*
leatherwork, 63, 67n14, *167*. *See also* animal skins
ledikant (field bed), 4
Legacy of Light exhibit, 192
Lesgo, 15
Lichtenstein, Henry, 63, 64, 65
Liesbet, Aia, 77
Liesbet, Martha, 77
Links, Piet, 63–64
Lloyd, Lucy, 63
log cabin pattern, 11, *98*
Lolale, Kate, *126*
Lombaard, Gori, *52*
Lone Star pattern, 129, *130*
longarm quilting machine, *19*
Lotz, Elizabeth, 78–79
Love2Give, 50
Lubisi, Pinky, *28*
Luttich, Erica, 26, *27*

Mabizela, Thembisile, *28*
Mabuza, Zenele, *28*
Mabuza-Suttle, Felicia, *126*
MacDowell, Marsha, 35, 186, 198n13
MacMurray, Moira, 41
Madiba Led the Way (Williamson and Parker), *40*, 41
Madiba: Prince of Freedom (Starke), *37*, 38
Madiba Shirt (Makhubele), *39*
Mageza, Nobuntu, *33*
Maggie Magaba Trust, 119, 127n4
Magogo, Princess Constance, *126*
Mahama, Elisa D., *27*
Maingard, Louis, 63
Makarapa Quilt (Intuthuko), *178*
makarapas, *178*
Makassari, Yusuf Al, 54
Makhari, Ammellah M., *27*
Makhubela, Winnie, 16
Makhubele, Billy, 41
Makhubele, Jamina, 41
Makhubele, Jane, *39*, 41
Makhubo, Mbuyisa, 24
Makola, Dina Tsibogo, 45–46, *47*, 95
Makubalo, Noseti, 152
Makwana, Selinah, *44*
Malan, Antonia, 3
Malekhwekhwe, Onice, 45–46, *47*, 95

Mandela, Nelson, 20; exhibition of quilts honoring, 186, 192; images of, restricted, *190*; quilts honoring, 35–38, 127, *182–83*, 186, *187–90*, 193n3; release of, *28*, *29*, 35–38, 185–86, 192; shirts worn by, 38–41, *39*, *40*, 186; trial of, 35, *36*, 186; in United States, 38, 186
Mandela, Winnie, 38, 57n76, *126*, 186; quilt for, 35, 129–30, *130*, 131n4
Mandela Leads the Way, 41
Manoff, Einart, 24
Mapula Embroidery Project, 13–14, 24, 26, 42, *44*, *143*
marriage, 95–96
Mashabela, Martinah P., *27*
masks, quilters making, 43
Masondo, Dudu, *126*
Matereality—A Testament to the Challenge of Tradition (exhibit), 48–49
Matigimu, Patience, 45, *47*
Matrix: The Center for Digital Humanities & Social Sciences, 195
Matshinge, Naledzani R., *27*
Mawela, Lilian Mary, *27*
Maxeke, Charlotte, *126*
Mazloomi, Carolyn, 30, 38, 186, 193n2
Mbanjwa, Martha Thembiswe, 19
Mbeki, Govan, 35, *36*
Mdakane, Tholakele, 137, *139*
Mei, Gerald, 161
Melula, Gloria, *27*
memory cloths, 26–29, *32*, 137–40
men: as kaross-makers, 63, 65, 67n14; objectification by, 135; sewing tapestries, 161
Menell, Irene, 38, 193n3
Merrington, Yvonne, 159, 161
Merwe, Ria van der, 24
Mgidi, Betty, *167*
Mhlaba, Raymond, 35, *36*
Michigan State University, 57n81, 195, 197
Michigan State University Museum, 38, 81, 127, *191*, 192, 196
Milky Way, the, 159, *159*
Miller, Gwenneth, 26, *27*, *28*
Miller, Kim, 134
Minceka, 41
mirror cloak blankets, 165
M'Kasibe, Florence, 119–20

Mkhize, Florence, *126*
Mkhung, Linda, *27*
Mlangeni, Andrew, 35, *36*
Mnguni, Lindo, *28*
Modise, Thandi, *126*
Mohati, Solomon, 16
Mokoena, Julie, *28*
Molope, Philippine, *143*
Moolman, Naomi, 23, 75–80, *76*
mosaic block patterns, 6, 11
Moshoeshoe I, 100n1
Motloung, Salaminha, *28*
Motsolaledi, Elias, 35, *36*
mourning, 96, *96*
Mpathi, Nomtandazo, *14*
Mpenyana, Elizabeth, 124
Mphahlele, D. Emmah, *27*
Msibi, Cynthia, 30, *32*
Mucavele, Angelina, *28*
Mudau, Sani, 16, *17*
Mukutu, Namukolo, 45, *46*
Munnik, Sara Christina, 6–7, *8*
museums, Quilt Index partnering with, 196, *197*, 198n8
My Heart Is Glad (Tolksdorf), 30, *31*
My Mandela (Biddle), *188*
Mzansi Zulu Quilt Center, 18, *19*

Nabukenya, Hellen, 50, *51*, 54
Nair, Billy, 35, *36*
Nama people, 52–53
Namaru, Angie, *28*
Nama Stap dance, 53
NAMES Project Foundation, 142
ǂnammi. *See* blanket-cloaks
Nare, Thabitha, *28*
National Arts Festival, 153
National Quilt Festival, 110, *111*
National Quilting Association (NQA), 111
Native American quilt artists, 38
nature, humans and, 135
Nchang, Lilian, 124
Ndala, Nomsa, *28*
Ndebele textile techniques, *167*, *181*
Ndimande, Francina, *167*
necklacing, 26, *27*, 29
needles, 9, 103; Indigenous use of, 1–2, 65; Stone Age, 1; terms for, 63, 65, 68n29

Nelson Mandela Museum, 192
Nettleton, Anitra, 153
Ngoyi, Lillian Masediba, *126*
Niederhumer, Gina, 115–16, *116*
Nieu Bethesda, 155, 158–59. *See also* Bushman Heritage Museum
Nieu Bethesda Art Center, 29
9/11 (Kaross Workers), *34*, 35
Nine Patch and Snowball (Sera), *121*
Nkabinde, Maria, *28*
Nkosi, Fina, 35, *36*, 125–27, *125-26*
No 7 Castle Hill, *168*
Nongqawuse, 152
Nontolwane, Mary, *126*
Ntshang, Lillian, *126*

ochre, 66n4, 67n23, 153
One Flag-Many Fans (Hermans), *182–83*
ON THE EDGE NO. 3—Zulu Headrest Series (Tolksdorf and Lailvaux), *179*
orange fabric, 7
Overberg (van Zyl), *172*

Pakapab, 63
palampores, 3–4
paper piecing, 6
Paper Prayer project, *145*, 146
Parker, Pat, 41, 164, *166*, *170*, *171*
parody, 149
Parzival, 116, 117n6
patchwork, 12, 53, 120
patchwork mending, 105–6, *105–6*
patterns, 11, 71, 163–64, 192; Attic Window, 79–80; King's X, 38; log cabin, 11, *98*; Lone Star, 129, *130*; Mandela-inspired, 36, 38, 41; mosaic block, 6, 11; Rocky Road to Freedom, 36; star, 11
Pavitt, Dawn, 57n76, 131n4
Pearson Conservatory, *168*
Pease, Fanny, 22
"Piano of Struggle" (Hlomuka), 121
Picasso, Pablo, 149
Pieterson, Hector, 24, *26*
Pike, Sarah, 7
Pilanesberg, the, 115
pioneers. *See* Voortrekkers
plastic, ix, 49, *49*
Pomegranate Quilters, 16, *18*

Port Elizabeth—Legacy of Settlers (Pretorius), *168*
Potchefstroom, 103–8
Potchefstroom Museum, 107–8, 108n4
Pouw, Bert, 48–49, *49*
"Prairie Points," *14*, 15
prayer rugs, 49
President's Emergency Plan for AIDS Relief (PEPFAR), 150–51
Pretorius, Kaffie, 109
Pretorius, Marilyn, *168*
Prince, F. T., 24
Prison Quilt (Hogan), *43*
Pro Dedicate Award, 110
protea flower, *52*, 54, 165n4, *174*
Protea Quilters, 112
Proto-Bantu, 67n23

quilt artists, communities of, 18–20, 45, 54, 107–8, 109, 117, 185–86, 192
quilted hats. *See* kappies
quilted petticoats, 9
Quilters' Guild, 120, 127n5, 131n4
Quilters' Hall of Fame, 110
quilt guilds of settler-colonial heritage, 13, 18, 111. *See also* South African Quilters' Guild (SAQG)
Quilt Index, 55n30, 111, 193n6, *196*; definition of quilt in, 195; expansion of, beyond US, 196–97; records in, 195–96; scholarship facilitated by, 197–98; and South African Quilters Guild, 197
Quilting Bees, 108n3
quiltmaking, *13*; as activism, 30–35, *32, 33, 34*; apartheid's effects on, viii, 12–13, 164, 185; books on, 41, 107, 164; as crafts-based economic development, viii–ix, 13–18, 24, *32*, 119, *175*, 198; as decolonial project, 24, 26; fabrics, 20–21; factors impacting engagement in, 12–13; history of, viii, 54, 163–64; materials used in, 48–50; regionality in, 163; reminiscences and literature on, 11–12. *See also* quiltmaking, twenty-first century
quiltmaking, twenty-first century: as art, 46, 48–54, *48, 49, 50–52*; border-crossing, 52–54, *52*; as business, 45–46, *46, 47*

quilts: as art, vii, ix, 38; auctioned for charity, 40–41; blood spatters on, 107; cost of, 11–12; defining, vii, 1, 195; documentation of, 163; enslaved people making, 4–6, *5*; exhibitions of, 20, 46; family connections created by, 12; health, illness, and, 41–45, 137–38; and historical memory, 21–26, 29–35, *32–34*, 79–80, 137–40, *138–39*; Indian and European, 4, 163–64; oldest, 6–7, 163–64; pictorial, 125–27, *125, 126*; South African, aesthetic of, 163–65
quilt studies, viii

Raal, Sarah, 76
Rabie, Hendrina, 76
Radebe, Cynthia, *28*
railway construction, *180*
Rainbow Nation, 53, 163, *191*
Ramdhani, Narissa, 38, 193n3
Randeree, Farhana, 52
Raseala, Flora, *27*
red coloring, 66n4, 67n23
Red Location Museum, 153–54
Remembering Children of South Africa (Block 5714), 143
Remember Our Fallen Comrades VI for Chris Hani (Kriel), *29*
Rey, Nonnie de la, 76
Rhodesian Bush War, 24
Rhyne, Willem ten, 61, 67n9
Richardson, Justine, 198n13
Riebeck, Jan van, 2, 53
rites of passage, 63, 65, 96
Rivonia Trial, 35–36, *36*, 127
Rivonia Trialists (Nkosi and Zulu), 35, *36*, 127
rock art, 60, 66n4
Rodds, Kate, 22
Roomanay, Shabodien, 52
Rooyen, Irma van, 16, *34*, 35
Rooyen, Petro van, 75, *76*, 80n3
Ross, Wendy, 26, *27, 28*
Rotary, 18
Roux, Ina le, 16

sacrificial rituals, 152
Salie, Fareida, 52
"Sampler" quilts, 109
Sanbonani eThekwini (Tolksdorf), *182*

San peoples, 16
Sasebola, Sannah, *28*
Schmahmann, Brenda, 24
Schonstein, Patricia, 12
Schouwenburg, Johannes Christiaan van, 6, *6*
Schreiner, Olive, 11, 76
Schreuders, Claudette, viii
Schutte, Paul, *181*
Schwellnus, Chris, 107, 164
Schwellnus, Hettie, 107, 164
Scott, Sally, 23–24, *25*
sea, the, *52*, 54
Segalo, Puleng, 24
Sekoto, Gerard, viii
Sera, Maria, *121*
settlers: British, 3, 6, 11, 154n1; complexion of, 69; Indigenous trade with, 3; quilting connected to, 12, 111. *See also* colonization; Voortrekkers
sewing: as art, 133–36; for income, viii–ix, 13–18, 45, 53, 119, 125, 146; terms for, 68n29
sewing machines, 18, 71
Sharpeville Massacre, 23, 26, *27*
Shaw, Ella Margaret, 64, 65
Shonibare, Yinka, 21
Shosholozas, *180*
shweshwe prints. *See* isishweshwe
Sigcau, Stella, *126*
Simons, Norma, *52*
singing, 156, 158, 160–61, *180*
Sisulu, Albertina, *126*
Sisulu, Lindiwe Nonceba, *126*
Sisulu, Walter, 35, *36*
Sittig, Susan, 23
Slabbert, Norma, *169*
slavery, 4–6, 21, 91
sloopkappies, 71–73, *72*
Smith, Pauline, 12
Smithsonian Institution, 163
smouskappies, 71
Somsodien, Gadija, *52*
Soni, Achmat, *52*, 53
Soni-Abed, Zaitoonisa, *52*, 53–54
Soroptimist's International, 13
Sound and Silence of the Mission Station (Slabbert), *The, 169*
South Africa: architecture of, 20, 165, *168*; art of, generally, viii, ix, 164; as Cradle of Humankind, 1; cultural influences in, 3; diamonds and gold in, 11, 85; elections in, *28*, 29, 30; flag of, 38, 164, *190*; HIV/AIDS in, 141, 149–51, 164; interior of, 7, 9; languages of, 59, 60–63, 64–65, 66n2, 67n15, 100n1, *183*; man-made fabric in, 1, 2; National Anthem of, *183*; natural history of, 54, 164–65, 165n4, *175*; sanctions on, 35, 164; slaves imported to, 91; visual elements evoking, 165n4, *175*. *See also* colonization
South Africa Foundation for Islamic Art, 53
South African AIDS Memorial Quilt, 142, 144, *144*, 146
South African Black Women Anti-Apartheid Heroes (Nkosi and Zulu), *126*, 127
South African Constitutional Court, 29
South African Quilters' Guild (SAQG), 18, 20, 107, 109–12, 198n13; banner, *110*; and crafts-based economic development, 45; founding of, 109; programs and special projects of, 110–12, *111*; and Quilt Index, 197; quilts commissioned from, 112; recognition by, 110; structure and membership of, 109, 111–12; teachers accredited by, 111; and Women of Color Quilters Network, 186
South Africa Quilt Heritage Project, 11, 55n30
South Africa Quilt History Project, 110–11, 197, 198n13
Soweto, 119
Soweto Uprising, 24, *26*, 30, 119, 124
Soweto Young Women's Christian Association (YWCA), 120–21
Sparks, Allistair, 129–30
Sparrman, Anders, 62, 67n9
Spirit of the Pilanesberg (Gilks), *114*, 115
Square Kilometre Array (SKA), 159, 162n2
star designs, 11
Starke, Roy, *37*, 38
stars, creation of, 159–60
Stellenbosch Triennale, 50, *51*
Steps to Freedom quilt, 41
Steyn, Tibbie, 76

Stitches (magazine), 164
Strutt, Daphne, 9, 69, 71
Sunbonnet Goes on Safari (Parker and Williamson), 166
Suzman, Helen, 35, 129–30, 131n4
Sweers, Sandra, 156–58
Swiers, Naasley, 161–62

Table Mountain, 52, 54
Tambani Embroidery Project, 16, 17
Tambo, Adelaide, 126
teachers: SAQG accrediting, 111; from UK, 120, 123, 124; from US, 20; in Zamani Soweto Sisters Council, 120–21
Teffo, Rosinah, 28
Teteb, 64
textiles as art and text, 11
"text quilt," ix–x
Thandi (Zamani quilt artist), 124
These Are Our Stories, 156–57, 156, 157
Thomas, N., 101n7
Tolksdorf, Odette, 30, 31, 177, 179, 182
To Zamani (Benberry), 124–25
trade, 3, 91, 198
trade routes, 2–3
Transvaal, 85
tribute quilts, 35–41, 36
Tribute to George Floyd, 33, 35
Tromp, Felicity, 158–60
Truth and Reconciliation Commission hearings, 28, 29
"Tsolwane," 14
Tsongas, Paul E., 57n76, 129, 130, 131n4
Tsotetsi, Lizzy, 28
Turner, Marline, 198n13
Turner, Patricia, 186
Tutu, Desmond, 20, 144, 146; quilt honoring, 191, 192; Rainbow Nation coined by, 53; on Ubuntu, 183, 191
Tutu, Leah, 20, 191, 192
2010 FIFA World Cup, 177, 178, 183
Tyers, Jo, 33

Ubuntu, 183, 191
Ubuntutu (Vandeyar), 191
Ubuntutu: Life Legacies of Peace and Action (MacDowell and Brown), 193n6
uitlanders, 85

Umtha Welanga (Rays of Sun) Treatment Centre, 150, 153
United States: anti-apartheid quilt from, 35, 57n76, 130; National Quilting Association (NQA) of, 111; Quilt Index originating in, 195–96; South African quilts popular in, 16; teachers from, 20
United States Civil War, 30
University of Fort Hare, 14–15, 14
University of South Africa (UNISA), 26–29, 27, 28, 42
urban life, 103, 165n4, 168, 170, 175

"Vaccination Is Very Important" (Makwana), 44
Vandeyar, Diane, 191
Vest, Hilda, 37–38, 57n81
Villiers, Celia de, 26, 28, 114
Vincent, Millist, 21, 22
Voices of Women Museum, 139
Voortrekkerkappies, 69–71, 70, 97
Voortrekkers, 7, 9, 10, 73; isishweshwe worn by, 73, 97, 98; karosses made by, 106; Potchefstroom founded by, 103; quilts of, 106–7
Vuvuzela Madonna (Tolksdorf), 177

wag-'n-bietjie bos lace collar, 78
Wagner, Richard, 117n6
Wall of Peace Quilt, 112
Walwyn, Sheila, 52, 53, 180
Warmelo, Nicolaas Jacobus van, 64, 65
War Museum of the Boer Republics, 23, 75, 80n1
war quilts, 21–22, 22, 81–87
wax prints, 20–21
Weeder, Michael, 144
White, Beverly, 36, 57n79
White South African women: apartheid opposed by, 30–35, 100; isishweshwe used by, 73, 91, 97–99, 100, 101n4
white work, 6, 6, 70, 71
Why Are You Afraid? (Kriel), 133, 134–36, 135
Wightman, Belinda, 52
Wikar, Hendrik, 62
Williamson, Jenny, 41, 164, 166, 170
Williamson, Marianne, 190
windmills, 171

Windmills on My Mind (Parker), *171*
woad, 89
Wolpe, Harold, 35, *36*
Wolpe, Howard, 35
Wolpert, Betty, 119–20, 127n4
women: Boer War and post-war experiences of, 76–79, *78, 79*, 97; and crafts-based economic development, 13–18, 20, 24–26, 30, *32*, 45, 111; experiences of, in quilts, 21, 23–24, 75–77, 78–80, 137–40; and gender, in art, 134–36; and gender decorum, 95–97; memories of, 137–40; sewing skills of, 13, 18, 45, 97, 119–20; as survivors, 134–36, *135*; violence against, 135, 139; work of, 67n14, 97. *See also* Black South African women; White South African women
Women of Color Quilters Network (WCQN), 38, 185, 193n2; Mandela celebrated by, 185–86, 192, 197; and Quilt Index, 197; in South Africa, 192; the Tutus celebrated by, 192, 197
Wood, John George, 1–2
Woodward, Caroline, 4
work songs, *180*
World AIDS Conference, 146
World Summit on Sustained Development Quilt, 112
Worrall, Mary, 195–96, 198, 198n13

X, Malcolm, *187*
Xaba, Dorothy, *28*
|Xam people, 155–56
|Xam stories, 155–56, 161; the ancestors and, 157–58, 161–62; wisdom and healing in, 161–62
xenophobia, 30, *32*
Xenophobia Memory Cloth (Msibi), *32*
Xhosa-speaking peoples, 18, 64, 152, 153
Ximba, Lobilile, 137, *138*

Zagel, Janine, 137
Zamani (Hlomuka), 123–24
Zamani Soweto Sisters Council (Zamani SSC), 18, *120*; Benberry and, 121, 124–25, 185; building owned by, 125; businesses started by members of, 125–27, *125*; exhibitions, 120, 124, 127; founding of, 119–20; newsletters, 123; teachers in, 120–21, 123
Zulu, Leonard, 137
Zulu, Vangile, 35, *36*, 125–27, *125–26*
Zulu artifacts, *181*
Zulu headrests, *179*
Zulu quiltmakers, 18
Zulu War, 21–22
Zulu War Army Quilt, *23*
Zyl, Bettie van, *172*

For Indiana University Press

Tony Brewer *Artist and Book Designer*
Allison Chaplin *Acquisitions Editor*
Anna Garnai *Production Coordinator*
Sophia Hebert *Assistant Acquisitions Editor*
Samantha Heffner *Marketing and Publicity Manager*
Katie Huggins *Production Manager*
Dave Hulsey *Associate Director and Director of Sales and Marketing*
Nancy Lightfoot *Project Manager/Editor*
Dan Pyle *Online Publishing Manager*
Michael Regoli *Director of Publishing Operations*
Pamela Rude *Senior Artist and Book Designer*
Stephen Williams *Assistant Director of Marketing*